any 2 people, kissing

Kate Dominic

Down There Press

San Francisco

any 2 people, kissing: New Erotic Fiction
©2003 by Kate Dominic

Library of Congress Cataloging-in–Publication Data

Dominic, Kate, 1955-
Any 2 people, kissing / Kate Dominic.
p. cm.
ISBN 0-940208-28-8 (alk. paper)
1. Erotic stories, American. I. Title: Any two people, kissing.
II. Title.
PS3604.O63 A84 2002
813'.6—dc21

2002002741

We also offer librarians an alternative CIP prepared by Sanford Berman.

Alternative Cataloging-in-Publication Data

Dominic, Kate, 1955-
 Any 2 people, kissing: new erotic fiction.
San Francisco, CA: copyright 2003.
 Thirteen short stories, dealing variously with "voyeurism and exhibitionism, fetishes, power plays, topping and bottoming, fantasies, toys, promiscuity and monogamy."
 1. Erotic fiction, American. 2. Short stories, American—21st Century. 3. Dildo use—Fiction. 4. Masturbation—Fiction. 5. Exhibitionism—Fiction. 6. Fetishism (Sexuality)—Fiction. 7. Sadomasochism—Fiction. 8. Bondage and discipline—Fiction. 9. Sexual fantasies—Fiction. I. Title. II. Title: Any two people kissing. III. Two people kissing. IV. Title: 2 people kissing. V. Title: New erotic fiction. VI. Down There Press.

Additional copies of this book are available at your favorite bookstore or directly from the publisher:
 Down There Press, 938 Howard St., #101, San Francisco CA 94103
Please enclose $18.45 for the first copy ordered, which includes $5.95 shipping and handling; add $2.00 for each additional copy.

Visit our website: www.goodvibes.com/dtp/dtp.html

Cover Design: Eileen Wagner
Book Design: Bill Brent (BB@blackbooks.com)
Printed in the United States of America 9 8 7 6 5 4 3 2 1

For Todd

Table of Contents

Acknowledgments

I owe an incredible debt of gratitude to many people for the help, knowledge, and advice they so freely shared. Thanks especially to Leigh Davidson, V. K. McCarty, and Lawrence Schimel for teaching me the business of publishing—and for their continuing patience with the tons of questions I'm still asking. John L. Myers for letting me pick his brain about the business of public sex and adult entertainment. Simon Sheppard and Hugh Coyle for friendship and for asking the thought-provoking questions that keep me honest. Barb Dozetos for helping me figure out the "do I want to date her or go shopping with her?" analogies. Patrick Califia-Rice for technical advice on "Cuff Links," Doug Harrison for technical advice on "Janus." Any screw-ups are, of course, entirely my own. Carol Queen for *Exhibitionism for the Shy*. My characters are definitely less shy these days. The real me, well . . . I'm working on it—and enjoying my homework.

Alex Krislov and Readers & Writers Ink for the CompuServe literary forums, especially LitForum and Writers. Margaret J. Campbell, indomitable leader of the RWI workshops where I first found the incredible community of writers online. Bonnee Pierson, Michael Stamp, and Barry Alexander for thoughtful, thorough, "bled all over it with red ink" comments on more stories than I could ever count. Rob Byrnes, Piper Fahrney, Veronica Kelly, Debra Hyde, Hall Owen Callwaugh, Shelley Marcus, Eve Ackerman, Joyce Moye, Isambard, Laura, and Dick for critiques and irreverent insights and highly appreciated immoral support. Bruce Edward Taylor

for pulling rabbits out of a hat in the hinterlands of Wisconsin. J. Scott Coatsworth, Shane D. Yorston, Jess Hays, and J. Fireagle for Q*Ink. Adrienne Benedicks, Lybbe, and the cast and crew of the Erotica Readers & Writers Association for selflessly sharing resources and anecdotes and for reminding me to always keep the romance in my stories. The members of the TransWorld Writers Society for introducing me to the professional potential as well as the fun in real-time internet chats.

Janeen and Gari and Diane and Julie for lunches and laughter and chocolate when the going got tough. My mother and siblings, who don't really understand, but offered unfailing support anyway. (Mom, if you ever read more than this introduction, keep in mind this is not my auto-biography!) My dad, for teaching me to go after my dreams. One pre-sumes you've won half of heaven in poker games by now. I miss you.

Jason for endless proofreading and James for reference materials—and both of you for letting me hog the phone lines and pretending to understand why I was surfing porn sites for "research." Matt for hugs when I was tired. Monty the Wonderdog and the kittens for company and for nodding vigorously when people asked if I really wore 4-inch stiletto heels and slinky negligees when I wrote. And always, always, to Todd. Your love freed me to write.

—Kate

Introduction

What's the hottest thing you've ever seen?
Any two people, kissing like they mean it.

I wrote one of my favorite stories from the viewpoint of a cat—a voyeuristic, opinionated (is there any other kind?), domineering (ditto) exhibitionist who just happened to be a reincarnated gay bar slut. He couldn't interact (so to speak) with the other characters, as they were now the wrong species. So, my furry little gossip watched and directed instead, exploring the deviously erotic possibilities of the new skin he was wearing, and getting turned on something fierce by telling his tales.

El Gato has gone on to other anthologies (and last I heard, a website or two). I'm still here, though. And now, more than ever, I'm hooked on exploring other people's erotic skin from the inside out—sliding up and down the Kinsey scale in male and female voices, blurring the lines where genders and orientations blend and cross. Like that blasted cat, I get off on voyeurism and exhibitionism, as well as fetishes, power plays,

topping and bottoming, fantasies, toys, promiscuity, solo sex, monogamy (one of my favorite kinks), and, of course, on telling. There's something so primal about sharing sex. Only now, my stories are peopled by, well, people. Okay, and one uppity young godling who needs a few lessons in internet commerce.

Come slip into someone else's skin with me—someone kissing, and meaning it.

—Kate

The Lady Jade

Lady Jade's Story

I didn't care what happened to my Western Civ grade. The only book I'd been studying for the last three days was Carol Queen's *Exhibitionism for the Shy*. I was depending on it to save my life—or at least my reputation.

I rested my head on the table, kicking myself again for getting in such a gawdawful embarrassing position. Pledging $400 in my sorority's National Masturbation Day fundraiser had seemed like such a wonderful idea. I mean, the proceeds went for breast cancer research, and I was paying the money myself, so I didn't have to prove to anyone that I'd, well, you know, met the letter of the law. Since I had so much homework to do, I figured I'd just pay my money and maybe grab a soda at the after-event party down in the lounge.

Much to my dismay, my friends promised to match me, dollar-for-dollar, if I joined in the masked, women-only free-for-all on the main floor of the house that afternoon. My roommate, Roxie, even offered a

$200 bonus if I participated the entire two hours of the event. Talk about mortified! I was going to say no. I mean, some things are just private, you know? But $600 was a lot of money, and it was for a good cause.

Besides, it sounded kind of kinky—like it could be fun, especially if I were wearing a mask, which was something I wouldn't even have thought of if Roxie hadn't left that damn book out where she knew I'd see it.

And I already had a sexual persona. Granted, I was a meek, mild-mannered Lit geek by day: horn-rimmed glasses, tortoiseshell clip to shove my hair up out of the way, uniform jeans and T-shirt. But at night, I put in my contacts, let down my hair—my long, blond hair—and changed into the wanton Lady Jade, an uninhibited pirated who kept a wicked treasure chest secreted in the bottom of her closet.

The treasure chest was real. Sometimes, I convinced myself it had been my destiny to visit that particular yard sale on that specific day last fall. An old lady had been cleaning out her attic and ran across her great-grandmother's steamer trunk. It sat in the far end of the garage while the woman waited for her neighbor's son to return from his errands and pry the lock open so she could see what was inside.

I tried to look disinterested, hoping that would keep the price low. But as I talked to the old lady, I couldn't help letting my excitement show. The chest was so old, and it held such potential! My runaway writer's imagination warred with my insatiable curiosity for historical fact. The lady and I bantered back and forth, eventually over lemonade, about what kind of treasures could be inside and how sad it was that her children, all grown and gone now, had no interest in "family artifacts."

Eventually, I ran out of time. I had a midterm that afternoon. As I reluctantly turned to leave, I cast one more longing look at the trunk and sighed heavily. My newfound friend burst out laughing.

"You take it, dear," she said as she wiped her eyes. "As-is, $15, providing you take proper care of anything you find that has historical value. For the amount of fun we've had guessing at what's behind that lock, I've more than gotten my money's worth."

I grinned all the way back to campus, carefully pulling my new acquisition in the rusty old wagon I bought with my remaining three dollars. When the locksmith finally left, I sat down on the rug in my dorm room, fingering my shiny new key and running my hands over the scratched but now open latch. Then I took a deep breath and slowly lifted the lid. The rich scents of dried floral sachets and old leather filled my nostrils.

Even now, I smiled when I thought about the fun I'd had meeting the old lady's great-grandmother. Talk about a wild woman! The Lady Jade's diary and letters were full of the pirate she'd loved and the adventures they'd had together. He brought her jewels from his raids, and lawdy, the clothing she wore! His ship went down when he was 27, and she only 23. But the passionate affair they'd shared was the hottest love story I'd ever read.

The clothing in the trunk fit like it had been made for me. I figured bringing Lady Jade back to life would more than get me in the right frame of mind for National Masturbation Day. Good ol' Roxie was going to be elected to read the diary while I acted it out. If she got too horny, well it was her own damn fault. She could bring a vibrator to keep herself entertained.

⬿

Christian took my innocence tonight. In the marquess' garden. On a wooden bench in the gazebo. With the stars as witnesses and a hundred

people waltzing on the other side of the hedges, close enough for me to hear the faint trills of their laughter. The air was hot and sultry, the breeze thick with the scent of night roses and the startling, heady perfume of our joining.

Father would not approve. Indeed, he would try to shoot my darling lover! I laugh as I write this. Not because of Father's anger. I love him dearly, and, I thank God, he is too blind to aim true. He will never know. What woman could ever admit to giving herself to an impoverished peer of the realm, much less one who was also a pirate with a sizeable bounty on his head? All and sundry agree, though, that Christian's long, dark hair and broad shoulders are dashing, his lecherous smile could melt ice even in winter, and he is ever so dangerous with a sword.

Again, I am laughing. He is ever so dexterous with my favorite sword. I am still sticky and tender, my skin alive with the joy of loving him. Without my Christian, I would never have known the pleasures of brazenly lifting my skirts to a man's questing tongue and shaft. While the night birds sang around me, my body opened, in pain and in wonder, to the hot slide of his thick and plundering flesh. Mine was a most willing seduction. I was mindless with wanting him. And Christian, oh, I cherish the memory of the look on his face as he shuddered and emptied himself into me.

Edward is furious. My dear brother can say nothing, of course, for to do so would ruin me—and his fiancee, Meredith, whom he loves to distraction. Everyone believed he was chaperoning me while I strolled into the darkened corners of the maze. Edward actually thought I sat stoically on a marble bench with Meredith's dozing elderly aunt, while Meredith and he were ravishing each other in the shadows. Hah! Since he was dallying with his love, why in God's name wouldn't I be doing the same with mine?

❧

Roxie was downstairs already, reading the introductory entries, getting the rest of the celebrants in the mood for some serious self-loving— or at least letting them know that I'd be upholding my end of the bargain, even from behind my mask.

Once she'd read the diary, Roxie had immediately started putting in bookmarks and associated letters and practicing her diction. And she'd announced that she'd be taking her plug-in vibrator with her—to be damn sure the electricity lasted!

I toweled off from my shower and unclipped my hair, brushing it out carefully before I picked up the crystal perfume vial I'd inherited from my own great-grandmother. I inhaled deeply, closing my eyes for a moment as the light musky spice slid into my nostrils. Then I dabbed a tiny drop of the golden liquid at my pulse points: on my wrists, behind my ears and knees, in the creases of my groin and down the valley between my breasts. Suddenly, I smelled like sex. I grinned and lifted the lid on the trunk.

❧

Meredith is pregnant. She is frantic, of course. Her father would disown her, no matter that he's always considered Edward a quite suitable match for his only daughter. So my brother and his love are eloping tonight. Officially, I am hying off to Gretna Green with them, in the company of an imaginary Frenchman who will then spirit me off to his estates on the continent. In reality, I am going directly from London to the Caribbean, where I will join my Christian on his ship, without benefit of any man's clergy.

This time, I suppose Edward's ire is understandable. After all, I am his only sister, and he feels responsible for my seduction. And yes, he, also, would gladly shoot Christian. But there is nothing Edward can do, especially with Meredith so indisposed. At least he will soon be too busy with his new wife and child, and his taskmaster of a father-in-law, for whom he will now work, in textiles, of all things, to do anything about his wayward sister. He will give my love to Father, and tell him I am well. And he will keep the secret of what has happened to me, and the true identity of my rogue of a "husband."

<div align="center">☙</div>

My hands trembled as I lifted the lid. I was surprised. After all, I'd done this so many times before. Three creamy white linen shirts rested on the left side of the trunk, stacked just the way she'd left them. Each had billowing sleeves and a wide-opened V front, held closed by only a tie string at top. A man's shirt, but with the shoulders taken in, with perfect, tiny stitches, to fit a woman's more delicate build. I chose the top one, my favorite because it was worn so smooth the fabric caressed my skin each time I moved. I slid my arms in, but left the string undone.

Beneath the shirts lay a single brown leather vest—the kind that laced below the breasts, pushing them up to strain against the drape of the shirt until the dusky shadows of areolas showed. I knew from experience how my nipples would harden when the soft linen tightened across them. I pulled the vest over my head, then stood in front of the mirror to watch while I reached into my shirt to lift first one breast, then the other, into the soft linen cup of the shirt. As I tightened the lacing, my breasts pushed up and out over the tightly cinched leather. I couldn't resist circling my palms over my nipples, shivering when the tips poked out of the

fabric, impudent and demanding and definitely not the way the breasts of a proper lady should be presenting themselves in public.

But Lady Jade was not a proper lady. I tied back my hair in a silken scarf. Then I reached beneath the shirts and drew out a small, simple mahogany chest. Inside, on a bed of deep green velvet, was a wealth of treasure.

∞

Christian spoils me with jewelry. I wear golden earrings, to match his. They were looted from a Spanish merchantman. I imagine they make me look as much the pirate as they do my incorrigible lover. He is so handsome with his long, dark hair flowing over his naked, sun-bronzed shoulders. He mans the wheel of his ship wearing just breeches and boots and a string of jade beads around his neck. And his earrings.

Mine swing freely beneath my earlobes. I keep my hair pulled back to show off my gold, a long, silken scarf tied around my head that fits like a tight cap with the ends flowing down my back. The scarf also keeps my hair out of Christian's way when he wants to take me quickly. He gave me pearls for my birthday, an elegant well-knotted strand he pulled from a velvet pouch. He'd been raiding again and grinned unrepentantly when he yanked the scarf from my head so my hair would flow freely in what he calls my "golden halo." He exaggerates—greatly. I am no angel. When I lay naked on our bed in the captain's cabin, he wrapped my wrists tightly in the rope of pearls and ravished me with his tongue, slowly and languidly, until I shook beneath him. So I demanded he give me his cock. I sucked him into my throat until he gasped and spewed his man cream.

It is his secret jewelry, though, that makes my belly tremble. At first, I'd thought the golden hoops were new earrings. I didn't understand the

sturdy balls at the end of each loop. When I lifted them to my ears, Christian laughed, deep and husky, and pulled me to him. He untied my shirt and sucked my nipples until I was desperate with wanting him. Then he ever so gently, ever so firmly, lifted a golden hoop to my nipple and slipped it on—and squeezed the little balls towards each other.

He took my cry into his mouth, pinching and tugging the other peak until it, too, was ready for his wicked golden ornament. Then he closed my shirt and said he would not touch me again until we had strolled the length of the deck in front of the men and admired the moonlight on the glassy sea—until my nipples burned with wanting him.

∽

I lowered the top of my shirt and tugged my nipple. It perked up red and hard into my fingers. Even though I was watching in the mirror, I gasped when I slipped the golden knobs over the peak. The pinch wasn't too tight—enough to keep the ring in place, but not enough to cut off circulation for the length of time I'd be wearing it. But the stimulation rippled all the way down to my pussy. Shivering, I did the same for my right side. With my shirt still open and the golden hoops rising and falling with each breath, I reached for the piece that was already making my pussy wet with anticipation.

∽

Two can play at this game. My beloved Christian had no doubt thought to teach me of the other jewelry today. Instead, I figured it out on my own, and I taught him a lesson he will not soon forget. The V-shaped silver clamp was sturdy, with heavy emeralds dangling from the apex and the ends of the close-fitting legs. The slight indentation inside the V gave

me my clue. I slipped it over my inner labia, gasping as it pinched my woman's lips together. By the gods, it was delightful! So wicked and stimulating. Like the nipple rings, it was loose enough to wear for a long time, but tight enough to stay in place and keep me almost mindless with wanting. The heavy jewels swayed when I walked, tugging mercilessly at my woman's nubbin.

I wore the damn piece all afternoon, and I made sure Christian knew. As he stood at the wheel, I walked up and whispered in his ear, thanking him for the emeralds. Just these words, I said, "Your emeralds are kissing my pussy, Christian. I'm wet and I want you, and we both know you can't have me until tonight." Then I bit his ear quickly and sauntered off to the galley, rolling my hips even more than usual, turning back to smile, even though I felt my face flush when a shiver trembled through my cunt. He was watching me like he wanted to devour me, his eyes dark and burning with desire, and his cock, dear God, I thought it would split the front of his breeches. When he saw my blush, he smiled like a wolf that had just eyed his prey.

I put the nipple hoops on before supper. I knew why he'd told cook we'd be dining in the cabin, a rarity for us. I'd barely set our food on the table when Christian slammed the door shut and grabbed me. I straddled his face and laughingly ordered him to lick me, to eat my pussy while I was wearing his wicked jewels. He did, with relish. And while I shuddered above him, he held the silvery ends together, tightly, until my nub stood out fiercely between them, and I surrendered to the delicious torture of his tongue.

☙

I worked the heavy silver over my swollen clit. I'd done it before, so many times, but I still shuddered when the delicious pressure sent a

rush of pleasure rippling through my cunt. I breathed deeply, letting the waves roll over me. And when the tremor passed, I turned back to the trunk and reached on the right side, into the pile of breeches. There were three pairs, one a buttery soft tan leather, the second a dark sturdy wool with a patch on the knee. The third—I shivered again when I lifted it. The third was a deep, jade-green silk. It fell over my arm like a second skin. All three pairs of breeches were crotchless. Not noticeably so. A talented seamstress had obviously designed the intricate seams. To an outsider's eye, they were traditional men's pants. But when I pulled on the silken breeches, my fingers slipped between the almost liquid soft folds and felt the warmth of my naked flesh.

Willing myself not to come yet, I carefully situated the emeralds so they could swing freely beneath me. Then I pulled on my knee-high, brown leather boots and tied on my mask. The gilded face piece ended just below my eyes, like a carnival mask. Christian had stolen it long before he met his lady, but he insisted she wear it the few times she accompanied him on his illicit quests. Like everything else in the trunk, it fit me perfectly. I picked up the treasure box and walked downstairs. With each step, the heavy jewels tugged and pulled against my swollen labia, and I knew what Lady Jade had meant by "need."

<div align="center">♋</div>

Christian had no idea how good a seamstress I am. I modified my work breeches first. When I saw how they fit, how they'd give him access while still hiding my nether regions from all but him, my womanhood got damp just thinking about how he'd react. I cornered him below decks, when he had just finished giving orders to reinforce the beam from which the men hung their hammocks. As the others trooped up top into the bright afternoon

sunlight to gather their supplies, I moved to Christian's side, slightly in front
of him, knowing he'd surreptitiously, almost unconsciously, rub between my
legs, the way he always did when no one was looking.

I knew the moment he realized. His whole body went still, and for a
just a second, his breath caught. Then the air left his lips and he grinned
fiendishly. His questing fingers slid into the hidden slit in the material, his
rough, calloused hands demanding, sinking into me, and his rock hard
erection pressing against my bottom. I'd thought to tease him and leave,
as I so often did. But as I moved to step away, he grabbed my shoulder and
pulled me up against him, his fingers still buried in my cunt. He looked
quickly around, and then dragged me in back of the pillar.

"Too late, my lady," he whispered. With a half dozen crewmen just
beyond the ladder, he bent me over in front of him. He tore open his
breeches and, covering my mouth with his hand, he plunged into me. Our
joining was quick and fierce, and when he pulled out, his cock was dripping
with his seed. He yanked me upright and stuffed his still-swollen shaft
back in his breeches as the first of the men came around the ladder. No
one seemed to notice my trembling, though to a man their nostrils flared.
Even I had trouble believing we could have done such things while fully
clothed. When I could breathe again, I fought to hide my grin.

∽

"Hot damn!" Roxie laughed. Although she was still holding the diary
in one hand, she'd opened her jeans and had the other hand shoved
down inside. Her face was flushed and I could see her fingers moving as
she pinched herself beneath the dark shadow of the dampened denim.

I was feeling so wanton that I didn't care who recognized me under
my mask. After all, it was National Masturbation Day. When Roxie set

down the book to peel off her jeans, I licked my finger and slid it slowly into the slit in my pants. I didn't expect the "unh!" of pleasure that slipped past my lips, but I couldn't control it either. I rubbed my distended clit until I was trembling. And when I pulled my finger back out, I lifted it to my lips and sucked.

∽

Christian's seed ran down my thighs as he nonchalantly, authoritatively, directed his men. I could have pummeled him. As he spoke, his hand once more teased over the outline of my hip and slid between my legs. I was shadowed by both him and the pillar, pretending to read the stores log. The log could have been upside down for all I cared, and it was too dark to read in there, but none of the men would have known that. None of them could read. So, while I stood there, staring blankly at the sheaves of paper in my hand, my face flaming hot, Christian fucked me with his fingers. My legs were still spread and his juices ran down onto his fingers. I could smell them, even over the sudden odor of vinegar as cook stepped to the other side of us and opened the pickle barrel. But Christian didn't stop. When the men all finally walked away, he twisted his hand, lifting me up onto my toes, his fingers buried deep in my cunt, and he rubbed his thumb fiercely over my clit. I shook as I came, biting my lips, trying so hard not to cry out as the orgasm rolled over my body and the sound of Christian's soft laughter filled my ears.

"Dear God, but I love you!" He hugged me to him, his tongue sweeping over mine as he kissed me. He lifted his hand between us, and God help me, he licked his fingers clean. I shook when he brushed the last one against my lips. I licked, tentatively, surprised at the salty, sticky tang. His smile lit his face.

"Wear the damn jewels, tonight," he growled, "so I can feast properly."
Then he was gone, up the ladder and into the bright afternoon light.

∽

"The jewels are real?!!"

The incredulous voice rose over the loud moans and the low hum of vibrators in the room. I slowly untied my shirt and lifted my breasts into my hands. My nipples looked so beautiful wearing the golden hoops. I flicked my thumbs over the deep red peaks and walked over to stand in front of the doubting Thomasina. I slowly slid the nipple ring off, letting myself gasp loudly as the flames of sensation surged through the tip.

"Pinch your nipple and Lady Jade will show you," Roxie purred. Hesitantly, the young woman did, blushing as her nipple perked up under her tugging fingers. "Now hold it out, and don't you dare move!"

I slipped the hoop on the dusky tip and pressed lightly on the ring, so the balls moved closer together. Her cry filled the room as she arched her warm, heavy breast into my hand. I'd never touched another woman's breast before. But somehow, I knew the Lady Jade would have been accommodating. I stroked the lower curve. My blushing new friend leaned into her partner's arms, wiggling and squirming. With no warning, the partner moved her vibrator to her girlfriend's clit and flicked the switch. Lady Friend screamed, her whole body arching up and shaking as I pressed the rings together and her girlfriend held the vibrator firmly in place. When the orgasm finally passed, our now-convinced listener smiled sheepishly and fell back into her girlfriend's arms. Their lips brushed together, in an, oh, so tender kiss. I slipped the ring off and smiled when she again cried into her lover's mouth. The sounds of horny women laughing again filled the room.

I stood up and moved back to the center of the floor. Roxie's eyes were sparkling. "Now, my lady friends, you will see some truly astonishing jewels."

To ooh's and aah's, I slipped the ring back on my nipple. It hurt, the throb tugging deep into my cunt. But I didn't fight it. I threw my head back and let them hear me moan as I fought to master the pain. Then, while they were still distracted and Roxie was laughing softly, I spread my legs wide, squatted, and opened the slit in my crotch. I gasped as the emeralds fell free. They swayed beneath me, each tug rocking through my labia, tormenting my clit. To the sound of passionate breathing and suddenly even louder buzzing, I slowly rocked my hips back and forth, letting the jewels squeeze a merciless orgasm from me. While the wet silk rubbed against me, I bowed my head and watched my pussy cream run down onto the jewels, until a single, crystalline drop fell onto the floor beneath the gently swaying green stones.

∞

Christian cannot keep his hands from me. He steals up in back of me, even when my head is bent over my cooking pot, and fills me with his fingers, caressing my woman's nub while we talk about spices to be picked up at the next port or the bribes we'll pay to maintain our anonymity near offices of the Crown or a hundred other minor things. He stops while I am chopping, grinning fiendishly until I've added the carrots or onions or nuts to our meal. Then his fingers slide into me again, slick and strong and demanding. To all the world, there is nothing going on as I finally come against his hand, quietly shaking and gasping into his stolen kisses and his smoldering brown eyes. If my climax gets him desperate enough, he takes me, sometimes a second time, or a third, sliding on his own cream until my trembling muscles milk another orgasm from him.

Dear God, how can I love him this much? How can I be so proudly shameless with him? Last night he fucked me while I kneaded the bread! I crave his touch as much as I relish making him tremble to mine.

∽

I pulled a long strand of incredibly smooth jade beads from my pocket and wound them around my fingers. Roxie turned the page, and I leaned back onto a pile of cushions on the floor. I lifted my knees to my chest and squished a pillow beneath my lower back, inhaling the scent of my juices and the faint hint of my perfume as my thighs opened. Then I placed my bead-draped hand between my legs.

∽

Christian fucked my bottom yesterday. We were in the stores room again, sweating in the blistering afternoon heat. Much of the crew was either napping in their hammocks or doing quiet chores on deck in stolen corners of shade. Christian had taken me twice already that day, but too quickly for me to reach fulfillment. My pussy was slick with my juices and his seed. As he pressed up against me, shielding me from the open door with his body, his fingers once more fucked my dripping cunny, his thumb sliding on my juices while he massaged my desperate nubbin.

Then he turned me around and rubbed my rosebud. I gripped the support beam, too stunned to do aught but hold on as he played with both of my holes. His fingers were magical, gliding in and out of my pussy while his thumb caught my dripping juices and teased and loosened until it was sliding freely through my startled, clenching sphincter. He pushed his thigh between my legs and forced them further apart. Then he once again opened his breeches and bent me over in front of him.

I gasped when his cock slid into my squishing pussy. He thrust, several times, until he was slick. And while I trembled beneath him, he spread my bottom cheeks. He pressed the tip of his cock to my rosebud and slowly, oh so slowly, entered my virgin nether hole. The painful, burning stretch was like nothing I'd ever felt before. So invasive. So intimate. So forbidden, even for a pirate. Christian squeezed my bottom reassuringly; slowly withdrawing his slippery shaft, and then sliding it back in again. I shuddered against him, pressing back to open myself to his torment. He sank in so deeply it felt like he was splitting me with his cock. In spite of myself, I moaned, feeling every tiny, exquisite motion of his velvet-skinned shaft sliding over my hidden sphincter lips. I hugged myself around him, clutching his swollen lance in a long, slow embrace, and I squeezed.

Christian went wild. He gasped and pulled me upright into his arms, fingering my clit as he thrust ferociously into me. He fucked me fast and raw, growling in my ear as he emptied himself up my ass and my climax finally, blessedly, washed through me. Laughing softly, I turned my head to kiss him. For once, my poor Christian looked well and truly spent. He crushed me to him, panting heavily. And oh, he smiled.

When he pulled out, he took the jade beads from around his neck and slowly threaded them up my bottom. I felt each luscious bump press in. Then he tugged. I gasped as the beads popped out, one after the other, sliding over my sensitized bottom lips. He did it again, and again, until I could scarcely breathe. Then he whispered in my ear.

"I will want your bottom often, love. Be ready for me."

So tonight, I sit at Christian's desk, squirming as I write, with the beads nestled deep in my bottom and only a bit of string peeking out. Much as it makes me blush to say this, I have made full use of the cream with

which I soften my hands, sending the beads in and out of my nether hole until I am desperate for the relief of Christian's cock. He will be coming off watch soon. I shall stop writing now and go to him.

∽

The beads rested half in and half out of my anus. As I lay there panting, Roxie stripped off her panties and twirled her fingers in the dark thatch between her legs.

"I'm really horny, guys, and this next part is just so hot! If anybody else wants to read, say so now. Otherwise, you'll just have to wait whenever I want to come." She looked carefully around the room. "No takers?"

There were no objections, just a breathy chorus of murmured "no thanks" and "you go, girl!" She turned to me and winked. "Proceed."

∽

Last night Christian fucked me in front of his crew. No one knew. He had just returned from two weeks of raiding. We were encamped on shore, resting while repairs were made to the ship. As darkness fell, several of the men went off with native women. The ones who didn't sat around the fire, waiting for news and stories.

Christian and I were seated at the edge of the shadows, leaning against a tree and each other. The first mate broke out the rum. As the bottle was passed, Christian pulled me onto his lap, facing him, my legs about his waist. I was so happy that I leaned my head back and laughed, teasing his men about how silly they looked upside down, and about how forceful their captain was. As I spoke, I wiggled brazenly on his lap, rubbing myself over his straining erection.

Christian's fingers slipped between my legs, quietly opening the silken shield while I boasted and giggled. He was so hard, and in moments, his breeches were open. The men cheered and raised a toast to their captain, drinking deeply. And while they were distracted, Christian lifted me up, just the barest of motions, and set me back down upon him. His steel-hard shaft slid into my cunt on one long, slow, breath-taking glide. As my sheath closed around him, his shoulders stiffened, but he said nothing, just pulled me closer to him and held my legs tighter around him.

"The cap'n's got his hands full," the boatswain laughed. He was one of the few who could get away with being that forward. He and Christian had sailed together since they were boys, and the crew was used to seeing the captain's lady sitting on her lover's lap.

Christian just chuckled, "She keeps my fires warmer than the rum does, boys."

Again the crew roared. Christian smiled. And while the hand toward the fire stroked my shoulder, the other one quietly, in the shadows away from the fire, untied my shirt. He ordered another round of rum for the men, at the same time cupping my breast and stroking his thumb over my nipple. Never looking at me, his eyes still on his crew, he told a raucous pirating story of the recent raid. I lifted my arms to rest on his shoulders, tangling my fingers in the fire reflected in his long, silky hair. As he stroked, my muscles squeezed around him, milking him while he casually teased first one hard peak, then the other.

He came right away. He barely paused in his speaking. Only I noticed the shudder rippling through him as he lifted his mug, resting the rim on his lips until he could breathe enough to drink of the well-aged rum. He bent down, kissing me deeply and letting the rum trickle from his mouth into mine. The burning liquid slid down my throat, hot and wet, while

the men laughed at their captain's lusty ways, and their lady's enthusiastic response.

"Aye, a lassie always needs a kiss."

"That she does, men," Christian grinned, lifting his mug. He was still hard within me. He didn't give away a thing as he slowly trailed his hand down my belly. His fingers touched my heat and his eyes grew smoky. I arched into his hand and moaned, very very softly.

He gave me no respite. He worked my nubbin, rocking his hips ever so slightly and twitching his cock deep inside me, against my womb, rubbing the cool pewter mug absently over my nipples as he spoke, so no one would notice. Eventually, he turned the storytelling over to his first mate and leaned back against the tree, so I could rest against him. But I wasn't resting. I was almost insane with lust. He was thrusting again. He made me come—three, four, five times. I silently trembled in his arms, climaxing over and over again around the hot, stiff shaft buried so deeply and lovingly in my hungry cunt. When the men were distracted by the pouring of another round, Christian bent his head and quietly sucked my nipples, his long hair brushing loose and unbound against me as he licked and laved and nibbled. Eventually, his breathing grew harsh again. He took advantage of the distraction of the mate's story and the drunkenness of his crew and the dying fire to quietly thrust into me, harder this time, until every inch of my body burned for him. When I once more started to shake, he took my lips with is own and kissed me, tonguing me through a final shattering orgasm while he once more emptied himself deep inside me. Heaven could be no better than this.

Yet even as I write the words, I am afraid, both of the depth of my love for him, and of the tremors I felt tonight, deep in my womb, when he planted his seed in me. Much as I would like to give Christian a child, the

bounty is so high on his head, and our lives so uncertain. If his seed takes root, I shall have to honor my word to him and return to Edward and England, to bear our child in safety.

∽

A small, gold wedding ring rested in the bottom of the box. Even without looking, my fingers found the worn inscription that read simply, "Beloved." I tucked the simple band carefully under the rope of pearls. Some things are not meant for public consumption.

Some things are. Roxie stretched, the book in one hand and her vibrator in the other, as she resituated herself in what had obviously become her favorite chair. Except for her socks, she was naked now, her eyes sparkling with anticipation.

A collective gasp filled the room when I pulled the final item from the treasure chest—an ebony phallus, long and thick, and fully erect. The details were exquisite, down to the fully retracted foreskin and the soft whorls of hair on the heavy, low-hanging balls. I caressed it briefly with my hands, and then passed it around the room, letting anyone who wanted to touch it and run her hands over the smooth, polished wood. To feel the memories and the love. With the beads once more nestled in my bottom, I rolled a condom over the beautiful, antique dildo and lifted it to my lips. I kissed it once, softly and delicately. Roxie cleared her throat one last time.

∽

Christian has given me his cock and balls. Not that he doesn't share the living, breathing ones between his legs with me every day we are together. But since I must leave soon, he had an ebony phallus made for me. I

blushed like my face was on fire. It was at once so vulgar and so wicked, and so beautiful. Christian laughed until he almost choked, rubbing "both" his cocks against me while I blushed and giggled like a schoolgirl.

God help me, it is exactly like his cock and balls. He had it custom made for me when we were in Hispaniola. Christian kept himself hard for hours, stroking himself, licking his palm to keep his erection slick and stiff so the old man carving the wood could get every detail perfect. Then Christian secreted the phallus in his trunk and gave it to me as a wedding present.

We'd married that afternoon, before a Methodist minister who disapproved heartily of my attire, even without knowing of the hidden slit in my crotch. But the crew looked dangerous, and Christian was persuasive. So while the paper meant nothing to us, we said the words to legitimize our child quickly, in front of God and Christian's crew and the self-righteous young man in the ridiculously heavy woolen suit. Then the men went off to drink, and my husband and I retired to a large bed in a well-guarded villa to once again consummate our union.

He took me slowly this time. Tenderly, with all his love showing in the burning passion in his eyes. The cool ocean breezes wafted in the open windows, bringing the smells I so loved—salt water and open flowers— and stirring the scent of our mingled sweat and sex. For once, we were fully naked. Christian had taken me twice in as many hours. I was facing him this time, kissing him languidly, laughing softly with him as we ravished each other yet again. When I was almost mindless with needing him, he drew the ebony phallus from its velvet wrapper and gave it to me.

I recognized it immediately. After all our torrid escapades, I knew every inch of his beloved cock. Blushing furiously, I nonetheless lifted his present to my lips and kissed it, tossing my hair back and insisting I must

taste every inch of this wooden cock, to be sure each detail was accurate. I licked it thoroughly, caressing it with my tongue and lips, humming as I sucked it, just the way Christian so loves to have me do when I swallow his shaft into my throat. His breathing grew rough as I satisfied myself. Eventually, he threw me back onto the bed and slipped down between my legs. He licked my pleasure nub until I cried out and shuddered in his arms.

While I was shaking, Christian slid the wooden phallus up my still-drenched woman's tunnel. I arched up to him, my cunt walls shuddering as he worked it deep. Then, he pulled the phallus from me and roughly turned me over, face down on the bed. I knew what was coming when he spread my legs and slid over my back. He fucked me once, twice, getting his cock slick with my pussy juices. I groaned when he slid the phallus back into my cunt and pressed his dripping cock against my rosebud.

I begged him to take me there. My words inflamed him. He grabbed my hips and yanked me onto my knees. I lifted my bottom, his cockhead slipped in, and I slowly impaled myself on the thick, velvety steel of his shaft. I cried out, matching him stroke for stroke, opening myself to him as he fucked himself over his own cock through the thin walls of my trembling, clenching, wildly spasming cunt.

"Finger yourself," he snarled. He arched up over me, thrusting deeper and deeper as I raised my hips to meet him. "This one time, beloved, let me hear you scream when you give yourself to me." He shuddered as I clenched his shaft. "My life, let me hear you take me, so I will have this memory to warm me, forever."

He bit my neck, grinding against me. I slid my hands down and stroked myself to fulfillment. As the climax took me, I screamed out his name, holding him tighter and drawing him deeper inside me, embracing

him with my body. Christian roared and once more emptied himself within me.

He collapsed beside me, wrapping me tightly into his arms. "Remember, beloved," he whispered. "Remember me, and know that I love you. My time with you has brought me a lifetime's worth of joy." I hid my tears, so close to the surface these days, then laughed in spite of myself when he added, "God help me, I do so love fucking you."

∽

I leaned back on the cushions, my legs splayed, my clothing askew, too exhausted from my climaxes to do much more than breathe. The ebony phallus still rested in my cunt, though the beads lay beside me, thick with the cream I'd stuffed up my ass. I wondered if even a vibrator could get another rise from my quivering clit.

The room was quieter now, with only one or two humming buzzes in the background, and those mostly massaging thighs and bellies as naked women stretched languidly all over the lounge. A few sniffed loudly, reaching for tissues. Roxie wiped her eyes and loudly blew her nose.

"So, what happened?" The woman who'd worn the nipple ring stretched and leaned back against her lover. "Did he join her in England? Did they live happily ever after and have a dozen kids?"

Roxie and I exchanged a glance, not wanting to spoil the mood. The ending always made me too sad to speak. But when I nodded, Roxie turned and faced her audience. Christian and his lady, Jade, deserved as much.

"His ship went down in a hurricane a few months later. They never saw each other again." All sound stopped as the room came to a dead still.

"You have got to be kidding!" The voice was indignant, as were the ones that echoed the sentiment. Roxie shrugged and opened the book to the final pages.

∞

Edward has reconciled himself to my situation. He and Meredith are happy together, and they have welcomed me into their home. I am comfortable, and the babe grows surprisingly fat within me. But I am uneasy. I dreamed of Christian last night. He came to me, laughing and smiling. As I slowly brought myself to climax with his wooden phallus, he held me close and warm in his arms and whispered that I was his heaven on earth—no man could ask for more. Something is wrong, and I am so very afraid.

∞

"That's the second-to-last entry," Roxie's steady voice filled the quiet room. "The date coincides with that of a letter from a friend in the islands, telling her of the hurricane and how the ship *The Lady Jade* went down with all hands. After that, our friend appears to have put the journal away, save for one final entry. Her brother quietly and quickly married her to an old friend of the family—a widower who, though gray-haired and kindly, was still randy as all hell, if his letters to Edward are any indication. He was moving to the Americas to expand his business. Since he'd outlived two 'barren' wives, he didn't care that his sons and heirs, for she bore him twins, were dark-haired hellions who looked nothing like him. He still loved them, and their mother, with a passion and consideration that I think she eventually came to share as well. At least, I like to think she did. But I'm kind of a romantic."

Roxie looked expectantly around the room, waiting for quiet one last time before she spoke. "The final entry in the diary reads, 'Last night, I gave my Christian two lusty sons. God help me, I miss him so. But he will live on—in another man's name.' Apparently, she never showed the contents of the trunk to her businessman husband, and he loved her enough to never ask. Her diary was packed away beside a stack of love letters from Christian and a few odds and ends from Edward and the rest of her family. We think that's why we needed a locksmith to open the trunk. It's been closed since the last time she turned the key."

As sniffles once more echoed through the room, Roxie smiled and grabbed her clothes. "That's it for this year, folks. Let's tally our results, and see how much money we raised. I'm thinking this will be one for the books."

To a rousing cheer, people dressed and headed into the kitchen for refreshments. As the room emptied, I slowly gathered my things and put them back in the chest. Then I headed upstairs to change. I'd wander downstairs for a snack in a bit, maybe join in the festivities a while later. But first, I was going to grab my vibrator and see if I could indulge in one more quick fuck before I joined the masses. Lady Jade had shown me just how good "good" sex could be. I intended to honor her name.

Alec's Birthday

Sarah's Story

My husband is more than bi-curious. He's bi-obsessed. Don't get me wrong—Alec likes women. It's just that he also gets hard looking at men's fitness magazines, the male models in my women's erotica, and especially, my openly bi and exceptionally well-endowed best friend, Brett.

I thought the idea of the two of them getting together was really hot. Actually, while my voyeuristic little soul would have been happy just watching, what I really wanted was for us to have a three-way. Brett and I had known each other since college. There had always been an attraction between the two of us. Not many people could resist his dark, Italian good looks. Women swooned at his charm and his gay dates called him a size queen's dream. But I'd never wanted to compete with his many lovers for his physical attentions. After Alec and I were married, Brett respected our mutual friendship too much to come on to the man he called "Sarah's cute hunk with the sexy ass."

In retrospect, Brett's reticence had probably been driving my "bi-curious" spouse nuts. Unlike my slutty friend, Alec came from a very conservative background. After three months of frustrated dating, I'd finally gotten him drunk and seduced him. At first, I could hardly believe a man that gorgeous was a virgin at 22. Blond hair, bright green eyes, and a body that showed the time he spent swimming laps each morning. He learned fast, though. In fact, he liked sex so much that the next weekend he tried to get me drunk. I told him the liquor wasn't necessary. We got married six months later.

Alec fucked like a man possessed. He grunted and groaned when I kneaded his strong, hard, and oh-so-sensitive butt muscles. The first time I slid my finger down and touched the sweet little pucker between his cheeks, he shot on the spot. So, of course, I did it again. Same reaction. Alec got all embarrassed. But he liked it so much that he actually admitted what a turn-on it was. I rewarded him with a nice little anal massage—just the outside, soft and gentle, with lots of lube. He acted like he'd died and gone to heaven. I'd climaxed already, but I got turned on all over again, just watching him.

An ass that responsive was too much temptation for me to avoid. Pretty soon, I was massaging inside as well as out almost every time we had sex. For our first anniversary, I got him a tiny little anal plug. I couldn't wait to try it out. Right there in the dining room, I yanked down his pants, dunked the plug in the butter, and bent him over the table on top of his cake plate. Then I slid that cute little toy straight up his ass. He was still gasping when I pushed him back down on his chair, rested my hands on his shoulders, and waited to see his reaction.

At first, he just sat there, wiggling silently, his pants around his ankles, his eyes closed as he concentrated on his breathing. His cock got

harder by the minute, turning a deep dusky red when I stroked the back of his neck. I could feel my panties getting wet. Alec's cock was even wetter. I love it when he leaks lots of precome; when he's so turned on he can't help his body's reactions. This was more than anything I'd ever seen. A steady stream of clear fluid ran down his shaft, like icing from the top layer of the carefully preserved wedding cake that was now sitting forgotten on our plates.

Finally, he opened his eyes and grabbed my hand.

"Sarah." He shuddered as he whispered my name. "Please!"

My pussy twitched like he'd kissed it. I lifted my skirt and peeled off my panties. Then I straddled his lap and slowly sank down over him, shivering as my pussy lips slid over his unbelievably hard shaft. I leaned forward and kissed him, clenching my lower muscles rhythmically over his cock while I sucked his tongue and milked him with both my pussy and my mouth. Alec's hips flexed against the chair, arching upwards. His cock twitched deep inside me. The waves rolled over me, and I wrapped my legs around him, grinding frantically against him. Alec's shout vibrated all the way to my pussy. He grabbed my waist and thrust up, his cock pulsing into me as we shook so hard we almost fell off the chair.

I went back to the store the next day, this time with Alec, and I watched while he nervously picked out a little dildo. He blushed and fumbled with his wallet as he paid the clerk, ignoring her smiles and desperately trying to hide his hard-on. But as soon as we got home, he stripped and stuck his butt in the air. I was amazed at the amount of fluid he ejaculated when I stimulated his prostate. The white ropes pulsed out all over his belly, thick and creamy and sweet. So we went back to the store again. Before long, Alec was addicted to dildos. I was

addicted to fucking him. And his long, wistful stares at Brett were getting more and more obvious.

I wanted to be there to see how Alec reacted when his anus finally experienced the ultimate stimulation. I just couldn't figure out how to approach the subject of a three-way. On the night I finally worked up my nerve, I gave him a glass of wine and took him to bed early. I slid a huge, smooth jelly rubber dildo up his well-lubed butt. I played with his dick until he was rock hard and leaking freely. Then I took a deep breath and rubbed my palm over the silky wet head of his penis and told him how much I wanted to see him with another man.

At first Alec didn't answer me. He just groaned, loudly, his eyes closed, like he was too lost in sensation to understand what I was saying. But the more detailed my fantasies got, the more he quivered. I brought him to the edge, over and over again, until his cock was crimson and hot to the touch.

"Do you like that, love?" I trailed my wet tongue up the side of his shaft, licking fast and furiously just below the rim, wiggling the dildo.

"Fuck me," he gasped. "Please, Sarah! Push it in harder!"

I got wetter each time he jerked under my hand, but I didn't let him come. I wouldn't let myself come, either, despite the vibrating dildo I had nestled deep inside myself.

"I bet you'd like it even better with a real, live cock." I stilled my hand. "A cock like Brett's."

Alec's eyes flew open. "Wh-what?"

I took a deep breath and twisted the dildo, just enough to make another drop form at the tiny eye of his penis. His groan almost made me come. I clenched my cunt muscles and willed myself to hold off.

"It's okay if you want a real cock up your ass, Alec." I kissed the tip of his penis gently, sucking the long pearl out of the slit. "If you want Brett to fuck you, just say so." Alec shuddered beneath me, closing his eyes again, avoiding my stare as he arched up towards me, his cock twitching involuntarily—reaching towards me as I licked him.

"You're thinking about it, aren't you, Alec?" I slowly slid the dildo out, over his open asslips, until just the head rested inside him. He shook at the stimulation. "Each time I shove this big latex shaft up your ass, you're fantasizing about the real thing." I pressed the dildo back in, gradually going deeper, rolling my wrist just enough to make him moan out loud. "You're dreaming about Brett's cock fucking you, aren't you, lover?"

"Fuck me," he gasped, shaking as the fake rubber dick bottomed out in his ass. I tapped the latex base. His cream oozed out.

"If you want a real dick, Alec, say so! Tell me you want Brett to fuck you!"

"Yes, dammit!" Alec's whole body stiffened, his breathing harsh as his dick started to pulse. "I want Brett to fuck me! Argghh!"

I pressed the dildo in as hard as I could and wrapped my lips around Alec's dick. He yelled, digging his heels into the mattress and thrusting up hard into my mouth. His semen bathed my tongue as he buried his fists in my hair. I reached between my legs and switched the vibrator in my pussy to high, swallowing over and over again as I shuddered through a bone-jarring climax.

Alec's thirty-first birthday was the next weekend. It seemed like the perfect setting for the three of us to get together. I called Brett at work. As usual, being blunt worked with him.

"I know you're as hot for my husband as he is for you. I want you to fuck Alec, and I want to watch. It's his birthday present."

When Brett stopped choking, my wonderful, slutty friend cleared his busy social calendar for us for the whole evening.

Friday night, I cooked a special birthday dinner. I make a Kung Pao chicken that's to die for. I had the Irish linen on the table, along with the good china and crystal. Alec walked in the door from work just as I was putting fresh beeswax candles in the silver candlesticks. I gave him a quick kiss and sent him off to shower before he had time to notice the table was set for three.

He noticed when he padded barefoot back into the kitchen. He was wearing a white merino sweater and the form-fitting jeans I so love to see hugging his ass.

"Three places?" He laughed. "Who's coming to dinner, especially on my birthday?"

"Brett," I smiled, kissing Alec softly on his lips. I reached down and gave his crotch a meaningful squeeze. He wasn't wearing underwear. "He's coming because it's your birthday."

My words sunk in, and Alec went very still.

"S-Sarah." Alec's face changed from shocked white to blushing embarrassment in one breath. "I kn-know I said a three-way sounded cool before, but now I'm not so s-sure . . ."

"Don't worry, babe." I touched my fingertip to his lower lip and pulled down gently, tracing over the soft smooth surface of his skin. "You don't have to do anything you don't want to do, okay? If you change your mind, Brett leaves right after dessert and I take you back in the bedroom and have my way with you—just me and the extra large vibrating friend that came in the mail today. Fair enough?"

I felt as much as saw his smile on my fingertip.

"Okay," he blushed. He wrapped his arms around me and hugged me to him, hard. We stayed that way for a long time, holding each other tightly. Eventually, his shoulders relaxed again. He took a deep breath and wiggled enticingly against me. "You said it's extra large?"

He jumped, laughing again as I gave him a quick, sharp birthday swat. Just then the doorbell rang. A minute later, Brett was hanging up his coat and announcing to the world that he'd perish from hunger if he couldn't get at that delicious-smelling food "right now!"

"Ten minutes, guys," I laughed, heading back into the kitchen as I continued to talk to them over the pass-through.

Alec and Brett stayed in the living room, my suddenly very nervous husband sitting forward on the edge of the couch and Brett lounging in the easy chair. In spite of their long-standing friendship, Alec was talking a mile a minute, latching onto any topic he could think of. He drained his wineglass in three swallows. When he reached a shaking hand towards the bottle for a refill, Brett waved him to stay put and got up. Instead of just taking the glass, though, Brett wrapped his long, strong fingers around Alec's and looked him straight in the eye.

"I think we need to get this out of the way right now, my friend."

Brett leaned over and kissed Alec, right smack on the lips.

At first, Alec's whole body went stiff. Then, he moaned and relaxed into Brett's arms. The kiss was a long, wet lip lock—very male, very aggressive. I could see their jaws moving rhythmically as their tongues thrust back and forth, their biceps rippling as they held each other. I couldn't believe how sexy they looked. It was better than anything I'd ever imagined! If I hadn't had my hands full of hot peppers, I would have lifted my skirt and masturbated right there in the kitchen. I was sopping just from watching them.

Brett stopped with the one kiss, but it was enough to get Alec calmed and smiling sheepishly, despite the beautiful erections they were now both sporting. Brett sat down on the arm of Alec's chair and stroked the back of Alec's neck, leading us in the usual "how was your day?" banter we usually engaged in when the three of us had dinner together. Alec didn't say much. Eventually, he just leaned into Brett's hands, closing his eyes and breathing deeply when Brett's fingers found the really sensitive spot just below his ear.

They both adjusted noticeable bulges as we settled down to eat. The ambiance of candles and good food—and the normalcy of our long acquaintance—kept us comfortable all the way through to the coconut birthday cake and piña colada ice cream. I could tell Brett's hands were busy under the tablecloth, though. Brett winked at me each time Alec dropped his fork.

I took the last of the dessert champagne with us when we adjourned to the bedroom. I could see Alec was getting nervous again. I refilled our glasses and led a toast to the birthday boy, insisting he drink with us. Then I took him in my arms and started kissing him.

At first, Brett just stood quietly next to the bed. Alec kept looking at him, shifting his weight from one foot to the other. I brushed my fingers over Alec's eyes and firmly turned him towards me, with his back to Brett. I threw myself into that kiss, making it as hot and sexy as I knew how.

Alec had had just enough to drink that he didn't expend much energy on nervous inhibitions. He opened his mouth and his sweet, hot, coconut- and champagne-flavored tongue swept over mine. We both jumped when Brett quietly came up behind Alec and started massaging the back of his neck again. Alec stiffened for a moment, then he groaned and relaxed, baring his throat for Brett to kiss him. Brett's tongue licked

slowly and determinedly up Alec's neck. He ran his hands up Alec's arms, sucking long and hard on Alec's earlobe. Alec moaned softly into my mouth.

Brett smiled at the sound, stroking more sensually. "I think you need a whole body massage, pal."

As he spoke his fingers slipped between Alec and me. Brett pulled up Alec's sweater. I started at the other end, loosening Alec's belt. Pretty soon, Alec was naked, sandwiched between us while we smothered him with kisses. When he started panting, Brett tipped him onto his back on the bed. I peeled my clothes off while Alec moaned into Brett's kisses.

When Brett saw me naked for the first time, his appreciative whistle added to the warmth between my legs.

"After all these years, I finally get to see what I've been missing," he chuckled. Alec's eyes flew open and he stared up at me, like he was surprised to see me standing there naked. I didn't give him time to think. I took Brett's place and kissed my husband senseless while Brett quickly stripped and joined us.

At first Brett and I concentrated on the massage. We rubbed handfuls of scented body lotion over the smooth muscles of Alec's arms and legs and torso. Alec was so relaxed, from both the champagne and the touching, that it wasn't long before his eyes were closed and even his shoulders were loose and pliant. When his breathing deepened, I quietly moved to the other side of the bed.

Alec stilled as the mattress shifted, like he'd suddenly realized only Brett's hands were stroking him. He opened his eyes and looked directly at me, his beautiful green eyes shimmering with passion and need.

"Are you sure, Sarah?" His voice was quiet, filled with desire, but also a little bit afraid.

I leaned over and gave him a long, wet, softly feminine kiss. "If this is what you want, lover, let yourself go." I sucked softly on his lower lip. "I think it would be so hot to see how good another man can make you feel."

The flush crept over his face, darker than I'd ever seen it, but Alec nodded. Then he turned to face our friend and gingerly lifted his hand to touch Brett's forearm. He stroked slowly, getting used to the feel of the soft, masculine hair on Brett's arms and chest. At first, his eyes stayed carefully glued to Brett's upper torso. I knew the moment he finally looked down. His breath caught and he trembled slightly, a beautiful blush creeping up his entire body as he locked his eyes on the long, swollen cock jutting up from the thick black thatch between Brett's legs.

"You're big." Alec swallowed hard, his hand falling back onto the sheet as he licked his lips. "Um, really big."

Brett's laughter shook the whole bed.

"You got that right!" Brett grinned and leaned over, running his hands over Alec's chest. The smile widened as Alec arched into his hands. "Don't worry about my endowment, bud. For now, we're going to think about you."

Brett took his slow, sweet time. In between kisses, his massage centered on Alec's nipples. Alec arched into Brett's hands, moaning as Brett rubbed the soft skin to tender peaks, jumping as Brett lightly pinched and tugged. I squirmed, rubbing my own sensitive breasts while Alec panted. I hadn't known a man's nipples could be that responsive. I made a mental note to start playing with Alec's pecs in the future.

Then Brett's massage moved lower. Alec tensed, his breathing growing ragged. Brett's hands stroked over Alec's abdomen and into the curly blond thatch. My pussy tingled as I realized they were both concentrating solely on sharing touches with another man. I slid my hand between my

legs, rubbing my vulva, fascinated by the sight of Brett's strong, firm strokes over my husband's thighs. Alec shivered, but he didn't pull away when Brett cupped his balls and rolled the wrinkled orbs between his fingers. I think Alec stopped breathing, though, when Brett's hand slid slowly back up and wrapped around the hard, leaking shaft—exploring, finding the sensitive places that made Alec pant and writhe. Pretty soon, Brett was straddling Alec's thigh, rubbing his crotch against the soft golden curls, the way I did when I was really turned on.

Then Brett moved over Alec, rubbing their cocks together. Alec's hand shot out and he grabbed my wrist, clutching it tightly, still blushing like crazy.

"You like that, pal?" Brett asked, slowly sliding back and forth. He laughed when Alec nodded sheepishly. "Good. Let's see if you like this better."

Brett lifted up on his hands so that the only place their bodies were touching was where their cocks slid together. Alec almost crushed my fingers, moaning like he was going to split open.

"Oh, yeah, babe," I said, wincing at the pain but incredibly excited by how turned on he was. I gently loosened his hand and put it between my legs, letting him feel how wet I was from watching them.

The smile that lit Alec's face made me tingle all over. I opened the nightstand drawer and took out the new anatomically correct vibrator—the one I was going to use on myself since the butt it had been intended for was going to be otherwise occupied. Alec's eyes widened and his hand fell back down.

"This may be your birthday present, but tonight, it's for me." I grinned, turning the knob and letting him hear the steady buzz. I grabbed a tube of lube and leaned back against the headboard. Then I spread my legs wide, knees bent and feet on the sheets, and I started fingering myself

and playing with the vibrator. Alec loves watching me masturbate. I wanted to be sure he understood how much his pleasure turned me on.

Brett sat back on his heels, grinning appreciatively. Then he laughed and flipped Alec over on his stomach.

"You see her every night. Pay attention to me now." He slapped Alec's butt lightly. Then he grabbed Alec's ankles and started massaging firmly up his legs. Fortunately, Brett's really laid back. He stroked hard, up Alec's calves and over his thighs, maintaining a slow, even, steady pressure. Still, Alec jumped like crazy the first time Brett's hand slid over his hips. Brett grabbed Alec's cheeks in both hands and squeezed, then he started rubbing in deep, firm circles. Alec moaned into the sheets, and Brett laughed again.

"Your ass is mine, pal. Let it happen."

I was so hot, watching my husband gradually relax as Brett teased his legs open. Brett knew just where that sweet spot is at the base of the hips, the lower curve where the butt meets the thigh, where—male or female—just being caressed makes you want to open your legs wider for more. Pretty soon, Alec was panting and his thighs were spread and my pussy was drenched.

"Put a pillow under his pelvis," I said, shivering as my fingers slipped over my clit. "He likes it when you lift his ass up to fuck him."

"Sarah!" Alec sputtered, lifting his head and giving me a totally shocked look.

"Well, you do." I said. "It angles your butt up just right so your cute little hole is really accessible."

Alec was stammering so much he didn't have words, and Brett roared with laughter. "Not bad, for a straight chick."

He stuffed a pillow under Alec's pelvis, then he went right back to playing with Alec's butt. Brett gentled Alec's anus open, just the way I do. I could see Brett's wrists moving from side to side as he pulled in opposite directions, stretching Alec's sphincter. Alec's back glowed with sweat, his moans telling me how much he loved the attention.

Brett's huge cock stood up hard, the thick, red head pressing against Alec's thigh. Brett looked me up and down once more, very thoroughly, and then nodded approvingly.

"You are definitely hot stuff, lady."

This time, I was the one who laughed. No matter how much Brett may have liked looking at me, I knew that the main thing making him hard was my husband's firm, round ass. Alec was responding, rocking back towards the very male hands that were pleasuring him.

Alec eyes were once more locked on me. I knew my lower lips were glistening from how aroused I was. I alternated between rubbing myself and playing the soft buzz of the vibrator on my clit. The vibration wasn't strong enough to make me come yet, just enough to make my pussy really wet.

"It feels so good, honey," I whispered. "I'm all hungry to be filled with a hard, warm cock. Is that what your hole feels like, sweetheart?"

Alec shivered at my words, his answer coming out as an inarticulate moan. Pretty soon Alec alternated between watching me and just closing his eyes and feeling.

Brett's good. He used tons of lube. He squeezed a huge glob on his index and middle fingers, wiggling them at me so I could see just how much he had on his hands. I giggled and nodded. Then Brett started stuffing the lube up Alec's butt.

Alec was groaning into the pillow now, but he wasn't moving. A nice little frisson ran through my body. I knew just what Brett's fingers were feeling, the way Alec's whole body turns to putty when he finally relaxes. That's usually my cue to start working a dildo up his butt.

But Brett wasn't going to use a dildo. Alec jumped when Brett tore the condom open.

"Look at me, babe," I purred. I held my labia open and slowly started sliding the dildo in. "You're going to feel a cock fucking you, just the way you fuck me." I pressed the dildo deep, trembling as Alec's wicked birthday toy hummed inside me. "It feels so good, Alec." I moaned and turned the knob further. The vibe against my G-spot was perfect, nice and slow, and it was building to one hell of a climax.

Alec's eyes were glassy with passion as he stared at my pussy. I could tell from his groans that Brett was doing something intense to him. Brett winked at me again, an evil grin on his face, then he tugged on Alec's hips, pulling his ass up in the air. My husband's cock pointed down towards the mattress, drooling precome. He arched and moaned to Brett's hands. His soft little cry as Brett lifted him caused a mini orgasm to ripple deep in my cunt.

Alec recognized the signs, the flush that covered my chest and caused the juice to drip from my slit around the sides of the vibrator. Even though his ass was swaying back and forth, dancing on Brett's fingers, Alec reached for me and choked out, "Please, Sarah. Let me have your pussy. I want you so much."

Even as he spoke, though, he arched back onto Brett's fingers. I looked at Brett, and he nodded. As Brett balanced Alec, I took the vibrator out, holding it briefly to Alec's tongue and sliding it in and out of his mouth until he'd licked it clean. Then I slid down until my pussy was

even with his face. I took a moment to position myself. I leaned my head back on a couple of pillows and spread my legs wide, pulling my knees back to open myself completely to Alec's waiting lips.

Alec was as hard as I'd ever seen him. His dripping cock swayed back and forth as he spread his legs wide over the sides of the pillow. He went absolutely still when Brett moved over him.

"Easy, bud," Brett said. "Wrap your arms around her thighs and relax. Get your face close enough that you can really smell her pussy."

I have to give it to Brett; he really knew what he was doing. No sudden movements, everything smooth and sensuous. He positioned himself, supporting his weight on one arm while he slowly leaned into Alec's body.

Alec was breathing hard, not moving, the breeze from his mouth cooling the moisture of my slit. Suddenly he gasped, his whole body arching forward and stiffening, his hands grabbing my thighs like he was holding on for dear life.

"Easy," Brett said. "It'll be better in a minute."

His voice was soothing and he held absolutely still, but he didn't back up. Instead, he leaned down and rubbed his face against Alec's back. "Damn, your ass is tight."

Alec groaned in response.

"You okay, babe?" I asked, stroking Alec's hair.

"Uh, huh," he gasped. "It . . . it burns. But it feels so good . . . Oh, God, Sarah. It feels so good!"

His fingers gripped my legs so hard I knew I'd have bruises, but I didn't care. Alec's breath was coming in short puffs against my pussy. Suddenly he groaned and dove into my cunt, his tongue swiping all the way up my slit, flicking hot and hard against my clit. He slurped his way back down,

burying his tongue inside of me and licking and sucking on the edges of my lips. I came so hard I thought I'd pass out.

Alec's mouth didn't let up. I knew I was going to come again. What he was doing felt so good I could hardly breathe. I grabbed his hands and massaged the backs of his knuckles, tracing the taut tendons up to his wrists. Then I waited, slowly stroking and caressing him. My eyes had closed as his mouth had assaulted me. I opened them just in time to see my beautiful husband lifting his ass up to meet my best friend's cock, impaling himself the rest of the way.

Alec's cry vibrated against my orgasm-sensitized pussy. I shook again, not quite a climax, but close, as I watched Brett's belly brush up against the curve of my husband's beautiful butt cheeks. The strokes started out slow and easy. But as Brett picked up the pace, Alec started lashing me with his tongue.

"You like that, love?" I gasped, trying unsuccessfully to clear my head. "You like slurping my honey while your ass is being stretched over a real live cock?"

Alec's answer was muffled in my folds, but he dug his face further into me. I was surprised he could breathe. Even his nose was mashed into me. Alec worked my clit like a man possessed. Each time Brett thrust forward into him, Alec surged forward against me.

Brett's chest was wet with exertion, but his eyes were twinkling. He smiled at me, a drop of sweat falling from his chest onto Alec's back. Brett leaned forward and licked it. Alec moaned again, pressing hard and deep against me. Then with no warning, Alec shoved his fingers all the way up into my cunt, rubbing hard against my G-spot the way only he knew how to. Waves of pleasure rolled from deep in my belly, and I screamed as I came, bucking up against his unrelenting mouth.

I was still throbbing, trying to catch my breath, when I saw Brett's ass lift high into the air. He thrust fast and deep into my husband. Alec fell forward, crying out against me, mashing his hips into the pillow as Brett pounded into him.

Suddenly, Alec stiffened and gasped. "I'm going to come. Oh, God, Sarah, I'm going to come!"

Brett's laughter rang in my ears. Alec pressed his face against my pubic bone, burying himself in my pussy. He grabbed my thighs as hard as he could, then he let out a low, keening cry and his whole body started to shake. He ground against the pillow like a wild man. Brett was breathing hard, his powerful thrusts slamming Alec into me. Then Alec shuddered like his bones were breaking. He pressed his face hard against me and held on for dear life, crying out over and over again while the orgasm racked his body.

I vaguely heard Brett grunting as he came. The next thing I knew, he had fallen forward, lying on Alec, smashing me with their combined weight. My totally limp husband lay face down in my crotch, barely breathing, while I ran my fingers gently through his hair. I was almost asleep when Brett planted a loud, smacking kiss on Alec's shoulder, then he rolled to his side and stood up.

"Damn, but you two are fun!"

"Thanks, Brett." I smiled as he dressed to leave. I knew he had to get up early the next morning for a soccer game.

"Any time, my friends," he grinned. He leaned down and gave me a quick hug. Then he reached over and slapped Alec sharply on the butt. "I owe you thirty more of those, too, pal. And I'm going to collect. Happy birthday!"

Alec jumped and looked up, his face slippery wet with my juices. I don't know that I'd ever seen his face that red, but he looked completely happy and totally sated as he whispered, "Thanks, Brett."

The front door clicked shut and I pulled Alec up into my arms.

"Happy dreams, lover," I whispered. I reached down and grabbed a firm, round, muscled cheek. "You get the rest of your presents in the morning."

I'm not certain if what I heard was a laugh or a moan or a snore, but Alec was smiling as he drifted off to sleep.

Hot Crossed Buns

Mitch's Story

I had reservations about taking Tara to the Folsom Street Faire. Despite her insistence that she thought BDSM was "hot" and that she really, really wanted to be my sub, I should have known what was going to happen when she took one look at the expensive gold necklace I'd gotten her and haughtily announced that as a collar, it would probably do. If she hadn't been such a good lay—and one of the smartest, sexiest, most wickedly fun people I'd ever been with—I would have packed my bags and been on my way a long time ago.

But even after six months of dealing with her "now I want it, now I don't" crap, I still hadn't made myself leave. I wanted her so badly. Almost as badly as I needed to fuck around with power exchanges. But every play party I'd taken her to had been a disaster. Whenever I got a hard-on watching other people, she got jealous. Yet when I'd lead her into a scene of our own, she'd back out at the last minute. By the time September rolled around, I was so horny to beat a willing female ass that I'd decided to go to the fair by myself.

Tara begged me to take her instead. She pleaded and promised. She swore up and down that this time she was ready; she'd just needed the right setting. She finally seduced me with the outfit she'd bought for the faire—a short, black, leather and lace creation that looked like it had been poured over her lithe, young body and accented her long, auburn hair. I think even then, I knew at some visceral level that my acquiescence was just my dick talking.

Folsom Street was obviously not "the right setting." I don't know that I've ever been more embarrassed in my life. Tara teased and pranced and behaved like the perfect little sub—until the exact moment when my hard-on was about to split my pants. Then she broke out of the scene I'd spent hours planning and, as loudly and rudely as possible, yanked off her necklace and stuffed it down the front of my pants, announcing to the world in general and my friends in particular that she just wasn't "in the mood." I dropped her off at home without even getting out of the car, then drove over to my buddy's house and drank myself into what I figured was a well-earned stupor.

By the next evening, I'd sobered up. I was disgusted with myself—about the booze and about the denial mind-games I'd been playing. This relationship just wasn't going to work. Power exchanges were an integral part of my sexual soul. If I had to drink to cope with my emotional needs not being met, it was time to end the relationship. Still, it was a bitter pill to swallow.

I didn't say much when I got home. Tara was on the phone—with one of her girlfriends, I supposed. I barely looked at her. I was intent on heading straight to the bedroom to pack.

The smell of homemade spaghetti sauce stopped me—that and fresh garlic bread. Tara knows I love Italian food. I glanced in the kitchen and

saw that the table was set for two, with a crisp linen tablecloth, her grandmother's china, and the good silverware. Fresh white candles burned in crystal holders next to a tossed green salad. My stomach growled loudly, even though it was in knots from stress. I hadn't eaten much all day, and I was starving. I sighed heavily and leaned against the kitchen door, torn between leaving and satisfying my hunger first—and wondering what the hell she was up to. If this was another mind fuck, I'd had about as much as I could take.

I turned and caught her eye, raising my eyebrows at her. Tara blushed and whispered into the phone, "Mitch is home. I have to go now."

She hung up, and I nodded towards the kitchen. "You're expecting company?" I'd planned the comment to be sarcastic. I was still pissed. But Tara's sudden and unexpected flush made her look so small and vulnerable that my voice came out in a fairly normal tone. I'd also finally seen what Tara was wearing. Not her usual daytime designer clothes or the seductive lingerie she wore at night to drive me nuts. She had on a simple knee-length floral print skirt and a filmy yellow peasant blouse. I could see her lacy bra and the dusky shadow of her nipples peeking out through her long, free-flowing curls. She was barefoot and she was wearing the thin gold ankle bracelet I'd gotten her on our first date. I closed my eyes and ran my fingers through my hair, telling myself I did not want to grab her and rip her clothes off her and make mad, passionate love to her right here on the carpet. When I opened my eyes again, she was looking at me, nervously rubbing her hands together.

"Um, I figured you might be hungry." She spoke softly, taking a deep breath and walking slowly over to stand in front of me. "And I know you love spaghetti." I was stunned to see tears sparkling in her eyes. For all her tantrums and inconsistencies, Tara had never used her theatrics to

deliberately deceive or manipulate me. "I'm really sorry about yesterday, Mitch. I mean, about the street fair, and sassing you in front of all your friends, especially when we were all dressed up and I was wearing your collar. I know that kind of stuff is important to you."

When she mentioned the street fair, I set my jaw, reminding myself that breaking up would be best for both of us, no matter what my dick was saying at the moment. I stared at her in surprise when she grabbed my hand, lifted it to her lips, and kissed it. A single tear fell on my knuckle, and she wiped it away with a quiet, "Aw, shit!"

"It's okay, Tara." I didn't know whether to laugh or cry myself. Tara never swore. Obviously, knowing we were breaking up was tearing her apart as well. I opened my mouth to launch into the speech I knew I had to give, but before I could speak, she let loose with a string of cursing I'd never imagined coming from her lips.

"Dammit, Mitch, I was just so fucking scared! I hate crowds, and I don't like leather armor between your skin and mine, and everything was so loud I couldn't even hear you talk. I wanted to go to your special place with you and do the things you'd talked about—they sounded so hot and I wanted to do it so fucking much! And then when we got there, all those people treated me like I was a dog, or like I wasn't there." Her voice fell to a whisper, and I could hear the real fear in her voice. "Some of those guys kept looking at me like they could just take me, like it didn't matter that I was giving myself to you—they could take me as soon as your back was turned or I was gagged and you couldn't hear me anymore." Her grip tightened as she angrily swiped her fist over her cheek. "I was afraid of what they'd do and afraid you'd . . . oh, shit, never mind." She stomped her foot angrily. "I want to make you happy, I really do. And I want to do those things with you. But damn it all, I was just so fucking scared!"

There's something about a woman's tears—I mean, real tears—that makes me want to comfort her, to take care of her. And Tara's shoulders were shaking she was so upset.

"C'mere, babe," I whispered, pulling her close and hugging her. "Afraid I'd do what?" She was rambling so much I wasn't sure exactly what was going on, but it was a window—and any window was worth trying if it gave Tara and me a ghost of a chance to stay together.

She sniffed loudly as her tears wet my shirt. "I was afraid that you wouldn't want me anymore if you saw how slutty and uninhibited I want to be with you. " Her voice was very small now. "So I was a total bitch instead."

"Not want you?" I lifted her chin to look at me. "Jesus, woman—how the hell could I do that? You're driving me nuts!"

She sighed heavily and leaned into my chest. "You must think I'm really silly."

"Tara," I rested my chin on the top of her head, holding her close as I took a really deep breath. "If kink doesn't turn you on, it doesn't. You don't have to change yourself for me. I fell in love with you the way you are." I tried to smile, and almost succeeded, feeling my throat tighten as I said the words I knew I had to say. "I think it's a chick thing to try to change your mate afterwards." I brushed her hair gently off her forehead, hating how my hand was shaking. "We can still be friends, Tara. Being sexually incompatible doesn't mean we have to hate each other."

"Fuck being friends!" she shouted, shoving angrily back from my arms. "I do want to do it—for me, you asshole! Just thinking about it makes me wet. Sometimes, when you're at work, I slip the leather cuffs on, and I walk around naked, pretending I'm your slave girl when I'm doing the dishes or cooking your dinner."

My cock jolted in surprise at the image of Tara standing in front of the kitchen sink, wearing just her golden necklace and the leather cuffs on her wrists and ankles, her hair curling around her face in the heat, maybe a sprinkle of marinara sauce on her breast.

"But I know you don't like that," she whispered, leaning her head back against me in defeat. I looked down at her in shock.

"I don't?"

She shook her head, sniffling loudly. "You want me to wear fishnet cat suits and leather skirts, like Steve's wife, Melanie. I saw you looking at her. " It felt like Tara was burying her head in my shirt. If the color of her neck was any inclination, her face was flaming. "I was sitting on your lap," she whispered, "and I could feel you getting hard when Steve bent her over in the stocks and whipped her shaved pussy with that little leather flogger. He was talking to other people, like she wasn't even there. But she was so turned on; I could see her pussy juices. I almost came watching her—I wanted you to do that to me! But I didn't want you treating me the way he did her." She pushed her face even deeper into my shoulder. "I wanted you getting hard about me, not her."

"Tara," I growled. "I got a hard-on because you were wiggling all over my lap! Yes, Melanie is beautiful, and that was a hot whipping. But Steve's an asshole. He always has been." I ran my finger slowly up her arm. It felt good to see her shiver. "I won't lie—I'd love to put you in stocks and whip your pussy until you screamed. But honey, you'd have my entire attention." I slowly stroked up her neck, caressing her hair, feeling my cock harden as she trembled. I was stunned to realize that, for the first time, Tara was truly giving herself to me. God, it was hot. "Do you think you'd like that, love?"

She nodded. I swatted her bottom lightly, and she quickly whispered a soft "yes."

"Would you tell me to stop, Tara?"

She shook her head hard, wiggling against me. "What would you do next?"

I sighed with relief, tightening my arms around her. "Would you want me to do more?"

She nodded, almost imperceptibly. I let the scene as I remembered it roll out in my mind, but with my own improvisations—and with Tara in the stocks. "I'd tell you to dress in a simple skirt and blouse, and your ankle bracelet, but nothing more. When it was time, I'd tell you to ignore everyone else and strip naked for me—just for me. Then I'd put you in the stocks, and bend you forward. I'd lock your head and arms into place, with your naked, shaved pussy exposed to everyone in the room and your legs spread so wide your pretty pink anus was peeking out. But even though all of those people could see you, only I could touch."

Tara shivered hard. I lowered my voice and moved closer, until I was almost breathing in her ear. "I'd clamp your nipples with shiny silver clips." My cock surged, both at the mental image, and the warm buttons of her aroused nipples against my chest. "I'd finger your pussy, get it nice and wet." I stroked one finger over the edge of her ear. "Maybe I'd kneel down in back of you and lick your cunt." I leaned forward and tongued the same path my fingers had just taken. "I'd make you stand on your tiptoes and spread as wide as you could for me, so I could taste you and make you squirm and wiggle, with everyone watching." I bit softly. "Then I'd clamp your clit."

Tara shuddered. I teethed lightly on her ear lobe, alternating between gentle sucking and sharper, more determined nibbles. "I'd tug on the

nipple chain, and when you were whimpering, I'd clip the other end of the chain to the clamp on your clit." I bit hard, groaning as Tara tightened her arms around my waist. She ground against my now-throbbing erection. "It would hurt, Tara. Don't ever think it wouldn't. And I'd get hard from watching your pain. But oh, I'd make you want it, love. Your juices would drip down my chin."

She trembled as I slowly licked the inner curves of her ear. "I'd walk on my knees in front of you, to where your head was leaning in the stocks, and I'd make you lick my face clean while I fingered you." I flicked the tip of my tongue into her ear, smiling when she jumped and moaned. "Then I'd whip your pussy, Tara. Light little tingles, then harder and harder, until you were yelping and dancing. I'd do it until you were crying, Tara." I slid my tongue slowly in and out of her ear, licking mercilessly while she pressed against the thigh I'd finally worked between her legs. "I'd comfort you, love, but I wouldn't stop. I'd tug on the chain so your nipples and your clit hurt so much you could hardly stand it, and every once in a while, I'd finger you again. But I'd whip your pussy until you were screaming." I blew softly and gently over her wet skin, cupping her backside and pulling her up against me. "I'd whip your cunt until you came."

"Oh, God, Mitch," she whispered, rocking back and forth. "That sounds so hot."

I realized too late that the position I'd moved us into had brought me dangerously close to coming. I took a deep breath and held her still.

"Even then, I wouldn't stop." I squeezed her bottom cheeks, kneading them firmly and steadily in my hands. "While your pussy was dripping and you were panting from your orgasm, I'd smear your pussy juice all over your beautiful pink pucker." I quietly pulled her bottom cheeks in

opposite directions. "I'd smear your juice on my dick, Tara, and I'd slather myself full of lube." Once again, I swept my tongue into her ear. She shook beneath me. "Then I'd fuck you, Tara. In front of all those panting, horny, jealous people, I'd fuck you right up your ass."

I'd wondered what her reaction to anal sex would be. When she snuggled hard against me, my cock felt like it was going to burst out of my jeans. Despite my best intentions, I thrust against her again. "When I was ready to come, I'd let the clamps loose, love. You'd scream and twitch when the pain made you climax again. Oh, honey, I'd make you be such a slut for me." I tongue fucked her ear. "When your ass was as tight around me as a velvet glove, when it was jerking me off from the echoes of your cunt coming, I'd shoot right up your ass. I'd fuck all the way through my climax, so everybody in the room could see my cock sliding in and out of your ass on my jism." I ground against her hard, not caring that I was panting. "I'd make sure everyone in the room saw that you turned me on so much, I had to come. Then I'd pull out and let them watch my juices run down your leg while I comforted your poor, tortured nipples and your sore, tender clitty." I kissed her gently, my hands shaking, my cock throbbing while I held her close and fought to keep from coming in my pants. "Would you like that, Tara?"

"Yes." Her voice was almost inaudible. She looked up at me, and I was stunned to see the wanton passion burning in her eyes.

I nodded, a scene slowly taking shape in my head, deciding how to turn our conversation into something that would make the fantasy into a reality we could live with—something we'd remember in our skin. I patted her bottom lightly.

"First we have to settle this, Tara. We'll play in private until you're comfortable, until you're secure enough and trust me enough to give

yourself in public." I swatted her again, this time a little more firmly. "But from now on, when you wear my collar, you will obey me, do you understand? And if you don't, I will punish you—in private or in public."

"I understand," she whispered, nodding her head vigorously against me.

I reached down and stroked her round, full bottom, teasing over the sensitive lower curves. "You should have told me."

She nodded again, clutching me fiercely. Then she took a deep breath and whispered, "Yes, sir." It came out in a sniffily little squeak, but it was pure music to my ears. She'd never called me "sir" before, not when she meant it. I hugged her back, feeling my own eyes burn with relief, my dick swelling with desire as I hugged her for the longest time. When I could speak, I cleared my throat and reached down to lift her tear-stained face to look at me. She was so beautiful, so vulnerable, her liquid brown eyes once more swimming with unshed tears.

"In the future, you will tell me whenever you're upset or afraid or even just bothered by something. Do you understand?" I spanked her, hard enough to make her yelp.

"Yes, sir," she nodded, reaching back to rub her behind. I knew she'd felt that swat. My hand was stinging from it.

I turned slightly and looked back into the kitchen. The wide bamboo stir-fry paddle was drying in the dish drainer. Without saying a word, I took Tara's hand, led her into the kitchen, into the wonderful food smells and the candlelight. I picked up the paddle and turned it over in my hand. It was about four inches in diameter, smooth and sturdy. Tara's eyes got big as saucers. I pulled a chair out from the table, sat down on it, and patted my lap.

"Mitch," she whispered, her voice shaky as I guided her over my thighs. I hoisted her bottom forward, pushing her off balance, lifting her full, round cheeks until they were perfectly positioned for spanking.

"Not a word," I said sternly. I stared at her until she looked away and lowered her head. Her bottom arched up even further, her long, lustrous hair falling down to brush the toe of my boot. I carefully lifted her skirt, my cock itching as I slid the hem up her legs, half afraid she'd bolt, and praying this wasn't all a dream. Then the creamy length of her thighs gave way to the rounded expanse of her nervously twitching behind.

She wasn't wearing panties. Her beautiful bottom was bare for me under her skirt. Tara had never done that before; even though I'd told her so many times how much it turned me on to find a woman's ass naked and waiting for me. As my fingers slid between her thighs, her labia were smooth and sleek and bare. She'd shaved her pussy. Her shudder told me the newly exposed skin was exquisitely sensitive. I cupped her soft, warm cheek and squeezed firmly.

"Thank you," I said quietly.

She opened her mouth to speak, but I shook my head.

"Just listen." I reached in my shirt pocket and drew out the gold necklace I'd planned to throw out. "Lift your hair."

She did, shivering uncontrollably when I slid the thin gold chain around her neck and locked the catch.

"As long as you wear my collar, Tara, you are mine." I fingered the chain, sighing with relief when she nodded. Until that moment, I hadn't realized how much I'd wanted her to give herself to me. My voice was husky as I growled, "Any time you truly want me to stop, say 'mercy,' and I will grant it to you. Just remember, love. Mercy is something I will give because I love you and respect your limits. It is not ever something you

have earned or deserve. Do you understand?" I punctuated my question with a sharp smack to her bottom.

Tara gasped, jerking upright as if I'd burned her. I didn't move, didn't say a word. I just waited, and was rewarded a moment later when she nodded and lay back down, her hair once again falling over my leg, the necklace shining against her upside down chin. She grabbed my ankle, arched her bottom back up at me, and waited.

I didn't say another word. I just laid into her butt with that paddle. I let her have it—long and hard and fast. No warm up. This was a punishment spanking; it was needed to clear the air between us. She yelped right away. She was crying by the fourth stroke. But I think the tears were close to the surface anyway, cathartic tears. When she reached back to protect herself, I wordlessly pulled her arm up against the small of her back and held it in place. And I kept right on spanking her, relishing the beautiful music of her sharp, pain-filled cries. After a good dozen hard strokes, I paused, rubbing my fingertips over the bright red flush of her butt, relishing the heat and the sounds of her sobs.

"You are so beautiful, Tara," I whispered, soothing her tears as I stroked her bottom. She jumped at each touch.

"It hurts," she sniffled. Her hair moved in waves and she inhaled on a shaky sob.

"I want it to hurt, love." I smiled; leaning over and kissing her deliciously heated flesh. "It's going to hurt a lot more before I'm done." She shivered as my fingers stroked a particularly red and hot spot. "I want it to hurt so much you know—in your skin—how much you mean to me. So much you'll always remember to tell me when you need me to take care of you. So much you'll always remember that I will."

I ran my fingers over her skin once more. "Hold onto my ankle, Tara. I'm going to spank you again now. It will hurt. You're going to cry and wiggle and yell until your throat hurts, but you are not to move your hands." I cupped her glowing and very warm fanny. "Tell me when you want me to start, sweetheart."

Her tiny "now, sir" was almost inaudible, and it took a long time coming. But as she spoke the words, her delicate hands grabbed hold of my ankle and held on for dear life. She whimpered when I lifted my right leg and pulled her outer thigh wider, exposing the tenderest parts of her bottom. Then I lifted that paddle, and I rained pure hellfire on her behind. Tara yelled and screamed and kicked, her ankle bracelet bouncing up and down as her legs flailed and her bottom arched and she cried until her whole body shook. But not once did she let go of my leg. She was so beautiful, so demonstrative—and she was wiggling uncontrollably on my now thoroughly engorged and throbbing cock.

"Is there anything you want to ask me for?" I paused, giving her time to remember her safe word, being sure she knew what I was asking her. I was so aroused I could hardly breathe.

"No, sir," she sobbed, shaking her head. "But my bottom really hurts." She spoke softly, rubbing her pelvis against my leg.

"I'm going to make your bottom so sore you'll think of me every time you try to sit, every time you even walk, for a very long time." I dragged my fingernail lightly over the tender, sweet junction where her backside met her thighs. Tara lurched forward and gasped. I'd paddled that area until it glowed bright red. Even the normally hidden valley between her bottom cheeks radiated heat. "If I have my way, beloved, you'll remember how much I love you every day of your life."

I reached between her legs. She groaned when my fingers sank into her heated, dripping pussy. "God, Tara. You're so beautiful. My cock's ready to burst!"

I wrapped my arm around her back, and I burned another two dozen scorching stingers over her thoroughly spanked bottom. Tara was beyond talking. She howled and bucked and tried to twist away from the burning punishment of that nasty little paddle. But she was mine now, holding on to me for dear life while I set her bottom completely on fire. She was still arching when I unceremoniously lifted her off my lap and stood her between my knees. Her skirt fell down, and she grabbed her blazing bottom, wailing in pain. Her eyes were squeezed tightly shut, tears pouring down her cheeks while she frantically rubbed her backside.

"Quiet!" I snapped. "Hands on your head and open your eyes."

She obeyed instantly, still dancing from foot to foot as she looked at me forlornly. I grabbed a paper towel from the counter and held it to her nose. "Blow."

She did, blushing deep red with embarrassment. I wiped her face and tossed the tissue in the trash, making myself resist the urge to comfort her.

"Lift your skirt."

Tara hissed as the light cotton slid over her hips. She slowly raised her hem and exposed her naked vulva. I couldn't take my eyes off her.

"Hush," I ordered, surprised at how husky my voice sounded. God, she was beautiful. I jerked my jeans open, pulling out my rock hard cock. Her eyes widened as I dragged her over me. When she was straddling my thighs, her legs spread wide and off balance, I grabbed a fingerful of butter off the table and pulled her butt cheeks open.

"Ow!!!" Tara cried out, gripping my shoulders tightly as I squeezed the hot flesh of her well paddled behind.

"Squat," I growled, spreading my legs to open her thighs further and roughly pulling her deliciously heated and wildly quivering as cheeks wider. I pressed my finger against her hot, tight sphincter. "Do it!" I snapped.

Tara whimpered, lowering herself slowly onto my finger, letting the tip slide into her hot, incredibly tight back door.

"Fuck yourself on my fingers," I commanded. "Show me you want it."

"Mitch," she wailed, flinching as I cupped her bottom again. But when I didn't move, she groaned and slowly impaled herself on my slicked finger. Then, without my saying another word, she started raising and lowering herself, swaying wantonly from side to side, moaning as eventually two fingers, then three, slid in to stretch and loosen her. She cried real tears each time I squeezed her flaming bottom cheeks and stretched her sweet, smooth anus open. I stuffed my fingers into her ass until she was moaning in my arms.

When my fingers moved smoothly, with no resistance, I pulled her to her feet.

"Hold still," I commanded. I grabbed another fingerful of butter and pressed it up her bottom. Then I slathered a handful over my cock. She blushed and whimpered, knowing what was coming, but never once moving away.

"Fuck yourself on my dick,"

"You're so big," she whimpered.

I swatted her as cheeks hard. "Do you want another spanking?"

"Oww!! No," she cried out. "Please, Mitch, don't!" She arched her back, her bottom lips fluttering over my fingertips. Then she froze and looked at me. "Um, unless you really want to spank me again, sir."

I almost choked, trying to stifle my grin. "Fuck me," I growled, bumping my cockhead against her butt hole.

Tara was slow and clumsy and she cried when I held her tender butt cheeks apart. Her slippery, welcoming sphincter inched slowly down over my dick, until her ass engulfed my shaft in her incredibly soft, clinging heat. She froze above me, seated to the hilt, the gold chain shimmering around her throat.

"Fuck," I snapped.

Tara obediently raised and lowered herself over my cock, panting and trembling while her velvety sheath jerked me off. It took all my self-control not to shoot. I reached between her legs and stroked her clit, ignoring her cries. "You're going to come right here at the dinner table, Tara. Here, now, with your ass full of butter. " I flicked my fingers mercilessly over her. "You're going to fuck your bottom over my dick and come in the kitchen with my cock buried up your ass."

She gasped as the spasms started to take her. I pinched the hard, slick nub beneath my fingertips, leaned forward and bit her pointed nipple, right through her blouse. Tara grabbed my shoulders, yelling as her ass clamped down around my cock. She ground against me, and I let go, my dick spurting up her ass until my cream ran back down over my dick. Then she was shaking in my arms. I hugged her ferociously, panting as the residual spasms fluttered over my shaft. We stayed that way for a long time, me stroking her heated backside, Tara clutching me and sobbing while her tears soaked into my shirt.

Eventually, she raised her head and smiled shyly at me, her eyes still swimming. "Thank you," she said shyly.

"Are you scared anymore?" I asked, raising an eyebrow.

"No," she blushed, ducking her head. "OW! I mean, no, sir." It was just a single slap, but my gut clenched with emotion when she didn't even move to reach back and cover her bottom. Then, her eyes still glistening with tears, she looked back up at me. "Are you ready for dinner now, sir?"

The spaghetti was cold and the candles had burned down, dripping wax on the expensive linen tablecloth. The scent of semen and fucking now mixed with the smell of garlic. I lifted Tara off my lap, shivering as my softening cock pulled free with a plop. She grimaced at the friction and stood shakily between my legs, reaching back to gingerly rub her bottom. She caught herself just in time and raised her eyebrows, waiting for permission.

"You may rub for two minutes," I said, pointing over my head to the clock on the wall. "Then microwave our dinners. You'll serve me naked and eat that way, too, wearing only your collar and the ankle bracelet." I nonchalantly tucked my sticky cock back in my jeans, then leaned forward and picked up my wineglass. "After dinner, you'll slip into the back yard—without putting on your clothes—and fetch me a switch, so I can make very sure that you'll never forget this lesson. Then I'm going to fuck you until we both pass out. " Tara nodded, her eyes filling with tears again and her hands clenching protectively over her bottom.

"I-I suppose you'll want fresh butter for dinner, sir?" Her shaky smile warmed my heart.

"And by the bed." Her eyes widened, and I grinned, settling back contentedly to sip the fine merlot she'd served. "I love you, Tara. I'm going to make you love being mine."

Softball

by Rosie's chica

Back in high school, I pranced around in my ultra short cheer-leading skirt and waved my pompoms for a losing-record home team. I flaunted my boobs in a push-up bra that advertised my decidedly pronounced assets even under my school sweater. Hell, I jumped and yelled with all my fool sistahs until everybody who was any-body knew this wannabe football honey was going to score in the big leagues.

Eight years after graduation, football players and their jock-strapped dicks held even less interest for me than they had back then. I'd used my team spirit connections to finesse a degree from the prestigious college of my choice. I had a solid reputation for my work and a nice stock port-folio in hand. So, I kissed the old-boy system good-bye and transferred to a successful dot.com where nobody cared what my nasty dyke ass did, so long as I got the job done. These days, when I paraded up and down in front of the bleachers in a skin-tight top, shortie shorts, and FM

shoes that showed off every inch of my curvaceous legs, I had only one goal in mind—to distract the cross-town fools trying to knock my darling Rosie's softball team out of the district championships.

I'd spent years mastering my femme mystique, and I could play the part to a "T." My favorite top was a milky white knit halter that unbuttoned all the way down to the front hooks of my sexy uplift bra—the one with the demi cups that let my gold-ringed nipples point out hard and naked beneath the smooth, creamy overlay. Even now, the accompanying pierced navel, spiked heels, and rings on my painted fingers and toes were all just part of the image. But this time, I got off on playing the part. Team rivalries aside, I had every intention of keeping my butch babe pitcher and her display case full of trophies happily at home in the evenings.

My Rosie got off on playing ball. Her real name was Rosalinda Guadalupe Esperanza María Flores. She was smart and quiet and shy. And she was so strong. Her thick black hair fell in waves over the muscular shoulders that got her an athletic scholarship to State. I called her "Peashes," after the way she pronounced the ice cream she'd been eating the day we met. Well, that's what I told her mother. Rosie blushed like crazy when she translated.

I'd become a softball fiend the moment I discovered the local women's team. Not that I played. I didn't work my ass off in academia to get my designer clothes dirty. But hot damn, I loved watching all those athletic female bodies running around on the field in their sweaty uniforms. Oooh, Rosie was voluptuous. Her tits were almost as big as mine, though she kept hers hidden in a sports bra. And her hips—yum. They were wide and firm, and the way her shorts rode up into her cleft when she wound up to pitch, well, let's just say I didn't need my nipple rings to perk me up. I could almost smell the juice running into her panties.

The day Rosie's team clinched the playoff position, I'd followed them to the local ice cream parlor to celebrate. I bought a round for everyone. Peach for Rosie. She blushed all the way to her hairline when I complimented her on the game. She told me later she thought I'd noticed how wet her crotch got when she and her girlfriends rehashed the winning innings.

Eventually, her friends left. Rosie and I stayed, talking. We ate a second ice cream. I kept my eyes glued to her, even when she started stammering. Especially then. She finally got distracted enough that the cream dripped down her cone. I leaned over and licked it up. I kept licking, right up over her fingers, watching her eyes glaze and her beautiful brown skin take on a glowing blush that made my pussy tingle. When I told her I wanted to take her home, she nodded and wordlessly took my hand. Her fingers trembled in mine as I picked up her glove and hat and led her back to my car, then to my apartment.

I didn't even open her shirt. I pushed her back on the bed, yanked her shorts and panties off, and dove between her legs. Her scent made me realize just how that dog of Pavlov's felt. Rosie's cunt was hot and tangy and slippery with pussy juice. The flavor had me pressing my legs together, squirming as I held her thighs apart and feasted on the soft flesh that opened to the heat inside her. I licked deep up into the soft ridges, savoring her juices until she was panting. Then I flattened my tongue and swiped up over her clit.

Rosie screamed. I almost did, too. She had the most beautiful clit I'd ever seen. It stuck up like a fingertip, red and thick and glistening as it pushed free of its hood. I held her thighs back and pointed my tongue, flicking like a snake in heat. Rosie went nuts, writhing and shaking and yelling at me in Spanish. She stiffened three times, yanking at my hair.

Each time, I sucked her clit all through her orgasm, working the hood over the tender nub beneath, doing her beautiful swollen clitty homage the way it deserved. Rosie twitched like her body was electrified. Then I buried my face in her pussy and lapped until she pushed me away.

When she finally caught her breath, she sat up and pulled me in front of her. Her hands still trembling, she unbuckled my high-heeled sandals and worked off my shorts and silky thong. Then she tugged my shirt over my head.

"I thought so," she whispered, her hands steadying as she rubbed her finger over the sensitive tip. "I've got a thing for nipple rings, chica."

Before I could speak, she put her hands on my sides and lifted me, until my nipple was even with her lips. Then she opened her mouth, and she bit.

In my entire fucking life, I have never felt anything like that. I twisted like a fish on a hook, yelling and shaking as sensation exploded straight down through my cunt. I could not believe how strong she was.

"Finger your pussy, chica. Bat a home run for me."

Before I could say a word, Rosie started to suck—hard, playing the ring with her tongue. My whole world was the liquid warmth of her open mouth and the deep rhythmic tugs pulling a climax from me. I reached between my legs and frantically fingered myself through a shattering orgasm. I was still shaking when Rosie laid me tenderly on the bed. She pulled off her shirt and bra, her heavy breasts swaying as she moved between my legs.

I lay there exhausted, panting. Rosie opened my nightstand and fished around for a rubber glove and a huge tube of lube. With a quick squirt, she slicked up her hand. Then her cool, latex-clad fingertips brushed against my pussy.

"Let me show you how I pitch handball, gorgeous."

A cool finger slid in, soft and slow.

"First base," she growled. My face flushed hot. At second base, two fingers pressed deep and demanding. Third, and I was writhing against her, whimpering as her knuckles stretched me open, demanding entrance. I'd never felt that full before—that hungry. Then, her fingers still in me, she leaned over and took my other breast into her mouth.

"Let's make this one happy, too," she purred, grazing her teeth over my nipple. "Home run, sweetheart, to cap off a perfect game." Her lips closed around me and she bit. She teethed where the rings pierced my skin until just the soft, slow swirl of her tongue made me gasp. Then she sucked my whole areola into her mouth. Four fingers. They hurt, like rug burn on my cunt walls. And God, I wanted more of her in me. I could feel my nipple elongating over her tongue, the rings undulating, the tingling bruising rush as my engorged flesh stretched into the wet heat between her inner cheeks. She sucked the sensation towards my skin, the vibrations echoing deep into my pussy.

Her knuckles and thumb pressed, stretching me. My pussy fluttered, opening, drawing her in, trying to swallow the weight and the pain and the unyielding force and strength of her hand. She was pressing, always pressing. With a rush, Rosie's fist slid home. I screamed. Waves of excruciating pain and pleasure washed through me. I clenched my cunt walls around her, twisting and shrieking and crying. She pressed deep, sucking hard on my nipple, rocking her hand until I felt the tingling spurt of my juice squirting out. I yelled until my throat hurt and my cunt felt like it had been pummeled to mush and my breasts were too sore and satisfied for me to even stop the tears when Rosie gently bit on the tender rings again.

"So beautiful, chica," she whispered. "I like a catcher who lets me score."

I came again when her hand slid free, shaking as tears squeezed out of my eyes and a final drop of liquid leaked free from my urethra.

"What do you say we play a double header, after we get some dinner?" she whispered. She leaned down and kissed me softly on the lips, the peachy sweetness of her breath flowing over me as I lifted my face to kiss her back. "You give me a play by play of today's game . . . " I froze as her fingers move purposely lower. "And I'll get you up to bat again." A shiver ran through my whole body as Rosie's slippery fingertips gently brushed my anus, and patted. "I'm going to score a second home run, chica. Count on it."

Janus

Lee and Gino's Story

- Lee -

I was late getting to Gino's club. I'd been babysitting. Not my normal evening's entertainment, but my niece's regular sitter wouldn't take the kid when he was sick, and she had a final for her paramedic class. I'm not sure what her ride thought when she saw the two of us waving goodbye out the picture window—the kid in his jammies and me in my leather jacket and chaps. Not that I cared. We spent the evening listening to Mozart on PBS, and we read a lot of books—when I wasn't wiping his nose or feeding him juice. By the time I left, he knew how to build a Harley out of those little plastic building blocks. I even made a kickstand out of a bent toothpick.

But I was late getting to the club. Gino was not having a good night. Some posers who were too inexperienced to hold their liquor were fighting in the corner. I could tell by the broken glass around them that it wasn't the first time that night.

"I said get the fuck out of my bar!" Gino's voice roared over the noise of the jukebox. He jumped over a chair and grabbed the two worst ones by the scruffs of their pristine leather jackets and threw them out the front door. A few people stopped talking to watch, but most everybody else just ignored them. Not a good sign. Designer jackets in a leather bar usually mean trouble, at least in my humble opinion. I have a lot of respect for my opinion.

Gino was dusting his hands off when he finally saw me leaning on the far end of the bar. He gave a quick nod. A few minutes later he was handing me a bourbon and water.

"What a fucking night," he said, setting a napkin down on the shining black lacquer. "If these assholes don't want their pretty little butts cruised, why the fuck are they coming in here with their shiny new chaps on and their tits hanging out! This is a leather bar, fer crissakes!" He tossed back a deep swallow of his beer, wiping his hand over the back of his mouth. "That little shit had the gall to tell me he came in here to make small talk! He actually said that! 'Small talk!' Can you fucking believe it?"

I shook my head. Sometimes I wondered what the world was coming to. A few weeks ago, I'd actually seen a guy in Gino's with a starched white hankie in his hip pocket. He'd pursed his lips in distaste at the lack of designer beers on tap. But he'd paid with real cash from his Italian leather wallet, so Gino and I kept our opinions to ourselves, shaking our heads while the newest bartender-in-training served the guy.

Gino and I went way back. We'd come up through the ranks together in the leather world of the late sixties. While we'd both been exclusively tops for years now—lots of years—we'd met at a house party in Laurel Canyon when we were both 19. We'd been hanging by cuffs from adjacent ceiling chains as part of a flogging demonstration. We spent a long

while afterwards silently leaning against each other for comfort while
the house slaves cleaned the blood and sweat and our own come off of us.

Things had changed a lot since then, but we'd always stayed in touch.
As I sipped my drink, I could tell, the way only a really old friend can,
that something was bothering Gino. Something more than yuppie
leathermen. I decided to stand there and wait. He'd talk when he was ready.

- Gino -

I was glad Lee had come by. It had been one helluva night—made me
think seriously about getting out of the bar business. And it was top-
ping off one fucking awful day.

I'd hurt a guy that afternoon. Hurt him bad. By accident. Some punk
kid who'd lied about his experience and panicked at the first taste of a
single tail. I should have known. When he turned ghost white and
screamed from a nipple clamp any novice could wear, I should have
seen through his line about being sensitive from a botched piercing as
just so much bullshit. I should have picked up on the way his whole
body tightened when I cracked his ass a couple of times for not telling
me about the "piercing" ahead of time.

But I'd been tired and the kid was cute and I was horny. And I'd been
inordinately pleased to discover that one of these new posers was the
real thing. So I'd believed him when he said he liked it real rough. When
he'd said a slow build-up was "baby" stuff and just made him irritable.
When he'd said he couldn't come unless it was hard and fast enough to
be believable—to draw blood—right from the start. Fuckin' shit, I know
better than that! I should have looked closer for scars rather than just
assuming he wasn't marked because his previous tops had been skilled
enough to just barely draw blood.

Shit, I don't know why the fuck I believed him. Maybe it was just my cock thinking for me. I ordered him to yell "safeword" if he needed to, even though he insisted he didn't need one. But I should have known even that wouldn't necessarily be enough.

My first blow caught him across the left shoulder blade, right on the thickest part of the muscle. I was admiring how right on I'd been—I always am—watching the red drops form and thinking I'd give him three stripes to get really turned on before I checked him again, before I tested the tension in his arms and tugged on his bindings and ran my hand over his cock to be sure he was getting as hard as he said he would. He caught me completely off guard when as he screamed and threw himself to the side. No safeword, no warning, nothing. Those eyebolts have held people who out-mass him by over a hundred pounds—I mean I put those suckers in myself; I know they're secure! —and he pulled one of them right out of the fucking wall. It was too late to stop the second blow. The tail was already in the air and all I could do was try to pull back, but by then I was off balance and it was too late. The tip caught him under the arm, right across where the skin is thinnest over the rib. And it cut almost to the bone.

It took a while to get things back under control. I grabbed his shirt off the floor and pressed it against the cut to staunch the flow of blood. But it took even longer to get him calmed down. I had to hold him down to get the restraints off. Even then he didn't stop screaming until he threw up. By then he'd turned sheet white and started shaking. Finally I threw a blanket around the both of us and just held him until he warmed up and got some color back in his face. And while I sat there sweating like a pig in my leathers, he started blabbering about how it didn't look like it hurt that much in the movies and about how the stories made it seem

like a whipping always made you come like gangbusters right away. Then he threw up again, this time on the blanket rather than himself.

I could not fucking believe it. Some novice little weekend biker punk—turns out he's never even been hit with a belt before—pulls a stunt like that on me, and I missed every single fucking clue! It took four stitches to close the cut on his ribs. I called one of his friends for him from the emergency room, left when the friend got there and started in with the "what the fuck are you doing with people like that?!" speech. Fuck, I was pissed off.

I didn't even think about it being blood that I'd been touching until later. Shit. I know better than that, too. I think that part's just starting to sink in now. Shit! I still can't believe it—every single goddamn clue!

It was good to talk to Lee about it. I knew he'd understand, even if he didn't really understand, if you know what I mean. He just stood there, nodding and sipping on his drink like he always does, while I told him the whole sordid story. I felt better afterwards. He motioned me off with that usual tight little smile of his when I went to break up another fight. Damn, sometimes I think I'm getting too old for this business.

- Lee -

I knew Gino'd been upset, but shit! I took another sip of my drink, real slow, letting the burn slip over my tongue. I make a point of always noticing the taste of the liquor. It keeps me from getting too far gone in the booze like a lot of my friends have. I figure that as long as I can still really feel the burn on my tongue, I'll keep paying attention to just how much of it I'm drinking.

I watched Gino sorting out the latest round of culprits from the inno-cent bystanders and tossing a couple of the former out on their butts. He was really beating himself up over this one. Hell, we all make mistakes. And it sounded like the kid had been a pretty good liar.

I took another sip of my drink—the ice was melting, but it was still good—as I watched Gino kick one guy in brand new jeans right square in the ass. But Gino was right. He had fucked up. Bad. Accidents happen, but neither of us cut a top much slack for making that kind of a mistake. Maybe we're just too old school. But in our world, no matter who really did what, the top is always in charge and he's always responsible. No excuses. Not many people believe that these days. But like I said, Gino and I came up together in the old days, and that's just the way we are. We've both made mistakes, both hurt people, especially in our younger days when we were still learning. But I'd never sent anybody to the hos-pital. And I knew Gino hadn't either. Until today.

Gino came back a bit later, still thoroughly pissed off and swearing up a storm about the latest fight. But he caught me off guard when, in the midst of his still very one-sided conversation, he said he had a friend, somebody I knew, who wanted to get together with me later that night. If I was free.

It was hard to see Gino's face; he was wiping up the bar as he talked, but I was surprised that the guy had approached him rather than com-ing directly up to me. I'm known for being pretty receptive to properly respectful inquiries. I nodded and looked around the room at the many bottoms I'd played with before, wondering who it was and wondering if he were looking for a good, old-fashioned strapping that night—I was sort of in the mood myself—when Gino stopped me cold.

"It's not somebody you've played with before. He usually works topside."

My eyebrows went up at that. This was getting interesting. I looked around again, not noticing anybody who seemed a likely candidate, but the bar was crowded, just dark and smoky enough that it was hard to see into the corners.

"Another top? And he wants me?" I squinted, taking another sip as I tried to figure out if I knew the guy sitting at the first table by the door. There were two young punks with him, both looking real interested in his boots. As I watched, one of them dropped to his knees and started rubbing his cheek over the toe. Nah, even if I knew the guy, he probably already had all the action he could handle for the night.

"He hasn't gone under in a long time. So he wants the best. I figured that's you."

Now that got my attention. I turned back to look at him, but Gino was looking away, pointing under the bar in response to something the bartender-trainee had asked him.

I couldn't imagine anybody turning down Gino. We're both "in our fifties," though only for another year or so, and I'm about as average looking as a person can get. Gino's still got pretty much the same sculpted body he had at 19. The muscles are deeper now, like he's really used to wearing them, and the lines on his face have started to show his personality as much as his good looks—even though I'd never thought of blond hair and blue eyes as Italian before I met him. He'd always said, "My ancestors were from northern Italy." Yeah, way north, I figured, like Austria. But he has that thick chest hair, even though it's blond—well, sprinkled with gray now. And he's loud like most Italians I know. Gino can wield a whip like nobody else I've ever met. I love watching him work. He has real style, real finesse. People damn near stand in line to bottom to him.

And he was sending somebody to me.

Gino's voice sounded really distant, and that bothered me. Made me think that his confidence might be shaken pretty badly right about now.

"I think you should take him instead." The words came out as I thought them. I was horny, but I was also thinking about the old "getting right back on the horse that threw you" crap.

Gino looked me right in the eye and said, "No."

Just like that. For a minute we looked at each other, almost staring each other down, but not quite. Then he shrugged and said, "You or nothing" and turned away. And I knew he meant it.

Well, shit, that wasn't getting us anywhere. I took another sip, waiting. I knew that wouldn't change anything. The drink was good though. And the prospect was interesting. So finally I said, "Okay."

Gino nodded once, then started swearing again as he went back to help the trainee, who'd just poured vodka into a Virgin Mary.

As the tables cleared out, I took a seat in one of the corners, where I could watch everybody coming and going. I sipped my way through a second drink, but stuck to water after that. I wanted to keep my head clear, and I was checking out the other patrons, trying to figure out who my future "date" was.

I was approached a couple of times. I admit it, I do look good in leather, and the handcuffs on the left side of my belt are all the advertising I tend to need, though my reputation usually precedes me. But tonight I sent them all on their merry ways, intrigued by the thought of playing with Gino's friend.

I was so intent on people watching that I almost missed the overture. It was nearly closing time, the bartender—Gino's assistant manager, this

time—had issued last call, and I was wondering if the person had changed his mind. Gino brought me another drink, and I almost didn't catch the words. My head was turned, looking at the people in line at the bar, when I finally heard him.

"Your drink, sir."

My head snapped back, the words still registering, when Gino sat down opposite me at the table. And then I realized he wasn't sitting down. He was kneeling. On the far side of the table, closest to the wall. Probably getting glass in his leather pants after all the fights that night. But Gino just waited, looking right at me. Then he very gracefully looked down at the floor.

For a minute I was stunned. This was not what I'd expected. Finally I just blurted out, "Why?"

I had to ask. My voice came out sharper than I'd meant it to. I didn't know if I was more shocked or surprised by what he was doing.

But his answer was very quiet. "I don't know. I do not fucking know. I only know I have to, and it has to be tonight, and it has to be with you." He hesitated just a second before he added, "Sir."

I think it was the hesitation that made me decide. Shit, who knows? Gino's a good-looking guy, as well as a friend. Maybe now I was the one who was just horny. I picked up the fresh drink and took one long, slow sip—to clear my head, though by then I'd already made up my mind. Then I didn't even look at him as I said, "Tell the bartender you're leaving. Now."

And he did. Just like that. By the time I stood up and walked across the room, Gino was waiting at the door, holding it open for me. We didn't say another word. We just got on our bikes and he followed me home.

- Gino -

I still don't know what made me do it. Maybe the kid earlier in the day. Maybe all the fights. Maybe a lot of things. All I know is I was standing there, planting my boot in some smartass' pants, when I suddenly knew that at that particular moment I was sick to death of the whole fucking scene. I was tired of having to be responsible for everybody I played with, I was tired of games, and I was as ready to puke from the smell of Faux Sweat 'N' Leather cologne as I had ever been from too much beer.

That's when I looked back at the bar and saw Lee again. I'd felt his eyes on me while I dragged the latest drunks aside, the same way I'd felt his censure while we'd talked, even though I knew he understood exactly how and why something like what happened this afternoon could have happened. It was like watching a curtain lift, watching him scratch his hand over his chin where the shadow was getting darker, the way his always did this time of day. Suddenly I knew there was only one way I was going to work myself out of this—that was to start over. To go under like I had years ago, when things were safe and sane and everybody knew the rules. To remember in my skin what it was like to be on the bottom. And then to work my way back up until I'd figured out where I fit into the new scheme of things. Just this one night, I wanted to let go enough to scream it all out of my system. And there was only one person I trusted enough to do that with.

I almost changed my mind quite a few times. I'd seen Lee work, and I knew that if I bottomed to him I'd be sweating pain from every pore in my skin before he was through. I hadn't bottomed in over 15 years, the

last time only because I'd gotten drunk and lost a bet. Before that, well it had been a long, long time. I'd been working topside since I was 25, and I'd never had any desire to go back. Until tonight.

I also knew Lee'd fuck me until my eyes crossed. He likes to mix sex with his beatings. I wasn't quite sure where that fit into the overall scheme of things. But I think I wanted that, too. He and I'd had sex a few times back in L.A., when we were in training. We'd jerk off together or suck each other off one last time on nights when we were too sore and exhausted to be taken back into the playrooms anymore. But we'd never fucked. We'd both started topping at about the same time. We'd even practiced on each other a few times when we were first learning to use braided cats. But after that, we'd just stayed friends.

I was still thinking of changing my mind when I took the drink over to him. He was watching the people at the bar. I could have left the drink on the table and walked away. He'd never have known.

But I didn't. The words just came out, the way they had back in the old days, on the times we were allowed to speak. I knelt down because I figured I owed him that much respect. Yeah, I was on the far side of the table, so he was the only one who saw me. But I didn't dare kneel in the middle of the floor. Hell, I'd never be able to keep order with that mob again if I did. Lee knew what I meant, though. And that was all that mattered.

It was saying the word "sir" that really made up my mind for me. I'm not like some of the little leather boytoys these days. The word means something to me. Saying it meant making a decision. I could see Lee appreciated that.

After that, it was easier. I didn't have to think so much anymore. I just had to do. Even though I knew I'd have to do a whole lot more before Lee was done with me.

- Lee -

I made Gino strip naked outside the back door of my house. There wasn't much chance of anybody seeing him at that hour. And aside from setting the tone for the evening, he had glass in his pants from the bar floor. It would have been a cast-iron bitch getting it out of the living room carpet, to say nothing of his knees.

Besides, Gino has a great body. His tits got hard when he took his shirt off. They still stood up the way they used to, a nice, dusky rose color. And those low-hanging balls of his were just the way I remembered them—big as eggs beneath his long, cut cock. He looked good, and I made sure he knew I was watching him undress. If he was going to go under, by God I wanted him in the right frame of mind. He knew better than to think we were going to play at it.

I'd forgotten that Gino always wore a cock ring. I told him he could keep that on. He was shivering. I don't think he would have been hard at all without the ring. So I led him straight down into the playroom where I turned on the space heater.

I made him tell me he was scared, though. I ran my fingers over the hair on his arms and his chest and the back of his neck, turning up the space heater bit by bit while I made him shiver even more than he already was, asking him if he was warm yet, until he finally said, "I'm not cold, sir. I'm scared."

He was looking gracefully down at the floor—it's amazing the old habits that surface, given the right impetus.

"You should be scared, boy." I slapped him when I said it. Not too hard, just enough to let him know I was in control. Then I felt him smile

as he relaxed and the tremors stopped. Yeah, ol' Gino was going to be okay. He was going to be sore as hell when I got through with him, but he was going to be okay. As he stood there, eyes respectfully on the floor, I could see his cock filling. I turned away so he couldn't see me smile. Or see the way my own cock was responding.

I took my long, slow time with him. I wrapped his wrists in leather restraints and attached them to a heavy chain that hung down in the middle of the room. Then I clamped his ankles in padded irons and attached them spread-eagled to eyebolts that poked up out of the slits in the black rubber floor mat. I liked the way his long white toes curled against the mat.

I ran my hands over every inch of his body, massaging the tension out of the tight places. I spent a lot of time on his shoulders and his ass. I kept up a steady conversation, letting the sound of my voice seep into his skin until I was comfortable that he'd respond without thinking too much. Then I started gently slapping him, all over, to get the feel of his skin. His muscles were in as great a shape as they looked.

I didn't warn him the first time I really smacked his ass. I liked the way he responded though—tightened, then relaxed again right away. Thinking back, I remembered that Gino'd always liked having his ass beaten. Then I remembered something else about him. I took off my belt, slowly, letting him hear, watching his muscles tighten. Then I laid the cool leather across his shoulders. I didn't have to wait for a reaction. He moaned softly and dropped his head onto his arms.

"You still hate having your back whipped, boy?" I kept my voice very soft as I slid the leather over his skin.

"Yes, sir," he whispered, his head still resting on his arms.

"I'll leave it alone if you ask me to." I held the belt taut between my hands, rubbing it back and forth over his shoulder blades like a towel. Gino moaned into his arms again.

"You know that, don't you boy?"

"Yes, sir." It looked like he was trying to bury his face in his biceps.

I smiled. I knew he couldn't see me. I was going to make him offer me his back. He knew it, too, and he hated that almost as much as he'd hate the whipping. Almost. I could see his cock was hard as a rock. Once more I dragged the belt over his back.

"You know I want your back, don't you boy?"

"Yes, sir." He was whispering again. I slapped his butt, hard.

"What?"

"Yes, sir!" This time his voice was clearer, though he still hadn't lifted his head.

I could feel myself getting harder as I fought to control my smile. Damn, Gino was good! Once more I rubbed my hands over his back, in broad sweeping motions, from his waist to his shoulders, where I massaged deep into the tight, straining muscles.

"Give it to me." As I spoke I pressed my fingers into the flesh above his shoulder blades, letting him feel the heat of my hands. Then I waited.

Gino was breathing deeply, like he was fighting to control himself. But I figured I could afford to be patient—it would be worth the wait. I stood there, kneading his back, until finally he took a deep breath and said, very, very softly, "It's yours, sir."

"What?" I tipped my ear towards him. "I didn't hear you."

"My back, sir. It's yours." His voice was stronger now. I smiled as he lifted his head off his arms. He stood up stronger in his chains. I don't think he even realized he was doing it.

"I want all of you, boy. No holds barred. No rules but mine." I let my hands drop lower, let my fingers slide along the curve of his ass and press ever so gently between the soft mounds of flesh. "Say the words."

"All yours, sir. No rules."

Which for both of us meant a code of rules so strict that only those initiated into them could ever really understand them.

In response I smacked the belt hard, just once across his ass. His whole body shivered. He was standing straight now. I leaned up hard against him, wrapping my arms around him and letting him feel the leather of my vest and the heat of my chest against his bare back. And my hard-on. Then I bit him, just once, but very sharply, on his ear lobe. He shuddered so hard he pushed me back a step. I couldn't help smiling again.

"Good boy."

I snapped a pair of nipple clamps on him. It felt good to hear him yelp.

- Gino -

I hate having my back beaten. I fucking hate it. Almost as much as I love the feel of leather on my ass. They both make me hard. And they both make me come. Which is one of the reasons I like whipping other people. I like making men hurt and I like making them come. I like it a lot.

Lee had asked if there was anything else he needed to know before we got too involved, but we'd been friends long enough to know each other's health pretty well. He even remembered which knee I'd messed up when I'd wiped out on my bike a few years back. So I let go and I let myself feel.

He whipped damn near every inch of my body. He even whipped the bottoms of my feet, though he probably just used a little deerskin flogger on them. I couldn't tell for sure. He'd blindfolded me. But Lee knows how ticklish I am, and for all he made me dance against the chains, my feet barely tingled when I put my weight back on them.

The rest of me, though. Damn. I knew I'd be sore as hell the next day from the ball stretcher. Each time I thought the pressure was getting to be more than I could stand, he'd start teasing my cock. He ran those rough, hard hands of his up and down my shaft until I was thrusting my hips up towards him. Then just as I was ready to shoot, he'd laugh and start working my tits.

I'd almost forgotten what nipple clamps feel like. It was embarrassing to yell like that. He put some minty smelling cream on so the burn never really went away, and he left the clamps on so long that flames shot through my chest when he took them off. I tried to hold back, but I could feel the tears running down my cheeks as he worked my nipples. Damn, it hurt! And when he was done, he put the clamps back on and started all over again. I stood there, smelling the mint and the stink of my own sweat, trying to pretend my tits and my balls weren't screaming, while Lee slowly and methodically set my body on fire.

He whipped my back until I thought I'd die. I hated it, every minute of it, as much as I always had. But I also knew how much he wanted it. After a while even the hating felt good—to know the sight and feel of my back was pleasing him, that my pain was pleasing him, until I didn't fight it anymore. I just gave it to him. I let the tears run down my face until I didn't even feel them dropping onto my chest. He'd switched to a heavy flogger and I only felt the bone-deep thudding as he beat the tension out of my shoulders.

And my ass, oh God, I knew from how soft and light his first touches were, how he ran his hands over me just for the feel of my skin, kissing me and pressing his cock against my thigh, I knew how much he'd hurt me to make me come. And I wanted it so fucking bad. He alternated even the lightest blows with long, soothing strokes—rubbing his hands over my skin and then gripping my ass hard, always keeping me attuned to every inch of hide his belt was touching. I'd forgotten how good that feels. And how fucking much a leather strap hurts.

Finally I just let loose. What the hell, he'd said the room was sound-proofed. I yelled until my throat hurt.

I think it was getting fucked, though, that surprised me the most. I almost never switch with my usual partners. I like fucking them, so that's what I do. When Lee's finger started playing with my asshole, I thought I knew how things were going to go between us. He used a lot of lube, and he spent a lot of time playing with my cock and balls. When he had three fingers up me, I figured he was about ready to fuck me. He pressed deep, right up into my joyspot, until my cock twitched and the precome oozed from my slit. Then he leaned hard against me and whispered just one word.

"Beg."

- Lee -

Gino's skin was beautiful. I loved the way it responded to my hands. He knew what was coming, knew how much it was going to hurt. And he gave himself to me anyway.

I hadn't known how it would go with his back. I had a pretty good scene mapped out in my head either way. I was surprised at how much

I appreciated his gift. I spent a long time running my hands over those firm strong muscles, knowing they were mine to play with, that I could wake every nerve with my hands and my whips. And that he gave them to me freely. It was an awesome feeling.

The nipple clamps were just a mind fuck. Hell, I'd seen him chained to a wall with his tits bleeding. These were little ones. Just for fun. Just a little extra sensation to keep his mind busy. The ball stretcher, too. I liked watching his cock leak when he got turned on. Me, I've never made much precome, always needed to use a lot of lube inside a rubber. But Gino, hell, his cock had always drooled when he was hot. I remembered how much I'd enjoyed watching his clear juice drip off the tip. So I made sure he was real hot.

I spent a long time on his back. When I wasn't beating him I was touching him, especially running my hands over the scars from the flogging demonstration where we'd first met. I don't know that Gino even remembered they were there. But his skin did. There was just the tiniest little tremor each time I touched the faded white lines, usually between strokes, while he was concentrating on the stripes and welts that I was raising. I knew it had taken a lot from him to give me his back. So I made sure I paid it the proper reverence.

And playing with Gino's ass, now that was sweet. I took a strap to him until just running my fingertip over those perfect, hot curves made him hiss. I didn't want to break the skin, I didn't even really want to raise welts. So I settled for a lot of repetition. I started soft and slow, and I laid that strap to his ass until he was squirming so much he couldn't seem to make up his mind whether he wanted to raise up for more or climb the chain to get away. But each time, he lifted his ass. I didn't have to tell him to kiss the whips. Whenever I held a new one to his lips, he kissed it

without hesitation, without having to be told. And he knew to say, "please, sir" and "thank you, sir" while he did it. It was nice to play with someone who'd been taught proper manners.

And he appreciated what I was doing. He yelled so much he drowned out the symphony I had on in the background. I'd told him the room was soundproofed, and it was. After a while I figured his throat was probably getting sore, so I gave him a few sips of water as I stroked my hands lovingly over his back, relaxing the muscles. But he was perfect to beat. I could tell by how warm and flexible his hands stayed that he was processing the sensations okay. So I whipped the shit out of him. And he loved every minute of it.

I almost made him come while I was beating him. His breath got short and he threw his head back, his eyes closed even though I'd taken the blindfold off. Each time that strap seared into his ass, his cock lurched up stiffer. His balls were pulled up as tight as the stretcher would let them.

So just like that, I let up. I eased up on the strap and let it fall softer, waiting a long minute before I struck him again, watching him breathe a couple of times as his body climbed back from the edge. Then I leaned up along his back and kissed him, sucking the skin at the back of his neck and running my tongue all over beneath his ears and down those long cords. Until he turned and offered me his lips.

I kissed him. I liked the taste of the salt on his soft, wet lips. He'd been crying a lot. As he stood there, with his head turned back over his shoulder, my tongue took his mouth, and I slid my fingers up the crack of his ass.

"Nice ass, boy." I growled it low in my throat.

His answering shudder made my dick twitch. He knew what was coming. The chains kept his legs spread, but he still flinched when my fingertip touched his hole. I'd felt virgins who were looser than Gino was

right then. It was like pressing against a stainless steel hex nut. But ol' Gino and I both knew he was going to relax those muscles for me. I was going to slick him full of lube, and then one at a time I was going to work my fingers into him. I was going to stretch and pull and press anywhere I wanted until he was loose and open. Then I was going to fuck my hot, thick cock right up his ass.

And he was going to want it bad enough to beg for it. Now that was sweet.

- Gino -

I didn't know whether to laugh or cry or get pissed off. My whole body stiffened when Lee pressed into my prostate. I knew I wasn't far enough under to beg for it. We both knew I was going to fight him.

And we both knew he was going to win. As much as I didn't want to, eventually I'd be far enough gone that I'd beg him to let me come. I'd beg him from my soul. At some subliminal level, it was nice knowing that eventually he'd let me. Eventually he'd make me. He'd make me be an absolute whore to him just so I could come.

And, oh God, he made me beg. He fingered my hole and sucked my cock and balls until I shook. I'd feel the "please, sir—please!" start to slip past my lips. Sometimes I screamed it into my teeth even as I bit the words back. Then his hand would clamp hard around my dick while he snapped out, "No." And when I'd stopped panting, he'd step back away from me, while my skin crawled with wanting his touch. He was almost naked by then, wearing just his chaps and boots. Sometimes he'd stand in front of me and make me watch while he jacked his own dick. Once, just once, he lowered the chains enough that I could drop to my knees

and take his thick, swollen cock in my mouth. I buried myself in his scent. I licked the sweat off his balls and sucked the velvety skin of his cock over my tongue and down my throat. I've given a lot of blowjobs in my life, but I don't know that I've ever worshiped any man's cock the way I did his that night.

I felt like crying when he took it away. He laughed and ran his fingers over my lips. My tongue kept chasing where he'd been. For a minute he let me suck his fingers, first one hand and then the other. When they were wet, he slid them down my chest and pulled off the nipple clamps, working my own spit into my tits while I jerked against the chains.

He didn't put the clamps back on after that. I was so sore that just his tongue made me wince. So, he chewed for a bit more, using his teeth until I was dancing on my feet. I was crying again, but I wasn't paying attention to the tears anymore. They were just there.

When he was done, he licked his way back up to my lips and kissed me again. I couldn't stand it anymore. The lube was running down my legs. Lee stood beside me now, at least three fingers shoved up my ass, maybe four, his fist moving over my cock in a slow, steady rhythm I could feel all the way to my balls. And I just couldn't stand it anymore.

It didn't even sound like my own voice as the words started choking out of my throat. It was like they were being dragged out of my lungs each time my heart beat. I didn't want to fight him anymore. Nothing existed but needing to please him. Needing him to make me come. Needing.

"Please sir please sir please fuck me . . ." Almost like a prayer.

I was half expecting the "no" again. When I heard the foil wrapper tearing, I almost cried with relief. Lee moved in back of me, digging his fingers in my ass, stretching me open. The smooth head of his dick

butted against my hole. He grabbed my hips and yanked me hard against him. I pushed out, gasping, and in one piercing thrust, his cock slid all the way into me. My back was so sore even the brush of his chest hair hurt. And my ass where he'd strapped me—I couldn't tell which was worse, the pain or my need to come. Then I realized they were pretty much the same thing.

It was a long, hard fuck. I don't come as fast as I used to. Lee plowed into me while the heat seared up my ass and back with each stroke. He worked my cock like he was jacking himself right through me. I don't know that I was even begging in words anymore. There was just sound coming from my throat. I shook against the chains, and Lee pulled the orgasm out from deep inside of me. He drew it through my cock and into his hands until he was sliding my cream between his fingers and over my burning, screaming skin. I came so hard I'd thought I'd died. My breath roared through me as I shot into his fist. I spurted until my cock was dry.

Lee kept fucking me, even when I hung there limp in the chains. He lifted my hips to meet his thrusts, slamming his cock up my sore, raw ass, over and over again. I was still gasping, trying to catch my breath, when I heard him grunt. He thrust hard into me, grinding against me, his cock stretching my hole even wider. Then he held me tight as his hot breath blew across my neck. His pelvis rocked against my ass. as his whole body shuddered.

We stood there for a long while, sweating like pigs, him leaning against me, me resting against the chains, not saying a word. Then he pulled out. But he kept his arms wrapped around me and his body over mine. Eventually I felt the rubber sliding down where his cock was softening against my thigh. Every place he touched me, I was suddenly,

keenly aware, that my skin hurt so much I wanted to scream. I was on fire. And then I started to laugh.

I laughed until he took me down. Then we lay on the floor and laughed together while Lee pinched my nipples and slapped my butt—gently now—and asked me if he'd beaten me enough. All I could do was respond with a resounding, "Yes, sir!" He wrapped me back up in his arms and we fell asleep right there on the floor.

- Lee -

We woke up an hour or so later, stiffer than shit. Yeah, Gino was a whole lot stiffer than I was. So we went upstairs and crashed on my king-sized waterbed. Gino woke up about 5:00 and took some Tylenol. I could see the bruises coming out already. Nice patterns. Then he climbed right back into bed and we both slept until damn near noon.

I was completely sated. I don't know that anyone has ever given so deeply to me. When that boy hung there in those chains, open and beaten and so completely vulnerable to me, I don't know that I've ever felt such power. He fought his hunger so hard, and his final surrender was so sweet. His skin was alive with the pain and sensation. I could see the little involuntary tremors everywhere I touched him, when I even blew against his skin. He was beautiful.

Even in his chains, even without his hands, I hadn't been able to let him suck my cock for very long. He was so in tune with his nerves, with my nerves, that I felt his touch all the way to my balls. His tongue and mouth were magic. And fucking him, I don't know that I've ever felt that close to someone. I fucked him until his asshole was so swollen I could

feel it, and still he begged me to fuck him more. I was inside of him, not just his ass. And when he came, when his whole body tensed with his orgasm, he still kept himself open, milking me deeper into him. His come was hot and thick and alive under my fingers. And his cries, I could tell they were coming from some primal, uncontrollable animal place deep inside him. Each time he screamed, I let the sound roll over me. It echoed all the way to my cock. And God, it made me come.

Whatever Gino needed to figure out, he seems to have done it. We went out to brunch and I don't think I've eaten that much since I was a teenager. The waitress couldn't bring us enough food. When I saw Gino at his club this past weekend, he was in a great frame of mind. He was slinging the punks around like he was having fun, every once in a while tossing one of them out on his ass into the parking lot. He grinned like one of those Cheshire cats when he saw me walk through the door.

Later that night, when some nervous kid in new chaps came up to me and asked if he could buy me a drink, "sir," why I felt downright companionable. And when he said his roommate was also with him, but was too shy to come up and talk to me himself, I made him send the roommate over to talk to Gino. By the time my date and I were leaving, the other kid was blushingly following Gino around, sweeping up glass. It took my boy and me a while to get out the door, though. I was laughing too hard. As I was sipping the last of my drink, somebody snuck up in back of Gino with a beer bottle. The shy kid grabbed the perpetrator and cold cocked him, and then just stood there—stunned—looking at his fist. I could hear Gino's laughter even over the bar noise as he ruffled the kid's hair.

Yeah, ol' Gino's going to be just fine.

Mr. Wonderful

Tom's Story

I never wanted a white picket fence. The home of my dreams was a nice fixer-upper on the outskirts of Smalltown, USA—somewhere with access to a video store that carried *Funny Girl* as well as the latest gay pornies. I also wanted a garage big enough for me to park a car that spent most of its time on the road rather than in the shop. So far, I was batting a thousand. My Nissan ran great. The Video Mart around the corner quietly carried every movie Barbra Streisand and Chi Chi LaRue had ever made—not that I was watching many movies these days. When I wasn't working overtime, trying to make journeyman electrician almost a year early, my spare time was spent gutting the front of the three-bedroom ranch I'd lucked into in my hometown. The house was a major project. The previous owners had appalling taste. I'd never imagined anyone could bury a hardwood floor under that shade of lime green shag. Now all I wanted was another Mr. Homebody for a partner—

somebody who knew which end of a hammer to hold and who got off on my kind of domestic entertainment.

Allen was obviously not Mr. Right. Despite loud protestations to the contrary, Allen was a total party animal. I should have been suspicious that the only place I'd ever seen him was at the one gay bar in town. Newcomer or not, in a population of 4,793, if he'd hung out anywhere else, I would have known.

It wasn't like I'd asked him to hang drywall with me. However, I didn't think mowing the grass once a week was too much to ask, especially when he was getting free room and board.

"Jeez, hon," he'd slurred when he stumbled in from the bar. "I'm sorry I forgot. Let me make it up to you." He kissed his way down my belly. I like blowjobs as much as the next guy, but I still had to get up at 5:00. By the third night in a row that he'd "made it up to me," I fell asleep "during" and I didn't wake up until the alarm went off.

Two weekends later, I came home from a fishing trip with my brother to find the geraniums drowned next to a still-running garden hose, gnats in the unwashed dishes—and Allen parked in front of the big screen TV, dressed in a leather jockstrap and watching Scooby Doo reruns while he did crunches.

So much for Mr. Wonderful. Booting him out almost felt good.

I got lonesome again pretty quickly, though. I was still working OT, and I had to get the new windows installed before it got cold out. Pretty much the only gay social life in town was the bar Allen frequented. That shit even stole the remote when he left. I decided that when winter came, I'd get out more, maybe get involved in the community theater. But first I had to finish the dining room windows. Builders Depot, here I come.

I walked in the door and almost ran face first into the most gorgeous ass I'd ever seen. I mean, I stepped through the sliding glass doors, turned the corner toward the wall, and came this close to planting my nose in a denim-covered bubblebutt. Mr. Perfect Ass was standing on the Employee's Only ladder, halfway up the lumber display. His faded work jeans were tight enough to show me curves I wanted to cup into my hands and pull straight up to my face. My dick and I wanted to inhale him and hang on tight.

Then I remembered where I was. Blushing, I stepped back, trying to surreptitiously stow my suddenly uncontrollable cock. Mr. Cute Butt started down the ladder, one lithe, muscular step at a time, his thigh and ass muscles rippling as he moved one leg surely and confidently past the other. A moment later, he was standing on the floor in front of me, balancing a load of boards on his shoulder, his head pretty much level with mine, and his gorgeous ass at the perfect height for fucking.

"May I help you?"

"Huh?" I flushed as I tore my gaze away from that fabulous ass and looked up into equally beautiful twinkling blue eyes. Hunk Boy was smiling over his shoulder, a thin trickle of sweat running down from the edge of his close-cropped blond hair, over a lightly tanned neck, and onto a torso every bit as muscular as the tight lines of his butt. His very kissable lips twitched as he obviously tried not to laugh.

"I said, 'May I help you'?" His gaze flicked down and back up my body, lingering for just a second too long at the throbbing hard-on pressing against my zipper. He shifted his weight, hefting the wood higher onto his shoulder. This time, the smile sparkled all the way to his eyes. "Feel free to look around. Just let me know if there's anything you need—or want."

I was too tongue-tied to answer. When I nodded, Dream Boat walked on and once more gifted me with the view of those gorgeous asscheeks, this time swaying lightly as he glided across the floor and set the heavy 4 x 4's on the counter.

"I think these should work just fine," he said to the nervous young couple standing by the register. "It's our top of the line stock, with full guarantees."

The very pregnant woman smiled as she ran her hands over the smooth, sturdy wood. "Thank you so much! This will be perfect for the nursery." Her husband nodded enthusiastically. It was obvious they had exactly what they wanted.

Blue Eyes laughed and started ringing up their order. "Glad to help. Is there anything else you need?"

The young couple might not be interested in anything else, but I sure as hell was. I'd placed the face. Stephan Dournay. He was a couple years younger than I was. He'd gone to high school with my sister, then straight into the Army. I'd heard he'd just finished his four years, but nobody had mentioned how he'd filled out in the time he'd been away. The young couple walked out the door. I felt Stephan's eyes on me and blushed again.

"You find what you're looking for yet, bud?"

I looked up, and this time I had to grin back. "Oh, yeah." I took my time checking him over, from his toes all the way back up to his baby blues. I let my eyes linger a long, sweet moment at the distinctive outline in the center of his faded, clinging jeans. Once I'd figured things out, I hadn't hidden who I was in town.

There were no customers in the immediate areas, so Stephan leaned back against the register; his arms folded on his chest, the bulge in the

front of his jeans telling me our minds were running on the same track. He stood up and stretched, then slowly wiped his hands over his thighs and around to his butt, arching his crotch out towards me as he shifted his weight onto both feet. "If you need more time to look around, we've got a special on hardware today—and on fixtures, if you're looking for something to mount."

I burst out laughing and stuck out my hand. "Oh, I've found what I want. But I still need varnish and latex gloves. Name's Tom."

Stephan's grip was warm and firm. His eyes twinkled the entire time we shook hands, which was way longer than necessary. He turned out to be an expert at building materials. Later on, over dinner at the supper club, he told me he'd spent his military time doing construction in the Corps of Engineers. Two weeks after he'd gotten home, he decided he'd had enough of watching TV. He walked into the lumberyard and they'd hired him on the spot.

"Their assistant manager is leaving next month, and they want me to take over for him. I'm spending some time on the floor first, learning the layout. Man, I really love this job. It's like working in a toy store." He took a long, slow drink of his soda, looking at me over the top of the glass. "And I can be who I am without having to watch over my shoulder anymore for military investigators."

As he spoke, he quietly pressed his leg up against mine. I pressed back. We kept our legs touching under the table while we finished off our trout and baked potatoes. We skipped dessert and went straight back to my place.

I took him in through the living room. Stephan kicked his shoes off without even being asked before he stepped onto the new Persian rug.

Even in the dim glow of the reading light I'd left on, he noticed the quality of the newly refinished oak trim.

"Damn," he whistled, running his hand along the edge of the door. "You do nice work."

"Anything worth doing is worth doing well," I growled. I wrapped my arms around him and slowly sucked his tongue into my mouth.

We kissed all the way into the bedroom. Stephan laughed when he saw the huge brass bed.

"You can tie me to it later, if you want," he laughed. He broke loose long enough to peel off his pure white T-shirt. "Or maybe I can tie you."

I didn't answer. Either idea sounded great. When his dark pink nipples appeared, I leaned down and licked long and slowly over the small, soft peaks in the middle.

"Man, that feels good," he groaned. "I was afraid to let anybody chew before, afraid if my nips started standing up too much, I'd look too queer. I didn't want to draw attention to myself."

"And now?" I whispered, blowing warm air over the wet flesh. I licked again and bit very softly. He hissed and arched up against me, sinking his hands into my hair.

"Now, you can bite those suckers until they bleed! Damn, I'm horny!"

I laughed and started to gently teethe and lick. "How about if I just chew until they feel really good? You tell me when to stop."

He took a lot more than I'd thought he would. I sat down on the edge of the bed and wrapped my arms around his waist, massaging his firm, strong back muscles while I feasted on his satiny smooth nipples. He held my head to his chest and moaned, holding himself still as long as he could stand it, then offering me the other side, back and forth until his tits were stiff and hot and engorged to such a tender deep red that even the tiniest licks made him gasp.

"FUCK that feels good!"

I smiled and licked up the side of his pecs, laughing quietly as a single soft kiss made him hiss like his nipple was electrified. I slid one hand down to cup his firm, round asscheek, slipped the other hand around to massage the warm, wet, and rock hard bulge of his crotch. He moaned out loud while I rubbed him.

"Man, I've missed sex. It has been way too fucking long!" He rocked his hips back and forth, like he couldn't decide which hand to press into. I yanked his pants open and tugged them down over his hips. A huge, wet circle covered the front of his pristine white briefs. His hands stayed laced in my hair as he worked his feet free. I leaned down and kissed the stiff, thick shaft outlined by the straining cotton.

"Mmmm. I like what you've been hiding here." I blew, hot and wet, against the swollen flesh. Before he could answer, I yanked the front of his waistband down and swallowed him, in one long, fast swoop.

"Fuck!" Stephan yelled, jerking my head back. I opened my mouth to dive down again, looked up surprised when his hands held me firmly away. His arms shook as my tongue reached out, almost, but not quite, able to reach his wildly straining cock.

"Don't," he gasped. "I'll shoot, man. I mean it, and I don't want to. Not yet. I want to suck you back and play around and fuck, and oh man, I want to do it all."

Stephan's nuts were hugging his deep red, twitching shaft. As he trembled against me, another clear pearl oozed out of the slit. I reached up and gently caught it on my finger.

"You really think you're going to last that long, pal?" I smiled at his groan, smearing the warm, viscous gel over his quivering cockhead. "I'm really hungry for the taste of your dick. Maybe you could come twice— just for me?" Stephan's whole body shook as I tenderly licked down the

shaft, shook harder as I worked my tongue into the V. I cupped his smooth, warm balls in my hand and tugged them gently out from his shaft. "Maybe you could come for me now if I fuck my throat real tightly over this hot hunk of man meat?" His hands clutched me like a man drowning. I dove back down, once, twice, slobbering him full of spit. I swallowed him to the root, and sucked—hard. He jerked me off him and I leaned back, smiling, watching his gorgeous body shake above me as his hot, creamy sperm bathed my face.

Stephan was still twitching when his glazed blue eyes opened. He looked down at me, his still-hard cock pointing towards my face and his nuts cupped firmly in my hands. He blushed and slowly untangled his hands from my hair.

"I'm sorry, man," he grinned sheepishly. "It's been a while, and what you were doing felt really good."

"It's nice to be appreciated," I laughed. I leaned back on the bed and stretched. My dick was about ready to burst my zipper, and man, did it want to be sucked. "Feel free to indulge yourself." I looked pointedly at my swollen crotch, then up at him.

Stephan had good hands. I'd seen that in him at work, but my skin concurred 100 percent when he yanked my clothes off, climbed up on the bed next to me, and wrapped both fists around my dick. It wasn't often that I'd had a man truly make love to my cock, but Stephan did. He licked and kissed and sucked, and then he nibbled—ever so gently—until I thought I was going to lose my mind. I could tell I was going to shoot one helluva load. I hadn't been deprived as long as he had, though, and I really wanted to fuck him. When he once more licked my quivering shaft, I ran my hand down the hard plane of his back and cupped the smooth curve of his ass.

"Roll over, Stephan."

His blue eyes peeked up at me, his cheeks bulging, my cock protruding red and thick from his swollen lips. I moaned when he pulled off and kissed the tip.

"You don't want to come?" he grinned.

I manhandled him over onto his belly. "I want to come up your ass, hot stuff." I grabbed a couple pillows and stuffed them under his crotch. "Make sure your dick's comfortable, because I'm going to eat you into fits first. Spread your legs—wide!"

He did. He moved his knees to the edges of the pillows, flexed his firm, rounded, creamy-smooth ass and arched it up at me. As his cheeks spread open, his tight pink pucker came into view. It was even more beautiful than I'd imagined, wrinkled in a perfect circle, the light dusting of golden hair swirling down in whorls to the tiny dark point of his asshole. It drew me like a magnet. I reached into the nightstand, pulling out lube and one of the thumbs I'd cut from my new stash of rubber gloves. Then I lay down on the bed behind him, cupped his cheeks, and buried my face between them, inhaling deeply.

"You have a beautiful ass." My voice was muffled as I nuzzled his crack. "Let me show you what else I can do with my varnishing gloves."

Stephan moaned and arched up towards me. I squirted lube on his sphincter. Then I laid the thumb cover against his glistening bud and leaned forward. I licked, tickling and teasing as I rocked my own throbbing dick against the mattress. He was hot and musky, with a faint scent of soap mixed with his sweat. "You're so hot, man, and you smell so good."

Stephan went nuts. His asslips kissed my tongue like they just couldn't get enough. I laved the edge of his sphincter, sucking lightly, then harder, while he moaned and wiggled beneath me—loosening to me.

"Fuck, oh FUCK, that feels good." Stephan's asshole spasmed as I rubbed his perineum and the back of his balls and slowly worked my tongue into him. I was tongue-fucking him freely now, meeting almost no resistance as I slipped in and out and sucked the silk-smooth band of his open hole. Each time his asshole twitched, my own dick throbbed and oozed in response. I leaned up and sank two fingers into him, smiling when he arched and cried out. He spread his legs even wider, trying to take in more of me as I pressed against his joyspot.

"I'm going to fuck you now, Stephan." I grabbed a condom from the nightstand. He jerked when I stuffed more of the cool, slick gel up his butt. "I'm going to fuck you hard and long, and I want to hear you grunt with each stroke."

I tore the packet open with my teeth, leaned to the side and gloved on the rubber, my fingers still buried up Stephan's gorgeous, open ass. Then I knelt between his legs, pulled his asscheeks even further apart, and leaned into him.

I slid all the way in on one stroke. Stephan yelled so loudly my ears rang. He arched back up towards me, milking me with his asshole.

"Fuck me," he begged. "Fuck me hard, hard, HARD!"

I gasped as his ass muscles clamped down on me. His asshole was so perfect, just tight enough to swallow me like an open, hungry throat. I felt like I was being sucked off by his asshole.

"Gonna shoot," I gasped, slamming into him. He rocked back against me and my nuts drew up. "Gonna come, so hard . . ."

Stephan twisted and reached under himself, his shoulder moving as he jerked off. "Me, too," he gasped. "Oh, fuck, I want to feel you shooting up my ass when I come." His ass muscles spasmed as he tightened against me. "Gonna come," he whispered.

Stephan shouted and his rectal walls convulsed around me, sucking the come up out of my dick. My body surged forward, and the most fantastic orgasm of my life tore through me. My dick spurted and I ground into his ass, yelling at the top of my lungs. I shot until my nuts were dry and Stephan was shaking beneath me.

I was asleep almost as soon as I pulled out. I tugged Stephan into my arms and before I knew it, I was dreaming of the heavenly scent of his ass on my face and the feel of his butt kisses when he climaxed.

I woke up to the smell of fresh coffee. Stephan was sitting naked on the edge of the bed, holding two steaming mugs.

"Hope you don't mind if I made myself at home in your kitchen. I'm an early riser, but I need coffee to get myself going in the morning." His blue eyes twinkled and he handed me the cup. "By the way, that's some neat stuff you're doing in the living room. What kind of windows are you putting in? I bet thermal seals would be wonderful. They're pricey, but worth it."

Maybe Stephan was wondering while I smiled so much as I sat up. I took a long, deep drink of the fragrant brew. Wonderful was only the beginning.

Living by Committee

The Committee's Story

For the record, I still hear voices. LOTS of voices. Women's voices. And they're always having great sex. It's just that these days, I'm careful not to answer back in public anymore—at least, not out loud. Dr. Clayton says that's a good thing. She had been "quite concerned."

Sometimes, though, I think I shouldn't tell Dr. Clayton about the voices at all. She has a way of quirking her lip that tells me she's still "concerned." But I do want to be honest with her. Being honest with her has helped me a lot. And the voices are my friends. They tell me such wonderful stories, and they give me such great ideas. I figure I shouldn't keep them to myself.

Besides, they are the reason I'm horny all the time. Dr. Clayton really raised her eyebrows when I told her I was masturbating nine or ten times a day. I didn't tell her that actually, I was just climaxing that many

times. There were only two or three marathon sessions each day, and sometimes an afternoon quickie.

Personally, I don't think that much sex is a problem. My clit's not going to wear out. Well, not if I use lube when it gets sore. Actually, sometimes, I kind of like sore. My vibrator and sex toys don't mind the workouts, either. Besides, they can't catch anything. I can't either, as long as I'm careful about what goes where.

However, I didn't tell Dr. Clayton that I'd named my sex toys—or that their personalities match the voices.

I'm into polyamory. While Sarah, my Hitachi magic wand, and I have been together for almost two years now, I still like to date around. Sarah's cool with that. She has a warm, well-worn furry cover and sleeps on my bed, even when I'm not in it. Sarah likes to snuggle against my clit and whisper sweet nothings against my skin while we look at sex toy catalogs together. If she really likes something, she hums me to an orgasm, and I get out the order form.

That's how I met Heather. She's pretty preppy, in a smart, no-nonsense, New England kind of way. She's always full of practical advice—she's not a romantic like Sarah. Heather's a long, slender, well-formed G-spot dildo, with a hollowed shaft for a vibrator. She and Sarah hang out together a lot. My pussy really likes that. But Heather was on her own when she took my virginity. I mean, when she took it for real—with my permission, so it counted.

It doesn't count otherwise. Heather said so, and Dr. C. agreed.

Heather and I worked together. I really wanted to be fucked, but I was so jumpy about it. It took Heather over a month of constant association, talking and laughing and watching silly movies on TV and eating ice cream—she let me lick it off her—and cuddling, always cuddling.

She and Sarah would tag-team me and kiss and caress my clit until I was so aroused and frantic and SORE that they brought Dora in, thick and squishy and oozing love and lube out of her pump top, and Mandy— she's a trannie box of condoms, to protect Sarah—and finally, one day, I got so turned on I just spread my legs and wiggled Heather in!

Heather swooned. Her tongue got tangled, telling me how beautiful my pussy was, how warm and sweet and pulsing with life, hugging her while she snuggled deeper, sniffing out my hidden special pleasure spot, until her nose bumped up against it and I gasped and she started nuzzling, deeper and harder and faster.

"You're so strong," she panted, pressing up and laughing breathlessly when I cried out at the sensations. "Oh, yes, honey. Like that. I love it when your muscles quiver around me like that, when they sing and clench and pulse like the strong, dyke pussy walls they are, when they reach out for the cunt waves that are going to come like your body's exploding. And you're going to come, beautiful. Rub just a little bit harder and faster, and I promise you, your pussy is going to squirt pure living energy. Help us out here, Sarah!"

Sarah did. She buzzed and I rubbed and pressed and Heather nosed my shuddering cunt nerves. I screamed when I came. I felt like the most perfect little dyke bride in the world, lying there with Heather gasping in my pussy and Sarah humming on the bed next to me, and Dora and Mandy cheering in the background.

Of course after that, *everybody* had to help with shopping. Pretty soon, Julia had joined us. She's into clamping nipples and labia and even my clit, if she thinks I'm getting too uppity in my demands. She says she loves watching me squirm and cry when the blood rushes back in, and she insists I have to keep rubbing all through my orgasm. She's such a bitch, and wow, do I love her for it!

Gail was next, her insertable vibrating egg sliding into Heather and making her shimmer and buzz so much I squirted juices for sure when I pressed deep. Raquel's little honey pot suction cup let Sarah take the night off when I wanted my hands free to pull on Julia's chains and wiggle Heather way in, hard. The bunch of us spent hours and hours and hours on the bed together, laughing and playing, until I decided maybe I wanted to be naked all the time, just lie on the bed and watch my friends and me play in Carla's mirrored eyes, just us girls. Dr. C. suggested I keep some clothes around, for when I needed to go out for groceries, and for our appointments, since the security guard wouldn't let nude people into her office.

That became kind of a moot point, though, when Beth and Laurie came along. They're really into clothes. Mostly leather, but I was surprised when they started insisting I buy short leather *skirts* and skimpy vests and heavy, sturdy boots. They even let Tiffany talk me into some femmy, black satin and lace underwear, and fishnet stockings. And bright red lipstick. I cut my hair short and dyed it green on the ends. And I paraded around in front of Carla while my other friends whooped and hollered because I looked so damn HOT! I even went out to the coffee house for a while that night. It's just down the street, and I pretty much kept to myself. I already had plenty of company! But the music was good, and my pussy got wet, watching a couple of women in corduroy pants standing on the edge of the room, their legs planted wide apart and no nonsense, as they surveyed the rest of the room. Even Heather thought they looked ultra butch and soooo sexy.

After that, I started going to the coffee house pretty often. If my friends really insisted, sometimes I'd even talk to people. It was fun to hear laughing, even though some of the jokes were so bad they made me groan. I still told them to Dr. Clayton, though. She laughed.

But I didn't tell her too much about Cicely. She came overnight delivery, and I still tiptoe around her.

Cicely takes care of me when I'm bad. I cried the first time her nasty, thin rubber tresses snapped across my naked butt. She ordered me to stand at the bottom of the bed and bend over, put my leg up on the mattress, and give myself 15 strokes "no holding back!!!" for lying to Dr. C. about the new cut on my wrist. I had said my hand slipped when I was slicing an apple. It was just a tiny cut. I didn't figure it counted, and I was really upset with myself for messing up on that job application. When I finished crying, Cicely marched me over to the phone, and I called Dr. C. right then and there and told her the truth. I apologized, and we met that afternoon, Dr. C. and I, in a special appointment. I made myself sit still and not fidget, even though my bottom really hurt, and I'd start sniffling each time Cicely snapped, "Sit still! You KNOW better than to pull crap like that! You don't do that shit anymore!!!"

Cicely also reminded me to write in my journal every damn night the rest of the week. I sure did, especially after Cicely tanned my butt again, just for hesitating to get started one evening. Now, she makes me keep her hanging on the closet door, in plain sight, so I won't forget that she's there to take care of me, every damn time I get out of line.

Cicely's the one who brought Esmerelda in. Actually, I really like Esmerelda, in spite of the fact that she and Cicely are so tight. Esmerelda is so old fashioned and demure and such a total petite Southern belle. She's a total femme, just like me. I've decided that's okay now, being a femme. It doesn't mean I'm saying I'm available to anybody who wants to use me, or that it's okay for bad people to do things to me. *I* get to decide whom I'm going to be with! And how I want to behave!

Like Esmerelda does. She's so loving, all the time, just like I want to be. She hugs up against my clit, her little vibrating butterfly pouch pressing against me, reassuring me, reminding me that the blood is flowing through my veins, through my heart and my arms and my comfy, happy, contented little lesbian pussy nub.

But Esmerelda gets totally squicked when I cut myself. She's such a wuss. She tells me I give her migraines every time I even open the silverware drawer when I'm upset. So I don't do it anymore. Well, and since I know Cicely is looking over her shoulder, just waiting for a chance to sting my poor, tender butt. And I know Esmerelda will narc.

The scars on my wrists are fading, though. I have to admit, my arms do look better now. I actually wore my rainbow tee in public the other day—without a Henley underneath! And with my black leather mini skirt. And with Esmerelda humming happily away. If I bring extra batteries, I can even wear her to work, at my new job at the bookstore. It turns out I didn't mess up the application as much as I thought.

And then there's Roxie. She's one of my closest friends, though we only met last spring. It was quite the introduction. Roxie turned me on to anal sex. A queer writers' conference was in town, and Erin, who was teaching me about tiny little anal beads, talked me into going. This new book on anal sex for women was one of the hot topics at the conference. I'd seen it at the bookstore, though I hadn't worked up the courage to look at it yet.

Erin just would not shut up about that book—especially when she found out there was a matching video.

"Please, please, PLEASE!!!! Can we just go look at the cover? I bet it's so hot!" She and Dora were teasing me, rubbing just one slippery wet

bead against my nervous little bottom pucker. "Just think about what could be in there!"

I thought about it. A lot. Finally, my pussy and my bottom got so curious I had to find out more. So I peeked at one of the conference copies. Then there were way more than nine erotic lives clamoring to try out all the new information in my head. We set out to go shopping!

It was lust at first sight. I walked into Condom World, and as my eyes feasted on the enormous purple and black marble-swirled rocket-shaped butt plug, a husky voice whispered inside my ear, "Bet you've never played with anybody like me, cute thing. I can make you feel *really* good."

And, ooh, Roxie did. She insisted I pick up a huge bottle of lube—one of Dora's friends—and a harness named Nan to keep her company. That night, while the floor at the hotel thrummed to the beat of the Dyke Dance, while the vibrations of the music shivered up my spine and I gyrated in the strobe lights, I danced with my legs wide open and my asshole quivering and clutching Roxie and I came and I came and I came.

Roxie still always makes me smile. We talk almost every day, with her nuzzling deep inside my bottom while my other friends and I discuss whatever other topics come to mind. Lately, though, despite our closeness, I've been getting nervous again.

Although Dr. Clayton doesn't know how often I hear the voices anymore, I wanted to tell Jilly the whole truth. I met her three months ago, at the bookstore. Jilly's a real, live woman. She bought some mysteries. We went out for iced mochas afterwards. She was even prettier than the other women I'd seen standing and rocking slightly on their heels as the music played at the coffee house. Jilly had short, soft blond hair—a real

butch haircut—and a worn leather jacket and strong shoulders and the most beautiful, muscular curve to her hips. She laughed a lot—warm, happy laughs that made her hazel eyes sparkle and my pussy tingle. When she spoke to me, her voice vibrated against my eardrum. Not imagination, not like when I'm necking in my mind with Sarah while she buzzes my clit. As the music played, Jilly blew in my ear and whispered, "You're so beautiful, babe. Let me show you . . ."

Eventually, I did. And she showed me things I'd never imagined. And I loved it. And her. The first time she tied me up on the bed, the voices all sat back and watched in awe. I thought I'd be so scared. Just the thought of being tied up made me go so cold. It made me remember when I didn't get to choose. I told Jilly so. While I was talking, Esmerelda marched right up front in my head and said she was going to sit there with me. She told me it was okay to say NO!!! any time I wanted, and that she'd remind me if I needed her to.

But Jilly was laughing and rubbing my arms to warm me up. She had silk ties with Daffy Duck and Bugs Bunny on them. She showed me how her knots were made so I could pull them loose myself, anytime I wanted to—presto, change-o! But if I wanted, if *I* wanted, I could leave them tied and pull against them. I could toss and fight and scream while she ate my pussy into fits. I could let myself buck and yell like a wild woman. I could come like the horny, uninhibited slutty little dyke I am, just because I wanted to, just because I was letting another woman play my cunt and make me come, because I got off on letting her play my body higher than I could myself, even with my secret friends helping me.

We all got off on watching Jilly's chest turn red and her body shake when she sat on my face with her knees against my outstretched arms. I sucked her clit raw. I strained against my bonds, trying to reach more of

her, and we all knew that even though I was the one tied up, Jilly wasn't making me do anything I didn't want to. I was licking her for one reason and one reason only—for the pure pleasure of the taste of her pussy in my mouth. With my face buried in Jilly's cunt, I heard my friends applauding in my head, then tiptoeing out of the room, so all I could think about was the tangy sweet, sticky slide of Jilly's juices over my tongue and down my throat.

Esmerelda whispered, "You're doing just fine on your own, sugar. Call us if you need us."

And Sarah's voice echoed in my ears, "Next time, use Erin's anal beads on her, dearie. She'll go nuts."

I finally took Jilly to meet Dr. Clayton last week. It was a long session. Dr. Clayton explained about the things I can't talk about yet. My friends all crowded around in my head, petting me, reminding me that although I was scared, I was also strong. And Jilly was strong, too. We could handle things together. I sat on the couch this time, not on the side chair like I always had before. I smiled when Jilly took my hand and sat next to me, on the overstuffed sofa arm. None of us had thought of that before.

"The upholstery is going to smell like Jilly's pussy now," Julia giggled. "I bet if she had a teeny tiny clamp on her clit, she'd leak so much the stuffing would be damp."

I squirmed and wiggled and tried to look calm and self-assured when Dr. Clayton explained how she encouraged my physical self-exploration and self-loving, how it was helping me heal. How it would always be a good thing. How she hoped Jilly would support me in it. Jilly laughed when she assured us that she most certainly would!

So last night, I took a deep breath and introduced Jilly to my friends. I took out my toy box and explained about Sarah and Heather and Dora, about Julia and Gail and Erin, and Roxie and Carla and Nan and everybody else, even Cicely and Esmerelda.

Fortunately, Jilly liked my friends. She said she thought it was cool that they played with me and told me stories. When she asked if it was okay with them if I passed the stories on to her, my friends giggled and nodded, and Roxie hooted, "Sure enough, hot stuff!"

Then Roxie started getting real specific. I squared my shoulders and walked over to Jilly. I kissed her on the cheek and slowly ran my hand down her butt, splaying my fingers, just the way Roxie had shown me how to do to myself, when we first started playing. And I whispered in Jilly's ear.

"Roxie says she knows you're all butch, but she wants you to take off your panties and bend over the back of the couch and spread your legs really wide. She wants me to hold you down and lick your little bottom hole until it's slippery and open and kissing me back. Then she wants me to thumb your clit while I'm licking—until you yell and arch your pretty pink pucker back over my tongue. She wants me to tongue you until you're loose and open and I can stuff fingerfuls of lube up into your anus." Jilly shivered as I gently bit her earlobe. "Then Roxie wants to come visiting. She wants me to finger you to another orgasm while she's wiggling and squirming in your butt and you're hugging her while you howl out your climax. Roxie says I can't stop until you show us all how slutty and horny and femmy you can be. She says I have to promise not to come until my face is covered with your juices and you're worn out from coming, and you beg me to let you lie down between my legs, with

your asshole still clutching her, while you eat me until I pass out from the pleasure."

For just a second, Jilly looked towards the phone, like she was maybe thinking of calling Dr. Clayton. I traced my toe on the carpet, watching my foot move over the patterns, trying not to tremble, listening to my friends hold their collective breath while I waited, with my hand resting, oh, so nonchalantly on Jilly's hip. Then Jilly took a really deep breath— and she laughed. She turned and grabbed me in a great big hug and kissed me until I could hardly breathe.

"Okay, lover. We'll give it a try."

While my friends applauded, Jilly walked over to the couch, shoved her cords and panties off, and then she was standing there in just her tee shirt and white sweat sox. She bent over, spread her legs wide, and wiggled her beautiful, muscular ass. Roxie wolf whistled, loud and long, as, I swear, Jilly's strong, pink sphincter winked back at us.

Jilly smiled over her shoulder at me. "Have at it, sugar lips. You and your—or should I say, *our*—girlfriends." She lifted her gorgeous, sexy, female ass to me and sighed happily. "I wonder what Dr. Clayton will say when I tell her we're both listening to your voices?!"

The girls were still laughing when they left the room. "We want a play-by-play in the morning, doll-face. This is going to be GOOD!"

And it was. Oh, it was!!!

Party Dogs

Cody's boy's Story

My asshole was hungry to be fucked. Even the fire hydrant out front was starting to look inviting, which meant my sorry ass would probably be in trouble before the night was over.

I always get this way when I'm wearing my dress dog collar. We were at a private party up in the Hollywood hills. My lover, Cody, trains animals for the movies. He specializes in canines. Tonight, he was showing off his most highly trained "pet" to his friends and competitors, that pet being me.

This particular soiree was the annual bash of a producer friend of Cody's. The house was crawling with guests like us and assorted entertainment bigwigs. By the time we got there, even the suits had changed into their jeans and motorcycle jackets. I was excited, getting off on the smell of leather and sweat and oiled bodies. All I had to worry about was remembering my doggy manners and making Cody proud of me. I did not want to think about what he'd do to my butt if I screwed up here,

which I had no intention of doing, no matter how much I wanted to be fucked. I was here to have fun.

The mansion we were in was the producer's home. Talk about money! Even the bar was huge, a replica of one of those '20s-style smoking lounges, all dark woods and leather, with the faint, lingering smell of sweet pipe tobacco. A year ago, I would have been totally intimidated by surroundings like this, nervous about people-type things like making formal introductions or keeping track of which salad fork to use at dinner. Back then, my life was nothing but stress—late nights studying for my college exams, dancing in bars, and flipping burgers to make ends meet.

Fortunately, I didn't have to worry about that crap anymore. I learned to relax the night Cody picked me up. I was cutting through the park on my way home from work. He was cruising in full leather, all the way to the cap on his thick, silver-flecked black hair. He called me over. We talked. I got hard just looking at the furry pelt peeking out of his unzipped jacket.

Cody took his time, petting me with his huge, strong hands. I could tell how muscular he was, even through his jacket. He kept his voice firm and low—called me his cute little stray and said he was going to take me home and keep me. I almost didn't notice when he slipped the collar around my neck. I was already panting after him. The heavy leather felt so good I shivered. I was willing to let him lead me. When we got back to his place, he fucked me until I saw stars.

I've been with him ever since. I have my dress dog collar now, in addition to my everyday one. But no matter what I'm wearing, over the past year, Cody and that nasty black belt he wears have sure as hell taught me proper doggy manners. I like simplicity. Cody keeps things real simple. Dogs obey. Unless they're at work or class, they don't speak

in public unless ordered to. They eat from weighted dog dishes. They don't wear clothes at home. If they're really talented, like me, they learn to lift their legs and piss into the bushes without spraying their boots.

And dogs suck cock. Any time. Any place. Nice and simple. I was one contented pup.

Tonight, like all the other two-legged pets at the party, I was naked except for my Doc Martens and a heavy metal cock ring. I knew I looked good. My short brown doggy hair—on my head and around my dick— had been trimmed and brushed until it shone. I'd put in clear contacts that not only let me see but also made my bright brown puppy dog eyes shine. Cody had oiled my body until every muscle I'd developed in all my years of gymnastics glistened in the golden glow of the period lamps in the bar. I knew better than to preen too much over my looks, though. When I sneaked a quick glance at myself in the bar mirror, I could see the half dozen hot red stripes I was already sporting on my butt from prancing around on the way to the car.

"Make me proud of you, boy," Cody crooned in my ear as he set my dog dish on the bar. "A good doggy gets to suck his master's dick later on."

He slapped my ass, hard. I jumped, and then bent over as fast as I could and licked his hand appreciatively. I knew what else happened to good doggies. A minute later, the hand holding my leash moved to caress my already well-lubed asshole. I whimpered and arched towards him. When Cody petted me, I was allowed to rub against his leg without permission. There were a couple of hoots from the bar as he fingered me. But as usual, I was in full slut mode from the moment he touched me. I didn't give a shit who saw me looking like a bitch in heat, so long as I got to be Cody's bitch.

He snapped his fingers. I obediently stepped back, my eyes lowered submissively and my butt suddenly and unhappily empty. A strand of precome stretched from my piss slit to his chaps. I hid a quiet smile as somebody, a big guy in black jeans, whistled. From the corner of my eye, I saw Cody look down and wink at me.

"Good boy," he laughed, ruffling my hair. "I'll be back later. Now STAY!" Then he set a note against my dog dish. "Thirsty dog. Give him a beer and he'll lick your dick."

Cody fancied himself a poet. Who was I to tell him his verse stinks? My tail was still twitching from being petted. And dogs don't speak "people," at least not in public. I especially stay quiet if it gets me a beer. Cody dumped a pile of rubbers next to my dish. Then he clipped my leash to the bar rail and left me alone while he went off to play. I knew he was watching me, though, making sure I obeyed my "stay" command and behaved like a good dog. He also made damn sure I could see him, petting the other puppies in the room until their tails wagged at him and their dicks stood up like wolf snouts howling at the moon.

My poor little doggy butt was lonesome for attention, too. I fidgeted against my collar. I was horny. I made myself hold still, but it was hard not to rub up against the bar like some mongrel. Cody'd spent a long time training me to have pedigree manners. While he'd never beat one of his four-legged animals, I knew he'd have no qualms about taking off his belt and turning my ass into hamburger if I did anything to embarrass him in public.

There were other boy dogs tied to the bar, belonging to different trainers. But they were too far away for me to reach them. Cody purposely tied me separately. He said he knew how "dogs" were together. Always sticking their noses into each other's crotches. Most times we went out,

Cody "fixed" me by locking my cock in a steel chastity cage, especially if he was going to leave a puppy like me alone with other dogs. I hated that cock cage. It hurt every time my dick tried to get hard, which it wanted to do every minute I sucked cock. Cody assured me the cage "fixing" didn't hurt nearly as much as a real trip to the vet would have. Still, those nasty metal rings forced me to stay soft until I howled with frustration and pain. Cody said it was good training. And even though I whined, I put up with it. He always fucked me afterwards.

Tonight, though, I didn't have to wear the cage. Cody said he wanted all my assets on display. It felt good to be loose in public. My cute little puppy pecker was swinging happily between my legs. It's pretty good sized for a puppy. Seven and three-quarters inches hard, which it had been pretty much since we'd walked in the door and my nostrils had filled with the scent of men in leather. As I stood there by the bar, alone, I seriously considered getting down on the floor, tipping back up on my shoulders, and bracing my legs against the bar so I could suck my own dick. I'm allowed to do that. Cody says it's something a dog can't help doing, especially a limber one like me. I was looking around for a place to get comfortable when somebody whistled and snapped his fingers at me.

Obediently, I looked up. It was the guy with the tight black jeans who'd noticed the precome strand between my dick and Cody's chaps. He was a rival trainer, Richard, if I remembered correctly—which fortunately, doggies didn't have to do. All I had to notice was that he was a hunk. About 6', 180. Short black hair and blue eyes. He was wearing a black leather vest. I stood up straight and smiled at him.

"Reowf," I barked politely. Cody says that damn well better translate into "Yes, sir!" Usually, it does, if I'm being a good boy. And I'm smart enough not to say so when it doesn't.

"Good dog," Richard said cheerfully. He reached over and grabbed one of my nipples, twisting it hard. "Doggy wants some beer?"

"Reowf," I winced, nodding and panting at the sudden pain. I tried not to move while he worked my tit. I closed my eyes, gasping as my flesh perked up hard and sore into his fingers. He grabbed the other one, too, digging in his fingernails. I forced myself to hold still and not whimper.

When he was satisfied that I could take it, he brushed his palms over the sensitive skin and let go. I shuddered at the soft touch, taking a deep breath as I looked up at him.

He was smiling, this time with approval. "You're a very good boy," he said, pleasantly. He poured half of his beer into my bowl.

I waited politely, still catching my breath, until he pointed towards the dish and snapped his fingers. Then I eagerly lapped up my reward. The panting had made me thirsty, and the beer was still cold. When I was done, I stood up and smiled appreciatively, beer dripping off my chin.

Richard laughed and wiped my mouth with his big fist. "You damn dogs are so messy," he sighed. Then he yanked my chain and pointed to his crotch. "Show me your appreciation, mutt."

I don't like being called a mutt. After all, Cody spent a long time training my sorry ass. But when I saw the size of Richard's basket, I forgot about any implied slights. I yipped out an enthusiastic "Reowf!!!," dropped to my knees, and set to unbuttoning his jeans with my teeth.

His dick was huge. There must have been 10 inches of meat snaking down inside the denim covering his left thigh. I eventually got his fly open, but his cock was too big for me to get it out with my tongue.

Finally, I gave up and used my hand. With my face stuck in Richard's crotch, I couldn't see where Cody was. I hoped he hadn't seen. He'd really

take it out on my ass for a slip like that. Just to be safe, I figured I'd wait before I took that big dick into my mouth. I started nuzzling.

A moment later, Cody voice was in back of me, snapping, "Dogs can't use their hands, fucker!"

His belt cracked into my ass and I jumped back, yelping and wiggling and trying not to move, as the thick leather burned across my butt a good dozen times. It hurt like hell, even though I knew Cody would have hit me a lot harder if he'd really been pissed. He doesn't fuck around when he's training me.

When he finished, Cody held out his hand to me. Whimpering, I rushed over and licked it, even licked the belt that dangled from his fist to show my remorse. I bathed his hand with doggy kisses. Pretty soon, the finger snaking up my asshole told me he'd forgiven me.

"Good boy. Now learn who Richard is before you suck his cock."

Cody motioned Richard to turn around. I immediately pressed my face against his denim-covered crack, sniffing through Richard's jeans while Cody's finger worked inside me. I sniffed and rubbed until I knew I'd be able to find Richard in any dark alley. I have a really good nose, and Cody was giving me a lot of incentive.

I looked back up at Cody and smiled, wiggling my ass against his finger. He pressed approvingly on my joyspot. My little puppy dick drooled happily at the attention it was getting. Then, without another word, Cody was gone. My horny little asshole was empty. I knew better than to pout though. I scrambled around to work on pleasing Richard's meat.

Fortunately, Cody had included extra large rubbers in the pile by my dish. The dick in front of me was definitely not one size fits all. And using rubbers when I sucked anybody but him was one of Cody's non-negotiable rules. Most of the other trainers he worked with felt the same way.

Personally, I prefer sucking dicks bare. But Cody said he didn't give a flying fuck what I wanted in that regard. My ass still twinged every time I remembered the beating I got over that one. I slept on my stomach for almost a week. Now, I was heaven's own star at being able to get a condom on using just my mouth.

The first packet fell to the floor when I tried to pick it up with my teeth. The second, I dropped neatly into Richard's hand. He opened the soft latex pool and set it on the head of his dick. I rolled it on him, taking my time so I could show off to him for Cody. With Richard being a rival trainer, I wanted to make sure I didn't do anything clumsy like get my teeth in the way or catch any of his dick hair. I moved so slowly my hot young doggy mouth made him shiver. Pretty soon, though, the size of his cock had me so enthusiastic I forgot all about making an impression. I wanted that thick, meaty flesh in my mouth like a puppy wants a new bone.

All of us puppies like sucking cock. Personally, I love licking nuts, too. I especially love the way a guy's scent is really heavy when I first dive under some sweaty low-hangers. I bathed Richard's balls until he quivered each time my tongue flicked out of my nasty doggy mouth.

I hoped he'd give me permission to rub against his leg. My poor little puppy prick was screaming for attention. But Richard wasn't paying attention to my wiggling around, just to my mouth. Finally I figured out that he was one of those trainers who didn't bother to teach his puppies to ask permission to rub. I started whining—loudly—arching my rock hard boner towards him. His tool was delicious, but my poor little pecker was in need! And I didn't dare touch myself with my own hand, not while Cody was in the same hemisphere.

Richard still didn't catch on. Finally, I gave up and tried to concentrate entirely on servicing him, which was what I was supposed to be doing

anyway. I loved the feel of his hot, sheathed flesh moving in and out of my throat, in spite of how miserably turned-on it made me. After all, it wasn't often I got a chance to suck a dick that big.

But it wasn't often I got to go out in public uncaged, either. I really wanted to jack off. I was wiggling around, trying to remember my training in spite of how frustrated I was, when suddenly I felt a boot move between my legs and press against my dick. I gasped in relief, and then looked up, whimpering appreciatively.

It was one of Cody's friends. Richard was too far-gone to care what was happening with me. John leaned against the bar next to us, grinning and teasing my cock just enough to keep me from losing my mind. John was rubbing his crotch, so I knew who was going to be next in line. And I knew he'd let me rub against his leg.

I took Richard all the way into my throat again. Now I could really get into sucking him. Let me tell you, I know my mouth made Cody proud. I worked that tube of man meat until suddenly Richard shoved me away, throwing the rubber. He jerked himself hard, three times, and then roared as he shot all over my chest.

I sat back on my heels, grinning puppy-proud at the dripping come and waiting patiently for Richard to give me my orders. I knew I'd be able to smell his come all evening, something my puppy prick would definitely appreciate. I was careful to keep my ass elevated enough for John to keep his toes on my cock, though. Patience is much easier for this puppy when his dick is happy.

"Damn, boy, that is one talented mouth you have," Richard finally choked out. I grinned up at him, hoping he'd remember his manners. Sure enough, he turned around and hollered across the room, "Nice work, Cody. Your dog's a good cocksucker."

I didn't hear Cody's response. The sound of his voice was muffled when John grabbed my ears and turned my face into his crotch, growling. "You better really show me your appreciation, boy."

Oh, did I show him. I didn't have to learn John's scent. He'd been over to the house a lot. I settled in to being really appreciative. He already had his cock out and a rubber on, so I dove straight for his balls. I sucked his meat until he was panting as hard as I was. Just like I'd known he would, when I whined, he snapped his fingers and said, "Rub that little doggy prick against my leg, boy. And you better be hard!"

Hard was no problem. I was so hard I thought my dick would split. I slurped and growled and rubbed against him until I was sure I was going to come. I wasn't supposed to, but I figured I wouldn't get in too much trouble if somebody made me do it. I figured John's giving me a cock to suck and ordering me to rub against his leg constituted "making" me come. My balls were pulling up so tight I knew I was almost there. I could feel the pressure building.

John knew what I was doing, too, the fucker. When he saw how hard I was panting, he laughed and pushed me off his leg. Then, before I could whine too much, he grabbed my head and face-fucked me hard and fast until I felt his warm, oozy juices filling the tip of the rubber. He groaned against me, letting me really feel his response—his belly pressing hard into my forehead while he shuddered, his strong pungent come sweat, his salty nuts as I licked them while he came down.

There was a puddle of precome under me when I finally knelt back. I was frustrated, but I always liked making John come. He smelled good. When he peeled the rubber off, he poured his cooling juice onto my chest, smearing it into my skin so I'd have even more man cologne to sniff as the night wore on.

Then, laughing, he passed me on to the next guy. By then, there was a line.

When I'd satisfied every dick that wanted me, Cody unhooked my leash and tossed me over in the corner with a pile of other tired puppies. We'd all been sucking cock, and none of us had been allowed to come. Even though we were worn out, we were also sporting frustrated little puppy boners. And we puppies aren't real good at controlling ourselves when we're all tumbled up in a heap like that.

There were five of us; all dressed pretty much the same—dog collars and boots. All with sore, red butts and raging hard-ons. I knew something was going to happen. There was too much pure, raw lust in our little corner for things to stay innocent.

A really cute puppy was lying next to me. Short blond hair and big blue eyes. Obviously somebody who spent a lot of time in a gym. I smiled smugly. He was bigger than me, but his dick was smaller. He watched, enviously, as I curled up against the wall and licked my tongue over my salty, slippery piss slit. I was deliberately teasing him. He lay down on his belly, rubbing against the floor and whining at me. Two small chains hung down from his collar, attached to his nipple rings. I guessed those pointy pink peaks were really sensitive. I like licking responsive flesh. I like it a lot more than teasing. I tipped down off the wall and crawled over next to him on my hands on knees, rubbing my hard-on against his leg and yipping playfully at him. Pretty soon, I was chewing on his nipples, somebody else was sniffing my butt, and we were all getting really frisky.

But like I said, Cody never lets me suck any naked dick but his. We didn't have any rubbers. One of the guys—swimmer type, with thick brown poodle curls—was licking my nuts. I lay on my back like a good dog, with my legs spread wide. But when he started on my dick, I pushed him away. He looked up at me, surprised. I yipped and pointed to my naked boner, mimicking pulling on a rubber. He looked around sheepishly—a little scared, actually—like he'd just remembered what his master had told him. Then his face flushed with relief as he realized no one had seen him.

I was glad Cody'd trained me so well, thankful for all the times he'd whipped my butt so I wouldn't forget. I reached out and slapped the other puppy's butt hard. He yelped. His ass was all red from where he'd been whipped earlier that evening. But he had the good grace to blush and look away, nodding in agreement as he whispered, "Sorry. I forgot."

Man, I didn't even want to think what Cody would do to me if I ever spoke in public when I was wearing my dog collar. That was only for life and death emergencies. Apologies sure as hell didn't qualify. I shook my head and nuzzled up next to the other puppy, rubbing my face against his chest to show how puppies say they're sorry. He caught on. Especially when I moved down and started tonguing his shaved puppy ballsac.

But we still didn't have any rubbers. Given our mutual oral fixations, I knew we were all going to be in trouble soon if we didn't do something to remedy the situation. I could see the condom I'd dropped earlier, still on the floor by the bar. Cody hadn't told me to stay, so I crawled back over towards it, trying to be unobtrusive.

I picked the packet up in my teeth, being careful not to bite through it. Suddenly, Richard was standing over me.

"Hell, boy, doesn't your master feed you?" He looked over his shoulder and yelled, "Cody! Your dog's trying to eat a rubber without a dick in it!" Richard shook his head and looked down at me again. "Shit, boy, what are you trying to do?"

I half expected to feel Cody's belt on my ass in answer. Instead, I heard him shout from across the room. "That dog wants something, he knows how to ask for it."

"Reowf!" I grinned. Oh, yeah. I knew how to speak.

Sitting back on my heels, I barked loudly a couple more times. Then I whined, shaking my head towards the pile of puppies. I took the rubber in my teeth and crawled over to my poodle-haired buddy. He grinned and rolled over, legs in the air and spread wide. I dragged the wrapped condom up his dick, then sat back on my heels and whined again.

I thought the whole place was going to collapse in laughter. Shit, for a response like that, I should do stand-up comedy. Richard and four of his friends came over, pushed the rest of us squirming puppies onto our backs, and rolled rubbers on our dicks. Then they stood around, laughing, as we chowed down on each other. Puppies are too young to fuck. But they sure know how to put everything they find in their mouths. We were one long daisy chain with each of us gnawing on a hot, hard, latex-covered chew toy.

Of course, puppies don't have a lot of self-control. They get spanked for misbehaving, but sometimes, they just can't help coming. My dick was in heaven in the warm, soft suction of the curly-haired puppy's mouth. Pretty soon I was yelping and whining and growling. My nuts tightened. I threw my head back, howling with pure joy as I shot into the heat of my pleasure puppy's mouth. I knew I'd get my puppy butt whipped for it, but I just couldn't help myself. It felt so good. I opened my throat and a moment later, a hard, thrashing blond-puppy cock pulsed in my mouth. The air was alive with yips of pleasure.

We were all squirming contentedly as we came down, the way happy, well-fed puppies do. I was licking somebody's nuts again—I couldn't see whose—when suddenly Cody grabbed me and dragged me unsteadily to my feet. I knew the feel of his hand, could smell the sweat from his leather vest before I even saw him. I yelped as his belt cracked across my butt. Again. And again.

"Bad dog," he snapped, holding me firmly over his arm, ignoring my yelps each time his belt bit into my ass. "Bad little slut puppy."

My softening dick wagged out in front of me, the come-filled rubber drooping off the tip as I danced around. I ignored the hoots and laughter in the background. Cody's belt had my full attention. By the time he was done, I was howling and crying in his arms. No matter how much I love it when Cody whips me, it still hurts like hell. And I'm undisciplined enough that I can't help carrying on when he whips me. After all, I'm only a dog.

Fortunately, Cody knew that. He held me tight enough that he could really set my butt on fire; just the way he knows his puppy likes it.

As soon as he was done, I dropped to my knees, licking his boots and whimpering, begging for forgiveness. Puppies get really scared when their master might be mad at them, though I wasn't sure that Cody was really mad. After all, he was the one who had thrown me in the puppy pile with a raging boner.

I figured it out when he heaved a theatrical sigh, then reached down and scratched behind my ear. I looked up at him and was rewarded with the deep blue twinkle in his eyes. Oh, yeah. He'd known how much I wanted my ass heated. He'd deliberately waited until after I'd come to whip me, so I'd feel every lick of his belt and not be distracted by my horny little puppy dick.

The rubber had fallen off sometime during the whipping. I was getting hard again, knowing Cody had deliberately taken the time to tend to my smartass doggy butt. Cody held out his hand. I licked it fervently.

"You still hungry, boy?"

"Reowf!" You better believe that meant "Yes, sir!"

There was a tone that told me when Cody's dick really wanted attention. His voice was thick with it now. He'd stripped down to just his chaps and a leather jock. I licked my way up his leg until I was nuzzling the hard bulge in his pouch, licking him the way a really attentive dog would. Doggies love the smell and taste of their master's crotch.

Then Cody did something totally unexpected. Something he'd never done in public, though he knows I love it almost as much as I love getting fucked. He turned towards the bar, spread his legs, and lifted one foot up onto the bar rail. He looked over his shoulder and said, "Are you sure I'm your master, boy?"

Yipping excitedly, I crawled forward on my knees and eagerly buried my face in his crack. Then I sniffed long and hard. Mmmmm.

"Reowf!" I leaned back and barked happily, grinning and ignoring the hoots of laughter around me.

It was Cody all right. We'd showered together before we came to the party, but this late in the evening he'd built up a really good sweat. His ass was musky and heavy with his own private scent. I rubbed my cheek against his. I couldn't control my puppy instincts any more. I buried my face between his hard, muscular cheeks, and I started licking. I love eating ass, and damn, Cody tasted good. At first, he was all salt. I dug in deep and shivered as his personal flavor started coming through.

Cody was carrying on a conversation as though I wasn't even there. Like my mouth wasn't doing anything to him. Like my nasty little puppy

tongue didn't know how to eat his ass into fits. But I could tell he was getting turned on. His asslips twitched each time I licked them. Those firm butt muscles of his flexed hard against my face each time I poked my naughty little puppy tongue into his hot, spicy asshole. I knew he'd whip my ass until I couldn't sit for a week for tongue fucking him in public. I was only supposed to show that I knew how to identify him. But he tasted so good and his ass was so hot, I didn't care. My spit was dripping down my chin, smearing his scent into my face, when I finally got him loose enough to really dig my tongue into him. He wasn't talking as much now. And he was breathing harder.

He almost dropped his drink—I heard the ice tinkle in the glass—when I started sucking on his asslips. I knew I was really going to pay for that one later, so I moved fast. I dug in as deep as I could get without his throwing his leg up on a barstool to give me better access.

Cody gasped and grabbed me by the hair, dragging me around to the front of his suddenly unsnapped jock. Then he shoved my face all the way down on his dick.

"Suck it, boy!"

I tried to bark, but it came out as a muffled "unh" as he slid straight down my throat. I could taste where the precome had run all the way to the base of his cock. His dick was stretched out to its full eight inches and every bit of that hot, tasty meat was in my mouth. Cody fucked my face until I thought I was going to pass out from lack of air. Then he yanked me off and growled, "Show your master's friends how well you can suck cock, boy. Show 'em good!"

Hell, with a challenge like that, I could have kept going all night. I nibbled up the underside of my puppy treat, paying a lot of attention to his frenulum. Even though Cody's cut, he's got a lot left there. It's really

sensitive, and he loves it when I really work it. I kissed his glans with the insides of my lips, sucking while my tongue tickled into his piss slit. I licked and sucked until his shaft was dark red and so thick I could hardly get my mouth around it. Then I turned my attention to his balls, bathing them the way a really good doggy would. I sucked first one, then the other into my mouth. They were too big for me to fit both in at once, so I made sure my tongue did its business on the bottom of his ballsac while I was working each heavy ball inside my mouth.

Then I dove back down on his dick. I was vaguely aware of catcalls and applause. Cody jerked a few times as people slapped him on the back for how well trained I was. He kept his hands tight on my head, rubbing me firmly in approval.

But sucking Cody's dick wasn't the only thing I wanted. My little puppy asshole itched, it was so hungry. And nobody gets to fuck this puppy but his master.

I nuzzled and licked appreciatively when Cody pulled his cock free. He put his fingers, first from one hand, then the other, in my mouth. I knew what was coming. I'd wanted it so bad all night. I worked up all the spit I could.

When his fingers were slobbery wet, he turned me around and snapped his fingers. "Down!"

I eagerly lowered my hands to the floor, quivering with anticipation as he squatted in back of me. Cody spread my still hot and sore ass cheeks. I yipped—partly with pain, but mostly with pleasure—dropping my head onto my arms and wagging my ass invitingly. I heard the pop of a lube pillow. One finger, then another, slid into me. Man, it felt so good. Then a whole lot more fingers were stretching me open. My horny little puppy dick was drooling precome. I heard the telltale sound of the

condom being torn open. I knew what that meant. My doggy ass twitched as I whimpered and begged for it.

Cody put his hands on my hips. His hard, hot dick pressed against my open hole. I yelped as the head popped in. Cody leaned over and took my doggy cock in his hand, jerking me as he slid in the rest of the way. He pulled on my dick until my asshole loosened and I was panting and yipping and arching against him like some lust-crazed bitch in heat. I howled as his thick, stiff dick slowly slid all the way up into my ass.

Cody fucked me hard and fast and long. I knelt beneath him, in heaven, dripping sweat as he pounded into me. My master loves me so much; he fucked me until I came again. I howled until my throat was raw, shaking, my dick spurting hot come onto the floor. Cody kept right on fucking me, searing my open hole with his dick. My asshole was burning when he finally pulled out and threw the rubber. It landed wetly on my shoulder. Then I felt his hot come splatting like melting wax across my back and spine and shoulder blades.

I was totally blissed out.

Cody was, too. We left shortly after that, to many kudos for his training skills. I fell asleep in the car, my naked skin curled up against the leather seats as he drove. I was still pretty sleepy when we got home. Cody woke me up to take out my contacts, and then tucked me into bed with him. I pushed both shepherds and the Rottweiler out of the way so I could snuggle up close to my master.

That's one of the secrets that Cody doesn't tell his competitors. He always lets his dogs sleep in his bed. But I'm the only lucky puppy who gets fucked.

Arianna's Breasts

Beth's Story

I was still adjusting to my lover becoming a mother. It wasn't that motherhood was a surprise. From the start, Arianna had been up front that having children was something she was going to do. I was cool with that. We'd talked about things a lot beforehand, and Calvin was a neat kid. I'd never been around a baby before, but I liked him a lot. He even smiled at me first, though I didn't tell Arianna that. Instead, I had fun getting all excited with her the next day when he gave her his "first" smile.

It was just that some very important things I hadn't expected had happened now that Calvin was here. Much to my embarrassment, Beth Reilly, the butchest, brassiest blond bombshell in town, was responding to a new baby by becoming totally obsessed with her partner. Instead of standing back and being responsibly adult, I wanted Arianna to spend every minute she wasn't with Calvin mothering me. I wanted her to hold me and kiss me, and let me fondle her milk-swollen breasts.

At the same time, I burned to make love to her. Not that it had ever taken much to get me going. Arianna was everything I'd ever wanted in a partner and more: intelligent, funny, passionate. She was beautiful before she got pregnant. She was gorgeous, sexy beyond belief, the night our friend Greg came over and made the donation so I could inseminate her. Just thinking about becoming a mother turned Arianna on so much she seemed to be emanating sexual vibrations. I rushed Greg out the door with his belt half-buckled. I wanted time to finger Arianna to orgasm—so she'd feel my hands making her come when I slid the syringe up her shivering pussy and squeezed. She came so hard she cried. And got pregnant.

She glowed the entire nine months. I was in awe of her. I'd lay with my head on her belly, listening to her talk about names, sniffing the way her sweat had changed. Her whole body seemed to come alive. Her skin was perfect. Her long, dark hair shined. And right away, her full, sensitive breasts swelled even further and her nipples grew huge and dusky—so silky and responsive, so lickable. I couldn't get enough of touching her, which was a good thing, because suddenly, Arianna wanted sex all the time. Although I could tell she was trying not to ask too often, especially when I was tired, she would cry out in relief whenever I'd gently, oh so gently, suckle her while my fingers rubbed her warm, wet pussy. In desperation, I finally got her a vibrator, so she wouldn't be so frustrated. We both had a good laugh when she and her fancy new toy showed me I often wasn't quite as tired as I'd thought.

What really surprised me, though, was that now that the baby was here, Arianna was even sexier. She laughingly called herself "a femme with a capital F." But this time, I was the one with the raging libido. I felt guilty as hell about it. I was still lusting after her breasts. Really, really

lusting. That just felt wrong. I mean, she was a mother! And all I could think about was how soft her breasts were, how full and heavy with milk. I wanted to touch them and smell them—to lick them, dammit! Me, the tough, butch dyke who spent her days crawling around inside of truck engines. At night, all I wanted to do was come home and bury my face in the warm pillows of my lover's breasts.

So I buried myself in my work instead. I took all the overtime I could get; rationalizing it by saying I needed to pay off the insurance deductibles from Calvin's birth so we'd be out of debt by the end of the year. But I was miserable. Eventually, I had to admit to myself that the OT really wasn't helping anything but my paycheck. As I stood in the door of the service bay, watching the leaves blow off of the trees in the evening darkness, I realized I was celebrating the autumn equinox by stuffing back cold pizza and washing it down with warm soda—at work—while Arianna was at home by herself with the baby. We were going to have to talk.

By the time I got home, though, I'd once more decided that serious conversations would have to wait. I was beat. The house was dark and quiet. I figured Arianna was already in bed. But as I walked in the door, I was surprised to see her sitting on a pile of pillows in front of the fireplace. She was brushing her hair. Her favorite tranquility CD was playing in the background. The cat was curled up at her feet. With the fire glowing in back of her, I could see the outline of her full curvy body through the white cotton of her nightgown. Arianna looked up at me, and suddenly I wasn't so tired anymore.

"Rough day?" she smiled, putting down the brush.

I nodded, kicking off my work boots and stashing them beside the front door. The fire had the room so warm that I took off my jacket right away, too. "As long as fools drive, I'll be employed."

"I'll bet," she laughed. She stood up and walked over to me, putting a chaste kiss on the tip of her finger and touching it to my lips. When I caught her finger in my teeth, she smiled and brushed her thumb over my lower lip. "I ran a bath for you. Come soak for a while. The baby's down for the night."

Her words sent a shiver straight down my spine. As always, my eyes locked on the faint shadows where her areolas pressed against the thin cloth of her nightgown. Before I met Calvin, I'd thought babies were up all night long. But he was only four months old, and he'd been sleeping straight through for a while now. My conscience warred with my hormones as I thought about what the rest of the evening could hold. A quick bath sounded good, though.

Quick was not what Arianna had in mind. I stepped into the bathroom and came to a dead stop. Arianna had filled the steaming tub with herbal bath salts. My bath pillow was floating in the warm water. A fluffy towel rested on the sink and the aromatherapy candles were burning. I'd washed up before I left the shop, but I was afraid to touch anything in that pristinely romantic room with my sweaty, greasy clothes.

"Strip," Arianna said sternly, pointing at the hamper.

I nodded, and without saying a word, I peeled off my clothes as fast as I could. No matter how butch I am to the rest of the world, I know better than to cross my sweet, dainty lover when she uses that tone of voice. A moment later, I sank into the water. It was pure bliss. I slid all the way down, until only my head was peeking out, resting on the pillow. The bath was deep enough that even my nipples were submerged. I closed my eyes and let my worries drift away as my muscles uncurled one slow stretch at a time.

"You look like an eel," Arianna laughed as she knelt down beside the tub. "One with short yellow hair and a lot of attitude."

I opened my eyes, sighing contentedly. I was too comfortable to even reach up to touch her. "You know the way to a woman's heart."

"Yeah," she winked. "A warm tub." She reached in the water and dragged her finger slowly up my thigh. "Lots of good loving." I twitched when she reached between my legs and tugged my pubic hair. Her full breasts were outlined by the cotton that dampened in the rising steam. I tried to look away, willing myself not to lick my lips, as a single drop of milk fell from first one, then the other. "Good food." Another drop fell. Arianna tickled my clit and smiled at my sharp intake of breath. "You're going to have to help me out here, hon. My breasts get so full when I'm turned on. I want you something fierce." Two more drops gathered on the wet spots on her bodice, swelled, then fell into the water. "You wouldn't want me to be hot and bothered all night, would you?"

"No," I whispered, shaking my head. I felt like I was in a trance. I reached up and touched my fingertip to the dark, damp spot. Arianna's breasts were hard with milk. She made so much more than Calvin needed. A drop slid onto my finger, over my wrist, down my arm towards the water. I closed my eyes and tried not to think, tried not to let her see my guilt and confusion and need. I wanted her so badly—to make love to her and caress her and hear her whimper with pleasure when she climaxed. And I was overwhelmed with shame that I wanted to bury my face in her heavy, motherly breasts and suckle the milk from her swollen nipples. I wanted to nurse until my greedy mouth was sated and her warm milk trickled down my throat and her hands pulled shattering orgasms from me.

"Your legs are so strong, Beth. So sexy. I want to touch them all the time." I shivered as her finger slid between my labia. When I opened my eyes, she was smiling at me again, her finger still exploring. "You're getting slippery, even in the bathwater. I like that."

"I like it, too." I was surprised how thick my voice was. I leaned up to get out of the tub, and then stared as Arianna firmly pushed me back down.

"First things first, love." Arianna grabbed the soap and a washcloth and started to scrub. "You have to be clean before you can have dinner."

"Yes, ma'am," I laughed.

She took her sweet time washing me. She wouldn't let me raise a finger as she rubbed her businesslike hands over and into every inch of my body. I complained when she scrubbed as far as she could reach into my pussy and ass. I was so turned on, and the cloth wasn't staying in any one place long enough to do any real good. She finally let me sit up while she shampooed me. By then, I was trembling, and she was soaked. Her breasts, stimulated by the warm, wet heat and her desire, were leaking constantly.

She wouldn't let me touch her, though. She helped me out of the tub and dried me, slipping a thick terrycloth robe over my arms. As I lowered the towel from drying my hair, I saw that she'd changed into her own soft, white robe. I could hardly wait to get my hands on her.

Arianna moved faster than I did. "Hold still," she said firmly. She grabbed the comb and quickly pulled the tangles from my hair. Then she took me by the hand and led me back out towards the living room. I stopped halfway down the hall.

"I thought you wanted to go to bed." I was surprised, though necking in front of the fireplace sounded intriguing.

"I have something else in mind," she said firmly. Then we stepped into the living room, and I realized that the couch was also covered in pillows and towels. A large glass of water rested on the end table, next to a bottle of oil. Arianna let go of my hand and sat down on the couch. She made a comfortable nest for herself and propped her elbow on the armrest. Then she smiled up at me and untied her belt.

"C'mere, babe." Arianna was naked under the robe. She held out her arms. I shuddered as my eyes slid down her body. Her breasts were so swollen with milk. A drop welled up from her right nipple and dripped down onto her belly. She wiped the bluish white drop onto her fingertip and held it up to me. "The right side first, hon. That one's really hot and full. It feels as hungry as you look."

I felt like I was in a trance. I took her finger into my mouth and sucked the sweet milk from it.

"Ooh, yes. Like that." She wiggled on the couch. I lay down and rested my head on her lap, letting the guilt fall away to the back of my mind. She readjusted me until my head was raised, resting on her arm, my mouth even with her nipple, the way she held the baby. Arianna reached over and tenderly rubbed my cheek, the way she'd done to Calvin when she was teaching him to nurse.

My mind didn't seem to want to work. I could only whisper, "I love you."

"I know," she smiled. "I love you, too." She nudged her nipple against my lips. "Now open your mouth and get busy."

I felt surrounded by her. My neck was supported by the crook of her arm, my cheek rested on her warm, engorged breast. She smelled like milk. My ears were wet where they pressed against her. Then I felt the dampness on my lips as another drop leaked out. I licked, instinctively. And I was lost. I lifted my hand, the palm splayed against the side of her breast, cupping the fullness. Then I started licking, stimulating the nipple, stimulating my tongue, making them both hungrier for each other. My mouth moved in long, sure strokes. I wanted every bit of Arianna's skin to crave me the way I did her. The leak was a steady stream of fast drips now, warm and sweet. I lapped at them like a cat.

"Dammit, Beth," Arianna hissed. "My nipple's ready to explode. Suck it, HARD!"

My tongue slid under her hot, swollen flesh and I wrapped my lips around her, taking all of her silky areola into my mouth. With no warning, I sucked, long, and strong, and fiercely. She gasped, stiffening and clutching me to her. Then her milk gushed out, and I choked, swallowing as fast as I could as the hard stream spurted into the back of my throat. I felt warm liquid hitting my belly and realized Arianna had opened my robe, so her other nipple could squirt onto me.

When the first soothing rush has passed, I settled into a contented suckling. Arianna's heart beat next to my ear. Each time I swallowed, her sweet, nourishing milk slid over my taste buds and down my throat, filling my belly with her warmth.

"Thanks, love," she sighed, relaxing against me. I smiled around her nipple, not missing a beat of my rhythm. Her finger stroked my cheek. "That feels so good, and it's so nice to know that for once I'll be sucked dry." I was surprised to see her flush. I lifted my eyebrows as her. She sighed again, this time much more heavily. "I'm sorry, Beth. I feel so damn guilty. I make so much milk that by evening every day, I want to grab you and beg you to suck me as hard as you can, so I'll finally feel empty. You're working so hard and so much these days that I don't want to bother you. But damn, I really want you sucking my boobs!"

I pulled again, much harder and longer than I ever had.

"Oh, YES!" She gasped. Her hand slid over mine and squeezed.

I leaned back and licked, teasing the nipple with my tongue, flicking it, biting ever so gently. Arianna groaned like her bones were breaking. I traced the outline of her areola with my lips, kissing softly, licking in long strokes over the curve of her breast and out to the tip of her nipple.

"And here *I* was feeling guilty." At Arianna's startled look, I blushed. "It didn't seem right for me to have such a thing for your breasts, you being a mother and all. Just thinking about them makes my cunt wet."

Her finger slid down over my belly, between my legs, slipping and gliding on my juices. I groaned.

"Aren't we a couple of idiots?" Arianna's chest shook. I looked up to see her giggling. "I'll tell you what, my gorgeous butch lady love. You suck away, and I'll show my favorite pussy just how much I appreciate what you're doing."

With that, she reached over and took a long, cool drink, the way she always did to keep her milk flowing when she nursed. Then she leaned back and poured a stream of oil between my legs. I sucked long and steadily while Arianna slipped her fingers between my lower lips and started to rub, slowly and sensuously.

"You're so demonstrative, Beth. I love that."

Hell, I was so hot for her I was gasping when her breast finally emptied and she switched us around so I could suckle the other side. As my mouth filled again, Arianna pinched my clit in her slick fingers. She rubbed mercilessly, ignoring my cries and bucking. I came so hard I almost choked on the milk sliding down my throat. I shuddered and cried out against her breast, my pussy convulsing from the inside out in waves of pure pleasure. Finally, I wrapped my arms around her and let my mouth fall away from her nipple. I was exhausted and sated—and full. My cunt was purring, and Arianna's breasts were finally dry. I looked up at her and smiled.

"That was wonderful, Beth" she sighed contentedly. The glass of water was empty. Her hand traced up the side of my face. This time I smelled cunt as well as milk and oil on her fingers. "You look exhausted, babe. Go to sleep."

I shook my head and slid down onto the floor between Arianna's legs. I was tired, but there was one more taste I wanted before I went to sleep. I opened her robe the rest of the way and tugged her hips forward to the edge of the couch. "I'm still going to take care of my favorite pussy."

Her laugh turned to a gasp as I lapped up her clear, slippery juices. She was so wet she glistened. The tang of her cunt was so different from the sweet, thin texture of her milk, but the two tastes mixed together on my tongue into something that was purely Arianna. Her clit was swollen, engorged almost as much as her breasts had been. She jerked when I flicked gently at the tip peeking out of its puffy hood. I let each long, slow lick glide over her until she quivered. Then I slid my fingers into her. She was looser now than she had been before the baby, but so much more responsive—like her whole cunt had been awakened. I pressed deeper, found what I was looking for, and was rewarded by her heartfelt groan. I started to rub.

"Oh, yes, Beth! Don't stop! Please!"

I grinned, my mouth still full of pussy, and reached my other hand up to grab a nipple. Arianna cried out, her whole body stiffening.

"Yes, dammit! YES!" she gasped. Arianna shoved her fist in her mouth, muffling her scream as she arched up against me. I held her firmly in place, pressed my fingers up hard inside her, sucked mercilessly against the now-pronounced bud of flesh beneath my tongue. She yelled again, and I felt the sudden stream of her warm, slick juice slide over my chin. I lapped it up until she'd stopped shaking—and we were both giggling.

I slid up next to Arianna, took her in my arms, and laid us both down on the couch, my face buried in the soft pillows of her breasts.

"Empty now, lover?" I couldn't stop grinning. I needed a bath all over again. So did she. But I wasn't going to take one. I wanted to smell our loving all night. In fact, I decided I wasn't going to shower before I went to work in the morning.

Arianna's chest shook again, this time with relieved laughter, and she hugged me fiercely to her. "Just come home hungry every night, Beth." She kissed the top of my head. "Come home hungry, and let me love you."

Now that was something I could live with.

Cupid's Valentine

Cupid's Story

Valentine's Day sucks. Not that I'd mind if my dick were the one being sucked. Unfortunately, now that I'm grown up, I'm well aware of my own raging hard-on while I'm flitting around shooting fuck-me arrows at pheromone-crazed lovers-to-be.

This year I was being a royal bitch about it. I knew Jupiter would be pissed if I spent the whole day cruising the drag shows in the Castro. But hey, I'd had my fill of dickless chicks at the Millennium parties. I was tired of playing god-of-the-gene-pool with the breeders!

Candy and flower sales dropped like rocks throughout the civilized world. By mid-afternoon on the 14th, the e-mail complaints were flooding Jupiter's computer—shut down the whole fucking Olympian network! That was the only reason nobody found me until long after I'd passed out on the floor of a lace-curtained parlor in a renovated Queen Anne condo.

Mercury told me later that Jupiter's cursing had echoed halfway around the world. I was sleeping too soundly to notice. As usual, my Valentine's Day exploits had left me too tired to even jack off—something I regretted the moment I woke up.

My morning boner felt like it reached all the way to my tits. Fuck, I was horny! I glanced down, saw the two tiny, golden arrows piercing my nipples and the matching charm dangling from the Prince Albert in my dick head, saw the force field shimmering between the arrows, and I started to shake. Fuck, oh, fuck, was I in deep shit! Jupiter had only been that pissed at me once before, when I'd accidentally shot a head of state and his assistant, rather than the guy's wife. Took Jupiter two years to clean up the mess!

The golden arrows were already doing their work on me. My nipples burned to be chewed, my lust-swollen dick pulsed and oozed, begging to be stroked, and my asshole was so hungry I would gladly have perched on top of a telephone pole for the day. I knew from painful experience that the force field surrounding my torso with a glowing light would stop only one hand—mine. I also knew old Jupiter wasn't going to let me come until my butt had paid the price for every penny his clients had lost yesterday.

Mercury was standing over me, laughing like a loon. "Transport spells are triple-priced today, lover boy, and I only have one—directly to Mistress Sheila. You can pay now, or you can wait until the price goes up, which will be in about five minutes." He glanced at the sundial in the courtyard. "'Course, as soon as the sun hits your ass and your buttcheeks start throbbing, too, you'll pay whatever I want."

I was already horny enough to kiss Mercury's feet if it would get me laid, but I wasn't going to give him the satisfaction of knowing that.

Besides, I figured he was pissed about the advertising money he'd lost the day before. I reached in my boot and tossed him the beaded handbag containing all the tips I'd earned yesterday.

"Just do it, fuckface. You'll get yours later."

Mercury grinned nastily, catching the pouch in mid air. "Maybe so, pal, but this will help cushion the blow."

His laughter was still echoing as the world shimmered around me and the wind of transport howled into my ears. Fuckface sent me naked through the sunlight in the courtyard on the way out, so my lust-stimulated ass was burning the whole way.

I landed on my knees, on thick wool carpet, with my nose pressed into the crotch of a red leather mini skirt. I smelled expensive perfume and leaking dick, saw the long, curvaceous legs that could belong to only one woman. I leaned forward and nuzzled, hoping to make brownie points with a dick I'd never seen but loved sucking.

"Nice try, Cupid." The voice was low and husky—and pissed. I sighed and rubbed my cheek hungrily over the generous bulge packed between Mistress Sheila's legs. She was the most infamous drag queen dominatrix in the world. Her silk-encased tits were full and suckable in those damn bustiers she always wore. Her long, thick, salty cock snaked halfway down my throat when she fucked my blindfolded face. And I knew for damn certain that no matter how many times I'd visited her for the pure fun of it, she didn't put up with crap from self-important young godlings who screwed up their assignments. Mistress Sheila was going to roast my ass before she fucked me. Jupiter was a major employer, and no matter how much I wanted her attentions, she'd make damn sure she could truthfully tell him he'd gotten his money's worth—and his revenge in full. I yipped as a riding crop seared across my butt.

"Do you have any idea how much that little stunt of yours cost me, lover boy?"

"No, ma'am," I whimpered, kissing my way down her silk-encased thigh. Holy shit! I'd forgotten she was one of the original investors in the Olympian network development! My miserably throbbing cock warned me my penance was now going to include significant monetary and service compensation, at least for Jupiter and her. She wasn't wearing her signature knee-length boots today. Instead, my lips traveled all the way down to four-inch stiletto fuck-me heels. I ran my tongue along the heel straps, shivering as Mistress Sheila brushed the crop over my asscheeks. I lifted my butt, groaning with need and submission and kissing back when she rubbed the tiny leather flap over my lower pucker.

"It's payback time, Cupie."

I yelped as the crop stung across my ass again. She leaned over me, the spicy musk of her perfume filling my nostrils as her long, dark hair brushed over my shoulders. A well-lubed finger slipped over my sphincter, gliding effortlessly into my hole, stretching me. Then a cold, slick buttplug slid in deep. A bolt of pure heat and vibration shot through my asshole and my prostate started to throb. I moaned and started to tremble. Without ever having seen that fucking plug, I knew it was a new and even more torturous addition to Jupiter's golden force field arsenal.

"Special delivery from our mutual employer, arrow boy. You're also getting twelve of the best. Keep your head down and your ass in the air." Her legs tightened around me and tapped me none-too-gently again. I shivered, the precome drooling through my dick. "When I'm done, maybe I'll let you come."

The crop swished, and I yelled as pure, awful, delicious pain seared across my butt. My voice was muffled in her skirt, but the smell of her

crotch still drove me nuts. Energy shimmered between the arrows in my tits and my dickhead and my now desperately hungry hole. I ground my face against her, shuddering as the vicious burn in my ass vibrated all the way up my back. When I could breathe again, I arched my butt up at her.

"One, ma'am."

I howled at the second stroke. Fuck, oh fuck! Mistress Sheila knew how to beat ass! My dick felt like it was ready to explode. And I knew damn well that if Mistress Sheila didn't get me off, I was going to be one miserable putti. My cock drooled as I gasped out, "Two, ma'am!"

By eight, my whole ass was on fire. I was on my feet by then, bent over and holding my ankles while Mistress Sheila blistered me from behind. I hissed when she unexpectedly pulled me upright and hugged me, the cool leather of her miniskirt both soothing and tormenting my poor sore ass. Her hands tugged on the golden arrows piercing my nipples and electric lust echoed all the way to my dick.

"I'm sensing some repentance, Cupid."

"Yes, ma'am," I nodded vigorously. No matter how great a time I'd had in the bars yesterday, today, all I wanted was for this lady to fuck me. "Next year, I'll be fair, ma'am. I'll shoot het couples and gay ones." I arched back, grinding my burning skin against her, impaling myself further on the butt plug that was mercifully filling my ravenous hole. "I promise, ma'am. I'll shoot lesbians and mixed triads and even whole orgies. I'll nail the entire U.S. Senate if you want! Just please, fuck me! I'm so horny I can hardly stand it!"

"All in good time, my little walking libido." Her strong, delicately manicured hand slapped hard on my ass. "You've got four more coming. Bend over and grab your ankles."

I knew she was going to really scorch my ass with the last four. She was royally pissed at the disruption of her business. And dammit, Jupiter's vengeance aside, she knew how much I loved getting my ass blistered. With my hard-on poking up into my belly, I took a deep breath and got back in position. I yelled my fucking head off while she laid four more lines of fire across my ass. Even through my tears, I could see my dick was so engorged it was damn near purple.

I groaned with relief when a silken blindfold slipped over my eyes. I knew what was coming now. Clothing rustled in back of me. I heard wrappers tear, smelled the faint whiff of latex and the scent of lube. I jumped when the plug was yanked out of my ass.

"Hands on your knees, Cupid, and spread your legs wide." Mistress Sheila's voice was calm now, husky with desire instead of anger. Hell, business or not, she had spent many a night cruising the Castro herself. She knew the temptations. I gasped when her cool fingers stroked delicately over my tender ass. "You've got some beautiful marks, lover boy."

A thick, hot condom-clad shaft pressed against my asshole and started burrowing in. She took her time, stretching me, filling me with the huge, full cock I dreamed about so often. She grabbed my tits again, tugging on the arrows until the tingle of the remaining force field had me almost insane with lust. Then her hands slid purposefully down my belly, teasing lower, brushing the base of my shaft but never quite stroking far enough up to touch the aura crackling around the quivering, leaking, arrow-charmed head.

"Next year, you'll share the passion around for everybody, right, Cupid?" Her hand slid closer, gliding on my slippery juices. "Everybody gets a valentine?"

"Yes, ma'am!" I nodded so hard my whole body bounced. "I'll shoot so many damn arrows, the whole world will be alive with fuck lust!" My ass muscles clenched around her cock, sealing my promises with frantic kisses.

"You better." Her voice was thicker and lower now. Hungry and horny. I cried out as she shoved in deep. Mistress Sheila fucked me until my eyes crossed. And as she pounded into my prostate, she grabbed my dick and jacked me off until the pain in my ass and the pressure in my balls and the pleasure shooting through my tits and shaft and joyspot exploded into a howling, shuddering, shimmering orgasm that left me trembling beneath her while she filled my asshole with her thick, living, pulsing cock.

A few silky strands of her hair tickled over my back. I squirmed against her, enjoying the feel of breasts and cock pressing against me at the same time, even enjoying the painful heat on my well-punished backside. I had no doubt that when I got back home, I'd find an itemized invoice on my bed, detailing every penny I owed both Jupiter and her. I'd pay, but the slate was already clean between us.

"I'll do better next year, Mistress Sheila," I sighed, cuddling back against her.

"I know you will, you little pain in the ass." I stiffened as Mistress Sheila cupped my tender backside and squeezed hard. "Because next year, if you're very good, I'll let you suck my cock with the blindfold off."

The arrows in my nipples and in my cock pierced me with a fresh jolt of lust, then I felt the tingle as the force field dissipated and it was once more just Mistress Sheila and me. For a prize like that, I'd remember.

Secret Passion

Don's Story

All my life I'd fantasized about erotic enemas. I'd never indulged in my secret passion. The whole idea seemed a little too kinky to bring up to even my open-minded wife. But after several especially grueling weeks at work, I was having so much trouble sleeping that I'd started sneaking back into the den late at night to wind down by surfing the Internet. It wasn't long before I was spending almost all of my online time reading stories and looking at pictures of people giving and getting enemas. I was mostly interested in the "getting" part—and in masturbating.

I caught a whiff of Laura's perfume just before her arms slipped around me from behind. Then her hands slid inside my robe to grasp my throbbing erection.

"Mmmm," she said, rubbing gently. "Looks like they're having fun."

I was so embarrassed I felt like my face was on fire.

"God, honey, I'm sorry. I was just checking this out . . ."

I stopped, not wanting to lie to her. In the ten years we'd been together, I never had. But I didn't know what to say. I was looking at a picture of a guy draped lovingly across his wife's lap, his arms braced against the side of the chair as he leaned up and kissed her. He had a bright red enema tube sticking out of his butt and a half-empty bottle was hanging from her hands. It was the hottest picture I'd ever seen.

"Shush." Laura's soft, sweet voice drew all my attention to what her hands were doing. She leaned over and kissed the side of my neck. I groaned as she sucked very softly, and then licked her way up so she was whispering right in my ear.

"Sweetheart, I know this is one of your favorite sites." She bit my ear gently. "I've peeked over your shoulder before." The next bite was softer, a tiny nibble. "I think that picture is incredibly sexy. He looks so relaxed, so turned on." She moved her hand down from my now thoroughly engorged penis to tenderly cup my testicles. "I'd really like to run warm water up your bottom to see if it makes you as happy as it makes the man in the picture. Would you like that?"

I was so stunned I couldn't make my mouth move. My wife was offering to make my hottest fantasy come true, and because it was something *she* wanted to do. I couldn't believe it! I pulled her hand up from my lap and kissed her palm—embarrassed and blushing and fervently nodding against her as she laughed against my back.

Laura's face was reflected in the monitor, her head now resting on my shoulder, the cloud of her soft brown curls framing her face, and a big smile touching her lips. Her eyes were twinkling wickedly.

"Come with me, Don." She stood up and tugged on my hand, pulling me gently to my feet. "You can keep your robe on for now. I'll take it off when it's time for your enema."

Her words sent shivers down my spine. I didn't bother turning off the computer. I just followed Laura up the stairs and into the hall, my eyes glued to the satin peignoir that hugged her perfectly rounded curves. My feet moved like I was in a trance, matching the rhythm of her heels on the hardwood floor.

Hold on a second. Heels? In the middle of the night?!

"Laura!" I sputtered. "You planned this!"

"I most certainly did." She wiggled her hips enticingly and looked back over her shoulder, winking at me. "I've been waiting for my chance." She squeezed my hand, grinning as we stopped at the guest bathroom. "Now let's make you feel good, sweetheart."

Her smile made me fall in love with her all over again. She opened the door, and I tripped right into her back, staring at what she'd done to the room. It was right out of the on-line picture. Her vanity chair was in the middle of the floor, on a large furry rug. The counter was lined with bottles and jars and measuring cups. And next to the chair, hanging on a shiny, silver hospital pole, was a bright red enema bag. The tube was already attached, draped back over the arm of the pole, a thick black nozzle jutting firmly out of the business end. I tugged my robe closed, trying to cover my raging erection. My cock seemed intent on peeking out to see this dream come true for itself.

"I see this meets with your approval." Laura was laughing again as she let go of my hand. She walked across the room to adjust the lights. Then she picked up a rectal thermometer, swiped a glob of petroleum jelly on it, and waved it at me. "Come lie over my lap and let me see if your insides are the right temperature for a nice, warm bath."

As she sat down, Laura opened the front of her robe. I gasped at what she had on beneath. A white lace half-bra lifted her small, firm breasts

so that the luscious rosy tips were held up, waiting to be kissed. A satiny patch of panty barely covered her neatly trimmed pubic hair and the firm mound of her vulva. Her long legs were encased in white lace stockings that rose to meet her lace and satin garter belt. My wife looked even better than the sexy woman in the picture. And Laura was holding a lubed thermometer in one hand, curling the index finger of her other hand seductively as she beckoned me towards her.

"Come here, sweetheart. You can keep your robe on a little longer, while the room finishes warming up. For now, I'll just lift it out of the way."

Her words made me shudder with anticipation. This was better than anything I'd imagined. I lifted her halfway off the chair and kissed her with a passion I swear I hadn't felt since our first night together. We were both gasping when I finally leaned back and looked her in the eye.

"Thank you." It was all I could think of to say.

"You're welcome," she said, patting my bottom through my robe. "Now get over my lap and let me at that sexy backside of yours."

I felt a little shaky as I draped myself over her legs. My robe fell open, so my erection was resting on her lacy stocking. I lowered my head towards the floor, balancing my hands on the thick, furry rug. Laura's hand slid up my thigh and slowly lifted the back of my robe. Her fingers trailed over my skin, caressing my lower cheeks until I shivered.

"I've always wanted you over my lap like this, with your bottom exposed." Her hand moved down to explore the crack between my cheeks. "Open your legs for me, dear."

I did, moaning as my leaking cock rubbed against her. Her fingers spread my cheeks. I gasped when the cold thermometer slid into me. My cock lurched against her, twitching at the stimulation in my anus.

"I see you like that," she laughed. "I bet you'll like it even more when I slide the nozzle into you." She wiggled the thermometer, ignoring my moans of pleasure. "First I'm going to wash you out with a nice soapsuds enema. Then I'll rinse you with lots of warm water. Then I'm going to fill you up with an herbal infusion that you're going to hold for a very long time, until I'm convinced the enemas have soothed away all the stresses that are making you so tense. Does that sound good to you, dear?"

"It sounds wonderful," I choked out. I couldn't remember when anything in my life had ever sounded—or felt—better. Laura kept wiggling the thermometer as she talked. Not a lot, just enough to keep me totally aware that something under her direction had the complete attention of my anus. With each movement, my cock jumped.

"I'm glad you agree with the rest of your body," she laughed, lifting her knee slightly so I felt the pressure on my erection. "By the way, I'd prefer if you held off coming until the last enema. But if you can't, well, you'll just have to come twice."

"Oh, God, Laura," I gasped, almost coming right then just thinking about it.

She laughed, sliding the thermometer out and patting my bottom gently. Suddenly, I felt very empty. I gasped as her finger touched softly, right in the middle of my anus.

"Don't worry. I'm going to fill you right back up." She emphasized her words with short, little touches. My breath caught on each one. "Stand up, Don."

I did. Then I waited, motionless, watching her every move, while she carefully measured one quart of warm water into a pitcher, stirred in a half teaspoon of castile soap, and poured the cloudy mixture into the bag. It bulged out, just the way I'd dreamed it would. I was shivering

again, though by now the room was warm enough that I definitely wasn't cold. It was all anticipation.

Laura ran the air out of the line, then clamped off the hose and hooked it back on the pole. She turned around and slipped off her peignoir, so that all she was wearing was her sexy underwear and those white stiletto heels. My eyes couldn't decide where to look. They were torn between wanting to eat her alive and being glued to that bulging red bag.

She walked over to me, stood on her tiptoes, and kissed me full on the mouth.

"It's time for your enema, honey."

All I could do was nod as she loosened the belt of my robe. The thick velour slid over my shoulders and fell to the floor. Then Laura took my hand and led me to the chair. She sat down, moved her legs apart, and patted her creamy white thigh. "Come over my lap again, Don. Remember to spread your legs wide this time. I need to be able to see your sweet little anus very clearly while I work the nozzle in."

I felt like I was moving in slow motion. I braced my arms on the rug, rubbing my face against her calf, trying to concentrate on the feel of the lace under my cheek rather than the exquisite pressure on my cock where it was trapped against her stocking. Then her finger was against my anus, pressing in.

"Just a little lube, love, so the nozzle slides in smoothly." Her finger slipped quickly in and out. I jumped, tightening, but before I could really react, the hard tip of the nozzle slid up into me. With a click, Laura released the clamp.

"Here we go."

I stiffened and gasped, my anal muscles quivering as they gripped the nozzle and warm, sudsy water gushed up into my rectum. Then I couldn't think at all anymore. The enema was better than anything I'd ever imagined, anything I'd ever dreamed. There was heat and pressure and a sudden urge to go combined with the startling feeling of liquid flowing relentlessly in through my ass, in and up and filling my gut. My prostate tingled, sensation washing forward to my cock with every exquisite second of the gradually increasing stimulation of my male G-spot. With a heartfelt groan, I relaxed my distending belly between Laura's widespread legs and just let myself *feel*.

Laura had positioned the bag so I could watch it empty. I turned my head so I could see the red rubber sides flattening as she slowly ran the enema into me. All the while she kept wiggling and rocking the nozzle. My anus fluttered against the little plastic pipe. I was aware to the core of my being that she, not I, was controlling the water surging in through that primally intimate part of my body. With each readjustment, my cock got harder; until I was so turned on I could hardly stand it.

Then the first strong wave of peristaltic action flowed over me. As I gasped and stiffened, Laura clicked the hose clamp closed and reached beneath me, massaging deep into my belly. She chased the cramps away until the tension passed to mostly just a comfortable fullness and an incredibly sexy pressure. I moaned in relief, relaxing back over her lap as she once more opened the line. By the time the bag was empty, my shaft and prostate and asshole were throbbing. I felt surprisingly and pleas-antly full.

Laura made me hold the enema for the entire 10 minutes she said were recommended for a thorough cleansing enema—that kind that I'd fantasized about for so long. As the minutes ticked by and the urges

grew stronger and more frequent, I felt like was becoming more attuned to my body than I ever had been before. Every nerve ending was awake and clamoring for attention. With each new wave, I panted and stiffened, clenching my sphincter tightly around the hard little tube and sweating with the desperate need to go. Laura soothed my trembling gut and murmured constant encouragement, squeezing my trembling butt cheeks closed as she held me firmly in place. When her watch timer beeped and the latest wave had passed, she finally let me up. I ran around the divider to the john.

By the time I came back, Laura was adding a teaspoon of salt to a steaming pitcher of clear rinse water. She poured it into the bag, and then grinned up at me.

"What did you think of your first enema, lover boy? Ready for another round?"

"It was great," I laughed, grabbing her in a ferocious hug. I ignored her giggles, kissing her with a resounding smack. "Bottoms up!"

She sat back down, I dove into position over her leg, and a moment later, I was groaning with pleasure again as the rinse water coursed into me.

The second enema was even better. I was cleaned out and opened, and I was most definitely relaxed. It was harder on my cock, though. With all the pressure on my prostate, every cell in my body wanted to come *now*. I could smell Laura's pussy juice soaking into her panties. That didn't help my self-control, especially when I reached for her and she smacked my hand away, insisting that I just relax and enjoy what she was doing to my butt.

She dropped the real bombshell, though, when I came back from the john the second time. She'd just finished mixing what she called "the

medicinal enema," something she'd gotten from the health food store. I could smell garlic and herbs, though I didn't recognize which ones. And she'd taken off her panties.

"Honey," she said, taking my hand and putting my fingers between her legs. My cock lurched as I touched her. She was dripping. "I'm afraid I've gotten too turned on for my own good." She lifted my fingers to my lips. I eagerly licked them clean. Her juices were sweet and sticky and tangy. "This next time, when I give you your enema, you can't release it, and you can't come, until you eat me to an orgasm—one that's every bit as good as what you're going to feel when I make you come with all that luscious warm water filling your tummy. Do you understand, sweetheart?"

I understood that I was going to be experiencing heaven on earth. I leaned over and kissed her perky pink nipples, sucking them until they pouted up wetly at me. Then I dropped to my knees on the rug, wrapped my arms around her legs, and buried my face in her pussy. I kissed and licked, as I tasted the sweetest nectar in the world. Then I stood up and sucked softly on her tongue so she could taste her own juices on my lips.

"For a night like this, Babe, I'll eat you until your screams echo off the roof. Thank you, from the bottom of my heart." I wiggled my eyebrows at her, suddenly feeling as young and carefree as I'd been when we first met. "And thank you from the bottom of my bottom, too."

Laura giggled. Then she slapped my backside sharply, and I was over her lap again, smelling her musk, watching the bag slowly empty as another wonderful enema washed up into me. My cock twitched, pressing my prostate until the fluid leaked from my shaft. I was so relaxed my bones felt like putty.

"Would you like this to help you hold it, honey?"

The bag was empty. I looked up to see Laura holding a tiny pink anal plug. It was glistening with lube. As she removed the nozzle, I realized how much I wanted something cuddling up against my now thoroughly stimulated anus while I ate her.

I told her yes, and then gasped as the slender plug slid slowly into me. It suddenly seemed much larger than it had looked. My anus felt incredibly stretched and full. I braced my arms on the chair and arched up against her, kissing her with all the fervor of the man in the picture. Laura was better than any dream, any fantasy. And she was all mine. I slid down between her legs, grabbed her hips towards me, and buried my face in her pussy.

She was sopping, her nether lips slippery with her clear, sweet juices. I don't know which of us moaned louder. I sucked her clit, teasing the swollen little nub out of its hiding place in her sensitive hood. The pressure inside me had my guts and prostate screaming for release as I licked inside her, drinking the cream that slid down each time she shuddered under my tongue. Then we were both on the floor, on our sides, sixty-nining on the rug. Her lips were wrapped around my erection as she tapped the base of the anal plug. I could hardly breathe, it felt so good. I wiggled my fingers inside of her, pressing up against her G-spot as I lapped her pussy, sucking her clit, swiping my tongue all over her. She arched towards me, taking me deeper into her mouth, the way she does when she getting ready to come really hard—when she's getting ready to scream. As she started to shudder, I quickly wet the index finger of my other hand in her pussy, and then pressed my dripping finger into the hot, tight ring of her anus.

Her scream vibrated through my cock. I couldn't remember Laura ever coming that hard before. My body responded with an orgasm that

shook me to my bones. I erupted into her mouth, roaring as my semen shot out, spurting over and over again, until finally I collapsed on the rug, my face nuzzling her thigh while my fingers rested inside of her.

I could have stayed there forever, except a wave of peristaltic action like I'd never felt in my life seized my gut. Laura held my cheeks together with a grip like steel. I lay there panting and sweating, and as soon as the spasm stopped, I jumped up and I ran for the john.

We slept in the guest room that night. In fact, I slept ten straight hours—hadn't done that in years. I woke up feeling contented and completely refreshed. And surprise of surprises, the office survived quite nicely without me for a few hours.

Laura has announced that she likes "tending to my bottom" so much that we're going to be doing it at least once a month from now on. She'll get no complaints from me about that. And my wife has also made it clear that she's going to be visiting some of the web sites that I've been frequenting.

I've drawn up a list of suggestions.

Farmer Carl's Woodshed

Melissa's Story

My job as a farm inspector paid well, but I chafed at the lack of social life in the small, mid-state towns I worked in. I reminded myself, frequently, that with three years' experience under my belt, I was no longer a just-out-of-college newbie with no choice of locations. As soon as possible, I was going to transfer to the main office, where all the social as well as professional action was and a girl could have an occasional wild fling without everybody knowing her business. In the meanwhile, I kept myself distracted by wearing the sexiest underthings I could buy from the Internet beneath my tastefully ordinary "business casual" attire. With each step, I was reminded that I was one libidinous babe, despite being trapped out in the backwaters in what had always been a man's job.

That particular July day, I was wearing a demure daisy-print sundress and a bright yellow linen blazer. I knew I looked good, even before I pulled my long, blond hair back in a jeweled clip. I'd spent the night

before fuming because I'd missed yet another application deadline, this time for a position that could have gotten me a transfer before winter. The slip-up was my own damn fault. I'd been working so much overtime that I'd lost track of almost everything except the due dates on my credit card bills. That morning, I'd given myself my usual "you'll do it next time" pep talk—and consoled myself by wearing my brand new, cream-colored satin and lace corset bra. It fit so tightly the tiny pearl buttons strained to confine my breasts. With my newly enhanced cleavage, I felt like a harlot, which definitely improved my disposition.

Fortunately, while the day was sunny, it was still cool enough that I didn't have to set the car's air conditioning at full blast to keep from melting in my new finery. I'd also made sure my bottom half was comfortable. As usual, I'd worn thigh-high silk stockings with embroidered satin garters rather than pantyhose. And I'd shaved my pussy again. As I drove onto the highway, I slid my hand under my slip and rubbed my ultra sensitive labia through the warmth of my tiny silk thong. I stroked and played until even my nipples tightened against the corset. What the hell, the weather was perfect, the redwing blackbirds were gliding past the cattails on the side of the road, and my fingers were tapping my clit to the beat of the hard rock oldies pulsing out of the stereo speakers. My underwear had cost me almost a week's salary, but it was worth it. I put the car on cruise control for the half-hour drive to my next inspection and I decided that maybe, just for today, my location wasn't all bad.

Carl Swenson's farm was a half-mile off the old highway. The jurisdiction lines had been redrawn last spring, so this was my first visit. I fell in love with the old farmhouse the moment I saw it. The traditional two-story frame had been completely renovated. A full-length porch ran across the front, sparkling storm windows were framed by lacy country

curtains, and shiny new weather-resistant eggshell white vinyl siding contrasted perfectly with the red brick fireplace. Two huge maple trees shaded the front of the house, and a basket of pink geraniums bloomed brightly beside the porch swing. Everything seemed so homey that I just leaned out my open window and smiled, imagining myself swinging in the afternoon heat, enjoying a cool glass of lemonade.

Then I saw the tall, handsome man striding towards me from what had once been a dairy barn and was now a beautifully redesigned tractor shed. I almost forgot about the house. The man was a total hunk: lean and graceful, with wavy brown hair that should have been cut last week and faded jeans that fit like he'd been poured into them. If this was Carl, he didn't look anything like the other farmers in the area. He was more the way I pictured an academic type, someone with a Ph.D. in literature. And he couldn't have been more than two years older than me. As I stepped out of my car, my slip brushed against my almost-naked bottom, and I had to remind myself that I was here to inspect the farm, not day-dream about sexy, suntanned studs and fairytale homesteads.

"Melissa Braun?" The man's handshake was warm. His smile twin-kled all the way to his intelligent and strikingly blue eyes. "Carl Swenson. I'm so very glad to meet you."

The feeling was mutual, though I tried to maintain a thoroughly pro-fessional demeanor, especially when I noticed he wasn't wearing a wed-ding ring. Lately, I'd become convinced that all the good-looking men in the county were either married or otherwise committed. Meeting Carl was a pleasant surprise. But business had to come first. When we'd fin-ished our introductions, I smiled brightly and picked up my clipboard. His grip had been warm and friendly. My fingers tingled from where they'd touched his. But I ignored both that and the feeling of my newly

shaved pussy lips brushing against my tiny panties, and I followed Carl into the storage sheds.

Over the course of the afternoon, I found out that Carl did indeed have a doctorate—in agriculture. As soon as he'd finished his dissertation, he'd moved east to raise ginseng, with a sideline in fish farming to help bring in cash. He was polite and charming and he made me laugh. And I blushed every time I noticed the way his jeans moved over his butt when he walked.

If Carl noticed my reaction, he didn't mention it. Everything with the farm was perfectly in order, and I told him so. It was the type of inspection that made some days on my job a breeze. Things had gone so smoothly I envisioned myself getting home at least an hour early, though I was surprised to discover I was in no hurry to be on my way. As we signed off on the paperwork and Carl pocketed his copies, he started telling me the history he'd gleaned about the farm since he'd purchased it, as-is, from an estate sale. Some things were pure conjecture, which he readily admitted, but more than a few appeared to be grounded in fact.

"I'll buy that you can prove the couple who lived here were very much in love—with each other and their home. But I bet you can't tell me who wore the pants in the family." I grinned over my shoulder at him as we walked down the gravel drive towards my car. "They say if the man did, the barn will be the best building on the farm. If the woman did, the house will be better. But these seem pretty much equal. Whoops!" I almost tripped as a fat cat zoomed past towards a movement in the edge of the cornfield. A firm hand reached out to steady me, and a jolt of pure electricity shot through my shoulder.

"The man wore the pants here," he said, carefully steadying me and brushing off the back of my shoulders. "That's not a guess, either."

"What m-makes you say that?" I felt like an idiot for stammering, but I was too stunned to think clearly. Despite the heat racing up my face, I turned around to face him, still totally aware of the warmth emanating from his hand.

"Damn, you're pretty," he grinned. I stiffened, and Carl stepped back so that he was clearly not in my personal space. But his smile was unrepentant. "Can't blame a man for noticing, Miss Melissa Braun, though I'm making a point of trying to concentrate purely on the business at hand—that being the renewal of my state certification." His smile seemed so sincere, and he had helped me, and he'd stepped back before I even had a chance to say anything—and every time I looked at him, I was aware of my long-neglected and very libidinous nether regions. I brushed my hair back out of my face and nodded, trying to regain my composure enough to put us back on equal footing—and neutral ground, at least until I got my bearings enough to offer a social opening. Structural history seemed like a very good topic.

"Why do you say the man was in charge?" I said primly, looking around at the immaculate buildings and noting again the soundness of the construction, as well as the beauty of the sun shining on the bright red of the old barn and the fresh white siding of the farmhouse. "The house is definitely on par with the barn and outbuildings. Perhaps they had an equal partnership."

"Oh, I'd say they were equal partners in most things, but I think she let him be the boss." Carl burst out laughing, and I realized just how mulish my frown must have been. When I finally smiled, Carl leaned back against the fence, and his face got serious. "I'll show you, Miss Melissa Braun, *if* you're up for some honest observations that have nothing at all to do with how well I run my farm."

"My follow-up report will say the same things as the preliminary information I gave you," I snapped. I didn't add that no man outlasts me in a stare-down. My eyes were burning when the movement at the edge of the cornfield caught both our attention. The cat was back, and pointedly ignoring us.

"Show me," I demanded, tossing my clipboard in the front seat, again trying to convince myself it was just the July heat making me perspire so, and not the fact that I was suddenly aware of the well-banked heat in Carl's eyes. He stood to the side and motioned me around the barn.

One of the outbuildings we hadn't visited caught my attention. Like all the others, it was immaculate. It was also farther out than the others—still close enough to be just a quick jaunt from the kitchen, but far enough that you'd have to really yell to call someone out there in for dinner. The structure was in good repair and the paint was fresh, but I could tell that the wood beneath was weather-beaten. The shed was sheltered on the north side by half a dozen poplar trees, their silvery leaves waving in the wind. A woodpile stood neatly to the right, complete with a stump with an ax buried in it. My heart jumped when I realized what I was looking at.

"It's a woodshed," I laughed, turning quickly away to fiddle with my hair. Again, I could feel the heat rushing to my face, and I was mortified that Carl might see my blush. How a city girl like me had developed such a long-standing and deep-seated fetish for woodsheds was beyond me, but I'd fantasized about them as far back as I could remember. My nightstands at home and my computer hard drive were crammed with stories about teary-eyed miscreants being marched firmly out back for a dose of good old-fashioned discipline on a bare, naughty bottom. However, I had no intention of letting my opinionated host notice my reaction.

"It's his woodshed," Carl grinned, unlatching the door and holding it open for me. Dust motes danced in the sunlight streaming in from behind us, outlining our shadows against the carefully cut and neatly stacked wood inside. A well-worn patchwork quilt was folded on a shelf by the door, next to a tall black glass vase.

"Why are you so sure?" I was irked that I hadn't kept the skittishness from my voice, but I was too damn curious to back down now.

"The wood pile is shorter, about hip high to a woman your size." Carl politely steered me to stand in front of the pile, so I once again felt the warmth of his hands on me, and the roughness of the wood on my thighs, even through my skirt. Then he carefully turned me around, so I felt the edge of the stack against my bottom. "He kept the quilt in here, so she wouldn't have to lie on the rough wood, no matter how much she'd misbehaved. And he used the vase to hold switches from the poplar trees, so she'd know he still thought she was pretty and feminine and sexy, even when he was tanning her behind."

"That's an interesting theory," I laughed shakily, tossing my hair. This time, I didn't even try to control my blush. "But *if* that's the case, she could have been the one spanking him, and not vice-versa."

"Oh, this wasn't used for spanking." Carl grinned when I raised my eyebrows. "There was a straight-backed chair in the bedroom for spankings." He grinned wickedly, turning my shoulder towards the other wall and pointing. "This woodshed was for full-up, serious whuppings."

I gasped as I saw the thick, black strap hanging from a nail on the wall. Carl gave me a quick, reassuring squeeze.

"That would have been too heavy for a slight woman like you to swing. Even if she could have, she wouldn't have needed this much room—her arms wouldn't have been that long. No, this was where he

tended to her naughty bottom, with a good, sound switching or one helluva butt-blistering strapping."

I gradually became aware of Carl's fingers on my shoulder, massaging. He wasn't holding me there, his touch was simply reassuring—strong and steady and so very, very male.

I could feel my heart racing. My face flushed again as I imagined myself lying over the woodpile, squirming with anticipation while Carl slowly raised the back of my skirt, his fingers as warm and determined as they were right now.

"This is ridiculous," I snapped, turning and pulling free of his grasp. "Who on earth would ever agree to that sort of thing?" My gut clenched as an inner voice screamed out, I would!

"I do," Carl said simply. I stared at him open-mouthed. He rubbed his backside and grinned. "My college roommate and I discovered we both studied better if we knew a night of debauchery got us a good, old-fashioned ass-whipping. Many's the time I crammed for a test sitting on a pillow with my sore butt burning against my jeans. I made the Dean's List every quarter." He reached over and closed my jaw, cupping my chin and running his fingers over the side of my face. "I still visit him every once in a while, when I really screw up. I drop my drawers and bend ass up over a straight-backed chair. He grabs a paddle or a strap, and he doesn't let up until I'm dancing on my toes and bawling like a baby. I do the same for him." Carl's stroked his fingers over my cheek, his eyes twinkling. "I've learned over the years, though, that I prefer thrashing a pretty woman's bottom, to his hairy butt."

I giggled nervously, shivering when he touched his thumb to my lips.

"What about you, Miss Melissa? Do you ever want a man to warm your behind?" Carl stroked my lips until they finally parted. His voice

was husky as he added, "Do you ever want to have a man thrash you, then make mad, passionate love to you afterwards?"

In retrospect, it was pure instinct that made me bite his finger. He inhaled sharply, and I smiled, sucking the tip into my mouth. Carl's other hand slipped down and cupped my behind. I froze as once again, his heat flowed through me.

"That's what I would do with you, Melissa. I'd thrash you until you cried, then I'd make love to you until you forgot everything in the world but me filling you." Carl slowly traced the lower curve of my hip, the sudden flash in his eyes letting me know he'd discovered my almost pantiless condition. "Have you done something you need to be punished for, Melissa?" He grinned wickedly. "Other than wearing sinful underwear?"

"My underwear is my business," I said primly, "as is the lack thereof." His fingers continued their seductive stroking. I wiggled against him, blushing as I looked hurriedly away. "Besides, I can take care of myself." Carl traced the path where my panties should have been. I willed myself not to moan. "This is silly." His fingertips stroked the sensitive juncture where my bottom met the tops of my thighs. I couldn't help a quick shiver. "I have my life perfectly under control, thank you very much."

"I imagine you do." Carl's voice stayed loose and easy, but his grip tightened on my backside, not enough to frighten me, just enough for me to be really certain of his strength and the quiet sincerity of his control—and my overwhelming attraction to him. "A good cry can be cathartic, though. It'll make you feel a lot better, real quick, even when it sets your backside on fire something fierce. And afterwards," he leaned over until I could feel his breath on my lips. "Afterwards, I'll make love to you until you forget your name." He licked over my lower lip. "What you're wearing has sin written all over it, sweetheart. Are you feeling sinful, Melissa?"

He smacked my bottom sharply. I jumped. It hadn't really hurt. There was just a surprisingly warm sting. Before I realized what I was doing, I giggled and buried my face in his shoulder. Even through the cotton of his work shirt, his chest was warm and hard and he smelled like clean, healthy sweat. I realized that I liked him enough that I didn't care if I was feeling embarrassed. Even if everyone in midstate ended up finding out about this afternoon's tryst, Carl was a hunk and I was horny, and he was offering to let me live out my favorite fantasy.

"What if I change my mind?"

I felt his smile against my hair as we both realized what I was agreeing to.

"Then I'll stop. And you'll go home." He kissed me again. "But I don't think either one of us wants that." He leaned slightly against me, the bulge of his erection pressing against my belly. "So tell me, Melissa, why do you need to be punished?"

I was quiet for a long time. I didn't say a word, just listened to the soft calls of the birds outside the open door, feeling the heat of the sunlight on my arms and the soft thud of Carl's heart under my cheek—and the pounding of my own heart. Carl didn't say another word, just held me while I thought, and, if I'm honest, while I sorted a few things out in my head. Much as I didn't want to admit it, most of my frustration with my job was caused by my own mismanagement of my time and funds. The only reason I wasn't in the city by now was that I hadn't gotten my act together. Maybe because I didn't really know what I wanted to do once I got there. Maybe I just hadn't been ready until now. I took a deep breath and leaned companionably against his chest.

"I suppose I don't take my job seriously enough," I sighed. Carl pulled back and looked down at me, lifting my chin and raising an eyebrow, surprise reflected in his bright blue eyes.

"You certainly are competent and thorough—for someone who doesn't take her job seriously."

I shook my head at him, trying to look nonchalant, though for once, I was feeling a little bit guilty. "Don't get me wrong, I do my job really well. I just want to be promoted—so I can move away from the blasted fieldwork. But I do stupid things like miss application deadlines because I'm working overtime to pay for all the slinky things I buy on the Internet." I laughed nervously up at him, trying to make light of it. "Silly, huh?"

"Does it bother you?" he asked mildly.

I shrugged and smiled. I couldn't look away from his eyes, and for once I wanted to lose the staredown. "I guess is does," I said quietly.

"Then it's not silly." He brushed my hair back and kissed my forehead lightly. When he stood back up, he swatted my bottom. I jumped, but he shook his head at me.

"Cut yourself a switch, Melissa." His voice was calm but very stern, a surprising steel burning in his eyes. "I'll show you just how effective a motivator a good thrashing can be."

Carl turned me towards the door and swatted my bottom again, this time hard enough to make me yelp. With a loud click, he opened his pocketknife and handed it to me, pointing to the line of trees just outside the door.

"A poplar switch will do a damn fine job of focusing your attention, young lady. And Melissa. . ." He stopped, and I turned as I stepped out onto the grass. "A switching is always given on a bare bottom. Cut a good one and bring it to me—leaves and all. I'll strip it while you're getting ready."

I hesitated, staring at him for a long moment, noticing again his confident smile and his lean, strong, and entirely too attractive build,

suddenly very aware of the thick, hard bulge in his crotch. A moment later, still stunned at what I was doing, I was back in the woodshed, my eyes glued to the intertwining rings of the patchwork quilt now spread ominously over the woodpile. Carl had rolled up his shirtsleeves. I handed him the poplar branch, gulping as he stripped the leaves in one quick swoop. He put the naked switch in the vase, in easy reach. Then he folded his arms and looked sternly at me.

"Step out of your shoes, Melissa." He spoke quietly, watching me intently. I nervously licked my lips and kicked off my flats, curling my toes against the warm, wooden floor. Then I lifted my skirt and carefully peeled down my stockings and garters and set them on the side of the blanket.

"Damn, woman. You could have kept those on." Carl's voice sounded choked. I batted my eyelashes at him, enjoying the freedom to be sassy that suddenly just seemed to be part of the uneasy waiting for a thrashing. But, no matter how hard I tried, my eyes were drawn like a magnets to the thick outline of his shaft, pressing against his tight, faded jeans. Without thinking, I reached back and rubbed my bottom. Carl laughed.

"You'll be rubbing your bottom for different reasons in a minute, Melissa. Take off your panties and put them on the quilt."

I waited a really long time. First I was thinking that I wanted to grab my clothes and shoes and run. Then I was thinking about how I'd always dreamed about doing something like this. Then I looked into Carl's deep blue eyes, and all I could think about was how much I wanted his hand on my bottom.

"I'm a little nervous," I said. I reached under my skirt and slid my fingers into the elastic waistband of my thong. "I've never done this before." Carl didn't say a word, just watched while I slid the panties over my hips

and stepped out of them. They were sopping. The smell of wet pussy filled the room and Carl's nostrils flared.

"Take off the rest of your clothes, sweetheart. Holding them up would only distract you. I don't want you thinking about anything but the switch kissing your sexy bottom cheeks."

My hands trembled as I pulled off my jacket and carefully folded it onto the quilt. I tugged off my slip, then picked up my hem and peeled the sundress over my head. Despite my fears, I blushed at the look on Carl's face. He was speechless, his eyes glued to where the corset bra strained against the buttons. In two steps, he had me in his arms and was kissing me fiercely, his tongue sweeping through my mouth, hot and sweet and searing my lips until I was breathless.

"God, you are beautiful." His breath was harsh and his hands held me tight. He kissed down my neck and across the tops of my breasts where they swelled over the lace-covered satin. "Leave this on, love. It will show off the redness of your bottom, and keep you feeling even sexier." His tongue stroked, hot and wet, down the valley of my tightly uplifted cleavage, his teeth tugging lightly on the tiny pearl buttons. "I'll warm you up with a good hand spanking first, Melissa. You'll be ready—for everything."

Carl turned me around and slid his hand onto the satiny middle of my back, firmly bending me over until my bottom jutted out towards him and the buttons on my corset pressed into the woodpile. The faint, almost floral smell of the quilt filled my nostrils. I rubbed my face against the soft, cool cotton, so different from the warm, living touch of Carl's hands on my skin. The summer air tickled over my bottom, and I shivered hard, my face burning with embarrassment—and uninhibited desire.

The first spanks took me by surprise. They were mostly noise. Carl caressed my bottom often between them. Gradually, though, the heat built. As much as I tried not to move, I found myself shifting from one foot to the other, rising up onto my toes and alternately clenching and relaxing my bottom, trying to ease the sting. Pretty soon I was yelping. My bottom hurt and it burned, way more than I'd ever expected it could. Another dozen sharp spanks cracked over my now unbelievably tender skin, and my eyes filled with tears. I buried my face in the quilt, wiggling and squirming, and mortified to realize that no matter how much the spanking hurt or how embarrassed I was, I wasn't going to tell him to stop. I wanted it. When Carl's hand stilled, I sniffled loudly, and raised up my bottom to him. He laughed softly and spread my legs further apart, running his fingers lightly over the very sensitive and now incredibly sore spot where my lower cheeks met my thighs.

"That's a good girl, sweetheart. Damn you're beautiful." He caressed my smarting bottom until my trembling subsided and I relaxed into the comforting though still painful warmth of his touch. When my breathing had calmed, he put his hand in the small of my back and again pressed me back onto the quilt, his fingertips caressing the slippery satin of the corset.

"I'm going to hold you now, honey, so you can fight if you want. I'll still stop if you tell me to. But I hope you don't." His other hand again stroked over my bottom, soothing me even as his touch once more emphasized just how much my backside burned.

"It will be five, Melissa. The switch is going to sting like blazes, and you're going to cry and kick and scream." I could hear the iron in his voice, even over my whimpers. "It's going to set your bottom on fire, so I want you to yell as loudly as you can. You'll feel better for it."

Despite all my fantasies, when that first line of fire burned across my butt cheeks, I yelled like my lungs would burst. I jerked up frantically, but Carl's palm gently and firmly held me in place. He pressed me forward with his big, strong hand, until only my toes were touching the floor and my bottom was arched up towards him and every inch of my backside was fully exposed. Then he slowly and methodically laid three more scorching lines of flame across my naked flesh. I screamed and kicked and cried, my legs flailing like pinwheels. Not once did I tell him to stop.

Carl laid the last stroke diagonally, across the other ones. My whole bottom reignited. I howled into the quilt, arching and bucking, straining against his hand. My behind was on fire, and oh, so was my cunt.

"God, Melissa. You're so beautiful," Carl's voice rasped. I heard the switch hit the floor, then he dropped to his knees in back of me. I lurched up, yelling, my eyes blurring with tears as his hands tenderly brushed over my scalded backside. Then all I could do was shudder and gasp while he traced healing kisses over the blazing tracks of fire. His fingers brushed softly down my thighs and he whispered, "Spread your legs, sweetheart."

I did, whimpering as the wet heat of his tongue glided upwards, laving the fiery lines, then mercifully, sliding back down over my slick, naked labia and sinking into my slit. I arched up against him, gasping.

"Melissa," he groaned. "You're so hot and sticky and sweet." He lapped my clit like a cat at a bowl of cream. "I've never licked a shaved pussy before. I love it!" I cried out, clutching the quilt with both hands, arching my butt up towards him as the orgasm rolled over me.

"Oh, yes, babe," he purred. "Give me more."

His fingers slid into me. I shook, the pain in my backside feeding the heat in my cunt as he kissed the lines of fire and fucked me with his

fingers. He pressed deep inside me, down and deep—and he bit. I yelled again, overwhelmed with sensation, my face burning as my juices unexpectedly squirted out of me.

"Oh, yeah," Carl crooned, laughing softly and pressing again. I cried out, another, bigger, climax building up close in back of the one before it. He moved up over me, pressing me gently into the woodpile as he reached up onto a shelf. Then he turned, unzipping his pants and tearing open a condom wrapper before he leaned into me again. His weight on my backside made my pussy flare with heat.

"My bottom hurts," I whispered. My voice sounded desperate, even to my own ears. I shuddered as his sheathed cockhead nudged my pussy lips.

"Do you feel better, Melissa?" he growled. "Did you like being thrashed?"

"Yes," I gasped, raising up on my tiptoes and pressing back against him, opening myself as his shaft slid into me. "Do it!"

I arched up onto him. Carl held himself perfectly still, stretching me wider and wider, his cock filling me as my pussy lips kissed down over his shaft and my bottom pressed up against him. I cried out, shaking from the pleasure and the pain.

"Your pussy's so hot," he groaned. "And so is your bottom." He lifted me by my waist and ground against me. "I love the way your body lets me know how much you appreciated your switching." He gasped as I squeezed my cunt muscles around him. "Your bottom is so red and beautiful, Melissa. Oh, God, you're so sweet."

He thrust into me, pressing hard, until I felt only the soreness in my ass and the strength of his cock twitching inside me. I couldn't stop the rhythmic spasms building in me. I cried out, arching up onto my tiptoes. Carl pressed deep, and I clenched his shaft as hard as I could. The waves of another shattering orgasm washed over me and I shook against the

tear and sweat-dampened quilt. Then he growled, and I felt the thick, creamy surges pulsing inside me. Carl wrapped his arms around me, holding me close and panting as his heart pounded into my back.

"Stay with me," he whispered, his breath hot and moist against my ear. "Move out here and let me love you like this every day of your life." He laughed shakily. "And maybe eventually we'll figure out why the hell those totally insane words just came out of my mouth." He kissed me again, his chest rumbling with laughter. "But I mean them. So help me, I do!"

The words were insane. But I moved out to the farm a month later. Eventually, I started telecommuting two days a week, so I could spend less time on the road. I finally realized how much I loved being in this old country house and outside in the fresh air. I'm still prone to wearing sundresses over my sinful underwear these days, and I keep my pussy shaved all the time now. And whenever I say I need it or even just when I want it, Carl marches me out to the woodshed. I take down my panties, and my hunky husband roasts my naked bottom with his hand and a switch, or, if I really want an attitude adjustment, with the heavy leather strap that leaves me wailing and dancing on my toes and keeps me from sitting down for days. And when I've cried myself back to being contented, Carl fucks me until my whole world is right again. I've come to love my country life: country house, country man, and definitely, our kinky country woodshed.

Cuff Links

Kelly's Story

The rainbow flags almost tipped the facade off the building, but in that part of the Midwest, almost any gay bar that played good dance music became "mixed" pretty damn fast. I paid the outrageous cover charge and joined the sweating, gyrating sea of gay/lesbian/het-and-I-don't-give-a-shit-what-you-are-so-long-as-I-get-to-dance bodies pulsating under the laser lights.

I'd had another long, rough week at my thoroughly crappy job. I wanted to dance. Maybe have a few drinks. Admire the scenery with no strings attached. I figured the drinks would help with that. I was still coming to terms with my attraction to women. I told my friends I was "bi-curious." In reality, it was more like bi-terrified. I liked men a whole lot. But I kept getting these gawdawful crushes on women—usually married ones. Then again, my ex-husband had been a *married* man, too. He just hadn't bothered to tell me. By the time I'd paid off the attorneys

to end that nightmare, I'd sworn off relationships for good. Well, except that I kept getting crushes on women.

Apparently, except on nights on which I'd paid an outrageous cover charge to meet women. After one quick dance with a woman who left me standing on the floor when her boyfriend came back from the bar, I suddenly found myself staring at the most attractive *man* I'd ever seen. We're talking primal instincts here. He was short and slender, like me, though his biceps flexed noticeably when he lifted his drink. He wasn't drop-dead gorgeous, just handsome in a graceful, artistic sort of way. But the overall impact had me squirming all the way down to my panties. His suit jacket was slung over his shoulder. Even though it was late in the evening, I figured he'd come here straight from work. His starched white shirt was still fairly pristine, his tie perfectly in place, and he was wearing gold cuff links.

I'd always had a thing for men in cuff links. They made me think of piercing and bondage, which I'd always secretly wanted to try. Which made me horny. Most people don't wear cuff links anymore. But they seemed to fit this guy's image—understated, but kind of commanding. His bright red hair was cut in a crisp crew cut. Not "red" like in punk-colored hair. I mean natural red, the kind that screams "Irish"—which matched the bridge of freckles across his nose. I shouldn't have been eyeballing him closely enough to see that last little detail. I mean, I was in a gay bar. I doubted he was here to cruise me. But I figured if I was really discreet, he'd be so busy watching the shirtless guy in the blue nylon running pants dancing up on the side table that he wouldn't notice me.

His eyes were a brilliant blue. I noticed that too late. He was smiling at me, his eyes wandering boldly down and back up my body. I blushed and looked away, shifting my weight from one foot to the other and

studiously directing my gaze to the various small knots of women dancing together. I concentrated on trying to remember why I'd worn three inch heels when I knew damn well there'd be no place to sit down. I kept my eyes on the dancers even as Dream Guy walked over and stood next to me.

"The punky girl in the leopard print has great legs," he said casually, speaking just loudly enough for me to hear him as he nodded towards the dance floor. "I like the way her hair brushes her butt when she raises her arms."

Even over the music, his voice was nice. A smooth, easy tenor. Voices get to me right away. I concentrated hard on not shivering.

"She even makes her partner look like a great dancer." My eyebrows lifted, and he laughed, holding held his hands up in a gesture of surrender. "That wasn't an insult. There aren't many butches who can compete with these guys in a dance-off. She's doing fine."

"She certainly is." I straightened my shoulders self-righteously. For some bizarre reason, I felt like I needed to defend Leopard Girl's partner, even though both of them suddenly seemed to be looking daggers in our direction. There was no way they could have heard him over the throb of the music, not at that distance. But I was still uncomfortable. This was not turning into a good night to meet women.

"I'm sorry." The blue eyes sparkling over the rim of the glass seemed anything but repentant. "I'm accustomed to making observations about Erica and her many partners. We're friends." He shrugged. "Or at least, we used to be." Something changed in his eyes as he spoke. He stepped back and motioned towards the bar. "I'm not a particularly good dancer myself. May I buy you a drink? The White Russians here are extremely potent, especially when Devon's working the bar and watching his

boyfriend at the same time." The gold rectangle at his right wrist flashed as he held out his hand to me. "My name's Ron."

"Kelly," I said. "A drink would be fine." I tried to ignore the jolt of electricity that shot up my arm when our palms connected—and the equally strong echo that vibrated down to my belly. Ron put his hand on the small of my back and guided me through the crowd to the bar. I was glad I was in front of him, because I was blushing furiously at my reaction to the heat emanating from his fingertips, even through the light silk of my blouse. Bi-curious or not, I'd gone into full het mode for the evening.

Fortunately, the bartender was fascinating enough to distract me. A tall, black man with rippling muscles and a shaved head, he was pouring drinks without even looking at his hands. His eyes were glued to a raised table on the other side of the room, where the slender, shirtless young blond in blue nylon sweat pants was now gyrating lewdly, in perfect synch with the beat. Each time the young man thrust out his hips, whatever drink Devon was pouring overflowed.

"We'd better order quick. When the owner sees him, there'll be hell to pay—as usual." Again the grin. Ron elbowed his way up to the bar and banged his glass down next to Devon's hand. "Scotch, sweetheart—*if* you can tear your eyes away from your lover's ass!"

Devon jumped and looked at Ron, his eyes unfocused, like he'd just been dragged out of a very pleasant dream. Then Devon stared, and his eyes got bigger. When he saw me, his eyes got huge and a grin split his face. He leaned over and whacked Ron soundly on the shoulder. "Long time, no see, buddy." He looked Ron up and down slowly. I wondered just how long it had been since they'd seen each other. "You're looking good, my friend." The appraisal was appreciative, and frankly interested. "Very, very good, if you know what I mean."

"Thanks, Devon." Ron's smile twinkled all the way to his eyes. "You're looking good, too. And no doubt building up quite an appetite for that sweet young thing melting the table top out there." Devon looked up just as the sweet thing, now sporting an obvious hard-on, reached back and cupped his ass—and rolled his hips. Devon's eyes were once more glued on his lover. He didn't even seem to hear when Ron said, "I'll have another Scotch and the lady will have a . . . ?" He nodded towards me.

"A White Russian," I said without thinking.

"My specialty," Devon muttered. He seemed to go on autopilot as he mixed the drink and slid it towards me. My "thanks" was lost in a gasp and I choked on what had to be at least half vodka. As a series of catcalls erupted beside me, Devon poured an overflowing shot into Ron's glass and handed it to him.

"Damn, that boy's good!" I covered my ears as Devon yelled out, "You go, sweetcheeks!" Then without missing a beat, and still without looking down, Devon reached out and pushed Ron's wallet away. "Trouble coming," he said conversationally. "And this one's on me, my friend. Good luck." I was surprised when Devon turned and winked conspiratorially at me. "With everything."

"Goddammit, Devon! Do you think I'm made of money? Watch what the fuck you're doing!" A short, stout, sweaty man with slicked-back hair pushed his way behind the bar and grabbed the liquor bottle from Devon's hand. "For godssakes, go fuck him in the john if you need to, but quit pouring my fucking profits down the drain!"

Devon and Ron exchanged a quick grin. "I'm on break, boss. Back in twenty." Devon's look slid past Ron's shoulder, then back. I had the odd feeling he was giving a warning. A second later, I turned to watch his gleaming black head bob off through the crowd. And I saw Leopard Girl

moving towards us. She was obviously pissed. Ron's fingers touched my back again, gently nudging me away from the bar.

Leopard Girl intercepted us. "Well, dear one. Don't you look positively handsome." The words dripped venom. Ron's fingers tightened almost imperceptibly on my back as she smiled nastily and patted his cheek. Then her hand turned and her fingers curled almost into claws, leaving light pink trails as they dragged along Ron's jaw. I gasped and Ron stiffened, his hand fisting against me. But in almost the same breath, he slowly and deliberately unclenched his hand.

"Same icy control, I see." Erica spat out the words, but as she started to raise her claws again, her girlfriend grabbed her wrist.

"Leave it, Erica." Leopard Girl's partner was dripping sweat from the long set, and her smile was no friendlier.

"Aptly put." Erica's tone was vicious. As her girlfriend pushed her forward, Erica turned and tapped the side of my glass, just enough to spill some of the drink onto my hand. "I hope you have a *very* interesting evening." She turned and almost hissed at Ron. "You, too—grrrrlfriend." This time her partner shoved, and with an angry shake of her shoulders, Erica stomped off towards the bathroom.

"You have interesting *friends*," I said dryly. I wasn't sure what the hell was going on, but when I turned to look over my shoulder at Ron, my back curved automatically against his arm. This time, I couldn't hide my tremor at the heat of his touch. I took a deep breath and tried to smile. "Will I bore you if I'm shockingly ordinary?"

For a moment, Ron just stared at me, his eyes still flashing with suppressed anger. Then he laughed wearily, his arm tightening around me as he lifted his glass to his forehead and rested it there, like he needed the coolness of the condensation to settle his brain. When he spoke

again, most of the anger was gone, replaced by resignation and a hint of sadness.

"I'm sorry, Kelly. Erica doesn't like me very much anymore."

"I gathered." I reached down and ran my fingers along the side of his wrist, toying with the edge of the cuff link. "Any particular reason?" From this close, I could see the light, red gold evening shadow across his jaw. I wondered what it would feel like to run my fingers over the bristling stubble—how it would feel under my lips if I kissed him.

"She's my ex," he sighed. As he turned his head, I could see that the pink marks Erica had made were almost gone.

"That makes sense," I smiled. "All exes are assholes." Without thinking, I leaned over and kissed him. I was just going to brush my lips against his, just a friendly kiss. But if Ron's touch had been electric, his kiss was pure fire. I couldn't think. I wrapped my arms around him, my drink tipping precariously in my hand, and lost myself in the heat of Ron's mouth. His kiss was greedy and hungry, his tongue both soft and demanding as he licked the insides of my cheeks. I could feel the warm, firm strength of his chest where he held me, the gentle weight of his balls against my thigh were he pressed me to him. Ron's kisses were more intoxicating than even Devon's drink had been, and infinitely sweeter.

"Jesus," I whispered when we came up for air. I leaned heavily against him, breathing hard, relishing the strong, masculine beat of his heart and the exquisitely tender feel of his fingers moving over my back again. "For kisses like that, I can see why she'd give up girls for a while."

The flow of the crowd had pushed us gradually towards one of the support beams near the dance floor. I was vaguely aware of Ron taking my glass and setting it down next to his on the adjoining shelf. Then he lifted my face to meet his and smiled hesitantly. "Erica's always been a

dyke." When I opened my mouth, he shook his head and quickly added, "So was I."

It was a good thing Ron was holding on to me, because when what he was saying finally sunk in, I damn near fell over. Ron was a female-to-male transsexual.

He told me that when he had been with Erica, he, Ron, that is, who was named Sharon back then, had been a lesbian. Now he was just Ron, and he was a man, who he figured he'd always been, regardless of what his body used to be like, and he definitely still liked women. He kept the explanations simple, but it wasn't long before my brain was reeling. Since he used to be Sharon, had I just kissed a woman for the first time? Even though, if I had, the woman I'd kissed was obviously a man? A masculine, sexy, and, if his kisses were any indication, a very horny man, whose touch made my pussy flutter and who felt so warm and so embarrassingly right in my arms that all I could think about was getting naked with him and fucking like weasels. I mean, I'd thought transsexual men would somehow still look feminine. Ron didn't. Although he was short like me, he had beard stubble and biceps I could feel through his shirt and pecs rather than boobs, and he held my drink and stroked my back and did all the things a straight guy on the make was supposed to do. And his name used to be Sharon. And Erica hated him for maybe making her not a lesbian.

"I loved her, she loved a butch dyke. She'll never forgive me for making the transition and, in her eyes, maybe making her straight." With his arm still around me, Ron stepped back to lean against the dance floor post. He picked up his drink again, swirling the dark amber liquid around the glass before he spoke. "I didn't want to be treated like shit, so I left." He shrugged and handed me my glass. "Erica's friends also got

pissed at me for 'selling out.' They assured her I'd always been a bitch anyway."

"Were you?" Without thinking, I reached over and traced the outline of his knuckles with my fingertip. Ron had freckles on the backs of his hands, too. They stood out starkly against the creamy whiteness of his skin and the edge of his cuff. My mind could handle thinking about freckles.

"Was I what?" he smiled distractedly, turning his hand and rubbing his thumb lightly over mine.

"Were you a bitch?" I kept my eyes mostly on my hands, stroking lightly as I once more reached up to play with his cuff link. Bitchiness I could also understand.

Ron just stared at me for a moment, then he leaned back and hooted with laughter. "Yes," he laughed. "I was one helluva bitch, though these days, I'm usually called 'assertive' instead." He ran his tongue over the edge of his glass, his eyes sparkling. "Devon still calls me one, but we go way back. Besides, he's so big, he can get away with calling people whatever he damn well pleases." Ron's smile faded and he held my hand lightly in his. "Are you okay with this, Kelly?"

I wasn't sure about even beginning to understand what was going on, much less having a clue what I thought. So I took the coward's way out and stalled.

"Um, am I the first woman you've dated now?" Then I realized what I'd said and blushed furiously. "Not that it's any of my business, of course. And I'm not trying to imply that we're dating or anything. I mean, we just met, I don't want to be putting any pressure on you, on either of us. . . ."

Ron shook my fingers as my voice trailed off. "I think we've got enough pressure without worrying about whether what we're doing is a date, Kelly." Then he smiled. "But I'd like it to be." He reached up and stroked the side of my face. "I've been living in San Francisco for the past three years. I started taking testosterone and living as a man right after I moved there. I dated a lot." Again, the smile sparkled all the way to his eyes. "Celibacy has never interested me."

"Did you get involved with them after you had the surgery?" I felt my face flame, but resolutely took a swallow of my drink. As my throat burned, I wished it had been 90% milk rather than liquor so my head would stay clear.

Ron shrugged. "Both." At my raised eyebrows, he smiled again. "I'd always had small tits. Helped enormously with my butch dyke image. Hell, even Erica the Bitch appreciated that," He grinned. "Quick snip below my nipples, and the doctor suctioned out the excess fatty tissue. After that, between gym time and the hormones, my chest "passed" pretty quickly."

"But what about . . ." I blushed furiously and stared into my drink. "Never mind. That's none of my business."

Ron cupped my cheek in his hand. "It is if you want it to be," he said quietly.

I leaned into his palm and closed my eyes for a moment. His touch was warm and strong and comfortable. Finally, I sighed and smiled at him. "I don't know what I want. Hell, I came in here tonight because I wanted to find out if I really like chicks as much as I think I do. Now I find myself falling ass over tea kettle for a man who *used* to be a woman." I took one more swallow, made a face, and set the glass down for good. "Now I can't figure out which one of us is straight, and which

one is queer, or maybe we both are—or aren't." I knew my smile was lop-
sided, but I was so confused. "You figure it out."

"Do we have to?" Ron took my hand again, kissed the back of my
knuckle, turned my hand over and kissed my palm. "Maybe tonight, we
can not think too much and just be us?"

We stood there for what seemed like a very long time, the throb of the
music and the crush of body heat flowing over us like they weren't even
there. I felt almost like I was watching someone else in some kind of a
dream. Except for where my hand rested in Ron's, the hand with the gold
cuff link at the wrist. Where my skin touched his, everything was startlingly
real. None of it made much sense, but Ron's fingers were warm and his
touch was sexy. And being with him made me so incredibly horny.

"Erica is a bitch," I said decisively. I looked once more around the
room, at the sea of sweating, dancing, and mostly on-the-make bodies.
Then I squeezed his hand and said, "Your place or mine?"

The heat in Ron's eyes made me squirm again. "I live two blocks from
here," he said. When I nodded, he added, "Anybody you need to call?"

I closed my eyes for a moment, then I looked back up at him and
shook my head. Not tonight. Tonight, it was pretty much all or nothing.
I was pretty sure I wanted it all. "Let's go."

▼▲▼

Ron's apartment was in the upstairs of a stately old Victorian. Whoever
had done the conversion had paid a lot of attention to details—even the
towel racks were authentic period pieces, and they hung over a claw-
footed tub. Ron gave me the grand tour while I sipped some herbal iced
tea. We ended up in the bedroom, which was taken up almost entirely by
a queen-sized brass bed. Antique lace curtains fluttered in the cool

breeze of the air conditioner. Ron hit the dimmer switch and we stood near the side of the bed, watching the diffused light from the corner streetlight fill the room with a pale, silvery glow.

"My great aunt Kay made the quilt." Ron moved in back of me and wrapped his arms lightly around my waist. "Her husband died in the Civil War. She spent the rest of her life making wedding quilts with her female companion." I shivered when Ron softly kissed the back of my neck. "I think being queer runs in the family." When I giggled, he trailed soft, wet, sucking kisses up the side of my neck. "We can neck on the couch if you like. But I'd rather see you in here, stretched out on my bed, with your hands over your head like you were tied." I tipped my head to give him access to more skin. He softly bit my ear. "I want to watch you grip the railings and scream when I make you come." I trembled, and Ron's hand trailed up the side of my thigh—slipped under my tight spandex skirt. Without thinking, I spread my legs for him. He laughed quietly, his hot breath almost cool against my wet neck. Turning slightly, he slid his hand between my legs. I gasped when his fingers tickled over my clit.

"God, I love a hot pussy." Ron sucked my earlobe softly. I trembled again, moaning as he cupped my vulva and ground the heel of his hand over my mons. "Your panties are soaked, Kelly. If I take them off with my teeth, will you let me eat you until you scream?"

"Uh-huh," I gasped. Ron was running his lips and tongue over the cord in my neck. Even through the wet silk, I could feel the heat of his fingertips in the unrelenting friction—feel the heat in his crotch where he ground his pelvis against my hip, heat and something hard poking me, not something big, but the way Ron thrust his hips against me was all man. I groaned and arched back against him.

With a short laugh, Ron turned me in his arms, and he kissed me again. Possessively, this time, his hands on my waist, he held me to him hard, like he knew how hungry I was. I wrapped my arms around his neck and kissed him back ferociously. I ran my fingers through his hair, relishing the spiky feel of the stiff, gelled bristles under my fingers.

"God, I love crew cuts." I wiggled against him while he sucked my lower lip.

His fingers slipped between us. I felt his smile as he unbuttoned my blouse. His palms slid over my collarbone, slowly pushed my shirt off my shoulders. He cupped my breasts for just a moment, then unhooked the clasp between them. When they fell into his hands, he rubbed the nipples with his thumbs. I shivered and gripped his shoulders. Ron laughed softly.

"I love a woman with large, sensitive breasts." He pinched lightly. I jumped and the bra slid all the way down my arms. "Do you like that?" When I nodded, he pinched again, then again, harder and longer each time. I shivered at the sting of his fingernails. "Maybe someday you'll let me clamp them." Ron bit my lip gently. "Let me tie you up and clamp your nipples with my pretty jewelry."

"Okay." I gasped. I arched into his hands, clenching my legs and rising up on my toes, my pussy quivering in response.

"Just like that?" He laughed. I gripped handfuls of his shirt and held on tight, panting against him as he added a wicked twist and my nipples burned. "You'd let me torture your nipples until they were sore and tender and so sensitive you wanted to cry?" He pinched again and I yelped. "Then you'd let me do it more, until I was licking the tears off your cheeks?"

I ground against him, wiggling my hips and thrusting my chest into his hands. "Unh-huh." My pussy was throbbing,

"I'll remember that, pretty one." He kissed tenderly down the side of my face. Then his hands were on the zipper of my skirt. His mouth returned to my lips and he shoved the tight fabric over my hips. My slip fell with it. I kicked off my heels as I stepped out of my skirt. Suddenly, I was three inches shorter. Ron laughed, cupping my backside through my panties.

"I like being taller than you." He kissed me quickly. "God, that's so sexist. But it's true." His tongue swept into my mouth and he kissed me again, this time possessively. "I like it a lot."

I liked it, too. Which made me blush. I mean, it's so stupid for size to matter. I started wondering what else I was being sexist about without realizing about it. But I didn't think too hard. Ron's kisses were like fire shooting through my veins. I shook my head and whispered against his lips. "Remember, tonight we don't have to think too much. We can be stupid sexists if we want."

Ron laughed, low and husky. I jumped when he slapped my butt.

"Keep your legs spread, sweetheart. I said I'd take your panties off with my teeth." The nibbles moved down my neck. "I'm going to work up an appetite, so I'm really hungry when I start sucking the pussy juice from that tiny scrap of silk."

I was already starving, and the things he said made me shiver even more. Ron kissed and sucked and licked his way down. I grabbed handfuls of his hair and held on for dear life. I tipped my head back and felt my own hair tickle across my back as the long, slow suckling on my nipples turned to sharp, hot stings that left me shuddering. Then Ron dropped to his knees and tongued my belly button. My giggle turned to a gasp when he nuzzled his face over my crotch. He inhaled deeply, pressing his nose into my clit. The sight of his thick, spiky red hair between my

legs was just so incredibly sexy. Ron looked so strong and commanding, and so horny, and I could see those damn gold cuff links at his wrists where his hands held my legs firmly open.

"There is nothing in the world sexier than a sopping pussy." Ron's tongue ravished me through the silk. I clutched his hair hard. Then he was sucking on my panties, sucking me through them. "Jesus, you taste good." He slurped loudly, tugging my panties out with his teeth. "I bet your juice tastes even better without these in the way."

I moaned as he kissed his way back to my pelvis. He took the elastic in his teeth. "If you shaved your pussy, I could pull your panties off just by tugging on your crotch."

"Okay," I gasped, shivering as the wet silk slid over my hips. Ron looked up at me and grinned, the edge of my panties in his teeth. He slowly dragged them off me.

"Lift your legs." The words were muffled in the silk. When I leaned on his head, he laughed and said, "One foot at a time." I blushed and obeyed. He turned his head and deposited my panties unceremoniously on top of my skirt. Then he grabbed my thighs and started kissing his way slowly and purposefully back up.

"Spread your legs, Kelly." I shivered as his tongue traced over my kneecap. "Open wide for me, so I can get a good grip on your pretty little clit." Ron's hands pressed my thighs further open. His eyes locked on mine and stayed there, startling blue sparkles as he stuck his tongue out and swiped all the way up to my slit. I shook against him. He kept looking at me as he wrapped his open mouth over my mons and took me in a wet, sucking kiss. I felt like I was falling into his eyes. His tongue reached up through the heat of his open mouth and started flicking over my clit. I wondered vaguely if this was what it would feel like if a woman

licked me. Then Ron rubbed his stubbled jaw up my slit, and my legs buckled.

"Oh, God," I gasped. His shirt brushed against my thighs and I fell back onto the bed. "I can't stand up."

"Then lie down," he said roughly. Still kneeling between my legs, he pushed my shoulders firmly onto the soft cotton quilt. His face glistened with my juices as his hands slid back down my body. He pinched my nipples, twisting them hard. I cried out and arched towards him.

"That feels so good," I moaned, squirming frantically. When his hands finally moved lower, I took my nipples in my fingers and tried to imitate his motions. I tried one position after the other, hissing in relief when Ron pushed my hands out of the way and once more gripped my nipples.

"Do you want them clamped, Kelly?" Ron's voice was gruff. "Say 'yes' and I'll do it. But then you have to leave them on until you come."

Ron's eyes were so brilliantly blue, so glazed with lust. He tugged my nipples up between his fingers and twisted again.

"Yes!" I tightened my knees against him, against the hard sides of his chest. I watched, mesmerized, as he took off a bright, golden cuff link and held the T-shaped back to the tip of my breast. The customized bars of the clasp were longer than I'd ever seen before. He pressed one arm of the T's top over his finger, so the metal bar pressed flat against the shiny faceplate—so I could see how tightly the clamp fit together. When I shivered, he released the bar and pulled my nipple almost painfully out, until it was long and stretched and the tension hurt. With his eyes locked to mine, he pressed the clamp closed again, this time trapping my fleshy peak between the shiny golden bar and the smooth back of the rectangle. The sudden pain was so sharp and so intense, I gasped and writhed against the bed.

"Do you like that, Kelly?" he growled, scratching his nails over the throbbing tip.

"It hurts," I whispered. The clamp stung so badly my eyes burned with tears. And it made me so horny I arched my pussy up against his chest. Ron pressed back against me, his eyes glittering.

"But do you like it, pretty one?" He pulled the other nipple out and touched the flat gold face of the other cuff link to the tip, rubbing the smooth, cool metal over my trembling skin. "Do you want me to clamp this nipple, too, so they both hurt with how much you want to come?" He pinched, hard, and smiled when I shivered. "Answer me now, Kelly. Or I'll stop."

"Yes!" I gasped. I watched in fascinated horror as Ron carefully positioned the second cuff link's T. Then, his fingers slowly and purposefully pressed the bar closed. I cried out, bucking up against him again. He cupped the sides of my breasts in his palms, scratching his fingernails lightly over my ultra sensitized and now flaming sore nipples.

"You are so incredibly beautiful," he said softly. He leaned down and kissed the valley between my breasts, then slowly worked his way down. As he kissed over my pubes, he took a mouthful of hair between his lips and tugged. "Next time, I'll shave your pussy," he kissed further down and licked the juncture of my groin. "Then you'll squirm each time I lick your labia." I cried out as Ron sucked first one lip, then the other, into his mouth. "And maybe I'll clamp your clit and fuck you. I'm real good with a strap-on."

My mind reeled with the images. Ron yanked my bottom to the edge of the bed and roughly lifted my thighs onto his shoulders. Then he once more buried his face in my cunt. "You're drenched, beautiful. Nobody's ever done that to you before, have they?" When I shook my head, he

laughed wickedly. "I love first times. You're slick and you're sweet—and tonight, you're mine." He lifted his head, his face once more glistening with my juices, and looked deep into my eyes. His finger slipped into me and I moaned, arching up to meet him as he pressed deep.

"Y-your clothes." My thighs rubbed frantically over the stiff, starched cotton of his shirt. It was hard to think. I felt so exposed, lying there with my naked pussy in his face while he was fully dressed.

Ron shook his head. "Later, babe. This time, it's just for you. Be greedy for me."

It was getting so hard to think, and I didn't really want to argue anyway. Ron's mouth and fingers were driving me crazy. I was embarrassed at how much I liked what he was doing. Then his lips closed around my clit and slowly pulled up. I groaned and stiffened beneath him.

"Such a pretty clit, Kelly. I'm going to love making you come." Ron pulled the tiny hood back and started lashing the swollen nub with his tongue. As I writhed and whimpered beneath him, he slid one finger into me, then another, and another, until his thumb was stroking my labia and the crown of his knuckles pressed against me. His fingertips reached up into the quivering spot inside my cunt, his rhythmic thrusts making waves of pleasure wash closer and closer to the surface.

"Oh, honey, the things I could do to your pussy—the things I *will* do, another time."

I grabbed Ron's head and held him close to me, moaning as my breasts moved and the cuff links burned. Then Ron started sucking me again, moving the prepuce over my clit while he fucked me with his fingers. My belly clenched, and I arched up against him, opening myself. Ron pushed into me once more, pressing up towards my belly button, rubbing deep and hard and mercilessly. The orgasm washed over me, and he

sucked my clit into his mouth. I bucked up into him, screaming as my body contracted around his fingers and I shook and shook and shook against him.

I whimpered and pushed Ron off my over-sensitized clit, but I didn't try to get away from his hand. He grinned at me, my juices dripping down his face as he leaned forward and kissed my pussy soundly. Then he slowly withdrew his fingers. He lowered my legs from his shoulders, giving my vulva one final pat before he scooted me fully onto the bed. As I smiled contentedly at him, he started working his tie loose.

"I want to fuck your face, Kelly." Ron yanked the tie over his head, then unbuttoned his shirt, pulling it free of his pants and working the now sweaty material over his shoulders. In just his stark, white T-shirt, his shoulders were even more muscular than I'd imagined, his upper arms bulging with muscles. With his eyes once more locked on mine, he pulled the tee over his head.

I was so dazed, I'd almost forgotten that I'd wondered what his chest would look like. The well-developed pecs were dusted in reddish-gold hair and looked surprisingly ordinary, at least for a gym-toned man like Ron. It took me a minute to realize his nipples were larger than I was used to, but that was because I was staring at the gold bars that kept them firmly erect. Without thinking, I licked my lips, then blushed as Ron laughed and stood up.

"I'll take that as approval," he smiled. He hesitated just a moment, then unbuckled and unzipped his pants and let them fall. He worked his shoes off without bending down. When his feet were free, he put his hands in the waistband of his blue plaid boxers and slipped them down over his hips.

I wasn't sure what I'd been expecting, but the tiny penis reaching up stiffly towards me wasn't it. A thick foreskin covered the entire shaft, and beneath were two very ordinary looking balls hanging loosely in a very ordinary looking red-furred scrotum. Ron didn't say anything, just stood there, watching me. After a moment he slowly stroked the ends of his fingers up his cock, pulling the foreskin over it, in a movement I'd seen damn near every man I'd ever been with do unconsciously when he was turned on and getting ready for sex. No matter what Ron's parts looked like and who he might have been before, he was all man now. And he wanted to fuck. I smiled and lifted my hands over my head to grab the cool metal bars of the headboard.

"I like foreskin." I have no idea why I said it. That was the first thing that came to mind. But, well, I do, and Ron's penis had a wonderful hood that I could hardly wait to feel beneath my lips. "And, um, it's okay if you'd like to tie me. I think I'd like that."

Ron burst out laughing. He reached down and picked up his tie, quickly working the knot out. Then, still grinning, he climbed up onto the bed and straddled my waist. From that close, I could see a faded line beneath each nipple, flat against the wall of muscle beneath. But my attention was all on my own breasts. Ron again cupped the sides. This time, my nipples burned when his thumbs wiggled the clamps. I moaned loudly. It hurt so much and so good, and it was making my pussy throb so badly.

"Are you comfortable, Kelly?" When I nodded, Ron moved further up, keeping his knees beneath my armpits and carefully avoiding my nipples as he tied my wrists to the headboard. Then he was straddling my face, the musky aroma of his crotch filling my nostrils and the warm weight of his balls resting on my mouth. I licked, tasting him as I swirled the

thick curly hairs with my tongue, wondering if that would be something he'd like. When he shivered, I smiled and settled in to washing the salt and sweat from every inch of his scrotum. He was slippery from the bottom up, his juice tangier than the precome I was used to. And there was so much more of it. His scent was so intense my nostrils tingled. When his skin was wet with my saliva, I gently sucked first one ball, then the other, into my mouth—back and forth, until he was panting.

"I'm going to fuck your mouth now, Kelly." Ron's voice was husky with desire. He slowly lowered himself, the warmth of his balls brushing onto my chin. "Say 'no' if you don't want me to. But unless you tell me to stop, I'm going to fuck my cock between your lips. And I'm going to do it now."

"Yes," I whispered, nodding. I gripped the railings tighter now. Ron slowly rubbed the underside of his penis over my lips. Without thinking, I opened my mouth and kissed it. He shuddered above me, then he held perfectly still, only his skin trembling as I opened my lips and slowly licked up his shaft. It was soft and silky, like the glans of any penis so aroused it was bursting free of its foreskin. I licked more, long and slowly, once again learning his taste. When he shuddered, I laid my tongue flat against the turgid flesh, washing the whole underside all at once. Then I carefully sucked his cock into my mouth, tugging ever so gently, with just the insides of my lips. Ron gasped and gripped the top of the headboard. As he trembled above me, I slowly and methodically slid his wonderfully loose foreskin back and delicately teased just the tip of my tongue over his extraordinarily sensitive penis. Then I started sucking—very, very gently.

Ron shook so hard the whole bed moved. He squatted down further, so I couldn't move my tongue or my mouth, so I was only lightly sucking his foreskin back and forth over the sensitive flesh below.

"Hold still," he gasped. "I'm going to fuck you, and I want you to just keep your mouth tight around me and suck gently, just the way you are now. Will you do that for me, Kelly?"

I nodded, smiling even though I knew he couldn't see my lips. I held perfectly still as Ron started fucking my face. His head was thrown back, his face drawn up almost in a grimace, the muscles in his arms and chest rippling as his hips thrust violently against my face and his penis got stiffer, harder and stiffer beneath my lips, as it slid in and out and in and out of the tight, wet suction of my mouth. Then Ron stiffened. He leaned harder into me, I don't think he even realized how hard, because his breath was short and his body shook, thrusting harder and faster and faster.

"Suck my cock," he gasped hoarsely. "Suck my cock. I'm going to come!"

I did. He yelled, grinding forward into me, shaking so hard the headboard rattled as he pressed his pelvis into my mouth. My tongue and lips cradled his penis, and I sucked gently and rhythmically until he pushed away from my face and leaned back, gasping for air.

When he finally opened his eyes, he grinned shakily at me. His face was still flushed, his chest heaving as he slid off to the side. He lay down beside me and kissed me, his tongue sliding into my mouth, probing me again. I shivered happily as his hand once more pressed unexpectedly into my cunt. I was so intent on kissing him, I didn't notice his other hand moving. With no warning, he snapped the cuff links off, one right after the other. I arched up into him, screaming as flames shot through my nipples and his fingers sank deep into me. I came again, this time in slow pulsing waves that lasted until I was almost crying.

Ron yanked the tie loose and rolled over, pulling me onto his chest. I snuggled close, my nipples sore but almost purring against him as he tenderly stroked my hair. A moment later, Ron was snoring. I refrained from making another sexist comment and fell asleep in his arms.

Resources

Safer sex isn't just about using condoms. If you don't have experience with something you've read about in *Any 2 People, Kissing* and want to explore further, here are some resources to help you play safely.

Anal Pleasure & Health: A Guide for Men and Women, rev. 3rd ed., Jack Morin, Ph.D. San Francisco: Down There Press, 1998.

Different Loving, Gloria Brame, Jon Jacobs, Will Brame. New York: Villard Books, 1996.

Exhibitionism for the Shy, Carol Queen. San Francisco: Down There Press, 1995.

Lesbian S/M Safety Manual, Pat Califia, editor. Denver: Lace Publications, 1988.

Leatherman's Handbook, 2nd ed., Larry Townsend. Los Angeles: LT Publications, 1997.

Safe, Sane, Consensual and Fun, John Warren, Ph.D., Brighton MA: Diversified Services, 1995.

SM 101: A Realistic Introduction, Jay Wiseman. San Francisco: Greenery Press, 1996.

The Compleat Spanker, Lady Green. San Francisco: Greenery Press, 1996.

The Good Vibrations Guide to Sex, 3rd ed., Anne Semans and Cathy Winks. San Francisco: Cleis Press, 2002.

The Guide to Getting It On, Paul Joannides. Waldport OR: Goofy Foot Press, 2000.

The New Bottoming Book, Dossie Easton & Catherine A. Liszt. Emeryville CA: Greenery Press, 2002.

The Topping Book: Or, Getting Good At Being Bad, Dossie Easton & Catherine A. Liszt. San Francisco: Greenery Press, 1995.

The Ultimate Guide to Anal Sex for Men, Bill Brent. San Francisco: Cleis Press, 2002.

The Ultimate Guide to Anal Sex for Women, Tristan Taormino. San Francisco: Cleis Press, 1998.

Ties That Bind, Guy Baldwin, M.S. San Francisco: Daedalus, 1993.

Videos

Bend Over Boyfriend. SIR Productions. VHS

Fire in the Valley: Female Genital Massage. Joseph Kramer Presents/Erospirit. VHS

Self Anal Massage for Men. Joseph Kramer Presents/Erospirit. VHS.

The Ultimate Guide to Anal Sex for Women. VHS/DVD.

WhipSmart: A Good Vibrations Guide to Beginning S/M for Couples. Sexpositive Productions/Good Vibrations. VHS.

Many of these titles are available from Good Vibrations, www.goodvibes.com, or toll-free at 800-289-8423.

About The Author

Kate Dominic's stories appear in the anthologies *Herotica 6* and *7; Best Lesbian Erotica 2000 and 2002; Best Women's Erotica 2000, 2001,* and *2002; Tough Girls; Sweet Life; Lip Service; Wicked Words I* and *IV;* and *Strange Bedfellows.* Under the penname of her male alter ego, she also has stories in *Best Gay Erotica 2000, Best Bisexual Erotica 1* and *2, Best Transgendered Erotica, The Mammoth Book of Historical Erotica, Friction 2* through *5* and *The Best of Friction, Tough Guys, Sex Toy Tales,* and many other anthologies and magazines. A graduate of the University of Wisconsin, Kate is a former aerospace editor and technical writer. She and her husband share their Los Angeles home with their extended family, a laid-back dog, and several highly opinionated cats.

Books from DOWN THERE PRESS

_____ **Any 2 People, Kissing**, Kate Dominic. 12.50

_____ **Herotica® 7,** Marcy Sheiner, editor, with Mary Anne Mohanraj, consulting editor. Race, religion and culture meet the erotic in journeys of desire. $12.50

_____ **Herotica® 6,** Marcy Sheiner, editor. Hot sex in committed relationships. _Foreword Magazine_ Erotic Book of the Year. $12.50

_____ **Herotica®: A Collection of Women's Erotic Fiction, 10th Anniversary Edition,** Susie Bright, editor. The underground classic that launched a genre! $11.00

_____ **Sex Toy Tales,** Anne Semans and Cathy Winks, editors. Tasty tales incorporating a variety of imaginative sexual accessories. $12.50

_____ **The Leather Daddy and The Femme: Author's Cut.** Carol Queen. No-holds-barred, over-the-top liaisons from the mistress of sexual storytelling, with new chapters. $13.50

_____ **Exhibitionism for the Shy: Show Off, Dress Up and Talk Hot**, Carol Queen. "...a sexual travel guide..." _Libido_. Firecracker Award nominee. $12.50

_____ **Sex Spoken Here,** Carol Queen and Jack Davis, editors. Cutting-edge erotica from San Francisco's leading sex writers and poets. $14.50

_____ **Anal Pleasure & Health, rev. 3rd ed.,** Jack Morin, Ph.D. The definitive guide, also discusses power dynamics and identifying sex-positive health practitioners. $18.00

_____ **I Am My Lover**, Joani Blank, editor. Artful duotone and B&W photos of twelve women pleasuring themselves. Lambda Literary Award nominee. $25.00

_____ **Femalia**, Joani Blank, editor. Thirty-two stunning color photographs of vulvas by four photographers, for aesthetic enjoyment and edification. $14.50

_____ **The BIG Book of Masturbation: From Angst to Zeal**, Martha Cornog. A marvelous compendium of readings and commentary, from anthropology to zoology. $22.00

_____ **Still Doing It: Women & Men Over 60 Write About Their Sexuality**, Joani Blank, editor. Proof-positive that sex never has to end. _Independent Publisher_ Award winner. $12.50

_____ **First Person Sexual,** Joani Blank, editor. Women and men share the myriad ways they experience solo sex. Small Press Book Award Winner. $14.50

_____ **Good Vibrations: The New Complete Guide to Vibrators, rev. 4th ed.,** Joani Blank with Ann Whidden. Everything you want to know about vibrators. $8.50

_____ **The Good Vibrations Guide: The G-Spot,** Cathy Winks. How to find and enjoy the elusive pleasure spot and understand female ejaculation. $7.00

_____ **Erotic by Nature**, David Steinberg, editor. A luscious volume of photos, line drawings, prose and poetry for, by and of women and men. Clothbound. $45.00

Catalogs — free

_____ Good Vibrations Mail Order. Sex toys, books and videos – including those from GV's own video production company, Sexpositive Productions.

_____ Passion Press. Sizzling erotic audio for hands-free reading! www.passionpress.com

Buy these books from your local bookstore, call toll-free at **1-800-289-8423,** log on to **www.goodvibes.com,** or mail a copy of this page with your name and street address:

Down There Press, 938 Howard St., #101, San Francisco CA 94103

Include $7.95 shipping costs for the first book ordered and $2.00 for each additional book. California residents please add sales tax. Please give us your street address for UPS shipping.

Name_____

UPS Street Address_____

_____ ZIP_____

SOME DAMES DON'T

It was a variation on an old game called Find the Lady. According to ex-movie actor Walt Kage, his wife had walked out one day and hadn't bothered to return. I followed a cool trail until it chilled up at a cheap motel, where a character figured that I ought to go down well with the rug on the floor. The case bristled with kooky type dames and various complications, culminating in a showdown proving only that some dames do and some dames — well, work it out for yourself.

Books by Paul Muller
in the Linford Mystery Library:

THE MAN FROM GER

PAUL MULLER

SOME
DAMES
DON'T

Complete and Unabridged

LINFORD
Leicester

First published in Great Britain in 1970 by
Robert Hale Limited
London

First Linford Edition
published 2004
by arrangement with
Robert Hale Limited
London

British Library CIP Data

Muller, Paul, *1924 –*
 Some dames don't.—Large print ed.—
Linford mystery library
 1. Missing persons—Investigation—Fiction
 2. Private investigators—Fiction
 3. Detective and mystery stories
 4. Large type books
 I. Title
 823.9'14 [F]

ISBN 1–84395–538–5

Published by
F. A. Thorpe (Publishing)
Anstey, Leicestershire

Set by Words & Graphics Ltd.
Anstey, Leicestershire
Printed and bound in Great Britain by
T. J. International Ltd., Padstow, Cornwall

This book is printed on acid-free paper

1

The house called Clifftop was perched on a shelf of sheer rock and overlooked a small bay where the sea washed up as far as the cliffs themselves. The inlet was rock-bound but on either side of the rocks was sand and plenty of it. It looked brown and warm and was dappled just now with the sunlight breaking out from a smother of white fluffy clouds. All in all, it was a very fine place to come to if you liked houses perching on high cliffs, lots of blue ocean and loneliness, and maybe wanted to do nothing more energetic than brood on your past follies and sins.

When the Jag came off the dirt track and hit the sand it seemed firm enough, which was something. I must have taken the wrong fork a couple of miles back, and instead of picking the hill road that would have made it easier to reach the house, there I was, right at the bottom of

the cliffs, with all this sand and rock and ocean and stuff.

I drove on for a quarter mile and stalled near the inlet. There was an anchored cabin cruiser riding the smooth waves. A path of sorts snaked upwards from the bay. I had lit a cigarette and was wondering if the path would take the Jag when I heard a sharp cry coming from the shoreline on my left.

'Hi, there!'

A dame came frolicking out of the waves, pulling off her bathing cap to shake loose a mass of chestnut hair. She was tall and curved the way I like my dames to be tall and curved. She was wearing a pink bikini that made it real easy for the imagination to get to work. She stooped to lift a towel and for two seconds the view was breathtaking before she straightened and came on towards me. I got out of the car and stared in uninhibited admiration.

'What's the matter with you?' she said when we were facing each other. 'Have you never seen a girl in a swimsuit before?'

'Yeah, I have,' I said in a thick sort of voice. 'But this is the first time I've seen a girl in a swimsuit who can give me the instant impression of being stark naked. Did you have to take many lessons before you learned to weave that old black magic?'

She spread the palms of her hands over the jutting peaks of her breasts and flashed me a lot of tiny white teeth in a contemptuous sneer.

'Maybe I ought to get into the water again until you have yourself under some kind of control. You aren't one of these maniacs who go around lonely beaches in the hope of picking up something you can ravish?'

'Not a chance of that, baby. I had a very strict up-bringing, as a matter of fact. I was always taught to have the greatest respect for the female form, and it might interest you to hear I was never more respectful than I am at this minute.'

'That's a relief and no mistake.' She flung me her towel and put her rear to me. 'Go easy round the back of my neck. I'm kind of tender at the back of my neck.

You can be as rough as you want to with the rest of me.'

It was a labour of love until the dame spoiled it all by snapping the towel from my hands and flashing her tiny white teeth some more.

'All right, all right, mister. I said rough, but not that rough. I'll want to sit down one of these days, you know.'

'How's about your front?' I suggested. 'You never can tell what you might catch if you wear that itsy-bitsy bikini top for much longer.'

'I can handle my own front,' she said in a soft snarl. 'Just untie the bow at the top is all.'

'One never knows what a day brings forth,' I said philosophically. 'Does one? And you're dead sure there isn't a beady-eyed guy watching from the deck of the cabin cruiser?'

'You should worry, shouldn't you?'

'Baby, all I was thinking of was your natural modesty.'

I flipped loose the knot and she tugged the top of her swimsuit away. She dropped the towel at her feet and beat me

4

to picking it up. She kneaded her breasts gently while I brought out another cigarette and lit it. At the same time I tried to figure out which boulder I had hit my head on and when I would waken up to the cruel realities of life, and the tanned bust would float back into the sea.

The dame must have found something amusing in the way I was looking at her. The ghost of a smile enhanced the sheer poetry of her lips and she flung the towel at me with a careless gesture.

'Don't let it give you other ideas, mister. All I want you to do is hold it while I fix my swimsuit in place.'

'You mean you don't want me to loosen any more knots today, honey? There's a word for that kind of behaviour, they tell me.'

'Tease?' She said it brutally and with a pagan flirt of her hourglass hips. 'Purely a matter of opinion, mister. By the way, you haven't told me what your name is.'

'It used to be Muller,' I said in a disappointed tone. 'All my friends used to call me Paul. From now on I'm going to answer to nothing but Mr Frustrated.'

'Tie me up again,' she ordered brusquely, shielding her eyes against the sun to peer up at the house on the cliff. 'If Walter sees us playing around like a pair of water-nymphs he might draw the wrong conclusions.'

'Walter like in Walter Kage?' I asked carefully while I tied the top of the bikini in place.

'You know him?' She turned and looked at me like she was only seeing me for the very first time. She had wide blue eyes with little flecks of green running through them. She had a knack of catching her tongue in her teeth and drawing it back before clicking her teeth together.

'I know the name. I and how many million others?'

'I think he's a lousy actor,' she said indifferently. 'I think if he hadn't met up with Gloria and gone to bed with all her loot he would have finished up in the trash can inside of two years flat.'

'You're not a Walter Kage fan?' I asked curiously. She flung her towel across one shoulder and took a moment to

debate with herself.

'Did you take all this trouble just to get his autograph? I'm surprised at someone so mature as you falling for Walter's brand of ham. Besides, he hasn't made a picture in a whole year.'

'He doesn't have to, baby. And Walter could be a lot smarter than you have him figured. Maybe he planned to move out of movies when he reached his popularity peak. You know, retire as undefeated champion of the wide screen.'

'What are you doing here if you didn't come to pay homage, Paul? Did you lose your way to the hills, or had you something intensely dramatic up your sleeve — like driving the Jaguar into the waves and saying good-bye to all your troubles?'

'I was aiming the Jaguar at Clifftop when I took a wrong turning a couple of miles back, just this side of the village. On the other hand I might have more salt in my veins than I thought possible.'

'You're kind of cute,' the dame said reflectively. She shielded her eyes against the sun again to look up at the house on

the cliff. I followed her gaze and caught the sparkle of sunshine striking glass.

'Does he spend much of the day watching you through binoculars?'

'You're talking about Walter?' she said humorously.

'And you too, baby. You've got to be a house guest or something. I mean, with Walter being married to Gloria already and all . . .'

She laughed outright then, a small explosive burst of merriment that did things to my spinal column.

'Don't work up to a bigger sweat than is comfortable for you, Paul. You've got a headful of dirty thoughts. Walter is my brother.'

'That makes you his sister,' I said happily.

'If you wish to look at it from your own angle. But keep your temperature at a decent level, Mr. Muller. I might horse around a little in a bikini but I certainly am careful about kicking my heels up in bed.'

'There goes that natural modesty I was speaking of,' I said admiringly. 'Mixed up

with about one fifth of my ego. Can I get the Jag along the path?'

'Must you? I can't recall Walter mentioning anyone called Muller, nor one called Paul, even. All right, if you're going to make your entrance in a smashed car I might as well accompany you and help you to concentrate. Even if it kills me!'

She set off for the Jag, her hips making sweet music in the scrap of pink material that was covering them. Half way to the car she halted and looked back at me, her blue eyes glinting.

'You haven't taken root, Paul? What are you waiting for?'

'I'm just weighing up the odds,' I told her. 'Go out screaming in a wrecked auto or settle for you screaming in a — No, I guess a gentleman would never do such a thing.'

'You can always dream about it, can't you?'

She snugged herself in the passenger seat and draped her towel over her thighs. 'Like I said, I came along to help you to concentrate. I never saw a car going up that path yet, but the experience should

9

be something to brag about afterwards.'

'How's about the beady-eyed guy in the cabin cruiser?' I said as we took off. 'Does he prefer to see the world through rose-tinted binoculars too?'

'You're very nervous, aren't you? The sign of a guilty conscience. Only don't ask me how I know. My name is Hetty if I didn't say . . . Take it easy round this bend.'

The end of the path gave on to a wide tarmac forecourt fringed with rustic railings and climbing roses. There was a stretch of emerald lawn with a fountain in the centre of it. Beyond the lawn the Pacific rolled peacefully. I put my back to it and looked at Hetty.

'It's quite a walk to have a swim. You mean to say Walter doesn't have a pool of his own?'

'There is a swell pool at the rear,' Hetty explained. 'I prefer the open sea all the time. I'm a very strong swimmer. Also, I enjoy the walk to the beach. It kind of gives me an outlet for my nervous energy, if you see what I mean.'

There was an opening there for a snide

remark, but I didn't bother to strain my brain thinking of one. A maid opened the front door and Hetty marched past her, flinging her towel into the air and asking if Walter was about.

'I believe Mr Kage is out somewhere,' the maid said to the twin mounds that comprised Hetty's hips. She sniffed her distaste and turned to take my hat. She was around forty, thin as a brush shaft, the type that was just bound to keep copies of True Tales of Passion under her pillow at night. 'Are you a friend of Miss Hetty's or are you one of those awful newspapermen?' she demanded. 'They keep plaguing poor Mr Kage all the time. They never give him a minute's peace, I swear.'

'Simmer down, cute eyes,' I told her. 'I'm not a newspaperman. Even if I was I bet I could find more interesting stories under rocks on the beach. You like studying the shoreline too, I believe — with the benefit of magnification.'

'Oh!' the biddy panted with twin flushes mounting in her cheeks. 'I can't take very much more of this. I swear I

can't take very much more of this. The whole house is going to the dogs. One thing on top of another. Well, it's enough to put a girl out of her mind, you'll have to admit.'

'Mr Kage isn't expecting me?'

'If your name happened to be Muller . . . '

'Then he is expecting me. Okay, dew-drop, bring him on, even if he hasn't put the final touches to his make-up. While you're at it tell him I'm a very busy guy.'

The biddy glanced this way and that to make sure nobody was listening to us. There was a door open across the hall that she tip-toed to and closed quietly. Then she tip-toed back again and dropped her voice to a sibilant whisper.

'Are you going to try and trace her?'

'Trace who, for heaven's sake?'

'Keep your voice down,' she hissed. 'You're a detective or something like that, aren't you?'

'Something like that for sure. But what's with the cloak and dagger stuff? If you're talking about Hetty then you can

forget it. I've already traced her, and plenty I might tell you,' I added with a leer that sent her squirming on her heels.

'That brazen hussy! I wouldn't care if she fell down a hole and got eaten by rats. I'm talking about his wife.'

'Gloria?' I queried with quickening interest. 'You're saying the hero of the wide screen has let her go astray?'

'Shush! It's a terrible thing she has done to him, I swear. Going off without so much as saying goodbye. Well, I mean it's the last thing you'd expect her to do, isn't it. Them so happy together and all. He can't eat. He does nothing but growl. The poor man is absolutely heart-broken.'

'Now somebody tells me! He didn't say so on the 'phone. He just used a couple of well chosen words to get me out here to the ocean air on the double.'

'He went for a walk. He'll be here to see you anytime. Don't breathe a word of what I've told you.'

'Cut my tongue out if I do,' I said sincerely.

I left her and found Hetty in the

lounge. She'd discarded the pink bikini and was wearing shorts and a halter instead. She loafed with a tall drink on a couch and told me to sit down beside her.

'Make a drink for yourself if you're thirsty,' she invited and gestured to a bar that took up one corner of the room. 'Whatever your poison is you're bound to find a rough equivalent.'

'Thanks,' I said and fell for an easy chair opposite her. 'But thirst isn't the only thing in life to be considered.' I was admiring her marvellous pins while I spoke and was treated to a revealing display before she crossed one long member over the other and fixed me with a veiled stare.

'You still haven't explained what you're doing at Clifftop, Paul. Is it a national secret, or could I coax you to talk about yourself?'

'Who wants to talk about me, baby?' I said reasonably. 'For a start I'd never be able to concentrate. Why can't we pass the time by talking about you?'

'Did Walter ask you here to talk about me?' she murmured curiously, sipping

some of the liquid from the tall glass.

'Better wait till Walter turns up and then we can find out. Huh?'

She seemed to think it over for a moment. She laid her glass aside and reached for a cigarette from the box on the nearby table. She lit her cigarette from the table lighter, shook out her chestnut hair in a gesture which could have meant she was getting angry with me. She puffed a mouthful of smoke and caressed the jutting front of her halter. Her long lashes quivered above her blue eyes.

'You don't give much away, do you?'

'Only when I figure the demanding cause is a truly worthy one,' I said frankly.

'That could make you a cop, couldn't it, Mr Muller?'

'Call me Paul,' I invited and lit a Lucky to give my hands something else to do besides itching.

'Call you Mr Frustrated,' she said softly and deliberately. 'But bear with it and maybe it'll decide to go away and leave you alone.'

'Voice of experience talking?' I jibed

gently. 'Or could it be that it's all happening in your cute imagination, honey?'

She lunged to her feet and came across to stand over me. I concentrated on her tanned navel and started counting to ten.

'I should slap you down for that crack, Paul.'

'I'm just enough of a masochist to enjoy the experience. Who wants cops?'

'What did Josie tell you in the hall?' she asked frostily. 'She kept you out there long enough to have told you her life story. She wasn't gossiping, I hope?'

'This is getting a trifle tedious, beautiful. I came here to see Walter Kage. I really didn't come to drive wedges into any wonderful friendships.'

Hetty swung away to the bar, switching her hips unhappily. That could be the truth of the matter, I figured. It wasn't all sunshine and ocean air for her here at Clifftop. If Walter Kage was wallowing in misery then his sister was being caught up in the ebb tide.

She stood at the bar and looked over her shoulder at me. 'If you aren't a cop

you look like one,' she accused. 'You didn't come here to collect Walter's autograph. You didn't come here to dry me off with a towel even. You did come because he's in more trouble than he knows how to deal with.'

'Trouble? The stuff that keeps folks counting sheep at night when they should be sleeping?'

'Oh, I shouldn't have said that! I mean if you aren't a — '

It was as far as she'd got when the lounge door burst inwards and was followed by a guy and a dame. The guy was almost as broad as he was long, and that's saying something when he stood as near as needn't matter to six feet tall. He had black crimpy hair, black bushy eyebrows, and black eyes that glared around the room before focusing on me. The dame was nothing but a reed in the wind by comparison. She was skinnny and washed out, with tinted stringy hair, plucked eyebrows and a mean mouth. She looked at everything too before finishing up looking savagely at me.

'Why, Dickie!' Hetty cried in affected

surprise and pleasure. 'Why Muriel! What brings you out here at this time of year?'

'I'll tell you what brought us out,' Dickie snarled. 'Walter did. He rang us on the 'phone and said that Gloria had disappeared. He said to come and visit and he would give us the facts. It's the facts we want,' Dickie rumbled on breathlessly. 'Ain't it, Muriel?'

'Isn't it,' Muriel corrected him. She kept staring at me for another half minute before switching her sharp eyes to Hetty. If I'd seen blatant disapproval from Josie in the hall, then I was seeing nothing short of the weightiest contempt from the newcomer. 'And yes it is,' she added to back up what Dickie had just said. 'Where is Walter Kage anyhow?'

'He's out,' Hetty told them both. She fixed a frozen smile on her face and went behind the bar to move bottles and glasses around. 'For a walk, I think. He shouldn't be long.'

'He'd better not be long,' Dickie wheezed and thudded down on the nearest chair that would take his weight. He brought a handkerchief from his

jacket pocket and mopped the sweat from his forehead.

'In the meantime you can use a drink, can't you?' Hetty suggested with saccharine sweetness.

'I don't want a drink,' Muriel said malevolently. 'I wouldn't take a thing out of this house.'

'Speak for yourself,' Dickie told her and gobbled down the drink that Hetty pushed into his fist. He eyed me some more over the rim of his glass, started to say something, then rattled the glass against his teeth and polished off the dregs. 'Where the hell is this guy Kage anyway?' he complained bitterly. 'I don't get paid for sitting around on my backside all day long. Some people work for a living, you understand. I didn't marry into bags of dough. I married the poor one of the Hazard dames. I didn't have a puss that would draw morons to movie theatres.'

'Why don't you just put something into your big mouth, Dickie?' the stringy-haired dame said snappishly. 'Nobody's saying you would make a movie star. We

Hazards had class whatever else we had,' she added with a heavy meaning directed at Hetty. 'You don't buy class at the nearest drugstore, you know. You have it or you haven't.'

'Class, she says!' Dickie sneered. 'The only thing you have with class is a tongue that bites, baby. What I want to know is where is Gloria. That's what I want to know. She gave us a new car for our anniversary. She isn't all that tight.'

'Yes, and she got the car right back again,' Muriel chipped in with her dime's worth. 'I tell you I wouldn't take a thing from her. But she happens to be my sister, and blood is thicker than water.'

'Okay, okay!' Hetty sang out in a high voice. 'So you wouldn't take a thing from this house. So blood is thicker than water. So Walter Kage is my brother and if one of you makes another snide crack behind his back I'll — I'll — '

Hetty burst out in tears and rushed from the room. She slammed the door after her and for a minute there was nothing but silence.

'You and your big yap,' Dickie grated at

the stringy-haired dame. 'I tell you you've got a tongue would saw a tree down. We didn't come here to start a row. It's Kage's house now, you understand. She's his sister. If he wanted he could kick us both out on our cans.'

'If my own sister has left home I want to know why she has left home,' Muriel rounded on the big guy. 'Hetty can turn on tears the way she can turn on — Well, I don't have to write it down, do I? You were lapping her up for all you were worth, Dickie Chalmers.'

'What the hell,' Dickie said carelessly. 'Why doesn't she put some clothes on?'

'You sex-mad sack! If you'd got some of your hormones in your head you'd be able to buy a new car for yourself.'

'Don't shout at me or I'll belt you,' Dickie panted in a stricken voice. 'It's your sister that's missing, according to Kage. Okay, so she's missing. Maybe she got itchy pants and took a plane to Hollywood to pick up another movie star. I just wish the hell you'd get itchy pants some of these days and take off in a plane somewhere. A space-craft maybe!' he

added with enthusiasm. 'And when you got back — '

'Dickie!'

'Yeah? I know what you're gonna say next. I got it all off in my head like one of Walter's movie scripts.'

'Someone is listening to us, Dickie.'

'I ain't blind,' Dickie said. He had reached the point of no return. He gave me an eagle-eyed glance, then hoisted himself from his chair and wandered over to the elaborate bar. 'Cheese!' he grunted wonderingly. 'Southern Comfort! Cranberry juice cocktail! I could make myself a Scarlett O'Hara.'

'Just dare and I'll scream,' the stringy-haired dame threatened. 'Yes, I will, Dickie Chalmers. A short beer is one thing. A little rye isn't so bad. But once you start meddling with those heathen drinks I'll start screaming.'

Dickie didn't get around to making his Scarlett O'Hara. He was carressing a bottle lovingly when the door of the lounge opened and Walter Kage walked into the room.

2

Picture a cross between Spencer Tracy and Rock Hudson, add a dash of Doug Fairbanks, then leaven the mixture with a squirt of would-be Hump Bogart, and you start getting a rough idea idea of a movie heart-throb as personified by Walter Kage. It wasn't as though Walter bore any direct resemblance to the foregoing movie idols: rather did one or other facet of his physical appearance suggest such an illusion. Immediately you began to study the guy for himself illusion became disillusion. You realized that Kage was simply an unfortunate hotch-potch of almost every male actor you had ever seen, and imagined you'd forgotten.

What he was reported as having was style — a critic referred to as *flair*. It was supposedly rooted in the tremendous faith he had in himself. His self-confidence surrounded him like a halo. Even if he had never met you before he

would give you the impression that you had met him, and found him winning and lovable, and you would never dream of taking him for anything less than the hundred per cent good guy he represented on the screen.

His entrance into the lounge just now was something that had to be seen to be believed. Gone was the bold swashbuckling air, gone too the merry glint in the level blue eyes. Walter Kage was clad in slacks and sweater. He had a baseball cap sitting askew on the crown of his head. He had a curved pipe in his left hand that was reeking like mad. He had a blank look on his face. He should have been clad in sackcloth for this part; his head should have been covered in ashes. Sad music should have been playing somewhere in the gloomy background. It made you feel you wanted to touch something sane and solid — like a biting dog maybe — to convince you that this wasn't the world of celluloid and phoney situations, and that right there, within arm's reach, was hard and comforting reality.

Nobody said a word as Walter stalked

deliberately to the ornate bar and just as deliberately made himself a double scotch which he proceeded to knock back in a couple of practised swallows. He was reaching for the bottle to do a re-take when Dickie Chalmers broke the tense silence.

'Cheese!' Dickie said in awe. 'And I figured I was three-quarters of the way to being a confirmed alcoholic!'

Walter wheeled at the sound of Dickie's voice and appeared to notice him for the first time. A faint smile grooved the firm mouth and the dark handsome head tilted upwards a little.

'Why, hello, Dickie! Muriel! Thank you for coming. And this gentleman here . . . Would you be Mr Paul Muller?'

'That's right,' I said. 'Somebody told us you had gone for a walk. I hope the fresh air and the exercise did what you wanted it to do.'

Kage's eye had begun to drift away from me, but now it anchored itself and a frown flitted over the fine masterful features. 'Yeah!' he said vaguely. 'Yeah! That's right. I did go for a walk. I walked

as far as the cliff edge. You know — right where it drops off into the boiling ocean . . . ' He paused for the effect to register on the three of us, then shuddered delicately and knocked back his second drink. 'You must forgive me. I'm a trifle upset about the whole thing.'

'You're talking about Gloria disappearing without saying where she was going to?' Muriel rapped out smartly. 'If you are you can include me in the upset bit. I'm just as upset as you are, Mr Kage — '

'Call me Walter, Muriel. Please! And Dickie, help yourself to a drink. No, allow me to make one for you.'

'Dickie has drunk all he needs to drink,' Muriel sniffed. She held her purse in front of her like she might use it for some purpose other than for holding her knick-knacks if Dickie's thirst won the battle with his self-control. 'We didn't come here to drink ourselves silly,' she went on in a thin monotone. 'We came to hear why Gloria has left home, where she went to, and when she's coming back again.'

'Alas, Muriel! If I had the answers to

your questions would I be in such a state? Would I have sent for you? Would I have sent for Mr Muller here?'

The guy sounded reasonable enough, and the very least the stringy-haired dame and her husband could do was listen to his tale.

'You mean she's really missing?' Dickie asked Walter. 'Took a powder, so to speak?'

'I'm afraid so, Dickie. Yes, I'm afraid so!'

Kage tugged his baseball cap from his head like it was the last hope he had been clinging to and flung it on to the nearest chair. Then he made another drink and sat down on the chair. He took a cigarette from a box and started chuffing miserably.

'Well, why aren't you out looking for her?' Muriel demanded. 'Why haven't you told the police she's missing from home? Is this man Muller a policeman?'

'Police?' Walter echoed and laughed shrilly. 'But my dear lady, you can't run to the police when your wife goes missing for a few days — '

'You said she left the house on Monday,' Muriel reminded him. 'This is Thursday. If that shouldn't interest the police then I don't know what would.'

'Please, Muriel,' Walter pleaded and took a pull from his glass. 'We must be logical. We must be calm and not do anything that would make us all look ridiculous. I shall inform the police of course if Mr Muller refuses my case, or in the event of his being unable to find Gloria.'

'If he isn't a policeman, what's his line?'

'He's a detective. A private detective. I asked him here to discuss my problem with me, to permit me to hire his services if he is available and willing to work for me.'

'Cheese!' Dickie said in wonderment. 'A private detective. 'Why didn't you say so in the first place, Muller?'

'You didn't give him much of a chance, did you?' his wife whipped back at him.

'Now lookit, Muriel, I'm not the one with the big mouth around here — ' Dickie began belligerently, then subsided

and settled for muttering to himself when the stringy-haired dame swung her purse ominously.

She breathed heavily down her nose and let her mean eyes run over me. 'Are you going to find my sister for us, Mr Muller?' she asked dubiously. 'Don't you think it's really a matter for the police?'

'That's for Walter here to decide,' I said generously. 'At the minute at any rate.'

'You mean the cops would want to know only when foul play was suspected?' Dickie came in sceptically.

'Please, Dickie!' Walter Kage interjected. 'Let's not mention foul play at this early stage. Gloria might have met a friend and is staying with her for a few days. I could have a letter saying so at any time. A 'phone call perhaps. There is the bright side to the picture as well, you must understand,' he added manfully.

I had to admire the guy in a way. He had never completely outgrown being an actor. He was having to cope with the realities of the situation, and at the same time cope with the wide screen Walter Kage who would have gone ahead

purposefully in the safe knowledge that the script-writer would find Gloria for him in the next reel. It made me feel glad I had never become a movie star. The facts of life might be cold and sometimes brutal, but they are facts and not a lot of stuff going round in your head.

'Then we're supposed to do nothing but sit tight and hope for the best to happen?' Muriel Chalmers said gratingly. 'Well, I don't know about that! I'd kind of feel a lot better if the police were searching for Gloria. One other thing, Walter Kage,' the dame said. 'I never was one to dabble in the lives or affairs of others, but I've got to ask you out straight if you and my sister had a row?'

'A row!' Kage seemed horrified at the very idea. 'Muriel, you can forget it immediately. Immediately! Gloria and I simply did not believe in rows. She is an intelligent person. I'd say that I'm a pretty intelligent person. Intelligent people never have rows, Muriel.'

'Not at all,' Dickie Chalmers cackled. 'They just slit each other's throat decently in the middle of the night. Well, it was

only a joke,' he went on weakly when the combined frozen stares of his wife and Walter Kage nullified his humour. 'Okay, so we've heard what you've got to say, Walt,' he rumbled on defensively. 'I gotta go now. Took the morning off when you called to come and see you. Maybe you'd like to sit around a while and get acquainted, Muriel. You could take a cab to home when you're ready.'

'I'm ready to leave now,' the stringy-haired dame said. 'I won't say that I'm satisfied.'

'That's for sure,' Dickie yammered mindlessly. 'I've got ten years of experience to prove your point.'

It was a revelation to see Muriel blushing, but blush she did. Then she grabbed Dickie by the arm and dragged him to the lounge door. He opened the lounge door and there was a brief tussle.

'Aw, what the hell, Muriel! You don't have to kick me so hard.'

The door slammed on them and they went away. Walter Kage sighed and killed the cigarette he was smoking on an ashtray. He lifted the curved pipe now

and clenched it in his strong white teeth. He gave me a feeble smile.

'A matter of poor timing, Mr Muller,' he apologized. 'I should have seen you before I saw them.'

'Or maybe you should have seen them before you saw me, pal. They could have pressured you into talking with the cops instead of a private eye.'

'Possibly,' Walter said thoughtfully. 'Possibly. But as I already mentioned, Mr Muller, what case would I have to present to the police?'

'They would have put your wife on Missing Persons for a start,' I told him. 'The cops are very good at finding people.'

'Yes, yes. I appreciate that. But Gloria might not be missing in the accepted sense of the term.'

I didn't reply to that one. I got a cigarette going and Walter struck a wooden match for his pipe. It was some kind of Turkish stuff he was smoking in the pipe and the reek came across as pretty awful. He blew the match out and dropped it on the tray. Then he found his

baseball cap and tugged it on to his head at a crazy angle. He looked like he might burst out in tears at any minute.

'Would you be interested in my case, Mr. Muller?' he said finally. 'Would you take on the task of tracing my wife for me? I realize I should have intimated the nature of my problem when I spoke to you on the telephone, but I thought I would like to see you first of all and make an assessment of your capabilities.'

'You mean my record doesn't speak for itself?' I said in a hurt voice.

'Oh, it does. It really does!'

'Where did you get your hands on my record?' I asked next.

The question took him off his guard, but not for long. He smiled and spread his slim-fingered hands towards me.

'Shall we say I asked around? Here and there?'

'Not the cops?'

'Oh, no indeed. Not the co — police. As I have endeavoured to impress on Muriel and Dickie, I don't imagine this is a task for the police — '

'If foul play is suspected it would be

their business,' I told him. 'Automatically. You haven't got anything against the cops?'

'Good heavens, no! Are you suggesting, Mr Muller, that I have adopted the wrong course, that you have no desire to take on an assignment from me. I'll pay you well for what you do . . . '

'In that event, I'm your boy, Mr Kage,' I said warmly. 'You don't mind if I call you Walter?'

'Please do. No doubt you know I was once a professional actor?' he said eagerly. 'Walter Kage!'

'*Three Ways to the Devil,*' I grinned. '*Storm at Dawn. The Last of the Lomaxes.*'

The recital caused him to drool in ecstasy. He lifted his head high. His eyes gleamed with fond remembrance. He seemed disappointed when nobody rattled drums or blew a trumpet. He came back to the moment with a bang, sighed some more and looked wistful.

'Then I met and married Gloria,' he said like it was some kind of anti-climax. 'She didn't want a husband who had to

work for a living. She wanted me to be around the house all day. Close to her, as she used to put it.'

'So maybe it was too close an association for a big guy like you who was used to spreading himself?' I was going to add, 'Over the wide screen,' but I didn't have the heart to kick him when he was down.

'You mustn't get the wrong idea,' he said patiently. 'You mustn't draw any wrong conclusions.'

'Okay,' I said. 'I've got the general picture. You want to hire me and I'm hired.'

'It's as easy as that!' He grinned as though he'd won an award but was much too modest to accept it. 'We don't have to draw up a document? Sign anything?'

'All you've got to do is sign a cheque, Walt, and I'm your boy, like I just told you.'

'For how much?' he asked instantly. 'I did a movie once about a private investigator. His client paid him a fat retainer. Yes, those were the exact words used in the script! Only this private

investigator didn't do too well by the end of the story.'

'He failed to solve the case? Shows you what these movie moguls know about our profession.'

'Oh, he solved the case all right. But he got killed in the final scene. Somebody stuck a knife in his back. The woman in the case, I believe.'

'Now you have me sweating, Walter! But to show you what I think of these guys who write their scripts in ivory penthouse suites, I'm going to take your case all the same.'

'Bravo, Mr Muller. Bravo! I'll write you out a cheque at once. A retainer. Then when you make a final reckoning you can present me with your full account. Done?'

'You've got a deal, Walt.'

We shook hands and he started looking better already. He pushed a bell and half a minute later a bald-headed butler came into the lounge.

'You rang, sir?' he intoned right on his cue.

'Yes, I did, Ferguson. Be a good chap and bring me my cheque book from my

office. Bring a pen as well, Ferguson.'

'Right away, sir.'

The guy headed off and Walter made himself another drink. He wanted to make me one as well but I told him I never drank before noon except in the most extraordinary of circumstances. My explanation appeared to intrigue Kage, but he went about fixing his drink without passing any comment.

The butler returned with the cheque book and pen. On his way out of the room he gave me a searching glance that might have meant he didn't find the experience hilarious. Kage scribbled like mad for a minute and walked over to hand me the cheque.

'Three thousand dollars, Mr Muller. It will defray your initial expenses, I'm sure.'

I thanked him and put the cheque into my wallet. I lit another cigarette and told him I was ready to commence investigating.

'What is the first thing you contemplate doing, Mr Muller?' he asked curiously.

'Interview the members of the staff. If it's okay by you.'

'Of course. I can't see what good will come of it,' he added doubtfully. 'I mean, if Gloria isn't here and — '

'Look, pal,' I broke in. 'I've got your money in my pocket. It gives me a job of work to do. What would you say if I told you how you should make an entrance in front of the cameras? Ridiculous, huh? Well, the same thing applies here.'

'Naturally,' Walter said feebly. 'Go ahead then,' he said magnanimously. 'Interview the members of the staff. Would you like to have them here or would you prefer the relative seclusion and privacy of my office?'

'Right here is secluded enough to suit me, Walt. What does your staff consist of?'

'The butler,' he said. 'Two maids. A cook. A handyman who keeps the grounds in order. It isn't a lot for a house of this size.'

'No? But I guess they'll have to do until more labour comes on to the market.'

My crack went past him by a mile. He had forgotten to mention his sister, Hetty, he told me. And shouldn't I know a smattering of the history of Clifftop, just

to give me as wide a picture as possible?

It was his dough he was spending, his time he was using up. I relaxed in my chair and let him have a free rein.

'Gloria was married before, Mr Muller. This house belonged to her first husband.'

'What happened to her first husband?'

'He died,' Walter enlarged. 'He was killed in a terrible car accident. Not far from here as a matter of fact. He made his fortune out of oil. He drank a lot, or so Gloria has led me to believe. Anyhow, he was drunk on the night he drove down the cliff path in his car. The car got out of control. It didn't stop until it reached the beach and the rocks of the bay. The car went on fire. Lauran Donovan wasn't much better than a bundle of ash by the time the accident was discovered.'

'I see,' I said hollowly. 'I wondered why even looking at that path gave me the jitters. Then you came along and met and married Donovan's widow. You were happy together?'

'Happier than doves, Mr Muller. But — but — ' He stopped speaking and

shifted uncomfortably as though the rest of the story might prove to be more blood-chilling. He had a pull from his glass, a chuff from his pipe. He went on quietly. 'There was a rumour — a rumour, mind you — that Donovan and Gloria had a row just before he left the house and got into his car at the front.'

'Who started the rumour?'

'The maid. She isn't here now. She left around the time I married Gloria.'

'What was her name?'

'Mr Muller! You're not taking the woman's wild rumour seriously, are you?'

'It was you who offered me the facts, Walt. Now that I'm getting some I might as well have them all. Her name?'

'Hilda Dornier.'

'You know where she lives?'

'I haven't got an idea. No one else in the house has either. The staff was changed when I married Gloria.'

'Donovan's accident could have looked like suicide,' I said casually. 'Didn't anybody think of the angle?'

'The insurance people did. Gloria and Donovan had each other's life insured.

They paid out on the policy, which to my mind at least is sufficient answer to the rumours.'

I puffed at my cigarette for a few moments. My mouth had gone dry. I went over to the bar and drew some fruit juice.

'While we're on the subject of insurance, Walt, would you think it too personal a question if I asked if you and Gloria — Mrs Kage — have your lives insured?'

'Why should I?' the guy grinned. 'If one of us dies the other comes into something in the region of a quarter of a million dollars.'

Nice chuck if you can get it. I didn't say so to Kage. I just finished my fruit juice and fished another Lucky from the pack in my pocket. I found myself thinking of Hetty on the beach. Hetty handing me her towel and telling me not to rub too hard. I could do with some beach air at this minute. I might even get around to — But what was I thinking? Haven't I always been a guy who puts business before pleasure? Well, I have

done it occasionally.

'I'm much obliged for the way you have opened your heart to me,' I told the ex-movie hero. 'And now I'll have a chat with the members of the household — counting your sister Hetty out. I've made her acquaintance already and I guess we can renew it if the need arises.'

The butler was the first to arrive when Walter had departed to set the ball rolling. Getting information out of him was tantamount to having fun with a clam. At last he opened up on the subject of Monday.

'Yes, sir. I did know that Mrs Kage had left the house. I saw her out of the house as a matter of fact. When she said she was going out I offered to drive her — '

'Did you make a habit of driving her?'

'Not a habit, sir. Now and then I did. She didn't care much for driving. She wasn't a very good driver, if I may say so.'

'Say all you want to, pal,' I encouraged him. 'The boss man has given his blessing to what I'm engaged on. So if you didn't drive her from Clifftop she must have driven herself?'

'No, sir. She asked me to call for a cab. She asked me not to make any fuss until she had gone.'

'You didn't tell Mr Kage when she left?'

'He was out in the village, sir. I told him immediately he came back.'

'What was his reaction?'

'He seemed slightly surprised. Nothing more.'

'Did Mrs Kage take any baggage along?'

'Only her purse, sir.'

'Hint at where she was going?'

'No, sir.'

'Which cab company did you call?'

'The Green Top, sir.'

'Did she ever go away from home like this before?'

The butler said no, not during his time at Clifftop. No, he didn't think Mr Kage and Mrs Kage ever had a row.

I thanked him and let him go. Before interviewing the rest of the staff I had a word with Walt Kage. Of course he knew that the butler had rung for a cab Monday and seen his wife off.

'Why didn't you say so?'

'I wanted you to make a thorough investigation, Mr Muller. I want you to be satisfied that, for my part, I have nothing whatsoever to hide.'

'That's big of you,' I said curtly. 'Send me the next subject, then dig up all the photographs you've got of your wife.'

'All of them? But there must be hundreds.'

'All of them,' I repeated and watched him leave the room.

The cook had nothing extra to offer, neither had the ancient handyman nor the younger maid. It was Josie who produced the next meaningful tit-bit. The biddy agreed that Mrs Kage didn't go in much for solo car driving.

'She used to have a chauffeur. I never liked him, I swear. Young and dark. Handsome in a greasy way. He drove Mrs Kage about a lot. Mr Kage found them in some kind of situation one day and fired him. Good riddance too, I swear. Nothing good was going on there, I bet. Mr Kage can tell you more about it than I ever can,' she added bleakly.

I wondered why he hadn't. I hit him with it when Josie had gone and he brought me the photographs I'd asked for.

'The chauffeur!' he echoed like he'd never have thought of it if somebody hadn't asked him. 'Who told you about him — one of the maids?'

'Never mind who told me. He was here and he's gone, and I'm curious enough to want to know why he left. You started off real good, Walt. In fact I was just beginning to take you for the ideal client. So frank, so forthright. Now you disappoint me, pal. We're going to waste a lot of time if you're not prepared to level with me all of the way. I'm not being too complicated for you, I trust?'

'He left because I fired him,' Kage said bluntly. 'His name was Marvin Luce. I fired him immediately I discovered he was a light-fingered bastard. If I hadn't fired him I might have been tempted to kill him.'

When Walter stopped speaking it was a half minute before I recovered from the shock. Here was a side to Walter Kage's

45

character that very few knew about. It was another half minute before I spoke to him again.

'Luce had a habit of lifting things he had no right to lift, maybe?' I said carefully. I'd met plenty of temperamental guys and learned that you must be careful with them, even if your caution begged the risk of having something nasty go bang in front of your face.

'You could say he had,' the ex-movie star grated. 'He got too fresh with Gloria.'

'Gloria told you all about it?'

Kage looked away for a few seconds before bringing his gaze back to my face. 'Yes, that's right. She did.'

I knew he was a liar. It wasn't the proper moment to tell him so. I nodded. 'So you fired him? On the spot?'

'That's right,' the guy repeated. 'I was so mad I had to get him out of my sight to keep my hands off him.'

'Where does he live?'

'I don't know,' he said. 'I can't remember.'

'Try hard, Walt. You must have kept

46

records. Wages, insurance, that kind of stuff.'

'Oh, all right,' he said truculently. 'I do remember now. He had an Anfield address. Cypress Drive. The number was two, treble two, I think. An apartment house.'

'But he stopped here while he worked for you?'

'Yes, he did. All of the staff live on the premises. Their quarters are at the back.' He smiled weakly and spread his hands to me. 'Sorry I overlooked Luce, Mr Muller.'

'Forget it, Walt. Let me have the photographs.'

He did and I spent ten minutes going through them. There were shots of Gloria dressed, shots of her in bathing costume by the swimming pool, in the swimming pool. She could have been anybody's sister but the stringy-haired dame's. She was taller for a start, younger. I would have guessed her age at around twenty-four or -five. Kage told me she was twenty-six. She was dark-haired and pretty. She had a good bust and good

47

hips, but then so had a million dames you could meet anytime on the street. That just about summed up Gloria Kage — Mrs Average. I couldn't find what had attracted the movie hero to her, but then I wasn't any movie hero and didn't know what would attract Kage in any case.

I selected half a dozen of the photographs and the guy gave me an envelope to put them in. I said thanks and told him I would get along about my business.

'You'll get in touch with me directly you're in possession of the slightest information regarding her whereabouts, Mr Muller?' he asked eagerly.

'You can bet on it, Walt. But don't expect too much too soon. It might take a day or two to pick up a trail.'

He took me to the front and saw me off. I bypassed the cliff path to the beach and drove round to the side of the house where a tarmac road sloped over the hills. I hadn't gone more than a hundred yards when Hetty stepped out in front of me and waved me down.

She was still wearing her shorts and

halter and she still looked nice enough to eat. She opened the passenger side door and dropped on to the seat beside me.

'You interviewed everybody but me, Paul,' she said in a disappointed voice. 'Do I look like I've got a fever or something?'

'So you knew who I was all along, baby?'

'Well, I did make a rough guess. I knew Walter had got in touch with a detective man, and — '

'And you knew too that your sister-in-law was missing from home.'

'But naturally! That's all I do know about Gloria, I can tell you. Oh, she's a sweet enough woman, if you see what I mean. But a little hard to get on with at times.'

'She didn't make you welcome at Clifftop?'

'Of course she made me welcome. Whatever made you imagine that she didn't. I told you she's a sweet enough woman. But she was susceptible to moods every now and then.'

'Just like her sister and Dickie are susceptible to moods?'

'Please, Paul! I can't bear them. Especially that Muriel. D'you know that she has only got to look at me once to make me feel I haven't washed in a month.'

'Could be she envies you, baby. Well, you couldn't imagine anyone offering to give her a rub-down with a towel if she got herself wet.'

Hetty emitted a thin peal of laughter.

'I see what you mean, Paul. I should pity her more than resent her. But the way she got on about Walter . . . '

'She figured Walter and Gloria might have had a squabble about this or that,' I said idly.

'She's a liar if she said any such thing! If either of them has anything to complain about concerning the other it's Walter.'

'Gloria didn't treat him fair and square?'

Hetty started to give me an answer to that one. Instead she changed her mind and laid her hand lightly on my knee.

'Are you going to find her?'

'I'm going to try.'

'Where will you search first of all?'

'Why ask me? All I have is a brief run-down from Walt, a few snapshots to help my inspiration along. Got any bright ideas on the subject?'

Again she started to say something I might have wanted to hear, but again she had second thoughts and applied gentle pressure to my knee.

'Don't worry. You'll make out. If I do think of a real sharp angle I'll let you know.'

'Promise?'

'Put your bottom buck on it,' she smiled. She removed her hand and allowed my blood to go back into circulation again. 'You'll be seeing plenty of Clifftop for a day or so, I expect?'

'Who wants to see Clifftop?' I gagged. I gave her a card in case she got confused about my address and she slid on out of the car — reluctantly, I hoped.

'Well, goodbye, Paul. Don't forget to dream about me.'

She waved and I waved back. I watched

51

her standing there in the road in the rear-view mirror until a corner took her away. Then I tried to concentrate on Walter's wife.

3

The village was known simply as the village. If it had ever had a name like Katenzook Corners or Blueberry Flat, well then I had never heard of it. Maybe the residents gave it a capital V and let it go at that. Maybe they liked to remain quietly anonymous and the hell with fancy tags anyhow. It was nothing better than a whistle stop on the mountain side for a bus or a taxicab. It had a filling station, a small hotel, a drugstore, a handful of clean, neat, freshly painted bungalows, and that was all.

Or so I figured until I parked the Jag outside of the hotel bar and went in to order a short beer and a salad sandwich. Then I found the village had the biggest mouth you could hope to find this side of the Rockies.

It was fitted on to the guy behind the bar. He was glad to see folks passing through, he said. He liked it fine when the

53

folks stopped off for a beer or a natter about the weather. The weather was hot, wasn't it? Even up here in the hills it was hot this time of year. Was I heading up north or was I heading down the coast? Had I heard that Aron D. Withers had bought a new house over by Darling's Cove? Did I figure that the hill people contracted rheumatism more easily than the flat dwellers did, or coronaries, come to that? Did I think that ocean air contributed anything to a man's sex-drive, or a woman's, come to that? Had I caught the rumour circulating through the village that Walter Kage — you're bound to have heard of Walter Kage at the very least! Big movie star he was one time — well, they're saying his wife took a powder. Mind you I wouldn't swear to it being the gospel truth. Walt comes in here now and again, you know. You didn't know? Oh, yeah, he does, he does. Got his autograph right here on the back wall. You don't believe me! Bend over and see it with your own eyes, dammit.

It was there too. The guy with the mouth knew most anything there was to

know about Walter Kage. Biggest celebrity they'd had in these parts for years. Latched on with Lauran Donovan's widow. Well, you must have heard of Lauran Donovan. Made a pile outa oil. Came to a bad end. Yeah, he did. Got into his car one night and took the wrong turning. Well, he musta took the wrong turning, mustn't he? Went down the beach path instead of taking the hill road. Drunk as sin. So the story goes. There was even talk of him committing suicide. Then somebody else said murder. Oh, we got them up here, mister. You bet the shirt on your back we got them. Fellas with loose tongues, women even. The things they say. I wouldn't dare to repeat half of it.

I got out of there while my brains were still in my head. The village didn't seem so staid and peaceful any more. Maybe the guy manning the filling station had buried his mother-in-law underneath that heap of junk. And then there were the drapes on the windows of the neat, freshly-painted bungalows. What secrets were the drapes supposed to hide? What

generations of rogues and rapists had the village suckled since the Indians decided civilization was too big a thing to impede?

I drove on through to Anfield and my office. My office is housed in my apartment and is the only place left where I can insulate myself and make music out of nonsense. Harry Peters, my secretary-cum-majordomo, said there had been a 'phone call for me. It had been police headquarters, he said. They had been on less than ten minutes ago.

I told Harry okay and to bring me a cup of coffee. I was taking on Walter Kage's case, which meant in essence that I had been hired to recover his wife.

'He really is a movie star, sir?'

'He was one time, Harry. From what I've gathered he went out to grass right after the wedding bells stopped ringing.'

Harry brought my coffee and went away. I drank and chuffed on a Lucky and mentally worked out a provisional *modus operandi*. Later I made some notes, writing down the name of the maid who'd instigated the rumour regarding a row Gloria and Lauran Donovan had just

before Donovan got into his car and took the short way out along the cliff path. I noted the chauffeur's name too, and the address supplied by Walter Kage. I scribbled a lot of wild questions and tentative answers before I thought of the 'phone call there had been from the cops.

I was stretching out my hand to the receiver when the 'phone jangled like crazy and the guy at the other end said he wanted to speak with Paul Muller.

'This is Paul Muller speaking. What can I do for you?'

'This is Sergeant Tyler at police headquarters, Mr Muller. We had a couple of alarms and thought we'd better check them out with you.'

'If it's some dame making with the alarms, I didn't do it, Sarge. I swear I didn't.' I wondered where I'd come by that swear gag. It appeared to be going round in my mind like a mad bee. Tyler made a grunting noise and said he'd ring me back again when I was sober.

'But I am sober, Sarge. I was never more sober in my life, I swear.'

'You mean you make with the wise-cracks all the time?' Tyler demanded drily. 'Well, I did hear about you, Mr Muller, but I've learned to take everything with a pinch of salt — '

'There's my boy,' I said admiringly. 'And if there were more cops like you in this man's town there'd be something real cheerful to read in the papers at breakfast.'

'All right, wise guy! I get the drift. If that's what you call co-operating with the police, then I get the idea. So now we know where we stand with each other, huh?'

'Get to the root of the matter, Sarge. Who's been complaining about whom?'

'A dame,' Tyler rasped. 'A woman. I think you might have met her a short time ago. Out at Clifftop, beyond the village.'

'She's lying in her teeth, Sarge. She was standing there, all wet and all. And she threw me this towel — '

'You're all wet yourself, Muller,' Tyler snarled. 'This dame — curse it! — woman is called Mrs Muriel Chalmers. She says her brother-in-law — Walter

58

Kage, no less — has hired you to find out where his wife is — '

'So Dickie was right when he said she'd got a big mouth. Boy, oh boy! The people I meet that have big mouths. Exactly what did she have to say about me, Sarge — nothing good, I'll bet a barrel of horse feathers?'

'Take it easy,' Tyler said patiently. 'Take it easy, will you? All I want is a couple of facts. Is Mrs Kage missing from home?'

'Why ask me? Why don't you ask Walt himself? While you're at it you might inform him what a dirty snitcher the stringy-haired dame has turned out to be.'

'I've been in touch with Kage, Muller. I didn't call him. He called me.'

'He did?' I asked weakly.

'Yeah, he did. He said he thought it would be a good idea to let us know his wife had gone missing.'

'You mean he asked you to find her?'

'No, he didn't. He said he had hired a private detective to trace her. He also said he doesn't want to create a fuss.'

'Why did he call you then?' I knew why

Walter had contacted the cops. To beat the stringy-haired dame to the punch. He had thought over the meeting at Clifftop, realized maybe that Muriel Chalmers was far from satisfied with his story and with the remedy he had hired to cure his troubles. Yes, it made Walt Kage a smarter guy than I'd figured him for in the first place.

'I guess he wanted it put on record, that's all,' Tyler rejoined wearily. 'What do you think of the deal yourself?'

'To be perfectly truthful with you, Sarge, I haven't given it all the thought it needs at this stage. For all we know it could be the old, old story. Happily married wife decides she could be a whole lot happier if she took a rest cure.'

'Rest cure?' Tyler babbled. 'I'm not sure that I follow you, Muller. If she's happily married then why in hades should she need a rest cure?'

'Work it out for yourself,' I told the guy. 'In the meantime don't pay much attention to Muriel C. She really is a hell raiser of the first water.'

'Well, all right. But if you do fall into a

hole that needs a man to pull you out, you'll let us know?'

'That's just what I like about you cops, Sarge. All heart and no brains. See you around the psychiatrist's waiting room.'

* * *

It was three in the afternoon when I left my office and set off for midtown and the headquarters of the Green Top cab company. The man in charge of operations took a close gander at my photostat and brought me into the cubby-hole he used to rest up in. He was middle-aged and greying and he fired a thin cigar before drawing over a thick book and flicking through the pages.

'Monday? That would be the fourteenth. Yeah, here it is. We did have a buzz from a party at Clifftop. I couldn't say if it was a man or a woman.'

'But you do know which driver answered the buzz?'

'Sure, I know. What sort of outfit do you think we run, Mr Culler?'

'Muller. I haven't got a thing against

your outfit. I think cab companies perform a swell service for the general public. What could we do without them?'

The driver was called Pike, he said. Pike Millet. No, I couldn't see Pike right now.

'It's impossible.'

'Why is it impossible?'

Pike wasn't around, that was why it was. In fact I couldn't see Pike today at all. He was doing a long run down to Sewell Oaks, and wouldn't get back till morning. He'd stop over some place down there, then set out for home early. What reason did I have for wanting to talk with Millet?

'Sometimes we get a request from the cops,' he said. 'We do what we can to help. One thing we wouldn't touch with a railroad tie is a scandal,' he added warningly.

'This is no scandal, Mr Orby.' The guy's name happened to be Orby. 'This is nothing but a job of work. You help me now and I help you sometime in the future maybe. I'll even give you one of my cards as a sign of my good faith.'

Orby said, 'Yeah?' in a doubtful fashion. He scratched his jaw and weighed me up. He took a couple of puffs from his cigar and perched it on the edge of his desk. 'So long as it doesn't lead to a backfire on us. Here's Pike's address. He won't come on until noon tomorrow, but I wouldn't call on him too early in the morning.'

I promised I wouldn't. I thanked Orby and left. His 'phone was ringing as I walked away from the cubbyhole.

The next hour I spent in trying to track down the chauffeur that Walt Kage had fired. I drew a blank. Marvin Luce had gone away. The manager of the apartment couldn't say where. He was just the type of character who wouldn't tell you anyhow, even if he knew.

I thought about going after Hilda Dornier next. She had been a maid at Clifftop in Lauran Donovan's time, and she had given somebody a hint that all had not been fun and games between Gloria and Donovan prior to his smash-up on the beach. I decided to leave her for later. Without a clue as to her

whereabouts it would be all uphill going, and I'd seen enough hills of one sort or another for one day.

Next morning I rose bright and early. At breakfast I ran through the *Morning Bell* to see if the papers were interested in Gloria Kage. Apparently they were not, or maybe it was on account of the stringy-haired dame not having thought of them yet. Or again, she might view all news outlets but her own with a jaundiced eye.

At ten-thirty I drove on to Westbury Avenue and hauled up out front of 934. It was an apartment building that had been erected in the last ten years. The listings said Pike Millet roomed in 4F and I used the elevator to reach the fourth floor.

Millet was around, which was something. I heard him whistling in tune with radio or phonograph music. He opened the door to my rap and gave me an uneasy grin. It said his conscience was bothering him or he had been told I might be calling to ask him some questions.

He was a thin guy, around thirty. He

was cleanly shaved. He was dressed in a white silk shirt and sported a gold wristlet watch on his left wrist. I told him good morning, then I told him who I was. He seemed to grow more uneasy when he heard my name. His laugh came over as pretty thin too.

'Oh, yeah!' he said. 'The boss told me on the 'phone you might be around. A private detective, huh? This is a new experience for me. Want to come inside?'

I said thanks and followed him into the apartment. The smell of coffee drifted out from the kitchenette in the rear. A jacket was lying here, a sweater and tie there. There was no sign of female about the joint and I took it for granted Millet was a bachelor. He looked like he might be a pretty gay one, given half of an opportunity.

He went over to a radio and turned it off, then he went into the kitchenette for a minute and came out wiping his hands on a towel. He slung the towel over a chair back, sat down on the chair and brought out a pack of Camel's. While he smoked I told him the reason for my visit.

'That's right,' he said. 'I did answer a call from the coast on Monday. Well, I didn't really answer it. I was sent. So if you've got any beef, Mr Muller, you'd better take it out on Orby. He's the boss, if he didn't say so.'

'He did. I don't have any beef, Pike. I'm just doing a job like you do a job. You remember who you picked up when you got to Clifftop?'

'Naturally,' Millet said. 'Some fares I forget at once. Others kind of stay in your mind. Walter Kage's wife. He's a movie actor. Retired, ain't he?'

'How did his wife strike you when you picked her up?'

'What do you mean exactly?' the guy queried. 'She's a nice dame. Not a bit starchy. She treated me good. A lot of dames are starchy and mean as hell. She talked about things. She gave me a big tip when she paid me off.'

'Where did she pay you off?' I asked curiously.

'Real close to the train station in Anfield,' Millet answered without hesitation.

I tried to keep a pulse of excitement out of my voice. 'Did she plan on taking a train to some place?'

'Hey! What's the jazz, Mr Muller?' the guy asked suspiciously. 'Some things I don't like talking about, and the fares I pick up is one of them. And people do have their rights, you know. How am I to believe this gag's on the level?'

He had just made a couple of good points. The five bucks I drew through my fingers settled one of them. A perusal of the photostat of my licence partially settled the other one. Millet pushed the money into his pocket.

'Are you saying this dame has flown the coop?' he asked eagerly. 'Well, what d'you know! And these movie actors figure they've got everything!'

'I wouldn't even repeat half of that, Pike, if I were you,' I warned. 'We don't want this to get any further. You don't want any bother with the cops?'

'Did I say I did? I'm doing you a favour, ain't I? Well, I do favours every day of the week.'

'I thought you were an understanding

man, Pike,' I soft-shoed him. 'Knew it the very minute I laid eyes on you. Did she plan on taking a train to some place?'

'She was a very nice dame,' Pike mused reflectively. 'And why do I have to beat a drum for movie stars?'

'You don't have to beat a drum, pal. All you have to do is be a swell guy with me. I've got more corns on my feet than you've had flats on your wheels. Do I look like a character would give a dame a raw deal?'

Pike took ten seconds to make up his mind.

'I didn't see her take a train. She got out near the train station. But we made a coupla stops before we got that far.'

'Where?'

'First at a leather goods store. She bought a suitcase. Next stop was at a clothing store. I had to give her half an hour there.'

'Go on,' I urged when he threatened to dry up on me. 'What happened next?'

'Well, she did say something that kind of made me think about it later.'

'What was it?'

'She spoke about Culver Springs. I thought it funny. Well, what is Culver Springs anyhow? You ever been there, Mr Muller?'

'Yeah,' I said. I hoped my eyes weren't glistening too much. 'I passed through it one time. The only reason I passed through it was because I had to get to the other side of it.'

Millet had a quiet chuckle to himself. He spread a hand when I looked at him expectantly. 'Well, that's what the dame said to me. Have you ever been in Culver Springs?'

'Nothing else?'

'I told you. That's all. Maybe she went to Culver Springs. Maybe she just mentioned it in passing. But if she bought a suitcase and she bought clothes, the rest ought to stick out a mile for you, Mr Muller.'

'It ought, Pike. Thanks a lot.' I stood up and turned to the door. Pike spoke before I left the apartment.

'There won't be any rebound from this? I wouldn't want to be labelled as the

cab driver who can't mind his own business.'

'We've got an understanding, haven't we? You keep your lip buttoned up. I do the same.'

I left him on that note and closed the door behind me.

4

The Chalmer's place was located in the northern suburbs of Anfield. I reached it around midday and drove past for twenty yards or so before stalling the Jag and getting out and locking up. First impressions might be playing tricks on me, but this was the sort of district that got me wondering if I'd find four wheels still on the car when I came to collect it.

The Chalmer's lived in a modest villa that had a pool table size front lawn where the grass was scraggy and defeated, and where a handful of flowers and shrubs struggled out a meagre existence in the poor soil. The house itself could have been painted around five years ago. If it had though, there was little evidence to suggest such a thing.

A short driveway led from the entrance to the front porch and door. The driveway also curved along a side wall to the rear of the house.

I was walking to the door when I saw the stringy-haired dame squatting close to a cypress hedge in the back yard. She had a pair of grass shears in her hands; a blue scarf covered her head and the nape of her neck to protect them from the scorching sun. She was wearing a pair of old slacks that looked just baggy enough to have accommodated Dickie, and a man's shirt open at the collar, and she squatted there like a wildcat waiting for the right moment to launch itself at me.

'Hi, there, Muriel!' I greeted in a feeble voice. Thought I'd drop by and say hello to you. And what is Dickie-boy up to on this fine morning?'

She just hunched there for another thirty seconds, working the handles of the shears gently like she was fondly contemplating the damage they could do to me without having to dirty her fingers. When she spoke she made it sound as if she begrudged every word she wasted on me.

'Dickie's out minding his own business. It's a wonder you can't do the same thing, Mr Muller. And if you felt like dropping by on somebody, why couldn't

you pick somebody else?'

It was enough to make any self-respecting private eye tuck his tail down and make a run for it. I didn't tuck my tail down and make a run for it. I went on towards the dame, cautiously, I'll admit. Well, she was plying the handles of the shears some more and they did look sharp enough to make more mischief than anybody in a hospital could set to rights.

'I'd like to have a word with you, Muriel — '

'I'm Mrs Chalmers, mister, and don't you forget it,' she said coldly. 'I know my place in the world. If everybody knew their places in the world there wouldn't be half of the goings-on we hear about on the television.'

'How true, Mrs Chalmers. How true!'

'What do you want to talk about?' she said next. She came off her haunches and tossed the shears to the wizened up grass. 'Did Kage really hire you to find out where Gloria is?'

'But you didn't think much of the idea, Mrs Chalmers? I mean, you mustn't have

thought it a very good idea when you got in touch with the police.'

She jumped as if something had stung her. Her cheeks began to colour up, but she soon had a grip on herself.

'Yes, I did report the matter to the police, Mr Muller. Well, she's my own sister, isn't she?' she added defiantly. 'Am I supposed to sit back and do nothing? What kind of sister would I be to her if I did that?'

'Nobody's saying you did wrong, Mrs Chalmers. Not me for sure. If I'd been in your shoes I'd have done the very same thing myself.'

My response seemed to mollify the stringy-haired dame, but not all that much. 'If you want to talk you'd better come into the house,' she suggested surprisingly.

It could be she wanted to use a carving knife on me instead of the shears, and it could be she didn't want the neighbours to see what she did with my body afterwards.

'You look frightened,' she sneered. 'I'd say you weren't nearly half as frightened

when Hetty was entertaining you.'

'That's strictly a matter of opinion, Mrs Chalmers,' I said with a sheepish grin. 'A woman dropped me when I was a baby and I never got over it.'

She used the back porch to lead me into a neat, cool, plainly furnished living-room and told me to take a chair. She said I could smoke if I wanted to. She couldn't offer me anything but a can of beer. Dickie drank more than was good for him, and he did have to get out in the mornings to work, didn't he?

'Thanks, Mrs Chalmers. I don't want a beer. What does Dickie do when he's working?'

She didn't answer that straightaway. First of all she dragged the blue scarf from her head to let loose the tumble of unruly and unattractive hair, then she tugged off the protective gloves she was wearing. She took an old leather bound chair opposite me and accepted a cigarette from the pack I extended. She grunted when I held a light.

'What has Dickie got to do with it?' she asked snappishly.

'Nothing of course, I'm sure. I was just being curious, I guess.'

'Well, he's a salesman, if you want to know. Works for one of the big warehouses in town. What he's selling depends on the time of year it is.'

I wondered what Dickie was selling this time of year, but I didn't dare ask her. Instead I said, 'I'd like to talk a little about your sister. Is it okay if I talk a little about your sister, Mrs Chalmers?'

'Nobody's stopping you,' the dame said. She drew on the cigarette I'd given her and let smoke trickle out of her nostrils. If I'd been a bookie I'd have given even money on her not being the fiery battleaxe she would have everybody believe she was. Her mouth softened slightly, which was a revelation in itself. A frown made twin vertical grooves between her eyes. She uttered a vague sound that could have been a sigh. 'Gloria was never happy,' she announced. 'Even when she married Lauran Donovan and had all that money, that big house and everything, she was never happy.' She paused but I didn't say anything. A truck went past on the

street. The walls of the house vibrated dully. I puffed slowly at my own cigarette and waited for her to continue. 'Gloria was always restless,' she said when a brief interval had gone by. 'I don't know why. Maybe she wanted kids. She never could have kids. I can't have kids myself.' She blushed when she made the confession. It had slipped out of her without her consciously thinking of what she was saying. I just sat there and didn't make any comment. I'd the feeling it was the first time she had ever put this regret into words — even taking Dickie into consideration.

'How did she and Donovan get along?' I said after a while.

The dame jerked like she had only realized who it was she was talking with. She flicked ash from the tip of her cigarette, cleared her throat roughly.

'They didn't. Not very well anyhow. I don't know whose fault it was. Maybe it was all Lauran Donovan's. They weren't really suited to each other. Lauran Donovan was nothing but a lousy rich tramp. It was none of my business, I

guess. I thought Gloria had struck it lucky when she met Donovan and married him. Well, she wouldn't win any beauty prizes. But neither would Donovan if you want to look at it that way. I was kind of jealous, you might say. No — not jealous — envious of the property and money. Well, there I was stuck with a man like Dickie Chalmers. He hadn't any more than two cents to rub together when I married him. He snores in his sleep. He drinks too much. He's got the most awful table manners . . . '

'You could hardly be blamed if you put him in a car and got him to drive off a cliff,' I said with a weak grin.

The dame's eyes went gelid for a minute. Her lips drew in on themselves. 'So you heard the rumours,' she accused. 'You heard what they said about Donovan's accident.'

'I heard it mentioned that he might have committed suicide when he smashed himself up.'

'Or was murdered,' Muriel Chalmers flared. 'I should cry! If I was given a guess between murder and suicide, I would say

he was murdered.'

'You would?' I croaked. Of a sudden it wasn't so cool in the living-room any more. I began to sweat. I stubbed out my cigarette and got another one going. I said tentatively, 'Who would have gone to the length of killing him?'

Muriel's cackle was reminiscent of Dickie's yesterday in the lounge at Clifftop.

'Anybody could have killed him! He spent the whole day drinking, the whole night gambling. And it wasn't Gloria who told me either. I heard! He went through money quicker than the sun can melt snow. There had to be an end to it sometime. He was fast and loose with the girls — single, married — it didn't matter one whit to Lauran Donovan. Maybe somebody's husband killed him for all I can tell.'

'But the coroner's verdict was accidental death.'

'I know what the coroner's verdict was. I'm not saying! I'm just talking. You wanted me to talk, didn't you?'

'Sure, I did. I'm much obliged to you,

Mrs Chalmers. I wanted to have somebody draw pictures and you've certainly done that, and then some.'

'You sure you don't want a beer?'

'No, thanks,' I told her.

'How is this going to help you find my sister, Mr Muller? You could sit here all day and talk and you still wouldn't know where she is.'

I gave her another weak grin. 'Yeah, we are getting off the main track, Mrs Chalmers. What I called here to ask you is this: did Gloria have any friends — anyone she might have gone to visit for a few days?'

She thought it over for a while before shaking her head.

'We don't have any relations, if that's what you mean. She might have had friends. Why shouldn't she have friends? But we weren't that close, you understand. Not since she married Lauran Donovan and came into Clifftop and the money. As for that man she's married to at the minute — Well, I never do look at his face but I want to scream out loud or break something.'

80

I worked round to another tack.

'Would she go anywhere for a vacation, like to some small town maybe? Say like New Haven, Chaterville, Culver Springs, even?'

The dame didn't bat an eyelid at any of these. She shook her head again. She pushed her cigarette into an ashtray and stood up. She lifted her blue scarf and covered her hair, knotting the scarf loosely beneath her chin.

'Sorry, Mr Muller. I just wouldn't know. But one thing's for sure, you won't find my sister sitting there in that chair.'

She accompanied me as far as the driveway when I left. She had donned her working gloves again and I walked off to the gentle clicking of the grass shears.

I didn't go home to lunch. I went to a diner where I rang Harry to say I wouldn't be home just yet. Maybe not today at all even.

'Is the case taking you out of town, sir?'

'It could, Harry. It could. Tell me something and tell me no more, pal. If you were a handsome ex-movie star like Walter Kage is, what would possess you

to marry a plain jane when you could have your pick of a million really beautiful gals?'

'I take it you're not being facetious, Mr Muller?'

'I'm asking for your opinion, Harry. This is something that beats me down senseless. Gloria Kage's photographs — the most flattering of them, mind you — do nothing but make me stick my tongue in my cheek. Are you dead sure you're giving me the right vitamins in my chow?'

'Beauty isn't everything, Mr Muller. It's not unusual for a handsome man to admire a plain woman. There are other qualities, you understand — '

'You're kidding, Harry!'

'Conversely,' Harry continued placidly, 'it is not unusual for a beautiful woman to admire an ugly man.'

'You might figure both go in the same context, Harry. I don't. And there are far more kinky dames to the square mile than there are kooky guys.'

'Then I'm afraid you leave me with only one other conclusion, sir.'

'It's the one I'm waiting for, old pal. Let's have it.'

'The handsome ex-movie actor had motives other than affection or love for marrying the lady in the case.'

'Like in dough, Harry?'

'I'm afraid you could be right, Mr Muller.'

'I was afraid of the same thing myself, pal. Thanks for lending weight to my viewpoint.'

I hung up on Harry and then poked through the 'phone book. It was a local one but the only one in the booth. I left the booth and asked a waiter if he could find me some more 'phone books. It was the guy who managed the diner who obliged with an offering from his own office.

I found the number I wanted, that of an agent acquaintance in West Hollywood. His name was Douglas Willmer and two minutes later I was talking with Willmer.

'Paul Muller? Sure I remember you! What can I do for you, Paul? But it must be legit, friend, ha, ha!'

'It is perfectly legit, friend, ha, ha. Look, Dougie-boy, maybe you can tell me who handled Walter Kage when he was in the arms of the movie moguls. If you can, don't bother to tell me. Just get in touch with the party and ask how Kage rated around the time he left Hollywood.'

'That all? It's a cinch, Paul. Easy as eating pie, practically. Danny Royal handled Kage. Give me fifteen minutes or so and then ring back. Danny might be out for lunch or something. Okay?'

I said okay and thanked Willmer. I ate some lunch myself and allowed twenty minutes to drift before giving the agent a further buzz.

'Hi, gumshoe. I got news for you. Cock your pointed ears and listen, Paul.'

Walter Kage's popularity had definitely been on the wane when he quit, I learned. The last two films he'd made had done little or nothing for his reputation.

'He was a very temperamental character,' Willmer explained. 'Even for a movie hero.'

There had been a row with the studio

bosses, then with his agent, Danny Royal. Royal had begged him to grit his teeth and hang on. He was angling for a big part for Walter in a new television series that was hot in the pipeline.

'Television spelled death for Kage,' Willmer told me. 'He figured it would be a cheapening of his talents.'

'Maybe I see his point, Doug. When a guy has stalked the wide screen for a few years he's naturally bound to see the small screen as a good place to cramp his style.'

'In my humble opinion, Kage ought to have had his head attended to, Paul. The guy was nuts for not going along with the times. He isn't in any trouble, is he?' Willmer added curiously. 'He married a rich dame, didn't he?'

I said yeah. I said Walt wasn't in too much trouble. His wife had taken off without telling him and he had hired me to find her for him.

'Some fellas have all the luck! Saw the wedding reports in the papers. A widow, wasn't she? Well, maybe Kage figured he might as well get himself some insurance

for his old age. I wish the hell I could, Paul.'

I thought over Willmer's remark when I'd thanked him and hung up. The angle was there and I'd be six different kinds of fool if I closed my eyes to it. Walter Kage hadn't bowed out of the movie business in a blaze of glory; he'd been frozen out, was more like it. It didn't necessarily say he was stony bust at the time, but it did say, as Doug Willmer had mentioned, that he was a candidate for running in the insurance stakes.

What had he and his wife insured themselves for — a cool quarter million bucks. That was gravy in any man's language. So now his ever-loving had gone missing. So now his wife might be as dead as a pickled crab, and all Walter had to do was sit back and wait for the quarter million bucks to fall into his lap.

I mulled this over for a while. It didn't add up the way it would have to add up if Kage was going to collect. Insurance people aren't philanthropists. They don't pay out on a big policy without some proof. In this instance the proof would

have to be provided in the shape of Gloria Kage's dead body. And Walt had hired me to find her, hadn't he? He had gone further and told the cops his wife was missing from home. So where was the snag, or if you wanted to be flippant about it, where was the gag that everybody laughed at?

Gloria hadn't been murdered at home and dropped in the cellar. She had left home with her breathing in order and on her own two feet, and if the cabbie I'd talked with had been telling the truth, she had left home of her own free will. Now it was my business to go out and find her.

5

It was a hundred and fifty miles run through the afternoon heat to Culver Springs. I didn't hurry it along, partly because of the languor-inducing heat and the sunshine that beat down like copper bars, and partly because I figured that haste would benefit me nothing just now.

After all, Gloria Kage had been gone since Monday, and by this time of the week she would have made it to whichever destination she had in mind. If she was in a condition for travelling. One thing kept buzzing at the back of my brain: the ease with which I'd accomplished everything so far.

I'd heard the dame left home by cab Monday. There had been little trouble in tracing the cab she used and the driver who drove the cab. There had been little trouble involved too in getting the cabbie to cough up what he'd been able to tell me. Easy? All too easy. It could be I was

becoming real bright as a private eye. Well, they do say that some guys are late developers. Again, this could be the year for private richards, and nobody could say I didn't have patience and perseverance.

Maybe.

The hell of it was I saw a gap in my halo. It would have been simple enough for Walt Kage to have accomplished precisely what I had done. He could have asked his butler about the cab, the company about the driver, and taken it on from there. He hadn't taken it on from there. The Green Top manager would have told me. The cab driver would have told me; at the very least he'd have dropped a hint that somebody else had been asking.

It showed that Kage hadn't exercised his curiosity too far. Or maybe he was a firm believer in the old saw about one man for one job, and wanted to get his money's worth out of me.

Maybe.

I pulled into the one-horse burg around sunset and made a direct line for the train

station. It comprised a platform, a booking office, and a news-stand close by the entrance, and little else.

There was a train on the line judging by the three cabs sitting on the stand, but it had still quite a ways to come judging by the fun the three drivers were having in the back seat of one of them. They gathered in their cards and quarters and eyed me suspiciously when I broke up the party with a wide smile.

'Excuse me, fellas. Don't mind me. All I want is a couple of words of innocent information.'

'Zat so?' one of the guys said. He was the biggest of the trio and also the most friendly looking. The other two looked like they might take a bite off your neck; the big guy looked like he'd only have a section of your pants. His tiny eyes roved over my rumpled suit before settling on my homely puss. He rolled a matchstick around in his lips and poked at his left ear.

'What do you want to know, bud — the best place in town to make some real friends?'

One of his pals sniggered and the big guy flexed his wit some more. 'Or maybe you just want to find the liveliest spot in town,' he said. 'It's right on the other side of town. You can't miss the name tag. The cemetery.'

'What happens when you run out of comic books?' I said to the witty joker. 'Is that when you shut your big mouth and kid everybody you're only half stupid?'

'Now look who's talking! Now look who's going to have sweet dreams when he drops off to sleep for two hours!'

He started getting out of the cab and his pals started holding him there. I could see the relief in the guy's face when his pals did what he expected them to do.

'Count yourself lucky I'm still on duty, mister,' he snarled and shook the hands off. 'Just count yourself lucky!'

'Count yourself lucky I don't pick on hackies,' I snarled right back at him. 'No wonder you've got a lousy town. No wonder you don't rate even a speck on a large-scale map.'

'All right, all right,' the guy said sullenly. 'You want information. So what?'

'That's better, chum. That's a whole lot better. Think of the impression you can make on folks. Think of the tourist industry, even. Were you fellas on the train station Monday, could I ask you?'

'Maybe you're a cop or something?' the guy said sardonically.

'Maybe,' I said coolly. 'What did the cops ever do to you, if you want to make a quiz out of it?'

'What was so special about Monday?' one of the other guys wanted to know. 'Sure we were on duty here. There are only two places in town you can pick up fares and this is one of them. We didn't come on until Monday evening though.'

'Where can I find the day-shift Monday?'

'You'll find one of them in Steve Morgan's bar. Half way along the street. His name is Arch Collins.'

'Much obliged,' I told them. I turned away but turned round and went back again. There was the chance that Gloria Kage hadn't come here until evening on Monday — if she had come to Culver Springs at all, that was. I flashed one of

the photographs and paid attention to their faces. They looked at the photograph and the big guy handed it to me.

'What do you figure we should do now — click our heels or something?'

'You didn't see the dame Monday? Lift her here at the station stand?'

'Not on Monday. Nor on Tuesday. Nor on any other day of the week.' The guy's voice was gentler now. 'You not lock your back door at night?' he asked seriously.

'More comic book stuff,' I grated and walked away from them.

I got into the Jag and drove up the street. For a small town Culver Springs had more neon lighting to the square yard than most other small towns I'd ever visited. Steve Morgan's bar was roughly where the cabbie had said it would be. It had half a dozen customers when I bellied in at the counter and ordered a Scotch on the rocks. Then I asked the barhop about Arch Collins and he pointed to a booth where a thin, middle-aged man in grey slacks and a sports coat was sipping at a beer and reading from a newspaper.

He lifted his head and stared from pale blue eyes when I carried my drink over and sat down opposite him.

'Arch Collins?' I gave him my best grin when I spoke his name, but all it did for Collins was make him lick his lips and fold up the paper he had been reading.

'That's right.' He spoke with a tautness and economy that was out of keeping with the cab driving fraternity. I went on quickly before suspicion could get a proper hold on him.

'You were on duty at the train station for most of Monday, Arch? Would I be right in saying that you were?'

'So what?' Collins queried. 'If this is some kind of pitch, mister, you can take off and forget it. I come in here for a quiet drink. I don't come in here on the off-chance of being picked up by strange men.'

'You and me, Arch,' I said understandingly. He glowered while I brought out some photographs of Walter Kage's wife and invited him to shuffle them around. He shuffled for a few seconds, then he swallowed thickly and flung the

photographs to the table.

'You're an out of town cop?'

'Did you ever see this dame before, Arch?'

'Could be,' he said warily and helped himself to a sip from his glass. 'And again, maybe I didn't,' he added when he put his glass down.

It was the same old story in any language and I evinced my ability to catch on by dropping a five-spot on the table in front of the guy. He looked at it before looking at my face.

'Yeah, I did see that dame.'

'Where?'

'At the train station.'

'When?'

'Monday.'

I relaxed and took a pull of smooth Scotch. 'How about something sharp and solid for a chaser?'

'Okay,' Collins said. 'I'm not a big drinker. I was working on my chaser. Then I usually go in back and watch TV. What the hell else can you do in this kind of town?'

'How true, Arch, how true.' I fingered

the single waiter in evidence, ordered two more Scotches on the rocks. In the interval I produced cigarettes and lit one. 'Now,' I said to the guy when the waiter had been and gone. 'What happened when you lifted the dame? Was she alone.'

'Sure she was alone.'

'Baggage?'

'One suitcase.'

'Go on,' I told Arch and marvelled at how easy everything was going. Three thousand bucks for doing nothing but this? Some movie actors did need their heads examined. 'Where did you take her?'

'To the Hillview Motel,' Arch said. 'I remember her well. Knew she was a stranger. Good looking in an odd sort of way. Some guys might call her sexy.'

'Why didn't she put up at an hotel in town? Surely there's one decent hotel in town, Arch?'

'Of course there is. Hotel Dorsey.'

'You didn't think to suggest it?'

'Look, mister, what is this anyway?' Arch griped. 'I drive a cab, remember. I get sent out by the dispatcher. I do what

I'm told. When a fare says take me to the Hillview Motel I take the fare to the Hillview Motel. I don't start an argument right there in the middle of the street, you understand.'

'Sure I understand. I'm just checking on an angle, Arch. So the dame told you to take her to the Hillview Motel? She didn't ask you to take her some place private and quiet?'

'I told you, didn't I?'

'You did, Arch. You're a pal. How many guys work the day shift besides you?'

'Four,' Collins told me. 'It's a small town.'

'It's good cab business for a small town. And you never laid eyes on this dame since Monday?'

'What do you take me for?' the guy raved. 'A sex maniac or something. I tell you I only looked at her twice. Well, maybe three times. She had this odd thing.'

He told me how to get to the Hillview Motel. It was ten miles or so on the other side of town. It was in the hills for sure, he explained.

'Take the right fork at the end of the street,' he said. 'If you take the left fork you'll end up in the ocean after a while.'

We finished our drinks and I went back to the street. There was some kind of hollow where my stomach ought to be and I drove on to the Hotel Dorsey, freshened out and had a big meal that would give me enough energy to keep going for another few hours.

A half hour later I drove to the end of the street, took the right-hand fork and kept rolling until I reached the Hillview Motel.

When you've seen one of them you've seen most. This didn't have anything extra that endeared it to me. Only Gloria Kage. Perhaps. Well, she had come here and even if she'd drifted afterwards all I needed was another guy like Arch Collins to thumb out the proper direction. Like I said, it looked easier than falling off a cliff. Hurtling down a narrow pathway to the ocean. Turning yourself into so much blood and stuff in the wrecked machinery of a car. Why couldn't my over-worked

imagination go away and give me a swell break?

Floodlights showed me a lot of little cabins scattered through a lot of little trees. There were hills too. They hunched up there against the sky and the stars and the sliver of cheese-yellow moon that was beginning to crawl over their crests. There was an entrance that led to a bar, a druggists, a large community hall and a tiny office with a blue light burning over a sign that said *Reception*.

I parked the Jag in the shadows and sniffed of the rare mountain air before heading for the small office. I halted at the glassed door and fired a cigarette while I peeked inside. There was a guy back of a desk. He was around fifty; he was fat and perspiring. He raised his head and saw me and we stared at each other for several seconds. Then I opened the door and walked into the office.

It was as humid as a sauna bath. A minute fan whirred ineffectually. The guy had been smoking something that started out as a cigar, maybe early this morning. He'd kept the fumes trapped here at the

mercy of the minute fan. He rose from his chair and pressed his fat stomach against the counter.

'Good evening, sir.' He had a high, thin voice that made you look twice at his mouth to see if it had made the noise. 'You want to book an apartment? You can have single or double. You can have by the day or the week. For longer if you want to,' he added generously. 'By the end of the month we book only by the week or longer. The season, you know. Hillview is very popular with vacationers.'

'I mightn't want to book at all,' I told the guy and prepared to hand him a tissue from a pack when he bust out crying.

'Really?' he said in his thin voice. 'Imagine that now! Would you care to be shown some of the units first? I can vouch for their cleanliness. I can vouch for their comfort . . . Telephone, television, fine bar — '

'I don't doubt a word of it,' I broke in on him. 'I must come out with the blunt truth, Mr — '

'Petersen,' he supplied slowly. 'The

blunt truth about what?' he queried uneasily.

I brought out my wallet and showed him my licence. He took a step away from me and rubbed the palm of his hand over his chubby chin. He eyed me with doubt clouding up his gaze.

'Private detective. Paul Muller. I just don't get it, Mr Muller. What can I do for you?'

'You'd be willing to do something for me if you could?'

It took him a few moments to orient himself.

'Why not?' he said cautiously. 'You work within the law, don't you?'

'I could bring you police references would stretch from here to Culver Springs and back again,' I said modestly. I produced a photograph of Gloria Kage and laid it on the counter before him. He went to his desk and came back wearing glasses. He tilted his head to one side and regarded the photograph. It didn't take long to make up his mind. He nodded jerkily.

'You're trying to find this woman?'

'You've hit it on the head first try, Mr Petersen. Is she stopping at your motel?'

'Yeah, she is. I checked her in myself. Monday afternoon. Maybe Tuesday. No, it was Monday. Yeah, it was. What name did you say she goes by?'

'I didn't say. What name did she use to sign the register?'

He poked through a batch of cards and surfaced one with nervous fingers. 'Here is her registration card. She signed as Judith Hazard.'

It fitted to a T. Gloria had signed the first name that popped into her head, and what more suitable name than the one she used before her marriages? Maybe she had always wished her parents had called her Judith instead of Gloria.

'And she's still here?'

'She hasn't checked out.'

'She came alone? Had she a reservation made?'

'Yeah,' the guy said to my first question. 'Yeah,' he said to the second one. 'The reservation was made early Monday morning.'

'By Judith Hazard herself or by some other party?'

'You're thinking of man, I take it? Well, I couldn't say for sure. It was Dolly who took the 'phone reservation. She goes off duty at five o'clock. I hope this doesn't mean there's going to be any trouble, Mr Muller?'

'Who wants trouble?' I grinned at the guy. 'Not me for sure. Not you either, I bet. It's the reason you're going to keep all this under your hat, Mr Petersen.'

'Naturally,' Petersen agreed in his high, thin voice. 'Mrs Hazard is in twenty-four. I can't say where she is at the minute.'

'Don't make any wild guesses, friend. Let me do some of the work for myself. What's going on at twenty-three? Twenty-five, even?'

'They're both booked. You could have twenty-six.'

'You're a pal and I'll buy it.'

I paid rent for one night and a day. If I was going to stay for any longer I would let Petersen know. I gave him five dollars as a bonus and he slid out one of his cigars to me.

'Where can I park my car?'

'Each unit has a carport. If you don't wish to leave it there you'll find plenty of space a short walk from the apartment.'

He got me to sign a card, then he brought a key from a drawer and came round the counter to accompany me.

'Don't bother, Mr Petersen. Just give me the general layout of the units. I'm used to finding my own way in the dark.'

With the key in my pocket I thanked him, said so-long and left him. I hiked to the Jag, drove the eighth of a mile to the batch of units where the one I'd rented was located. The Jag was nothing Gloria Kage could put a finger on, so I eased it under the carport. I'd noticed a light in twenty-four as I drove past and my morale soared up there with the cheese-yellow moon.

In a short time I'd be nattering with Gloria Kage; a little later than that I'd be bringing her home to her ever-loving movie star husband. I figured I'd earned a pat on the shoulder for my efforts.

6

It couldn't have been much more than five minutes afterwards when I left my apartment again and sneaked round a stand of saplings to the front of twenty-four. Some cloud had blown up from the ocean and the moon was partly obscured; all the same there were wide patterns of light that kept shifting and changing places over on the hills, and the air coming off the hills had a keen and bracing nip to it. The pattern of the immediate vicinity had changed too, I noticed, when I stared at the apartment across the way. It was in total darkness now. Strange. I glanced at my strapwatch and saw the time was hovering on a quarter after ten.

Gloria Kage had gone out some place or she had turned in for an early night. It meant I had slipped up inside those five short minutes. Things had been riding too nicely for me. The deck had seemed

stacked in my favour. I had been the golden boy with three thousand bucks practically sewed up in my wallet; now I might have to strain my brain a little further to earn them. Immediately I'd noticed the light gleaming behind the shades I should have hotfooted to the dame and made myself known.

I stood for a while and looked at the building. It was a single-room affair like the one I'd rented for myself The doubles were much larger and had a longer porch straddling the front, together with an extended carport. I hadn't wasted the five minutes I'd taken off however. I'd gone over the unit with an eye to its weak points and its strong ones. Back of my brain somewhere I must have had the conviction that golden apples really don't grow on trees and that the long green stuff doesn't respond to even the latest chemical additives. Effort is still the keystone of advancement and achievement.

While I hesitated music drifted through the shadows. There was a ball going on at another apartment, not far from the one

rented by Gloria Kage. A lot of cars were parked over there and the shades were open to reveal young guys and young dolls horsing around. The thought occurred to me that Gloria might have made friends with the neighbours and was a member of the jitterbugging crowd.

There was no solid reason for banking on it, so I moved back to the Jag, recovered a flash from the glove compartment, then returned to the spot I'd vacated and went on waiting.

I waited for another five minutes. Nobody came out of Gloria Kage's unit and nobody went in. I went on to the door and gave the bell a buzz anyhow. Nothing happened, which wasn't so surprising. Another idea paraded for examination. Supposing — just supposing — that the dame had heard I was sniffing on her trail. For the present it was immaterial how she had heard I was. Would she pack the suitcase she had bought in Anfield in this event and take a powder to make it more difficult for me to find her?

A good way to check my hunch was to

return to Petersen and ask him if Judith Hazard had checked out. But it might be a good way too to make Petersen more nervous regarding my presence than he was already.

I gave the bell button a further push. Inside the unit it made a mellow tinkling sound. When nothing stirred I tried the handle of the door. It was locked, naturally. I left the front and went round to the back. Here was a porch with a fixed bench if you wanted to take the air in privacy or read a book without having the neighbours disturb you. Here too was a door and a fairly wide window.

The window I'd checked in my own unit had a catch that wouldn't offer more than a token resistance to a hard draught. I tried the door first of all, then went to the window and tested the catch. It was at the on position, but there was as much play between the frame and the surround as there was in the other window I'd played with. I inserted my finger-tips between the metal frame and the surround and gave it a hard shake. A little noise resulted from the operation but not

enough to attract any attention. The slot of the catch rod rode over the locking device on the second shake and I swung the window frame outwards. A few seconds later I was climbing through the opening and finding the floor of the bedroom on the other side.

In the bedroom I adjusted the shades to prevent any reflection from the flash leaking through. It was a bedroom identical with the one in the other cabin, the only difference being in the colour of the rug on the floor. The bed was neatly made up and there didn't seem to be anything lying around that would tell me whether Gloria had left temporarily or permanently.

I let the flash play on the walls. It hit the tiny dressing table and was wandering on when I noticed a powder compact that surely didn't come for free with the rental. At least I'd noticed no such item in the bedroom I might have to pass the night in. There was nothing else on the table to suggest the dame's absence being temporary.

Next I pulled aside the curtain that

gave access to the small closet. A coat hung there on a hanger as did a pink and yellow dress. Smothering my smugness I went on to the living-room. As soon as I passed through the doorway I got this feeling — the feeling that I wasn't the only prowler abroad in the motel tonight. I switched off the flash, shifting my position quickly when I did so. If Gloria Kage was at home it didn't mean she was in a mood to accept visitors, without a fight.

'Okay, Gloria baby,' I said in a cool voice. 'I know you're hiding around somewhere. Don't be bashful, baby. I didn't break in to ravish you or raid your goodies. I'm simply a bearer of best wishes from your ever-loving husband, Walt.'

I kept moving round the edge of the room as I spoke. Then I halted and held my breath to listen. I figured I heard a dull shuffling sound in front of me and flipped on the flash for purposes of identification. I didn't see anything remotely recognizable as Gloria Kage, but what I did see in the thin beam wasn't

without some interest. It was a chair I was looking at, but not so much the chair as what was lying on the chair. A hat, and a man's hat at that, no less.

Now the shuffling was behind me. Now I tried to do a couple of things at the same time. I swung to be facing the noise and I snaked my right hand into my jacket for the .38 that snugged in its shoulder harness. I didn't accomplish either endeavour nearly fast enough. The shuffling halted. There was a blurring shadow in front of me — all very confusing. Next thing I knew was nothing with bells on. The shadow had divided and come at me from front and back, with the result that it took me far down into a deep black pit with it.

The bells were for real in my skull when I came to. Well, maybe I hadn't come to. Some guys are slated for a sky-ride when they leave this world of woe; other less fortunate guys are slated for a black pit anyhow. I was in some black pit for sure. Lights kept trying to chisel through and the bells gave off with a weird cacophony.

There were more shadows shuffling around. Voices were babbling like mad.

'Why don't you just shut up, Mr Petersen,' one of them said. 'I got here as fast as I could, didn't I?'

'Not fast enough to preserve the good name of this motel, you didn't, Sergeant. Didn't you see the people gathered round the door when you drove up?'

'Yah! Rubbernecks. What are you worried about? A guy got conked on the head. The guy was snooting in when he should have been minding his own business. Nobody got murdered, did they?'

'Why don't you speak for yourself?' I said. 'Somebody murdered me, didn't they? If Petersen doesn't kick up a fuss I can tell you that somebody is.'

'He's coming round, I think . . . '

'He's making noises anyhow. Give him another snort outa that bottle.'

The snort was sharp and made me gag. But it also made me sit up and take notice of my surroundings. Mr Petersen was standing in a hunched position like he might have kittens at any minute.

There was one other person in the room. He sat on the edge of a chair in front of me and studied me with the compassion he might evince for a swatted fly.

'Maybe we should get a doctor for him,' Mr Petersen said. 'Are you okay, Mr Muller? You promised me there wouldn't be any trouble, and see how you let me down,' he added reproachfully.

'You want to be down here to really appreciate the experience,' I snarled. I took the bottle he was holding and had a hefty swig from the neck. I gave him back his bottle and started climbing to my feet. The guy on the chair stood up with me. He was wearing plain clothes but cop was written over him in luminous foot-high letters.

'How does your head feel?' he asked dispassionately.

'Like two,' I told him. I felt it to make sure I hadn't grown more than two. There was a swelling just about the region of my right ear. It stung when my fingers touched it. Whoever had slugged me had meant to keep me slugged for long enough to let him cover up his tracks.

A man, I thought then. There had been a man in this apartment when I'd gained entrance. Had Gloria Kage been here as well, I wondered feverishly. Still another and more awful idea occurred to me at that moment. Was Gloria Kage still in the unit?

The sergeant gave a yell when I headed for the door of the bedroom. Petersen made a groaning noise in his throat.

'Where do you figure you're going?' the cop grated.

'We should get a doctor for him,' Petersen chattered. 'A knock on the head can have very harmful effects.'

'If he doesn't come to heel he'll get one conk on the noggin he won't get over so easy,' the cop predicted.

They stood while I gaped at the dressing-table. The powder compact had gone. I pushed past Petersen to have a gander at the closet. The coat and the pink and yellow dress had gone. I went back into the living-room and began searching round for the man's hat. There was no hat. No Gloria Kage. No trace of the punk who had slugged me.

It was at this stage that my legs decided to turn cissy on me and I plopped down on the nearest chair. Petersen plopped down on another chair and cuffed sweat from his forehead and jaws. The cop just stood there like he'd seen everything anyhow and was daring me to dream up something original or at least unusual.

'Are you quite finished?' the cop said. 'Your name is Muller, isn't it?'

'That's right,' I said. 'Paul Muller. But from now on I'm just plain stupid. Be a good guy and call me stupid.'

'I'd better get a medico,' Petersen yammered. 'Maybe he's going to become violent.'

'Let him get violent,' the cop said. 'I've met all sorts and I've learned how to deal with them.'

'You and me,' I muttered vaguely.

'What's that you say, mister?' the cop snorted.

'Who, me? I wasn't talking. If I was I was talking to myself. What about another shot from your bottle, Mr Petersen?'

'Sure!' Petersen said eagerly and brought me the bottle. 'Have another big

drink, Mr Muller. Does your head still hurt? Tell me what happened.'

'I'll ask the questions,' the cop told the guy. 'And go easy on the bottle, Muller. Looks like to me you've been hitting it enough for one night. Why don't you go get rid of the rubbernecks,' he said to Petersen. 'Get rid of that party in the doorway for a start. Then close the door, huh? From the outside.'

'You — you want me to leave? You don't need me here?'

'I don't want you at the minute. I know where I can find you when I need you. At your office. Understand?'

'Sure I understand,' Petersen said, bringing the tattered shreds of his dignity to bear. He cuffed at his larded forehead.

He was heading for the door when I spoke after him.

'Did Judith Hazard check out, did you notice?'

'I never want to hear that name again, Mr Muller. If she checked out she did it without my knowledge. And, Mr Muller . . . '

'Yeah?' I said when the guy ran down.

'You're going to apologize for the way things fall on people around here? Don't give it a passing thought, pal. I — '

'I wasn't going to do anything of the sort,' the motel manager said icily. 'I was going to tell you that we can do without you as a guest. As from the moment the sergeant is through with you. You may collect a refund at my office as you leave.'

'All these characters are the same,' I grumbled to the cop when Petersen had left and closed the door behind him. 'Talk about stumblebums! The only thing they're interested in is your money.'

'Are you going to make some sense for a few minutes, Muller? You realize the charge you've left yourself open for?'

'You mean I get charged as well as having to put up with being beefed around?'

'You wouldn't have been beefed around if you'd been minding your own business.'

'You ought to put a tune to that, Charley.'

'I'm not Charley. I'm Sergeant Dubois. What were you doing in this apartment

in the first place?'

'I was searching for somebody.'

'A dame,' Dubois sneered. 'You were hired to find this dame?'

'I'm a private detective, ain't I? I got to do something for an honest living.'

'Don't make me sick,' the cop said. 'I wouldn't trust one of you guys around a lame hen. The dame signed in as Judith Hazard. Where does she hail from? What for are you looking for her?'

I took a half minute to think of it all. I got a cigarette going and tried to figure out if Dubois had a thing against the English language or if something had gotten twisted up in my brains to make me just imagine he had.

'How did you come to find me here?'

'I didn't find you. Petersen did. He thought you might be up to no good and was making a check of this unit and yours when he came in and saw you lying on the floor.'

'He entered by the front door?'

'What way do you think he entered — by burrowing a hole like a mole? He said the door was locked when he got

118

here. He keeps duplicate keys.'

'I'll tell a man he does. And spare keyholes too to go along with them. What made him come in here to look around?'

'He couldn't find you in your own place. Your car was there. He came here to have a look-see. He saw a light on the floor. Your flash. He entered, saw you, then hustled off to give me a call.'

'And that made your night for you, Sarge.'

'One last chance,' the cop said ominously. 'I never pull tails unless they need to be pulled. You can open up here or you can open up at the station house. Does that make any sorta sense to you?'

'Yeah,' I said. 'Sure it does. Give me another drink out of that bottle.'

'You're tanked up enough, Muller. You've got a bruise, but you'll live. What happened when you came searching for the dame. She wouldn't let you in and you busted in on her?'

'Be a good guy, Sarge! How in blue hades could I bust in on her when I

didn't have a key?'

'You used the rear window, smarty-pants. So you see how I'm not making hot air when I talk about charges. What happened when you came in through the window?'

I pretended to be confused for a while. There was nothing to prevent me telling the whole truth and nothing but the truth. I could say I heard noises and saw shadows and things before the punk with the mayhem complex laid a knot at the back of my ear. That way the Culver Springs cops might spread a net for the mayhem merchant and save me a packet of time and trouble. On the other hand if the story reached the ears of Walter Kage the guy might go crazy with jealousy and take off down the cliff path in his car to a gory end on the bay rocks.

I told the story with the slightest of variations on the true theme. I'd entered by the back window because nobody bothered to answer my ring on the front doorbell. Why did I enter at all when nobody answered the doorbell? Well, I

had the feeling the dame was in her apartment and that she was playing possum on me.

'So it turned out you were right?' Dubois urged with another sneer building at his mouth. 'So when you started muscling around in the dark the dame sneaked up on you and crowned you with something for a keepsake?'

'I really hate to admit it, Sarge. But you've taken the words straight out of my mouth.'

'What have you got on this dame anyhow?' Dubois demanded next.

'I've got very little on the dame. Just a thing. I wish I could go into all the romantic details, but ethics do happen to loom large and meaningful in my sphere of activities.'

'Well, I don't know, Muller. I've got you figured for a kook. Petersen's got you figured for bad news. Can you give me a promise to pack up and chase dames in somebody else's bailiwick?'

Sure I could and sure I would, I told the cop. He left me after a while and I went back to my own unit. I didn't dash

off anywhere else that night. I needed rest and plenty of it. After that I needed to make a fresh assessment of Gloria Kage's possible plans and potential.

7

It was around noon next day when I tooled the Jag to the sandy stretch of beach below Clifftop and stalled close to the rock-bound inlet where the cabin cruiser still rode the smooth waves. I wasn't quite sure why I'd bypassed the high road to the house of Walter Kage, unless I wanted to throw out a challenge to nature and dare it to have lightning strike twice in the same place.

It did too. I was scraping a match for a cigarette when I heard a sharp cry coming from the shoreline on my left.

'Hi, there!'

As on my previous visit a dame came frolicking out of the waves towards me. She was wearing the same pink bikini and not a single curve was missing. She tugged off her rubber cap, shook out her chestnut hair, then stooped to lift a towel and gave a ribald pagan laugh before completing her journey to the car.

I'd been watching the whole scene with a sort of fascination, so that I was caught flat-footed in the driving seat when she flung the towel at me.

'All right, Paul. Don't be a complete stick. Climb out of there and do your stuff.'

I said, 'Huh?' I said, 'You surely must be kidding, Hetty baby. Last time I used up my whole year's supply of self-control. From here on in the going could be rugged. And who's to say the dame with two glass eyes up there isn't teetering on the final throes of frustration?'

'Josie?' she said with her eyes lifting to the house on the cliffs. 'So long as it's only Josie you don't have to worry. The time to start worrying is when Walter takes to watching you through binoculars. He figures he's got the most beautiful and virginal sister in the whole damn state. It isn't a tag that I'd use much sweat in living up to,' she added reflectively. 'Well, what do I get for being the most beautiful and virginal female in the state anyhow?'

'You'd better not ask me, Hetty honey,' I said apologetically. 'A question of that

nature requires a more detailed answer than I'm qualified to offer. And then of course my cogitations would have to be based on knowing all the facts.'

Hetty flung her head back and laughed. Her firm, perfectly moulded body was seal wet. The rounded hips screamed protest at the flimsy covering that was their sole line of defence. The thrusting tanned breasts launched their rearing tips at the pink material cupping them. I climbed out of the car and held the towel firmly.

'On second thoughts, Hetty, I wouldn't want you to catch a cold or something. Turn around and let's get started while my feet are still warm.'

'And have Josie curl up and die inside!' she gurgled. 'Not very likely, Paul. I've got a much better idea if you're willing to listen to it.'

'Baby, I never thought the day would come when I'd be anybody's slave. Just make signs and I'll take it from there.'

'Let's head for the boat then,' she suggested and walked off towards the cabin cruiser.

I watched her trim back for a minute, then glanced at the big house brooding over the bay. The swinging hips pulled my gaze to them like they were a magnet and I was nothing more resistant than a steel filing. I followed Hetty to the boat, on to the deck, down the companion-way to the small, luxuriously appointed cabin. The boat seemed to rock a little when Hetty flung herself on to a couch and stretched herself sensuously.

'Well, don't just stand there and drool, Paul. Get weaving with the towel. But don't be rough, like I told you before. I am very tender in certain places.'

'Where do you want me to start first, baby? I mean those knots can't be all that comfortable when you're sitting on them.'

'Oh, well, if you must, you must.'

She stood up and put her back to me. A second later the lower half of the bikini was a damp blob on the cabin floor. I was getting ready to use the towel when she came round like a volcano blowing its top. The tanned arms were strong and fierce about my neck. Her lips brushed my nose and she groaned before grinding

them into my own. She was taking me with her to the couch when a man's voice penetrated my senses.

'Hetty! Where are you?'

'It's Walter!' she panted, leaping upright and pushing me from her. 'Oh, the meddling corn-brain! Oh, the dirty snooping spoilsport . . . '

'Don't use up all the best names for him, honey,' I objected thickly. 'Give me a chance to call him a couple. What an awful shame! There goes your virginal reputation blowing in the four winds.'

'Like hell it has,' Hetty panted and pulled the piece of pink dampness around her golden thighs. 'I was just showing you the cruiser, that's all. Do you hear me, Paul, that's all!'

'Don't beat it in,' I snarled. 'This joint just reeks of frustration. Do you figure I want to be labelled as the guy who ravished the last surviving virgin?'

We beat Walter Kage to the deck, but only just. He was in the process of climbing aboard. He stared coldly at Hetty before he stared coldly at me.

'Why, hi, Walt,' I chirped at him.

'Imagine running across you in a place like this.'

'Just imagine,' Kage said bleakly. He took Hetty's arm to help her back to the rocks. I knew by the way he glared at me he was hoping I'd slip and break something vital in my fall.

'I was showing Mr Muller over the boat, Walt . . . '

'I've got eyes,' Kage said thinly. 'Did you never see a cabin cruiser before. Muller?'

'Oh, I did, sure. As a matter of fact I've got one of my own that I visit about twice a year. Over on White Surf Bay. I didn't see you when I arrived on the beach,' I added, wondering how the guy had made it down here so quickly.

'I walked down to fetch Hetty,' he told me. His eyes went back to his sister and ran over her from tip to toe. If he hadn't been my client I'd have busted his nose for the dirty thoughts I could see crawling through his mind. 'The cook has lunch ready and I didn't want her to miss it,' he added abstractedly.

'You can say that again!' Hetty said

enthusiastically. 'I never was so hungry in my whole life.' She glanced at me as she spoke and Kage missed the wink of meaning she tipped. 'Well, exercise does give you an appetite, doesn't it, Mr Muller?'

'Given half a chance to exercise I bet I could work up to a good appetite,' I told the dame.

'You're welcome to stay and join us,' Walter offered. 'I take it you would have finally gotten round to seeing me at the house,' he appended dryly.

'I would have been at the house already if I hadn't spotted your sister and displayed my interest in boats. The cabin is very nice and I fell for the couch especially.'

We went on to the Jag and Kage betrayed his uneasiness at bumming a ride up the cliff path.

'It's highly dangerous,' he averred. 'You really should use the proper road, Mr Muller.'

'Maybe private detectives prefer to live dangerously,' Hetty giggled coyly. 'But I'm not a bit frightened of riding in your

car. You look so cautious and careful and — and, well self-contained, I guess.'

'That's me right down the line,' I said and hoped Walter didn't notice much of the bitterness in my voice. 'But so long as we're all covered by insurance what do we have to worry about?'

Kage gave me a hard glare at that. He piled into the car first and was followed by his sister. My hand stroked her thigh accidentally and she reacted with a tiny delicate shudder of anticipation. Our eyes locked and held before I broke off the huddle and settled myself back of the wheel.

'Take it easy now,' Kage breathed nervously. The guy's face was so red on the drive up that I figured he had held his breath in all of the way. I stalled at the front door and let them out. The door opened and the butler had a long puzzled gander.

'I could always call back again after lunch, Walt. I mean, if the cook has made preparations only for two . . .'

Kage wouldn't hear of my leaving. He took me into the lounge for a drink while

Hetty disappeared to dress. The last I saw of her was her trim hips wiggling their disappointment.

With a glass in his hand Walter took a chair opposite me and waited expectantly.

'Well,' he urged after a minute. 'You have something to report, I gather? I rang your number late last night, but your man said you wouldn't be home until morning. Would I be right in construing that your absence was related to the investigation you're engaged in?'

'Roughly speaking, you would, Walt. It might interest you also to hear that I was within a hound's growl of your wife last night.'

Kage said, 'What!' on a high note, his fingers tightening on his glass when it threatened to fall. 'But if you were that close how did you allow her to get away from you again?' he cried.

'Now hold on a moment, chum,' I said slowly. 'You're not to suppose for one second that I go around snatching folks with or without their consent. I never was a body-snatcher and I'm not starting this late in life.'

'It doesn't say you haven't got an eye for the female form as displayed by Hetty only a short time ago,' he came back tartly.

'But Hetty was showing me nothing but the boat — '

'Let it ride,' the guy said tautly. 'If you aren't exaggerating will you please explain how you came to be close to my wife and allowed her to get lost again. I assume you did lose her in the long run?'

'It was a pretty long run at that, Walt. All of the way to Culver Springs and beyond.'

'You're saying my wife went to Culver Springs?'

His tone implied that his surprise would have been no greater had he heard his wife had stowed away on a space craft heading for the moon.

'You know Culver Springs?' I said.

'Of course I know Culver Springs! A street of houses. You couldn't get a decent meal. You couldn't get a decent drink, even. Are you certain it was my wife you just missed making contact with, Mr Muller?'

'Reasonably certain.'

'Well then, get on with it, man! Tell me everything. Tell me the whole story from the begining.'

He was asking for it, so I started in to tell him.

'It all began right here at Clifftop,' I explained and watched him closely while I talked. 'Finding out what I found out was as easy as tying your shoelace, Walt. In fact, if you'd exercised the minimum of initiative you could have culled enough clues and taken enough moves to land where I landed.'

'Oh, please do stop beating round the bush, Mr Muller! I could have done a certain amount of things on my own, I suppose. But you're a detective, aren't you? You're qualified for this sort of thing.'

'I began with the butler,' I said. 'He was able to tell me he had summoned a Green Top cab for your wife on Monday. The manager of the company in turn was able to tell me the name of the cabbie who'd come here to pick up your wife — '

'Excellent, Mr Muller, excellent! Oh,

133

yes it all sounds amazingly elementary to you, but to me it represents the smooth functioning of an intelligence trained to follow definite patterns. Continue, please . . . '

I did, wondering if I really was underestimating myself and selling myself short as a result. I explained how the trail had taken me to Culver Springs and from there to the cheap motel run by the guy called Petersen. Kage's features settled into a pained mask. His eyes clouded and he forgot all about the drink he held in his hand.

'A cheap motel!' he marvelled. 'Could it be that darling Gloria is mentally disturbed?'

I didn't even start to answer that one. I plodded on doggedly, telling Kage how his wife had registered as Judith Hazard, how there had been a light in the apartment she'd rented when I arrived, but how the light had been extinguished five minutes afterwards when I went to call on Gloria.

'You waited five minutes!' Kage ejaculated. 'And that was where you slipped

up, Mr Muller? But why did you wait those five minutes before moving?'

'I had to wash my hands, didn't I? Be reasonable, Walt, like a good pal.'

'Of course! And naturally you didn't dream she would have gone in such a short time. She — she had gone when you finally arrived at the apartment?'

'I figured she had.'

'What! Oh, no, you're not going to tell me — '

'I'll tell you when you give me a chance. Like you said, I visited finally. The door was locked. Nobody answered when I pressed the buzzer. To cut out some of the irrelevant details, I went round back and got in through a window. It was a bedroom I entered. There was a powder compact on a dressing table, a coat and a dress in a closet. And here for the purpose of checking, Walt, does your wife own a pink and yellow dress?'

Kage thought it over briefly. He shook his head.

'I can't say she does,' he said and lowered his drink.

'It must have been one she bought at

the clothing store in Anfield. You see how easy it is for even me to get mixed up, Walt. The rest of the story is a trifle hurtful. I found it so and I dare say you'll agree with me.'

I told him about going into the living room of the unit, about the feeling I'd had of not being alone. About the man's hat I'd seen on a chair a few seconds before I got slugged from behind.

Kage's reaction to the news was right in character. He covered his face and groaned. Then he hiked off to the bar to fix himself another drink. When he sat down again his mouth was slack and his eyes had a vacant look about them.

'My wife had a man with her in that lousy cheap motel apartment,' he said in a hoarse whisper. 'Oh, no! Oh, Gloria!'

Oh, hell, I thought, without saying so to Kage. I gave him a minute to pull himself together. He did it with the aid of the contents of his glass.

'I'm not saying your wife was there with this man, Walt. The place was in darkness. It was difficult to see.'

'But you are suggesting there were two

136

people present when one of them attacked you,' he groaned.

'Well, there appeared to be,' I said reflectively. 'I could be wrong.'

'What does it matter! If there was a man in the motel unit my wife had rented she must have met him. She must have known who he was . . . '

Here was reasonable deduction if anybody wanted to buy it. I couldn't help feeling sorry for the guy in a way. Well, he had been an actor, hadn't he? It wasn't altogether his fault if he interpreted real life in terms of ham.

'You were attacked to prevent you finding out too much, Mr Muller. You were attacked to give them time to pack up their dirty bags and flee. What am I going to do now? Just tell me what I'm going to do now, Mr Muller?'

It was his question and he had every right to put it to somebody. I wished I could give him a good answer. I couldn't give him any kind of answer without putting a question of my own to him.

'Where do I take it from here, Walt?' I said bluntly.

He laid down the empty glass and stared at me like I'd taken leave of my senses.

'You surely wouldn't run out on me at this stage of affairs, Mr Muller?' he asked in horror.

I could and I might and I felt like saying so to the guy. After all, it wasn't his head that had been bounced around last night. And he was so busy being dramatic over his own troubles that he couldn't spare a thought for the injury I'd suffered.

'You want me to continue searching for your wife, Walt?' I said at last.

'Of course I do, Mr Muller. I want you to search harder than ever. I want you to find her, to bring her home here to me. After we've had a civilized discussion she can go her own way if she pleases.'

'Okay,' I said and put a match to a cigarette. 'For the moment we'll assume she met this man at Hillview Motel. We'll assume also that she knows who he is. What I need to ask you is, can you give me a clearer picture of who he might be?'

'Luce!' he snarled violently. 'Marvin Luce. The chauffeur, Mr Muller. I've

been blind. Blind, I tell you! But how was I to know there was anything between them?'

'You're dead right,' I said wearily. 'How were you to know there was anything between them?'

Kage was making for the bar again when the door of the lounge opened and the butler announced that lunch was ready.

The ex-movie actor showed me where I could freshen up before eating, then he joined Hetty on her way to the dining-room. When I left them they were going into some kind of private huddle.

8

The meal turned out to be one of those occasions that, with a little luck and the passage of time, become nothing more significant than a bad memory.

Walt Kage ate like he had a duty to eat but was finding the entire experience as enjoyable as a kick in the teeth. Hetty Kage, demure and touchingly virginal in a pale yellow linen dress, kept her head averted and her eyes down as though something was about to fall on us, and what right had we to complain when we were asking for the worst to happen in any case?

Finally Walt flung his fork to the table and caused his sister to jump a foot from her chair. She coloured and brought her gaze to bear fully on the handsome and blank-eyed ex-actor.

'Really, Walt!' she erupted. 'You play another trick like that one and you can eat by your own self in future. So Gloria

has gone off with another man? So what? It doesn't say the world has to run down and we've all got to climb into a hole or something.'

'One does not climb into a hole,' Kage reminded his sister in an icy tone. 'One falls into a hole. One climbs out of one.'

'Now he tells me!' Hetty retorted and glared at him. 'What the hell does it matter one way or the other? A hole's a hole in anybody's book, and if you don't get out of the one you're in pretty soon, they're going to be carting you away to a bughouse.'

For an instant Kage appeared to teeter on the verge of a vast explosion. He half rose from his chair, a knife that he'd gathered up from the table clutched in his hand. His mouth opened and closed a couple of times. He wheezed breath noisily and plopped down on his chair again.

'I'm sorry,' he said. 'Please forgive me, Hetty. You too, Mr Muller. I guess I'm a trifle distraught.'

'A trifle!' Hetty echoed. 'Oh, boy! Now who needs to look up the meaning of

words in the dictionary? I'm telling you, brother mine, if I had gone to the lengths of hiring a detective — which I wouldn't do in my sane senses — I'd certainly let him do all the worrying. After all, you are paying the man to carry your burden. You'll agree that what I say is true, Mr Muller?'

'By and large I'd agree,' I said carefully. The dame might imagine she had to strain herself to impress on her brother that I was nothing very special in her eyes, but if she was working round to sticking anything into my back then she was travelling on her own as far as I was concerned.

What answer Walt might have given was precluded by the door opening and the butler putting his head through.

'A telephone call for you, Mr Kage,' he announced.

'A 'phone call!' the ex-movie star babbled. 'Who is it calling? What does he want?'

'Could be it's your agent, Walt,' I said. 'Well, what if it is? You might as well give free rein to your talents someplace where

they'll be appreciated.'

The guy gave me a look hot enough to slice steel before flouncing from his chair and heading from the room with the butler. When the door had banged behind them Hetty sighed heavily.

'It wasn't necessary to rub salt in the wound, Paul. Poor Walter really is distraught.'

'Sure he is,' I growled. 'And then some. And speaking of salt, baby, you weren't exactly sugaring him up yourself a moment ago. Talk about the Mad Hatter's tea party! If cute little Alice had ever wandered into this version of Wonderland she'd have puked all over the March Hare's whiskers.' I rose from my chair as I spoke and Hetty bunched her fingers into fists.

'Where are you going, Paul?' she demanded feebly.

'I'm going to see if I can find darling Gloria, baby. When and if I do find her, I'm going to suggest that she moves a thousand miles further away from this joint than she is at the moment of finding.'

'But that's mutiny or something of the sort.'

'Not in my language it isn't, cutie. It's what I call being plain smart. If I was cooped up in this kook-shack for two days on the trot you know what I might catch myself doing?'

'Don't spoil it all by telling me,' Hetty sneered. 'Just let me guess. Walter would have the most ravished sister ever to come out of the Barbary coast.'

'Let me tell you something about the Barbary coast, beautiful — '

'Don't bother!' Hetty bit back. She lunged to her feet and flung her own fork to the table. It clattered on a plate and went spinning to the floor. 'Go and collect another crack on the head, Mr Muller. Yes, Walter told me how you traced Gloria to a shack in the hills and forgot it was your brains you're supposed to use to solve a case and not your skull.'

'A lot you care what happens to my skull,' I said bitterly.

'You should have been more careful. And maybe you told Walter your own side of the story.'

'What would that come out as, if you got somebody to translate for you?'

Hetty's eyes danced with satanic glee.

'Oh, I'm not saying you didn't run Gloria to earth in a shack. Well, she's had as much experience at shacking up as any other dame has. But there I could put a twist in your tale, Paul. You might have given Gloria the wrong ideas regarding your night visit. The way I see it you could have been slinging your sex-appeal around when Gloria slung a loaded sock to the back of your ear.'

'You've implanted this nasty thought in Walter's innocent mind?'

'Do me a favour when you're feeling magnanimous, Paul! I'm not completely doggie species, you know. When a guy needs a break I give him a break.'

'No kidding?' I jeered. 'Which is what brother Walter has been doing to his virgin complex all these years.'

I ducked when she flung the first plate at me. It hit the wall and the contents spattered here and yonder. I was at the door and had it open when she launched the second offering into orbit. As fate —

145

or the guardian angel of private eyes — would have it, brother Walter was on his way to the room when the plate arrived on his chest and he staggered backwards in a haze of blue air.

'Have you taken leave of your senses?' he roared at Hetty, picking crockery from his shirt front and coming on into the room.

'Don't blame me; blame Muller.'

'You're bound to be making a joke!'

'Sure she is, Walt,' I comforted the guy. 'Your sister figured I didn't have nearly enough tricks up my sleeve, and there we were, practising, when the plate suddenly slipped.'

'Two of them?' Kage gobbled, his gaze fiery with blatant suspicion.

'Like I said, Walt, you've got to practice to make perfect. Isn't that so, Hetty?'

'Utterly so, Mr Muller. Trouble with practising with plates, things can get broken. From now on I'm going to take up knife-throwing. Nobody is any the wiser when you make your first couple of mistakes,' she added blithely.

'I've got to go now,' Walter was saying

in a sort of trance. He'd forgotten all about the plate-throwing incident, and there was an air of distraction about him that meant he was really on the point of flipping his own plate or that the 'phone message he'd taken had jolted him badly.

'You've got to go where, for heaven's sake?' Hetty queried impatiently. 'You don't usually go out directly you've had lunch, Walter.'

'You must excuse me, Mr Muller,' he said as if Hetty hadn't spoken. 'I'm in rather a hurry. There's no reason why you can't stay here for a while and chat with my sister. Perhaps you could think of something interesting you have in common.'

'Like what, for the love of mike?' Hetty cried. 'Walter, are you sure you are one hundred per cent?'

'Like boats,' Kage said with a smug detached grin that made me want to do something real intriguing with him — such as having him go down on his hands and knees and pick up his teeth from the floor. 'And yes, I do believe I am one hundred per cent.'

There was no time to say good-bye to the guy, even. One minute he was there and the next he was half way to minding his own business. I didn't go for this change about face at all, and when I looked at Hetty her equally blank stare told me she was sharing my mystification.

'It must have been the 'phone call that did it.'

'That's what I call a pretty bright remark, Paul. I've seen Walter in many moods. I've seen so many sides to him I get the feeling sometimes that one of us has a split personality. Split into about two hundred pieces at least ... Where are you off to?' she snapped when I spun on my heel and swung to the door. 'If you're planning on following Walter you're making a big mistake, Paul. He'll be a very angry man when he finds out. And aren't you becoming mixed up in your ambitions? You're not supposed to be tracing my brother. You're supposed to be engaged in tracing Gloria. I've got the best suggestion of all, Paul,' she added eagerly. 'Why don't we make the most of Walter's departure and go find a

cabin to play in?'

'Later, baby,' I told her reluctantly. 'But duty calls and I must go.'

'You're just too corny to be real, Paul Muller,' was Hetty's parting broadside. 'And for all I know you only wanted me to strip off my costume so you could dry me down.'

As a dame must, she had to have the last word, so I let her have it and went on along the hall to the front. I was almost at the door when I heard a sibilant hissing from another doorway and turned to see Josie wiggling her forefinger at me.

'Mr Muller . . . '

'Yeah?' I said when I'd joined her. 'You really shouldn't make such noises, Josie. Last time I reacted to a sound like that I whipped out my gun and blew the head off a snake.'

'Well, at least it must have been a change from rattle-snakes,' the maid said coolly. 'I swear the whole world is full of them. You haven't found Mrs Kage for him yet?'

'Not yet,' I said patiently. 'But I am

doing my very best, I promise you. Now, I'd better — '

'He was talking to her, Mr Muller,' Josie broke in quickly.

I did a double-take and caught her shoulders when the message clicked home. 'He being Walter and her being Gloria?' I queried excitedly.

'I wasn't meant to hear. I didn't intend to hear. She was on the telephone with him. He said Gloria. Then he said yes, yes, yes. Anything.'

'Nothing else, baby?'

'That's all, Mr Muller. And please remove your hands from my shoulders. I swear it's doing something to me that hasn't happened in ten years.'

'He didn't say where he was going?' I asked her. 'He didn't mention a rendezvous?'

Josie shook her head. She glanced down the hall in case we were being overheard. 'There's some queer stuff around this place, Mr Muller. I swear there is!'

I said thanks and left her, hustling to the front and on out to the sunshine. If I

made it fast to the Jag and made it fast to the hill road there was a chance of following Kage and discovering what was simmering on the stove. So it was Gloria who had called him on the 'phone. What had she said to him, I wondered. Why didn't he explain the 'phone call to me before he took off. Well, I was working for him, wasn't I?

I was behind the wheel and about to gun the car motor to life when I heard the muted throaty snarl of another motor. It wasn't coming off the hill road for sure. It was coming from somewhere down there on the cliff path.

I was hesitating when Hetty burst from the front door and ran screaming towards me.

'Oh, no!' she wailed. 'Paul, do you hear it? Walter has taken the path to the beach. In his car! He never did that before . . . '

'Never?' I asked grimly while pictures flitted through my mind. Pictures of a man in a car on a cliff path. Another man on another day in another car. Lauran Donovan raging to his death on the bay rocks. 'The guy must have lost his plug.'

I switched on the motor, was slewing the Jag round to face the path to the beach when Hetty hurled herself at the passenger side door, grabbing the handle and yelling while she hung on.

'Let me in! I'm going down there with you.'

There was no time to argue and I had the choice of accelerating away and hoping Hetty wouldn't harm much more than her pride when she fell, or of opening the door and allowing her to accompany me. I snapped the door open and she flung herself on to the seat beside me, her breasts heaving against the linen dress.

'Get going!' she urged in a thin taut voice. Her face was wild and her eyes glared furiously. 'I might have known the punk would lose his nerve when it came to the crunch.'

Asking her what she meant by the crack would have to keep for some other occasion. Her body dashed against me when I went into a corner and was forced to throw out the anchors. The Jag skidded madly, righted itself, straightened, and

nosed on down to the blue expanse of sea fringed by the brown sand and the grey-blue rocks of the bay.

'Hurry, Paul, hurry!'

'If he's planning on suicide it's all over but the cheering,' I grated at her. 'And what the hell does he expect when he can't trust the man he hires?'

We hit the sand on two wheels, bounced, rocked back on to four wheels. The Jag slithered to a halt at the tail of a cream Chrysler sedan. The sedan was intact and there was no sign of Walt Kage. Hetty leaped from the car a second before I did. She started running on towards the inlet. I was glancing into the car when a put-putting filled the air.

'Walter!' Hetty screamed. 'Come back. Come back on this instant!'

The cabin cruiser swept to the curve of the bay, swung to the open sea and kept on going. Hetty was crouched on the sand when I reached her. She had one hand stuffed half way into her mouth and tears were streaming down her cheeks. For the minute it was difficult to guess

whether they were tears of disappointment or fury, or maybe just a mixture of both.

'Whatever she said to him, it sure put little old Walt out to sea in style,' I murmured.

Hetty came to her feet and put her hot, tear-damp face close to mine. 'What are you talking about?' she demanded. 'Whatever who said to him?'

'I'm just making a wild guess,' I told her. 'Gloria. He had a 'phone call, hadn't he? He dashed off without stopping to give anybody an explanation — '

'You mean the caller was Gloria? But if it was, he could have said so. He hired you to find her, didn't he? And how in hell could she 'phone him if she's out there on the ocean some place?'

'Communication is a sophisticated service these days, honey. Suppose Gloria got stranded on a South Pacific island, and then supposing she — '

'Why don't you just shut up?' Hetty snarled. 'You've no more idea of where Walter is going than I have.'

'Do you have any?' I asked curiously.

She didn't answer me for a minute, just kept staring out to sea where the cabin cruiser was toiling through froth-tipped troughs. Kage had altered his course and was bearing down along the coast. Watching the dame I could read the tension in her, the doubt and indecision that were struggling with what she wanted to believe concerning Kage. I sensed something that refused to jell with the pattern I'd familiarized with. For the moment I couldn't put a finger on it.

'He must intend to stop somewhere along the coast,' Hetty said presently. 'But where, that's the damn question? Do you know this stretch well, Paul?'

'Reasonably well.' I could see what she was thinking about then. I was thinking on the same lines myself. 'There are at least a hundred places where Walt could put in,' I told her. 'You really don't have a clue on the subject?'

'If I had, wouldn't I say so? How long would it take to find him when he does put in?'

'Maybe a day would do it, honey. Two possibly. Why the big steam anyhow? He's

your brother, isn't he? He wouldn't just take a boat trip and leave you. Even if he did, you can think about him comfortably up there in the house.'

She laughed suddenly and swung to face me again. There was no trace of the tears in her eyes.

'Of course! What am I worrying about? Walter's an adult and can fend for himself. And as I said before, he wouldn't take kindly to either of us prying into his business, whatever it is.'

It was this last which occupied my mind on the journey back to the house on the cliffs. When we reached the front door Hetty grabbed my hand and invited me to come in and amuse her for a while.

'There isn't much you can do until you hear from Walter again, Paul. If he did hear from Gloria, then there mightn't be any case for you to solve.'

'Thanks for the kindly thought, baby. But I've got to drop off at my office to pick up the afternoon mail.'

She held on to my fingers for another few seconds, then sighed and released

them. 'Make it soon, Paul,' she whispered invitingly.

She was standing there, gazing after me, when I revved up the Jag's motor and took the high road winding through the hills.

9

I went home and raised my West Hollywood contact on the 'phone. 'Muller here again, Doug,' I said to Douglas Willmer. 'Any chance of doing another favour in the interest of the Old Pal league?'

Willmer hesitated for a moment. 'It doesn't have to be Walter Kage this time?' he asked dubiously. 'You can strike a few sparks around certain people, Paul, and nothing very much gets singed. But too many questions could arouse curiosity and light a fire under Kage maybe. I don't have to tell you what newspaper guys are.'

'I know what newspaper guys are. What are you running these days anyhow — a correspondence course for ageing philosophers? What did Kage ever do for you that you've got to metal-polish his halo? We're pals, ain't we?'

'Ha, ha,' Willmer said. 'Okay, Paul,

drop your brick into the pool and let's see what happens.'

'I'm seeking a little more info on Walter. Maybe you can help me. If you can't, maybe Danny Royal might donate another paragraph.'

'You said old Walt had hired you to find his wife, Paul?'

'That's right. But the picture has become somewhat puzzling. Now do you or don't you, Doug?'

'What choice do I have?' Willmer grunted. 'You're just the type of ghostie that might want to haunt my dreams nights. I go for the blonde brand of nightmare, if you see what I'm getting at, Paul.'

'Sure sign of an unshakable mother complex, Dougieboy. But you've got it and I haven't. How long do I stick around?'

'Don't call us, Paul, we'll call you,' the guy said and hung up.

It was one of those hotter than hot days when even your brains seem to be frying in your head. I used a shower to cool off, my shaver to trim down my chin fuzz and

make me look more beautiful. I wondered what it was about me that got Hetty going. But then one should never look gift horses in the mouth, whatever in hell that's supposed to mean anyway.

I went back to my office and thought over this and that. I started right back with Lauran Donovan and did a re-run up to the present state of affairs at Clifftop. There were more wild ideas in my skull than I was able to cope with. But would I have to cope with them for very much longer? At this exact moment Walt Kage and his wife could have decided to make amends and were cooing some place like a couple of lovesick doves.

It was ten minutes later when the 'phone rang and Douglas Willmer spoke to me again. 'I've got a straight line with Danny Royal himself, Paul. Want to go direct to the fountainhead for the gas on Walter? It might save my ears getting heated up if the passages do have to come out in purple ink.'

'You're a good pal, Dougie-boy. What are you?'

'Don't drive it into the ground,

gumshoe. Just stay off my tender toes for a day or so. I do have a business to run, if it didn't occur to you.'

A short time afterwards I was speaking with Danny Royal, the guy who had managed Kage's bookings with the movie-makers. He had a drawling voice that reminded me of Jimmie Stewart wakening up in the morning.

' 'Lo, Mr Muller,' he said. 'Hear you're using a long rope to bring Walt's wife back to the home corral. Naturally I'll be happy to do what I can. But my latter-day knowledge of the guy is limited, you understand.'

'Of course I do, Danny,' I said. 'What I'm interested in at the minute is Walter's family tree — '

'You surely must be joking, Mr Muller!'

'Seriously, Mr Royal, did Walter have any blood relations you ever heard of?'

'You mean like in mother and father?' Royal prodded in a voice carrying overtones of a sneer. 'Well, I — '

'How about brothers and sister, that sort of stuff? Did he have any?'

'He did have a sister . . . ' Royal said cagily.

'Oh!'

'You sound disappointed. Yeah, he did. I remember him talking about her. She used to be something of an actress herself. Started off in amateur productions, graduated to night club stands — '

'Never any further?'

'Not really. He pressured me into getting her an audition one time. I did too. But who wants to look at a flat-chested female with big hands and two feet of proportionate dimensions?'

'You're still talking of Walt's sister?' I said hoarsely. 'He didn't have two of them?'

'Two of what, Mr Muller? Oh, I get it — sisters. Not that I ever heard of. The one he tried to get into the limelight was enough in any man's book.'

'What was her name, do you recall?' I asked next.

'Let me see now. Hilary — Betty — something like that, I believe. I'm not exactly sure.'

'How about Hetty?'

'That's it! Hetty. Well, some things you like to remember, and some you'd much rather forget.'

'Thanks a bunch, Danny,' I said gratefully. 'And all this is between us and the four walls?'

'It's a pity,' Royal said reflectively. 'A godamn dirty shame. I could have made that Walter Kage in a television series.'

'I'm sure you could, Doug, Shows what a gilt-edged birdbrain the chump is. Happy landings and all that stuff. Good-bye for now, Danny.'

'A godamn dirty shame,' Royal was saying musingly when I hung up on him.

I smoked a cigarette and did a lot of permutations, then I pulled Harry in and told him to listen closely while I cleared my chest.

'This is one of those times when I require a second opinion, pal. But I'd better warn you that it doesn't make the most interesting reading.'

Harry just sat there and said nothing until I'd run down. When I had he coughed delicately and studied the floor at his feet for a minute.

'And now you want my assessment, Mr Muller?'

'You mean you can make sense out of it all, pal?'

'I'll try,' the guy said calmly. 'Mr Kage hired you to find his wife, but so far you haven't quite succeeded.'

'Quite is the word, Harry, and don't you forget it. I did arrive at Hillview Motel when she was in residence there under an assumed name, and very nearly managed to get my hands on her. I would have too if I'd acted real fast. I guess that must be the trouble with me. I'm too ready to underestimate the cunning of some dames.'

'Your hands on whom, Mr Muller? Gloria Kage? You were led to think so, but the woman you traced to Hillview Motel registered there as Judith Hazard.'

'I've just told you as much,' I said irritably. 'Hazard was Gloria's maiden name. She didn't want to register as Gloria Kage, so she did so as Judith Hazard.'

Harry took my peevishness on the chin without blinking.

'But you don't have one shred of proof that the woman who went to the motel and checked in as Judith Hazard was in reality Gloria Kage,' he rejoined coolly.

I didn't say anything for a long time. I just sat there and stared at Harry. A chat with him often does things for me when I can't see the wood for the trees. He had certainly triggered off a lot more cogs in my head with a vengeance.

'You're suggesting, pal, that I wasn't following Gloria Kage at all, but some other dame? You're suggesting that Kage led me up the path, that the butler who called for the Green Top cab led me up the path? In short, you want me to believe it wasn't Kage's wife who left Clifftop on Monday, took a cab to the railroad station and finished up at Hillview Motel? But if that wasn't Gloria, who was it? What is the purpose of the runaround? And don't tell me my guilty conscience is conjuring up dames who aren't really there.'

'You must remember, Mr Muller, that I'm simply speculating, taking the known facts that are available and endeavouring to make sense of them.'

'Don't stop now, Harry. The suspense will kill me if you do. Are you saying — But you are, pal, you are! What you mean is that Gloria Kage had left Clifftop before this other dame did. The chase I was led was nothing more than an elaborate hoax designed to put me on to the wrong track. The trail was too obvious to be real. So, okay, Harry, I'll buy it. At least I'll think about it. The pieces could fit. My being beefed around in that apartment by a guy — No! It mightn't have been a guy at all. The hat could have been part of the gag too, just to add the right touch of confusion. Only one point we mustn't overlook in the excitement. Kage did hire me to find his wife for him. If he'd wanted to throw his dough around he could have dreamed up a more amusing way of doing it. Also, Harry, much as I hate to prick your bubble, the guy did give me photographs of his wife. I flashed one to Petersen of Hillview Motel and he identified it as a likeness of the woman he knew as Judith Hazard.'

'Perhaps the photographs were of the woman he knew as Judith Hazard. But it

doesn't necessarily follow that they were photographs of Walter Kage's wife.'

'Now and again you stun me, Harry. You really do, pal. So I might be mixed up in enough intrigue to keep a whole police department going for a month? I do know that Kage's light was dimming at the time he quit the movie business. He's bound to have made a lot of money. But if he was prodigal with it and if the tax man was biting into the remainder — why, he might just settle for marrying some rich dame, taking out a big insurance policy on her, and dropping her — Now where would he drop her, Harry? Not into the ocean for sure. Not anywhere where she can't be found before too much time has elapsed.'

'You think he could have murdered her, sir? Afterwards — to display his concern and to create a passable alibi — he called in the services of a private investigator to prove to all and sundry that he is completely ignorant of his wife's fate?'

'It's an angle, isn't it?'

'And the woman he calls his sister,'

Harry ploughed on with growing enthusiasm. 'She is also part of the overall mystery? If you don't mind me saying so, Mr Muller, I feel that this is a case for police investigation.'

Harry could be right, I figured later. Where did Hetty of the pink bikini fit into the drama? Was she Walt's sister, and had she been taking body-building advice since the disappointing audition Danny Royal had spoken of?

It was only one of the questions in search of a satisfactory answer. If the woman who checked in at Hillview Motel wasn't Gloria Kage, then who was she? Walt Kage's real sister?

If half of all these speculations were true it meant that a plot was brewing and that everyone at Clifftop — barring none — was in it up to his or her neck. Somehow it didn't jell. The pieces of the puzzle I'd gathered had to fit into a different pattern. And maybe there were more pieces to be found before the picture would emerge as meaningful and acceptable.

The burring of the 'phone broke in on

my thoughts. I lifted the receiver and heard Walter Kage's voice in my ear.

'Mr Muller, I've got to talk to you,' he said thickly. 'I rang home first of all to see if you were still there. When I learned you had left I thought of the next best thing — '

'You mean you have decided to tell me the full truth, chum?'

'What truth?' Kage bellowed. 'What the hell are you driving at, Mr Muller?'

'Why ask me?' I growled. 'Why don't you ask my psychiatrist? He says if I spent less time listening to kooks and paid more heed to my protective instincts I wouldn't have a thing to worry about.'

'Mr Muller, have you gone out of your mind! I've hired you to work for me, haven't I? It gives me the right to contact you as and when I wish . . . '

'Okay, okay, Walt. Don't bust a seam. Where are you calling from if you're not at Clifftop?'

'Dawson's Pier,' Kage said. 'By boat was the shortest route from home. I'm sorry I ran off and didn't stop to explain. Could you come here or shall I go to you?

There's a car rental close by.'

'Yeah, you do that, Walt.'

'What?' he almost screamed.

'Come to me,' I said and hung up.

It was thirty minutes before he arrived. Even with a load on his shoulders he didn't forget to make the perfect entrance. He strode into my office, halted and passed the back of his hand across his forehead. It was a scene he had played in *Desert Dirge*. His water canteen had sprung a leak and there he was, with nothing between him and the hovering buzzards but fifty feet of cloudless sky.

I fixed him a drink to reassure him, told him to sit down and make himself comfortable.

'Comfortable!' he babbled. 'I'll never be comfortable in my whole life again. Were I not the most self-controlled of men, Mr Muller, the bastard would be stone dead at this very instant. I could scarcely keep my hands from his neck. I could scarcely refrain from lifting a bottle and wiping the smug sneer from his greasy face!'

'Who?' I said and put the drink into his fingers.

'Marvin Luce, that's who!'

'It was Luce who rang you up at home while I was there?'

'Yes, it was. He said he wanted to see me immediately. He said to come to a bar at Dawson's Pier. He said the cabin cruiser would be the fastest way to reach him. He told me that I mustn't tell anyone where I was going or whom I was seeing.'

'You mean you did tell someone and spoilt everything for Marvin?'

'Oh, don't be juvenile, Mr Muller. The first thing I thought of, naturally, was Gloria. Well, she could have been with Luce, couldn't she?'

'But she wasn't?' I urged when he stuck his nose into the glass.

'It was a trick,' Kage grated when he had gulped off the dregs. 'A dirty, unfeeling trick. He must have learned that Gloria had left home. How he did I have no idea. Certainly there has been no mention of it in the newspapers.'

'No thanks to you and Muriel,' I said

dryly. 'If anybody should draw credit for being discreet in this battle of nerves it ought to be the cops. So Luce heard your wife had taken a powder. What did he want to make out of it?'

'I don't know. That is, I'm not sure. All he did was drop veiled hints. He knew something I would be greatly interested to hear, he said. It would be in my best interests if I paid attention to the information he was in a position to offer me.'

'He was going to tell you where Gloria is at? Didn't you trust the guy or something?'

'Trust him! I wouldn't trust that dirty bastard out of my sight, Mr Muller, and that isn't far. He didn't state anything specific. All he would divulge was the fact that he had information, and that it was available to me — at a price.'

'I figured there had to be a catch, Walt. And of course you figured the same. How much?'

'Ten thousand dollars,' Kage bleated. He looked longingly at my visitors' bottle

and I took the glass from him to freshen it up. 'What would you have done in similar circumstances, Mr Muller?' he said when he'd dipped his nose and brought it out again.

It was a difficult question and I said as much to the guy. I also said that he must have had some idea of what brand of news Marvin Luce was putting on the market.

'That's just the point. I didn't. I asked Luce if he knew where my wife was? He refused to give me a straight answer. He said he had an item that was worth ten thousand at the very least. If I wasn't willing to meet his demand then I would just have to put up with the consequences.'

'The consequences? What was he beating around? Walt, you don't suppose that Luce could have kidnapped your wife and is holding her to ransom?'

The guy blinked like the idea had never occurred to him. Then he gave me a feeble grin. 'But that is ridiculous, Mr Muller. You traced Gloria to that cheap motel. She checked in of her own free

will — I know! The pair of them could be hatching some plot. Not satisfied with running off and leaving me, my wife is bent on subjecting me to the most exquisite torture.'

On that note I got up to fix a drink for myself. I felt I needed one about then. Why should the guy's wife want to subject him to torture — exquisite or otherwise — I wondered. I asked him as much.

'I don't know,' he groaned. 'I just don't know. You'll have to get to the bottom of it, Mr Muller. Find my wife! Find out what it is that Luce is talking about.'

'You could have paid him ten grand and taken your chances, Walt.'

'Pay ten thousand dollars to that scum! That nothing!' The very thought of it seemed to make the guy sick.

'He didn't say where you might contact him if you changed your mind?'

Kage shook his head. 'He knows where I live. He might try again.'

He might at that. Next I asked Walt if he'd tried to follow Luce when he left the bar on the pier. How could he follow

him without a car?

'It shows how cunning he is. He told me to use a boat. I couldn't drive around town in a damn boat, could I?'

It was a good point. It raised another problem to be solved. I didn't say so to Kage. To have done so might have landed me with more ex-movie actor than I could stomach in a single session.

It occurred to me then to bring up the subject of his sister, Hetty. I could face him with what I'd learned from Danny Royal and demand that he render the whole thing to a digestible form. On second thoughts I decided against it. If Kage was playing for high stakes there was no knowing how far his ambition would take him.

In the meantime there was one solid fact at least to consider. He had hired me to unearth his wife. Was I still willing to go ahead and search for his wife?

'You won't let me down, Mr Muller? When you discover Gloria I'll see that you're well taken care of.'

There just had to be gold in his promise somewhere. I said I wouldn't let

him down. I said he was still my client. Then I asked him politely if he would mind going away and letting me get on with his case.

10

I drove out to Dawson's Pier and pretended to be an old friend of Marvin Luce who was anxious to renew our acquaintanceship. I might as well have broadcast that I was after Luce with a loaded gun for all the good it did me. Nobody had heard the name Marvin Luce. What was he anyway — an act that got away from a circus? was a sample of the milder form of wit I encountered. I'd almost covered the entire vicinity before I struck oil in one of the dingy waterfront bars.

'Yeah, I did have two strange guys in here,' a stringy garrulous type barhop volunteered after he'd cleared his throat a couple of times and quit looking mysterious when I showed him a five-buck come on. 'I couldn't tell you who they were, though,' he added after he'd slid me out a drink. 'They weren't regulars. Well, I do get to know all the regulars, bums, winos,

etcetera, etcetera, and like I tell you, a coupla strangers stick out about half a mile.'

'Could you describe them?' I asked patiently.

'I could try, couldn't I?'

He did too, and his first description fitted Walter Kage down to the last dramatic arching of his elegant eyebrows.

'Got a feeling I saw him before somewhere,' the garrulous type barhop ran on. 'Not in here, you must understand — '

'Maybe you saw him in an accident one time,' I suggested helpfully. 'He got run over with a car and you went to watch when you heard the screaming.'

The guy opened his mouth to deliver a considered answer, then his mouth twisted and he sneered at me instead.

'You some kind of funny man, mister? Because if you are, you're in the right quarter to get a real big laugh — if you can still laugh with all your teeth broken into tiny pieces.'

'Skip it, palsy. I didn't come here to have dental treatment. How about the

other guy — the one that didn't get caught up in a car accident?'

The barhop described him too. He described him the way I'd heard Marvin Luce described. It proved one thing at least. Walt had been meeting Luce here and not his wife. It showed that Josie back at Clifftop hadn't been listening as closely to the 'phone conversation as she'd imagined she had. Gloria's name could have been mentioned. It must have been mentioned or she wouldn't have said it was. But it was Luce speaking with Kage, and Luce who had made the rendezvous here at the waterfront.

No, the barhop had never seen either party before. 'I told you, didn't I?' he said.

I said sure and thanks and left him. I went back to the Jag, drove through midtown to the northern suburbs and finished up at the modest villa where Dickie and Muriel Chalmers lived.

Muriel wasn't busy with her grass shears this time. She answered my ring on the front doorbell wearing a faded blue dress and an apron tied around her

179

skinny waist. Her cold eyes swept over me while her mean mouth tightened up like a rat-trap that hadn't caught anything in a long time, and was hungry as heck.

'What do you want now?' she said for openers. 'Don't tell me that you've found my sister, because I know you haven't. I was in touch with Clifftop a half hour ago and you're as far away from finding Gloria as you ever were.'

'You mean you're not going to ask me in and invite me to share a can of beer, even?' I said in a disappointed voice.

'Oh, come on then,' she snapped and stood aside for me to enter. 'More questions, I'll warrant. All you private detectives seem good for is ogling over-sexed women and asking questions. You get your money for old rope is my estimation of your worth, Mr Muller.'

She took me into the living-room, opened two cans of beer and tugged off her apron before sitting down opposite me. There was no sign of Dickie, so I concluded he was still selling stuff for the warehouse that employed him.

'This is just a simple matter, Muriel — '

'Mrs Chalmers,' she cracked back like a whip going out over the hides of a span of mules. 'And don't you forget it ever. There happen to be enough marriage casualties. Man starts off at calling a married woman by her first name, and the first thing you know you've got a casualty on your hands. I'm not saying you'd look at me twice, Mr Muller, but my old mother did tell me never to trust roving men nor the kind that try to get on a first-name footing with you.'

'Okay, Mrs Chalmers,' I butted in brusquely. 'I've taken your point and I stand corrected. Now, could we get down to the reason for my visit?'

'You really do have a reason?' she said curiously. 'You're not just bluffing everybody by going around asking them questions?'

It didn't make for a favourable opportunity to pose the query that was forming on my tongue. I revised the method of approach I'd planned. I drew out two of the photographs purporting to be those of Walter Kage's wife and the stringy-haired dame's sister and extended

them towards her.

'Would you say they bear a good enough likeness of Gloria to have folks recognize her when they see them?'

She took the photographs and studied them for a moment. Then she put them together and handed them back.

'They're pretty good,' she said. 'Is that the only reason you came here to see me?'

'They are photos of your sister, Gloria, Mrs Chalmers?'

'Of course they are.' A thought occurred to her and her brows knitted up. 'Mr Muller, I have the feeling that you're holding out on me. If you are, you have no right to. Did you show these to somebody and did the person recognize them?'

It was plain that her contact at Clifftop had told her nothing of my visit to Culver Springs and Hilview Motel. I didn't see why I should be the one to break the news. I shook my head. I returned the snapshots to my wallet and finished off my beer before standing up and giving her a reassuring grin.

'Thanks for being so co-operative, Mrs

Chalmers.' I went to the door and pretended I'd been hit by an idea when I reached there. 'Oh, yes, and speaking of Hetty Kage . . . '

'Nobody mentioned Hetty Kage,' she snapped suspiciously. 'It isn't that hussy who's lost, Mr Muller. Well, she might be lost for all I know, but I never was one to discuss the morals of other women. So you do have a bee in your hat after all?'

'Can I be candid with you, Mrs Chalmers?'

'If it'll help you to find my sister I can't see why not. But what has Hetty got to do with Gloria?'

'I'm not saying she has anything to do with her. How long has she been at Clifftop?'

The dame frowned again and her mouth knotted up at the very memory of Hetty.

'I'm not sure when she arrived,' she admitted. 'I'm not even sure why she arrived. About six months ago, I'd say.'

'What does she do for a living?'

'She breathes, doesn't she? That's about the only thing she does for a living.

I heard she used to be an actress. It wouldn't surprise me if she was. What are you going on about Hetty for? Do you imagine it was on account of her that my sister ran away from home?'

I said I didn't think so. I thanked her again for the beer and the chat. She saw me to the front door and was still standing in the doorway when I drove off.

★　★　★

The theory that Harry and I had begun to cook up had been blown apart with that visit to the stringy-haired dame. If anybody knew what Gloria Kage looked like, her own sister did. Her own sister had identified Gloria with the snapshots I was carrying around, and while it brought one line of thought to a dead end it certainly bolstered another.

I was now left with what I hoped were a handful of incontrovertible facts. Gloria Kage had slipped the leash and taken off from Clifftop on Monday. She had used a cab to take her to the vicinity of the train station. She had gone to Culver Springs

and booked in at the crummy motel as Judith Hazard. She had met a man there — and here was where a little help from the imagination was necessary to fill some gaps — the man had been none other than Marvin Luce, one-time chauffeur at Clifftop. Walter Kage had gone for this angle too when I'd given him the story of the incident. He hadn't appeared to doubt for one minute that the hat I'd seen had belonged to Marvin Luce, and Luce was the punk who'd slugged me.

At this rate of travel and at this point of observation it was plain as the nose on anybody's face that Kage's wife and Kage's butler had been in the habit of listening to the same kind of music. It gave ex-movie actor Walt the hot end of a poker and a dent in his ego, whatever it left him short of.

So okay, I said to myself. Gloria had tired of life at Clifftop with its overtones of drama and Hetty. She had decided to turn to the earthiness of Marvin Luce for the purpose of attaining a fresh perspective. So why should Walter bother with bringing her back again? Why spend his

dough on hiring a private detective to beat his brains out accomplishing something that was going to be declared redundant anyhow?

Yet another thought intruded for inspection.

If Luce and Gloria had decided to give Clifftop and the ex-movie actor the cold shoulder, what sort of game was Luce playing at on the sly? According to Walt the guy had demanded the sum of ten thousand dollars for information Walt ought to have, without explaining how he would benefit from the news on offer.

Was Gloria Kage the victim of a kidnapping plot? Was Marvin Luce more cunning and less fond of Gloria than some of the evidence I'd garnered would suggest?

I'd been setting my sights for my office but now I changed my mind and direction and finished up at the run-down building that houses The Star Detective Agency. The agency is controlled by an old buddy called Larry Stern, who is usually willing to chip in with his genius

when the occasion demands.

An ancient elevator took me to a gloomy corridor that I trod to a pebbled glass door where I rapped smartly before twisting the handle and entering.

Before me was a battered desk where a dame who was anything but battered lifted her head from a letter she was typing and gave me a blank stare.

'If it isn't little old Paul Muller come back from the grave!' she said in a blank voice that went along with her stare. 'If you aren't for real, Paul, you're one of the liveliest ghosts I ever did see. How many years has it been now? No, don't tell me! Just give me a chance to figure it out for myself. Four, maybe, come next Thanksgiving?'

'Cut it out at the root,' I said to Milly Wheeler. I crossed to the desk and gave her a brotherly peck on the cheek. She caught my jaws in her hands and gave me the full treatment on the mouth. We were floating on up to Cloud Nine when an inner door opened and Larry Stern came into the office.

'What the hell's going on here

anyhow?' he grated. 'Lay off with the necking, lover-boy. She's my secretary and I'm paying her a good salary to keep reminding her of the fact.'

'Listen to the man talk!' Milly said in a voice pulsating with pleasure. 'Gee, and it's the first time I've been kissed in months too. Ain't life tedious?'

'When you see Muller busting in like a fifth-rate heel searching for a shoe in the pants, you ought to be on your guard, Milly. Well, all right, Paul, you've made an entrance in your inimitable fashion. What is it this time? But before you even get around to telling me I'd better tell you that I've got more work on hand than I can possibly cope with.'

It was the same old story and I picked a moth-eaten chair and let the guy go on rattling his sabre for a minute. When he'd finished he brought out a bottle, three paper cups and poured drinks for the three of us. Then he took one of my cigarettes and waited for me to open the ball.

'It's an assignment you could trust to a six-year-old kid,' I told him casually,

eyeing Milly's legs and tipping her a big wink.

'Oh, yeah? Then you know what to do with it, pal, don't you? Find a six-year-old kid and let me get on with something that's around man-size.'

'You can afford to turn your nose up at a couple of hundred bucks? In that case I'd better find somebody who'll appreciate a couple of hundred bucks.'

'Doing what?' Larry said sharply when I levered myself to my feet. 'Not if it's a week's work I'm not buying it.'

'Information, buster. A dime's worth of time and expense. I'm too busy for trifles. A 'phone call here, a 'phone call there. You have access to holes in the ground. You move in circles I wouldn't be found dead in.'

'This is the day he makes me blow my top,' Larry snarled at Milly. 'This is the day I put civilization back a thousand years and murder him. You know what to tell the cops when they come to gather up the pieces? I've been aggravated beyond the limits of human endurance.'

'Why don't you just grow up and view

the scene around you from a mature point of view?'

'One more word out of him and he pushes me right to the brink,' Larry chest-thumped.

'I've got a better plan for him,' Milly gagged.

'Yeah, you would have, wouldn't you?' I griped. 'Give you an inch and you take a mile is your trouble, cute chops.'

'Turn him over to me and I'll guarantee you won't recognize him from a patch on your pants by the time I'm through,' Milly elaborated.

'A patch on whose pants?' I jeered. 'Yours, baby? Do me a favour, will you? Since when did you wear pants anyhow?'

'Oh!' Milly panted. 'If it's possible to be ravished without having a hand laid on you, somebody in this office has just gone and done it.'

'Okay, you guys,' I snorted carelessly. 'A joke is a joke, but who's going to pay us for horsing around? Do you do what I'm asking, or do I walk out of that door and never darken it again in my whole life?'

Larry sighed and jerked his head to the inner door.

'After you, Sherlock. I got stabbed in the back once and it was a hell of an experience.'

I went on into his cubby hole and took the chair at the back of his desk. I helped myself to a cigar from a humidor and planted my heels on a bundle of notes the guy had been working on. Larry winced and perched on the edge of the desk. He scraped a match alight and held it to the sole of my shoe until I shifted my feet to the floor.

'Barbarian acts demand barbarian counter-measures. And lay off Milly, will you? Every time you throw your weight around this joint she takes a week to resume her twenty-five words a minute. Okay, big brain, you've got a problem. Unload it and let me have a look at it, then get the hell quietly out of my life until I send you my account.'

He was getting more like the old Larry I knew with every second that passed. But one thing I knew I could depend on — if he said yes and he would help me out,

then he would help me out, come an earthquake or a wet Sunday.

I spent the next five minutes telling him what was on my mind. Larry took a further half minute in coming to a decision. Finally he reached it.

'All right, Paul. You're on. It might prove more expensive than you figure. If it does my account goes up accordingly. Those are my terms and you can take them or leave them.'

'Now you're quoting my clichés, pal,' I grinned. 'But you've got yourself a deal and so have I. The only qualification I'll add is the necessity for speed. The minute you have a smoke signal to make I want to be the first to get the message.'

11

By the end of the day I had tired of searching for Marvin Luce. I had covered every angle and lead that presented itself, left no stone unturned in my efforts to dig up the guy. I should have been searching for Gloria Kage, I knew. I was being paid to find Gloria, and Luce was merely an incidental. Maybe. On the other hand it could be a case of find Marvin Luce and the rest would follow as the natural order of events.

The nearest I'd come to a brush with Luce was when I ran against his name in the records of an employment agency. He had gone off the current register but I found out he'd been a bus driver, a truck driver, and only latterly a chauffeur hiring out to the people who could afford to hire chauffeurs. Before going to work for the Kages he'd worked for the Fultons out on Nob Hill. I'd gone to the Fulton mansion and learned that Luce's stay there had

terminated abruptly when Pearce Fulton discovered the guy canoodling with his eighteen-year-old daughter, Cindy.

In a way you could say it added another clue to the nature of the character. He was a bundle of no-good in anybody's book, and Walt Kage might not have been committing that big a sin if he'd given him a push over a cliff some night.

I arrived home around eight, had a meal and heard from Harry that Sergeant Tyler had been on the 'phone. Tyler wanted me to give him a buzz as soon as I came in.

'But you didn't do that, did you? I mean you didn't tell me about Tyler calling until now. Are you practising at throwing yourself into a huff or something?'

'I thought you should have a meal, Mr Muller. You've had a long day. It isn't anything very important, I'm sure.'

Harry could be right, I realized. He was in the process of making himself nice to go out on the town for a few hours. I told him to go ahead and got a Lucky going before dropping on to an easy chair and

lifting the telephone receiver. A minute later Sergeant Tyler was speaking to me.

'I hope I'm not disturbing you, Paul. Are you still involved in trying to find Walter Kage's wife?'

'Don't tell me you guys have really beaten me to the punch?'

'I didn't say so, did I,' Tyler retorted in an edgy tone. 'As a matter of fact we're taking this one with the proverbial grain of salt. Well, dames do tend to take a break now and then. What I do have to keep tabs on is the seriousness of the situation. Do you figure it is serious?'

'I don't know,' I said carefully. 'I'm not sure. I traced Kage's wife to a little motel up in the hills. She must have felt a breeze and blew before I could get within talking distance.'

'That proves it,' Tyler said smugly.

'Does it?' I asked curiously. 'How do you know it proves it? How do you know it proves anything? Why don't you come right out and admit you're sitting on your fanny while I do all the dirty work?'

'Hold on there, chum! That's no way to co-operate with a police officer. You're

hired, ain't you? You're being paid, ain't you? If we guys muscled in on your pitch and found the dame overnight, it wouldn't put more than one ostrich feather in your hat. Now I'm not getting chesty with you, Muller — '

'You do that,' I snarled at Tyler. 'You just go ahead and get as chesty as your ulcers prompt you. I've never licked a cop's boot yet and I'm not starting this late in life.'

'But, Paul . . . '

'Okay, okay! When you call me Paul it does something to my heart, Sarge. I'll give you a tinkle if I start sweating. Is there anything else I can do for you?'

'Yeah, there is,' the guy said coldly. 'You can tell me how-come private eyes ever had to be invented.'

I wasn't listening when he banged down the receiver. All I got was a faint echo as I replaced my own receiver on the hook. I puffed at my cigarette and thought about this and that. I was stubbing out the butt on a tray when the doorbell commenced ringing.

It just had to be Walt Kage, I told

myself miserably. They ask you to do a chore, pay you a retainer to lull you into a sense of your own importance, then they come thumping on your door at an hour when even the most active day-shift worker has retired to rest.

I ambled to the door and opened it. Before I could say help and go away, the visitor urged me back into the room at gunpoint. It was a big gun he was holding too, a .45 automatic that could pump seven hefty slugs while you were licking around for your dry lips.

'Mr Paul Muller.'

It was a statement rather than a question. The guy was dark and hand-some, and I suppose you could have called him greasy. He had a mop of well-oiled hair plastered back from his high bronzed forehead. He had sloe-black eyes that surveyed me from shadowed sockets. He was wearing a sleek Italian suit and suede shoes. His shirt was whiter than white and sported a neatly folded dark blue tie. He made another motion with the gun, this one to tell me I'd better hoist my arms into the air. As I did so he

197

kicked the door shut behind him. It made a dull thud.

'How long before your jack of all trades comes home again, Mr Muller?'

'Right after he finds the first cop that's working a beat,' I told him.

'Very funny.' The guy didn't laugh. 'Go over to the wall and spread your hands there.'

'I'm not heeled, Marve.'

'So you know who I am?'

'I was told what sort of smell to expect when I came inside a two-mile radius of you, Marve.'

'Very funny,' the guy repeated. 'Your Jeeves caught a bus. I passed the beat cop on the way in. Do like I told you, Mr Muller. Be a good fellah and do it quick, huh?'

This wasn't exactly Luce's line of business. He was holding the gun the way he'd seen it done in the gangster films on TV. He was using the dialogue he'd picked up from the same films. Yet there was a tension about him — maybe it was an urgency — that could easily turn volatile and dangerous.

198

I went over to the wall and humoured him. At one stage, when he stopped to pat around my legs, I was sure I could have taken him in the teeth and made him wish he'd broken the rules of common courtesy in somebody else's apartment. Something prevented me from yielding to my lower instincts. Curiosity perhaps. I was curious about then to know what the episode was in aid of, for sure.

'Okay,' he grunted and straightened. 'You're clean, I guess.'

'I wish I could say the same for you, Marve honey. You smell like you'd just popped out of a trash can. Or maybe it was nothing more sinister than a place where rats hole up.'

'Cut out the double talk,' the guy said in a taut voice. 'Take that chair and sit down. Carefully.'

He was as jumpy as an old maid that had just found a burglar under her bed. I went to the chair like he said and sat down like he said. Luce took the chair opposite me and wiped some of the surplus grease from his forehead with a white handkerchief. He did it left-handed,

making certain the muzzle of the .45 didn't waver any more than an inch from my chest.

'You're wondering why I've come here like this?'

'Am I?' I said disinterestedly. 'Tell me something more about myself, Marve. But don't bother to do it now. Make a disc and I promise to listen to it the very first time I'm feeling low. It'll keep reminding me of the way you're eating your heart out on a government rockpile.'

A nerve jumped in the guy's cheek. It backed up the original assessment I'd made of him. A sneer began to build at his mouth, but it didn't have a lot of conviction about it.

'I'm willing to make a deal with you, Mr Muller.'

'Give me two guesses to tickle my palate. If I let you shoot me, you won't beef me any more when I bust into motel apartments in the dark?'

The nerve jumped again. His lips peeled away from his teeth. More sweat started out on his forehead. He patted it off.

'You gumshoes figure you're smart, don't you?'

'Sure we're smart. Most of us grow up when it's time to grow up. There's one advantage we have over you, pal.'

His black eyes began doing things to themselves and he brought his teeth snapping together.

'I tell you, I'm willing to do a deal. Don't you want to do a deal? You're trying to trace Walter Kage's wife, ain't you?'

'You know where she is?'

'I know where she is,' he said smugly. 'It's all wrapped up in the deal. You've been asking around for me, Muller. Well, now you've got me. Do you want me to keep on talking?'

'I don't want you to, buster. But if you must, you must.'

'I can tell you where Gloria Kage is at this minute. You can go there and take her home to her husband. But first there is the small matter of reward. Financial.'

'I never heard Kage was offering a reward to have his wife back. What made you decide to throw her to the lions?

Have you grown tired of ex-movie actors' wives and are going in for something different for a change?'

Luce made a dull menacing noise in his throat.

'You classify yourself as a funny man, maybe,' he said. 'It isn't a bit funny — '

'Not for Walter Kage it isn't, pal. It won't be so funny for you either if Walt ever gets his two hands on you at the same time. Would you care to hear what he's dreamed up for you, Marve?'

'Hot air!' Luce said contemptuously. 'He had his chance when we talked in the waterfront bar.'

'You offered him his wife for a consideration and he turned you down flat?'

'Is that what he said?'

'Roughly.'

'Then he's a liar. I was offering to sell him information, Muller. It was worth every cent of the dough I asked.'

'So the information has gone off the market because Walter refused to bite?' I asked tautly.

Luce didn't answer me immediately.

He appeared to have deep and disturbing thoughts. Fear flickered across his features momentarily. His laugh was a harsh, humourless sound.

'You're trying to pick me, ain't you?'

'I'm trying to be reasonable with you, Marve honey. In return I'm asking you to be reasonable with me. Why not give me the full woeful tale, starting with the day when Walter found you and Gloria necking?'

'You think I'm crazy or something?'

'I think you're just crazy. But I think you're frightened as well, Marve. A crazy guy is bad enough. But when he's frightened as well — '

'Shut up, damn you!' he rasped and made a threatening gesture with the .45. 'You aim to keep me here for as long as possible. I'm on to your gumshoe tricks, Muller. Keep me sitting here and talking until your lackey gets back!'

'All right,' I said calmly and hoped Marve would take the hint and calm down himself. 'You offered Kage information which he refused to buy. Is the same offer open to me?'

'Forget it, Muller. I'm here to do a deal with you. A different deal. You're searching for Gloria Kage and I know where you can find her. That's all you should be concerned with.'

'And you want dough?'

'Not much. I want to float, mister. Drift. I want to do it soon. I need a few bucks to help me on my way.'

Oddly enough I believed him. He did want to blow town and he didn't want to take Gloria Kage along. He was willing to sell out the dame and have her off his back. What puzzled me was the guy's obvious fear. Fear of what? Of whom?

'How much do you want me to donate?'

'Three thousand bucks.'

'You must be joking. Do you know what Kage is paying me to return his ever-loving to the family fold?'

'I don't know,' Luce growled. 'I'm not interested. If he's not paying you enough that's your gripe. Get him to up the ante. Tell him how costs are rising. You might spend weeks, months, even, trying to track down Gloria Kage. I can give her

to you on a plate. Tonight. Right now!'

His proposition was tempting for sure, and for a minute I considered consummating the deal. But supposing I did pay him three thousand dollars? It was the exact amount of the retainer Walter Kage had paid me. True, Kage had said I would qualify for out-of-pocket expenses. But a further three thousand bucks worth?

Why not pull a bluff on the character, I thought. Pretend to him that I would think over his offer and ask him to ring me back, in the morning maybe. Then when he left me I would hotfoot after him and let him lead me to the whereabouts of the wayward Gloria.

'Well, what are you waiting for?' Luce demanded impatiently. 'I'm doing you a favour, ain't I? You can pressure Kage for enough dough to cover everything.'

'I'll have to think about it, Marve.'

'Think, he says! What the hell is there to think about? I want to get out of this mess while there's still time.'

'All the same, Marve, you will admit you've taken me on the hop. I'll need a few hours to settle, and think about it,

like I said. Give me two hours and then ring me on the 'phone. Okay?'

He sweated some more while he deliberated. Finally he nodded jerkily.

'What else can I do? But three grand, Muller. Not a buck less. In the meantime don't dream of getting smart with me. Do you get me loud and clear?'

'I get you, palsy.'

'How about a little drink before I go?' The guy suggested thirstily as he rose to his feet. 'You've got a cabinet over there. Scotch if you have it.'

'Why not?'

I climbed out of my chair and swung to the cabinet. I started to swing back when I heard a rustle of fast movement. I didn't make it quick enough. One second I was trying to grapple with the guy, and the very next I was plucking at a roomful of swirling shadows.

* * *

I had another knot at the back of my ear when I came to. I had a thick head and a mouth that tasted like the stuff at the

bottom of a dirty wash. I had, also, a homicidal complex that would never leave me until I had a chance to work it out on the guy who used to drive limousines for the Kage clan. Suckered by a rank amateur, I thought bitterly. Well, maybe it wasn't an entirely accurate assessment of my late guest. Luce might have started out in the amateur class but he was learning fast, and if he wasn't stopped soon there was no limit to the mischief he could perpetrate.

I made it to the bathroom and ran cold water over my head. There was a budding bump that would make a goose egg green with envy by breakfast time in the morning. A stiff drink helped, and with a cigarette burning I felt only half as mad with Marve. Well, you did have to hand something to the guy, and as it couldn't be a hatchet in the skull I might as well give him a modicum of credit for his cunning.

Cunning. That was little old Marve Luce with tinkling bells on. The hell of it was the character had helped himself to a drink right after he'd bopped me

and before he'd taken a powder. There was a paper cup lying an the floor to prove it.

Three thousand bucks, he'd said. I scrabbled through the petty cash until I made sure he hadn't pilfered any of it. Whatever else Marve might be, he wasn't a two-bit snitcher. Would he call me back as he'd said he would? I didn't know. I wasn't sure that I cared very much. I was setting fire to my second cigarette when the 'phone rang and I struggled over to reach it.

It was a dame who spoke to me. She said, 'I'd like to speak to Mr Paul Muller.'

The voice didn't belong to Hetty Kage, I knew, nor, when I reflected as best I could, did it belong to Muriel Chalmers. It left one intriguing alternative.

'Paul Muller at your service, ma'am. What can I do for you that wouldn't win me a slap on the face?'

'This is Gloria Kage, Mr Muller,' the dame said tersely. 'I know that my husband has hired you to trace me. No doubt you have heard all sorts of stories

concerning me and the reason why I left Clifftop so abruptly and mysteriously . . . '

'Oh, I have. I have! But would you believe it, baby, that I've been holding back judgment on you until I had the opportunity of finding out for myself? How about it, Mrs Kage? I could see you there, or you could see me here. We could talk things over and maybe come to some sort of understanding.'

'No,' she said firmly. 'It is utterly impossible. You can't imagine what it was like living with Walter Kage.'

'Don't bet too heavily on it, baby. But if you don't want to see me, and you don't want to go home to Walt, what is it you do want me to do for you?'

'I just want to be left alone, Mr Muller. Stop searching for me and find yourself another client. Please, Mr Muller! He threatened once he would kill me if I looked at another man. If he does get his hands on me he will kill me.'

'He will?' I said hoarsely.

'There isn't any doubt of it, Mr Muller. If you managed to trace me and take me to Clifftop you would have to share the

responsibility of murder.'

'But I fail to see — ' I ran down there when I realized I was talking to myself. Gloria Kage had faded off the scene as suddenly as she'd come on.

12

I was eating breakfast next morning when Harry brought the *Bell* in, carefully creased and folded at a column he wanted me to read.

'This should prove interesting, Mr Muller.'

It turned out it was Harry's morning for making understatements and my morning for practically choking on the piece of toast that slid on down my nerveless throat.

'Oh, no, Harry!' I panted when I'd got my breath back and washed the whole thing away with a slug of coffee. 'And to think I could have saved the guy's life had I coughed up with a measly three thousand bucks. I knew he was scared, Harry. I could see it in his eyes, in the pallor of his skin. In the furtive way he had of unloading bruises to the backs of my ears. Poor Marve! The hell of it is he must have felt the cold hand of death

sneaking up on his own self.'

'Perhaps, sir,' Harry conceded with a noisy clearing of his tonsils. 'But men who live on violence and court disaster very often become victims of their twisted schemes.'

'How true, Harry. How true.'

Harry went away and I read over the newspaper story for the second time. Late last night the police had been called to a cheap apartment house on Western Avenue by the manager of the place. According to the manager the tenant of 3C complained about some noises he had heard in the apartment next door. On investigating, the manager discovered a dead man in the apartment. The man had been slain by a heavy blunt instrument that had made mush of his skull. At the time of going to press the police were sparing no effort in an endeavour to track down the killer.

I was sweating when I flung the newspaper from me and poured another cup of coffee. It didn't need a genius to solve the case of the killing of Marve. Anyone in possession of a smattering of

the facts could put the pieces together and come up with the right answer.

Marve Luce running off with Gloria. Marve Luce getting the wind up and deciding to run off by himself. Bring on an ex-movie actor called Walter Kage. Give him the sort of homicidal urges he had been harbouring ever since he learned that Luce and Gloria were getting up to no good, add a dash of frightened Gloria, and what did you get when the ex-movie actor succeeded in tracking them to a cheap apartment on Western Avenue?

The 'phone started ringing before I could parade my wits in any kind of order. The speaker was a desk sergeant at police headquarters. Naturally.

'Mr Muller? Come to headquarters right away, will you?'

'What happens if I can't make it?' I said weakly. 'What happens if I tell you I'm in the process of packing my bags to go off on a long vacation?'

'Ha, ha,' the cop said. 'Like that, is it? But you're only making with the usual harmless gags, aren't you?' There was a

213

dark sneer to his tone that did nothing to lessen the torrent of ice-water tumbling over my spine.

'You're right,' I said bleakly. 'I'm only making with the usual harmless gags. Is Matt Bayley in charge of the case?'

'What case?' the guy chirped. 'Be a good little private detective and come to the aid of the party, huh?'

I said okay and hung up. Before leaving to keep the appointment I brought out my licence and looked at it lovingly and regretfully. It had taken me round plenty of corners, into and out of plenty of dark holes. The one consolation I had left was a picture of me in a natty doorman's uniform. I have always had a crazy yen to get into one of those uniforms. But it must be decorated with lots of large buttons and have loads of gold braid around the collar and cuffs. I made a vow to myself there and then. If the uniform didn't come with large buttons and gold braid they could find somebody else to open doors for them.

Outside it was a clear morning with nothing more than a suggestion of fog

drifting off to seaward. In an hour or so the heat would be blasting down again. But when you're in the middle of a raging furnace you don't have to worry about the sun beating down on you.

There was an air of tension around police headquarters. It hit me immediately I stepped through to the front office and was confronted with the cheerful charley who'd summoned me on the 'phone. The tension was all in my head, I suppose.

'Sorry to knock you about, Mr Muller. But the lieutenant went out right after he ordered the call for you.'

'You mean he doesn't want me after all?' I said hopefully.

'He wants you to drop by the morgue, Mr Muller. You'll find him there when you arrive.'

'I always knew that guy would end up on a slab anyhow. So I guess a bunch of fragrant flowers wouldn't go amiss?'

'Please, Mr Muller,' the guy grimaced. 'Why don't you write it all down sometime and get it off'n your chest. But it's only fair to warn you that your brand

of wit went out about the time they stopped burning witches.'

'It has to do with Marve, hasn't it, Sarge?'

'Who's Marve when he stops being a witch?' the sarge cackled. 'Amble on over to the morgue and crack gags till you're blue in the face. One thing you won't do is bore anybody stiff. They're that way already. Get it?' He babbled on the verge of hysterics. 'Bored stiff!'

'Sure I get it,' I said coldly and left him.

I forgot about witty desk sergeants on the run to the morgue. I thought of Walter Kage instead. Kage was still my client, wasn't he? And how did I know I wouldn't murder somebody too if the guy had run off with my wife?

Bayley and a uniformed cop were waiting for me. The lieutenant was chewing at a cigarette like it might provide some kind of insulation from the deadly atmosphere of the place. The cop just twiddled his fingers and pretended he had learned to live with everything — including cadavers.

'I want you to look at somebody,' was

216

the lieutenant's opening line. 'Mr Rossi, will you open that drawer again?'

Mr Rossi opened the drawer with the sort of quiet smile that convinced me he got his kicks out of scaring the pants off people. The cop twiddled his fingers like mad and turned a delicate shade of green. Matt Bayley plucked his cigarette from his lips and jerked his thumb towards the drawer occupant.

'Take a look, Muller,' he said thinly.

'I am looking, chief.'

'Take a good look when you're at it, Muller.'

'It's what I'm doing, Matt. I've got the same sensation I had when I walked into the joint. Should I feel something different when I've been here a while?'

'You know that guy?'

'I — uh — Well, I might have seen him around.'

'Don't come the close-mouth with me, Muller,' the lieutenant snarled. 'You know who he is?'

'I figure I might know who he used to be,' I said with a fixed grin. The grin didn't even begin to melt the ice in

Bayley's heart. He spoke deliberately.

'His name is Marvin Luce.'

'You've got to be kidding, Matt.'

'He ought to show a little respect at least,' Mr Rossi said in a reproachful voice.

'I know how to deal with this punk. Okay, Mr Rossi. Thanks for the help. Outside now, Muller.'

'You mean I can go?'

'The guy never heard of the word respect,' the cop said.

'Leave him to me, Raker,' the lieutenant grated. He pushed me on before him to the front of the building. He kept me moving towards the Jag and told me to get in. When I slid under the wheel he dropped on to the passenger seat and fingered out a fresh cigarette. 'Give me a match.'

'Wouldn't five minutes of deep breathing exercises be a lot better for your nerves, chief?'

'There's nothing the matter with my nerves, Muller. There is a hell of a lot the matter with your nerves. I have learned to read the signs by this time,' he added with

a sneer and puffed when I flicked a wooden match to life for him. 'Tell me all about it, gumshoe.'

'How I killed Marve, you mean? Come off it, Matt. You know killing people with blunt instruments isn't my line. I outgrew that one after my seventh victim.'

'You were searching for this guy, weren't you? Don't say you weren't.'

'What if I was?' I asked reasonably. 'I wasn't searching for him just to hang a rock on his head.'

'You were working under orders, Muller. You were hired by a guy to find Luce. That guy happens to be Walter Kage, the movie actor. It's common knowledge that Kage's wife took off and left him. The stiff in there used to drive Kage's cars. I might be dumb in my dull moments, mister, but I'm never dumb enough to miss the point when it's shoved within one inch of my face.'

'You didn't find the dame?'

'We didn't find the dame,' Bayley mimicked. He stopped puffing at his cigarette and screwed up his eyes thoughtfully, then he gave me the full

benefit of their glare. 'You're still talking in terms of Kage's wife?' he said slowly.

'Aren't you, Matt?'

'Yeah, I am,' he said in a gruff tone. He went on as if he was speaking for his own enlightenment. 'He could have murdered her as well, and stashed her body away someplace.'

'Who? You're sure you're not allowing all this murder stuff to interfere with your common sense?'

'Who the hell do you think, Muller. This crazy actor, Kage, of course.'

'Now take it easy right there, Matt! Just because you happen to be given a murdered man on a plate, it doesn't say that Walt Kage rubbed him out. Then you go on and suggest he might have killed his own wife as well! Where is your sense of proportion? Where is your perspective? What became of all the police training you got?'

'For crying out loud! Don't give me that guff, Muller. You do figure I'm completely dumb, don't you?'

'Well, not exactly, Lieutenant. Not

completely. It's just that you spoil your image in one fell swoop if you allow your eagerness to find a fall guy interfere with that cold analytical style you're famed for.'

'Don't lay it on too thick, shamus. You've got a client who's shaking in his pants and you damn well know it.'

'Walt Kage?'

'Why not Walt Kage? If he slew this Marvin Luce character — as I'm certain he did — then there's every possibility that he also slew his wife.'

'But why? Just because a man's wife leaves home, it doesn't have to follow he'll murder her when he finds her. And Walt hasn't found his wife. If he had he wouldn't be hiring me to do the footwork.'

Bayley put his cigarette back in his mouth and moved it around for a moment without saying anything.

'Have you spoken with the guy this morning?' he asked finally and blew a mouthful of smoke at my face.

I shook my head. I knew by the glint in Bayley's eye that he was still half a mile

in front of me — or imagined that he was, at least.

'You haven't gone and charged Walt, Lieutenant?' I said hollowly.

'Not yet. Where's the hurry. The guy has rigged up such a wacky scheme to throw us off the scent, he thinks we're stupid enough to fall for it.'

'But you're not going to fall for his wacky scheme? You're going to bulldoze ahead and dream up some wacky scheme of your own.'

'Slow down, gumshoe. Slow down before I do something drastic to bring you to a full stop.'

'All right, Matt,' I said wearily. 'Truth is never the nicest music to listen to. I'll take a trip with you for part of the way. Kage's wife is missing from home. Kage hires a private detective to trace her — '

'Yeah, but he didn't overlook to tell the police the same story, bright-eyes, and don't you forget it. All part of the wacky scheme he worked out.'

'Okay, okay!' I plodded on doggedly. 'Like I was saying, Kage's wife does a disappearing act on him and he hires a

private detective to find her. Kage's ex-chauffeur turns up with his head bashed in. Two isolated instances. They might have happened in a different world.'

'But they didn't. They both happened right here in town. And where do you dig up this isolation stuff?'

'All right, chief. I won't dig up anything that isn't revealed for all to see and comment on. Now tell me, do, where is the connection between a vanishing dame and a murdered ex-chauffeur?'

'You crumb!' Bayley said derisively. 'You'll never learn, will you? Dumb you say I look and dumb you say I am. I got to being a lieutenant by the simple process of knocking down everybody who stood in front of me. That's your evaluation of my standing, ain't it?'

'Isn't it.'

'What the hell! I could murder somebody about this minute myself, Muller. But who would give me a medal for stamping on a miserable louse?'

'Please, chief! Like I say, all this talk of murder is sending up your blood

pressure. And we were talking about connections.'

'I'll give you a connection, smart guy. Marvin Luce didn't leave the Kage mansion because he got tired of the scenery. He left because he was kicked off. Now, big-brain, why don't you ask me why he was kicked off?'

'Who told you the dirty details?' I asked hoarsely.

'I heard, palsy, I heard! Gloria Kage was playing fast and loose with the chauffeur. Talk about Lady Chatterly and her lover! They didn't have a thing on this pair of love-birds. Passion must have got the better of discretion, because crazy actor Kage caught them in the middle of their fun and games one day. He didn't give Luce time to get his jacket, even. Does that give me a case for booking Kage, or doesn't it?'

I opened my mouth to say something, but closed it again. If Bayley was in possession of this amount of knowledge — as he obviously was — why did he have to kill time by telling me about it? Why didn't he simply take off for Clifftop, with

a set of manacles and an iron ball? Did it mean he wasn't half as sure of his ground as he pretended to be? In short, was he using me as a sounding-board and was hoping to learn enough from me as a result of his bomb-dropping tactics, to be in a firmer position for charging Kage?

'It's your reputation at stake, Matt, and not mine. But if I were you I would be careful from this on in. Anybody can plaster a smear on a guy. The trouble starts when you've got to wipe it off again. That could cost dough — not to mention the heads that might roll.'

I got the feeling then that the lieutenant had made his spiel and was content to dry up for a while. It didn't figure exactly. He turned his face to the windshield and squinted at the official car parked in front of the Jag. The uniformed cop was in the car and had his head bent in an attitude that could have meant he was listening in on something.

'What the blue blazes is going on here?' I spluttered when the dime clicked home. 'You been taking lessons on the finer

points of making like a fox or something? Go and sit in your own heap if you want to sit — '

'Shut up, Muller,' Bayley returned flatly and went on squinting through the windshield. 'You ought to count yourself lucky I've got a soft spot for you.'

'Like hell you've got a soft spot, chief. The only thing soft about you is your belly. And if you don't — '

'Shut up,' he repeated and glared balefully. 'One of these days we'll find out who's dumb and who's smart around here.'

'One of these days!' I panted.

I was reaching for the starter switch when the uniformed cop climbed out of the car and hustled back to poke his head through to Bayley.

'Bad news, I guess, Lieutenant. He isn't there — '

'Who isn't there?' I roared. 'I'm gonna have you two punks drawn and quartered. I'm gonna — '

'You're gonna get a shoe shoved in your false teeth if you don't tone down on the racket,' the lieutenant admonished icily.

'Go on,' he said to the cop. 'Why isn't he there?'

'Butler says he took off two minutes after he brought in the morning papers to him. Guess that about gives us our killer on a silver platter,' the guy added with a smug smile.

'You're talking about Walt Kage!' I exploded.

'Wrap it up, you cheap chiseller,' Bayley snorted and hefted himself out of the Jag. 'Best advice I can give you, Muller, is to get yourself a lawyer. A good one too. You're sure going to need him, shamus, if you're planning on beating this rap.'

In another minute he and the cop were slamming away into the harsh sunshine.

13

'Why, if it isn't Mr Muller!' Hetty ejaculated when the front door of Clifftop opened to my second heave at the bellpush, and the dame stood there, wide-eyed and expectant. 'One never knows what a day will bring forth, does one?' She opened the door to its fullest extent and made a movement with her hand. 'Well, are you coming in to say hello, or do you plan to stand there until you take root?'

She was wearing skin-tight black pants and a form-hugging black sweater, and I wondered if she was in mourning for Marve Luce on account of him having been a chauffeur here at one time, or if she had just dressed like this to match her mood when she learned the awful truth about Walt. Her face was somewhat pale, I thought, but the paleness lent the right touch of contrast to the black outfit and the mass of chestnut hair that tumbled in

228

untamed fashion about her shoulders.

I said nothing until she brought me through to the lounge and took a cigarette from a humidor which she proceded to light nervously. She turned and smiled wanly and I asked her where Walt was.

'You mean you haven't heard?' she said bitterly and puffed a cloud of smoke at the ceiling in a gesture that was at once reckless and defiant.

'I heard that Marvin Luce was murdered,' I said conversationally and sat down on a chair. 'I read about it in the paper, then the cops came on and invited me to the morgue to ask me if he was the same guy I'd been asking around for.'

'You were asking around for Luce? You made it so obvious?'

'Slow down, baby. There are certain things that you can't hide under the rug. The cops were here too, I gather?'

Hetty didn't answer me for a few seconds. She stood in front of me with her head lifted slightly, her body arched so that the firm lines of her bosom were thrown up in stark and seductive relief. It

was an entirely unconscious pose, as I could see that her thoughts were ranging far out from cosy couches and frolics in a cabin cruiser.

'Yes,' she said finally, 'the police were here. A whole car-load of them. The way they searched the house you would think it was a hide-out for the lowest type of criminal.'

'Well, you can't get much lower than murder, can you, baby?'

It was an unfortunate remark to make. Hetty's right hand flashed out and crashed solidly against my jaw.

'You're accusing Walter of being the murderer of this — this man Luce?' she panted.

I fingered my jaw and worked my teeth around for a minute. I stood up and Hetty came into my arms.

'Oh, Paul, I'm sorry! How can you forgive me? But — but I'm so upset. I don't know which way to turn. You must help me. You must help Walter. He ran away immediately he read of the murder in the newspaper. I tried to stop him, tried to reason with him. He — he

wouldn't listen. He said you had made a mess of everything and the police would believe he had killed Luce.'

'Did he, honey?'

Her breath came gushing from her throat in a hard rasp. She untwined her arms from my neck and took a step away from me. A tear shone in the corner of her eye.

'You've gone over to their side!' she groaned. 'Oh, this is the last straw. And I thought we could trust you, Paul. Now you're saying that Walter is a killer . . . '

'I didn't say he was a killer. I asked you a straightforward question, Hetty. All it requires is a straightforward answer. In your opinion, did Walt murder Luce?'

'Of course he didn't!'

'Did he leave the house at all last night?'

'Did he — Well, how do I know?'

'So he did,' I said. 'Did the cops ask you the same question? I take it they did interrogate you and the staff?'

'They didn't talk with anybody. They just asked if Walter was at home. When I said he wasn't they flashed a warrant and

231

started in to search.'

'You've no idea where he's gone?'

'How should I know? Why should I tell you, even if I did know? The first thing you'd do would be to turn him over to the police.'

'Wrong,' I said. 'The first thing I'd do is ask Walt if he did kill Luce.'

'And you'd believe him if he said no?' she flashed.

'I'd think about it, baby. One thing sticks out a mile. If Walt is innocent of this caper, then he couldn't have picked a worse method of proving it.'

'I know,' she moaned and knuckled a tear from her eye. 'He should have stood his ground. His nerve must have cracked when he read the item in the newspaper. Paul, you aren't really going to turn against us? You will do what you can to help Walter?'

'He's still my client,' I granted. 'Until the cops decide he's guilty and charge him. Then I'll have to drop him. You too, honey. It's a real shame, isn't it?'

It was another unfortunate remark to make. Hetty closed with me and pushed

her mouth against my own. The clinch lasted until I found the will-power to break it off. I left the dame while I was still winning and swung about to the door.

'Where are you going, Paul?'

'To scout around,' I grinned. 'I've been paid a retainer to find Walt's wife. The cops will be straining themselves to do likewise. They don't necessarily see this the way we see it, baby. Now that Marvin has finished up dead, they figure Walt might settle for nothing less than the whole jackpot.'

Hetty uttered a sharp cry of horror.

'They imagine that if Walter murdered Luce he will be tempted to murder Gloria as well, if he finds her? But how did they hear that Walter fired Luce because of — . Well, you know that Walter did fire Luce,' she ended weakly.

'Sure,' I told her. 'They heard. Not from me. I've got a hunch about how they might have heard.'

I left her standing like the latest thing in frozen food and slammed the door behind me. The butler, Ferguson, was

hovering in the hall and I asked him to find Josie and send her on the double.

'This is an awful state of affairs, Mr Muller,' the guy said dolefully. 'Is there the chance that Mr Kage might be arrested, do you think?'

I told him I couldn't say. I told him to find Josie. I went on to the front door and waited there for the dame. She bustled out at last, eyes snapping anxiously, her lips turned tightly in on themselves.

'Oh, Mr Muller, what a how-do-you-do we have on our hands now! It's enough to drive a woman out of her mind, I swear. Do you wish to see me about something?'

'Yeah, I do, buttercup,' I said dryly. 'It was you who contacted the cops and gave them the lowdown on Mr Kage firing Marvin Luce, wasn't it?'

Her face flamed madly and she clenched her hands together protectively. It was a moment before she could answer.

'I — I saw the report in the newspaper, Mr Muller. I always glance at it when it arrives. Then — then when I saw Mr Kage charging out of the house I got alarmed.'

'So you reacted accordingly,' I urged. 'You 'phoned the police and drew their attention to the way Luce had left?'

The dame drew herself up to her full height and fixed me with a level, unflinching stare.

'His wife ran away and left him, didn't she? Who's to say that the poor man didn't lose his reason and kill Marvin Luce if he thought she had gone to join Luce? I'm not saying that greasy so-and-so didn't deserve what he got, but if Mr Kage is so sick in the head, the best thing for him is to have treatment, at least.'

There just had to be sense somewhere in what she was saying. She had done what she thought was right and she wasn't ashamed to admit it. I figured her days at Clifftop were numbered, all the same.

'Did Walt leave the house last night, do you know, Josie?' I asked carefully.

She hesitated briefly before nodding reluctantly.

'He left in his car around eleven. I know it was him because I peeked out

and saw him drive off.'

'Did you happen to be peeking out also when he came home again? Do you know the time he did come home?'

'It must have been almost two when he came home again. I was in bed, but I wasn't sleeping. Nights I lie awake a long time before I drop off to sleep.'

'But you're sure it was around two? It couldn't have been earlier? You wouldn't have made a rough guess at the time?'

'There's no doubt it was almost two. I keep a bedside alarm. I remember looking at it and it was a quarter to two. It was later when I heard the car come back. Mr Muller, should I tell the police what I've told you, if they ask me?'

'I don't see why not, Josie. It would hardly be consistent if you shut your big mouth at this stage. But for pete's sake keep quiet until they ask you.'

I left her coping with the pink fit she was building up to. I got into the Jag and started for the hill road to the village, but stalled before I had gone too far and nosed to the cliff path dipping down to the beach. Another idea had occurred to

me that I might as well put to the test.

Arriving on the sand I spotted the cabin cruiser riding the smooth waves of the bay. I drove as close to the rocks as possible, then killed the motor and climbed out. It didn't seem likely that Kage would have come to the beach to lie low in the cruiser. His car wasn't here for one thing, and if he had thought of going to earth in the boat he would surely have cast off long before now.

I clambered aboard all the same and went down the companionway to look around. No Walt Kage. Nothing but a lot of spine-tingling memories of Hetty peeling off her bikini. Some guys had all the luck. Some guys never made anything more than the tail end of frustration.

Back on the sand I was heading to the car when a flickering of bright glare from the cliff top made me blink for a moment. There was nothing visible when I looked up at the house, nothing that seemed suspicious, that was. The glare had been caused by the brilliant sunlight reflecting from binoculars. Who was spying on me this time, I wondered. Josie of the beady

eyes and the loose mouth? Hetty trying to figure out what I was up to? Ferguson, the butler, maybe?

I quit beating my brains and drove back up the path. The straight run across the sand to the dirt-track off-shoot wasn't worth the time I'd save. I hit the hill road and kept moving. A quarter mile along I spotted a car parked in off the main drag. It was supposed to be sitting there quietly anonymous, but in fact it stuck out like a sore thumb.

I grated to a halt, reversed into my own dust until I was on a level with the front of the car. Two pairs of eyes peered coldly at me. One of the guys got out and flung a cigarette butt into the ditch.

'Would you please keep moving, Mr Muller?' he said in a constrained voice. 'A car parked where yours is sitting is very conspicuous. It might spoil our — ' He broke off when he realized we might be on opposite sides, then finished abruptly, 'Well, keep moving, will you?'

'Are you waiting here to spring out on Walter Kage?' I asked the cop. 'Or was it part of your strategy to let me ride past

and then put a tail on me?'

The cop's face turned a dull red.

'We're under orders,' he said curtly. 'I can't divulge the nature of our orders. All I'm doing is asking you — '

'Yeah, I know. Move on. I'm moving. Did it occur to the genius in charge of the exercise to detail a peep on the beach as well?'

It was plain it hadn't. The cop looked back at his pal in the car. Then he looked worried.

'The beach could provide a point of access to the house that could bypass the road here?'

'That's right. I don't know why I'm bothering to tell you. Maybe I only hate cops as half as much as I figured I did. Maybe I'm getting soft in the attic.'

The guy gave me a wave and a big grin, then trotted to the car to make appropriate signals with headquarters.

I resumed my seat in the Jag, resumed my journey to Anfield. I was behaving as though Walt Kage was a murderer, I realized. But where had he been last night, and what had he been doing if he

hadn't been hunting up Luce and smashing his skull? Why had he taken off if he was innocent? Where was he at this minute? Where was his wife Gloria at this minute? What condition of health was she in?

The possibilities were legion, of course, and I didn't have the nerve to whittle them down to reasonable proportions. In this context the process of elimination would finally present me with one terrifying conclusion, and I didn't want to face up to it.

Not until I had no alternative.

★ ★ ★

Western Avenue was a street of dingy stores and cheap apartment buildings. The apartment house where Marvin Luce had cashed his chips was half way along the street, and I bypassed the building by a block before trundling in to the kerb and parking. There were no cars in the immediate vicinity, which meant that the police had finished with their initial operations here at least.

I locked up the Jag, lit a cigarette, and strolled back to the entrance hall of the joint. It was dusty and dilapidated, and for all anybody seemed to care, was dying a slow but inevitable death.

The manager had an office on the ground floor, right beside the menacing-looking elevator car. I fixed a smooth and confident smile in place, went over to the door bearing the tiny, grimy name-plate legend and rapped smartly with my knuckles.

There was a radio playing inside, and when a half minute had gone by the radio music was muted and the door swung open to reveal a nasty scowl. The character who wore it was middle-aged and getting paunchy. He was clad in shirt and sneakers and had a cigar butt trapped between thin, unyielding lips. By the looks of him the Luce slaying had provided him with enough excitement to do him for a year. Evidently too he was of the opinion that the murder meant the Indian sign was on the joint, and what did I hope to do about it anyhow.

'Yeah?' he grunted grudgingly around

the cigar. 'What d'ya want? If you're another newspaper reporter you've bought it, buddy. Everything has been covered. No more questions. No more godamn photographs. I'm just sitting around here waiting. And you know what for?' The guy didn't give me an opening to reply. 'I'll tell you what for if you want to hear, buddy. The bulldozers. Four tenants checked out this morning. By night there'll be nothing left but the bugs. All because a joker has to get hisself killed. Fellas get killed every day, don't they? They get knocked down by automobiles. They crash in the godamn things. They crash in planes. Then some joker gets hisself killed in one of my apartments. You call that lucky?'

'I call it rough,' I said carefully. 'I call it a godamn dirty shame.'

'You do?' he grunted suspiciously. 'Is that so? Who are you anyhow, buddy? If you aren't a newspaper reporter you gotta be a cop.'

'I don't really have to, friend. I'm a private detective. I'm working for a client who used to have the dead man as a

chauffeur. You know, he drove the family limousines.'

'Yeah! He did? So where do we go from here?'

I told him where I was hoping to go. I told him I'd like to hear if Marvin Luce ever had a dame visiting. Then I told him if he was short on this information I would like to have a word with the occupant of 3C.

'Hard luck,' the manager said. 'That was Mr Ferris. He was one of the scaredy-cats that checked out.'

The police had asked this question too. A dame had visited with Luce occasionally. No, the manager had never seen her. No, he didn't know her name. Mr Ferris had seen her once, though. He had happened to open his door when the dame passed on her way to 4C.

'What did she look like?'

'Ferris said she was a pretty woman. But that don't mean such a lot because the old guy figured every woman was pretty anyway. Call him an idealist. Call him crazy in the head.'

'It's all he was able to say about her?'

'Yeah. Pretty. She was dressed nicely too, Ferris said. He said she was a dame with class. I can't tell you any more. If you want to hear more you'd better go talk with the cops.'

I said sure and thanked him. He was muttering like mad about the bulldozers when I left him and went back to the street.

14

I should have requested to look at the room where Marvin Luce had died, I realized as I slumped behind the wheel of the Jag and lit a cigarette. As Luce was found there on the floor with his head bashed in, wasn't there the possibility of Gloria's body having been stashed underneath the floorboards? If not under the floorboards, then behind a couch maybe; in the closet? I, wondered how thoroughly the cops had searched. I supposed I'd have to depend on them having made a clean sweep.

I flicked the cigarette through the window and gunned the motor to life. Swinging out from Western Avenue other ideas began crowding in for appraisal. I recalled the 'phone call from Gloria Kage. She'd pleaded with me to give her a break and leave her alone. She was frightened, she'd said, frightened of what Walt might do to her if he caught up with

her. He had told her one time he would kill her if ever she latched on with another man. She had latched on with another man. The other man was dead, so if Gloria Kage had been frightened before the murder of Marve, she was just bound to be hysterical at this moment, if she was alive.

Another notion stemmed from this picture. It was a long shot, but I was used to laying wads on long shots. I cruised in at a drugstore, shut myself in the 'phone booth and called Harry at home.

' 'Lo, Harry,' I said when he answered me. 'There haven't been any 'phone messages during my absence?'

'Mr Muller,' Harry said urgently. 'You'd better get here immediately. You have a visitor who is most anxious to see you.'

'Don't tell me who it is, pal. Just let me guess. I'll collect my prize when we compare notes.'

I breezed out of the drugstore and was soon aiming the Jag for my apartment. There were a few cars parked in the vicinity when I got there, but I didn't

recognize any of them. My guess could be wrong, I figured. It wasn't. I flung Harry my hat and he gestured to the office door. I strode inside and found Walter Kage in the initial stages of a nervous breakdown.

He had been helping himself from my cabinet and there was a high flush in his cheeks. He was wearing slacks and sweater, and the baseball cap was sitting at a rakish angle on his head. He jumped up from a chair and came towards me with both arms extended in a gesture of supplication.

'Mr Muller, I know you're shocked at finding me here. But it was the only place I could think of on the spur of the moment. The police will be searching everywhere for me. You know that Luce is dead, that somebody murdered him?'

'Yeah,' I said tautly. 'I do. But what inspiration told you it was safe to come here? I might cut dashes round the fringe of the law, pal, but so far I've managed to observe my limitations.'

I was swinging to the 'phone on my desk when Kage got his fingers fastened on to my sleeve.

'Mr Muller, what are you going to do?' he cried in horror. 'You aren't going to turn me over to the police?'

'Why shouldn't I turn you over to the police, Walt?' I demanded and brushed his hand away. 'You killed little old Marve, chum, and for all I know you might have performed a similar feat on your wife. You'd better come down out of the clouds, Walt. This isn't a B-grade gangster movie, where you have licence to wipe out all the baddies. The blunt instrument you used on Marvin was for real. He's dead for real. His name won't appear in any more credit lists. In short, you've just played your own final role, and now is the moment to splash two meaningful words on the wide screen. The End.'

'You're crazy!' Kage panted furiously. 'You're out of your mind, Muller. I didn't kill Luce. Why, I couldn't kill a fly without being sick afterwards.'

'There's a good point to stick to when the cops start grilling you, Walt. It was interesting having you for a client, but now I'm afraid it's good-bye and — '

I had the telephone receiver lifted when he slugged me. It wasn't exactly a murderous blow, but there was enough power behind it to put me to my knees. I hunkered there and watched the receiver dangling from its cord. Then I looked at Kage and realized he was heading for the exit. I went out after him in a fast tackle. He yelled when I hugged his legs and brought him down on top of me in a heap. He thumped my chest a couple of times and I sent my right knee surging into his crotch. He gurgled and doubled up in agony.

'Sorry I had to do that, pal. But when you decide to play rough you've got to live with the consequences.'

'You've destroyed me,' he babbled and lifted a face that was streaming with tears.

The door burst open and Harry lunged in. He came to a full stop and stared regretfully at the ex-movie actor.

'Does he require medical attention, sir?'

'All he requires is the sense he was born with, Harry. Just leave us alone for a few minutes.'

Harry went out and I gathered up the telephone receiver. I held it for a moment while I looked at Kage, then I laid it on its rest. Immediately I did it began ringing.

'Yeah?' I said into the mouthpiece. 'Paul Muller here.'

'This is Mrs Chalmers, Mr Muller. Have you heard that Marvin Luce was murdered out on Western Avenue?'

'Sure, I've heard, Muriel.'

'Then I suppose you understand that it could be my sister's turn next. You haven't found her yet?' she added bleatingly.

'I'm still trying, baby.'

'Don't give me that baby stuff, Mr Muller,' the stringy-haired dame admonished. 'The police have been here. They've just left. They asked me dozens of questions.'

'What sort of questions?' I said sharply.

'About my sister. About where she could be. How do I know where she could be? Dead, I expect, for all you care!' The rest was swamped out in a smother of tears. I listened for a moment,

then I hung up and gave my attention to Kage.

He sat on the floor and nursed himself. His baseball cap had come off and the handsome features were twisted with pain and frustration.

'I thought I could trust you, Muller,' he wheezed reproachfully. 'I hired you to work for me, didn't I? I paid you a retainer and what do I get in exchange?'

I thought it over for a few seconds. Then I fixed him a stiff drink and had him clasp it in his shaking fingers.

'Don't spill it all on your pants. Throw it back and then we'll settle down to brass tacks.'

'You — you're not going to sell me out to the police?'

'I'll decide when we've had a chat. A long one. Okay with you?'

'Who was calling on the 'phone?'

'Her sister.'

'Muriel?'

'That's right,' I said and helped myself to a drink. I took a chair and sipped and waited for Kage to stop holding himself

251

and commence talking.

I was still waiting when the outer door-bell buzzed. Kage heard it too and gave me a blank stare. He pushed himself to his feet and then began to look frightened again.

'Who — who is it?'

It was Harry Peters who answered his question. He opened the office door an inch and whispered sibilantly:

'The police, Mr Muller. Lieutenant Bayley.'

'Stall him for a minute, Harry.'

Kage emitted a low groan and gaped around him like a cornered rat, which was what he could be for all I knew. I grabbed his arm and hustled him through to the living quarters.

'I'm sunk,' he yammered in a stricken voice. 'Sunk!'

'You will be if you don't keep your trap shut, Walt. Did you drive here in your own car?'

He shook his head wordlessly and I heaved him into a bedroom. He turned and clutched my sleeve, then opened his mouth to say something.

'Keep it for later, mister. And remember, I'm not laying any guarantee on the line. Get it? You don't level with me later and I feed you to the wolves.'

I slammed the door quickly and headed back to my office. Not a second too soon. Bayley and a uniformed cop had muscled past Harry and were already entering the office. The lieutenant had a cigarette caught in the corner of his mouth and his small eyes swept from the floor to fasten on me suspiciously.

'Okay, shamus, where is that punk?'

'What punk, Matt? And you might have said you were coming so's I could have laid out the welcome mat.'

'Don't give me that guff, Muller. He's here and I know he's here. Have you added up what you can get for this kind of caper? Kage might have been your client yesterday, but today he rates nothing higher than a name on a wanted sheet.'

He was ambling to the inner door when I got in his way and laid a restraining hand on his chest.

'Think it over well before you do

anything rash, chief. About now you could be charging at the first wall that's going to stop you with a hell of a bang.'

'You mean you're threatening me?' As he spoke the lieutenant's brows arched triumphantly and he glanced at the uniformed cop to make sure he was a ready witness.

'Sounds like a threat to me, Lieutenant. Want me to fix him so he'll need a set of crutches for the next six months?'

'Ha, ha,' I sneered. 'Typical of the minions of the law. When they run out of brains they call on the only substitute they can lay their hands on. Violence.'

'Nobody mentioned violence,' Bayley snapped impatiently.

'He just did,' I snarled. 'And if you want to see it done with bells on, tell him to slip out of his uniform jacket.'

'Feeling your oats, huh? There's one sure sign you've got a lot to hide, Muller. Now, for the final time, gumshoe, are you going to let me go in there?'

'The bed hasn't been made up yet,' I said desperately.

'So what? So who cares? And don't tell

me I might embarrass some dame either. I know your level, and nothing would ever surprise me.'

He removed my hand from his chest, then he pushed me roughly aside and ploughed on through the doorway. The cop gave me a beady glare and ploughed after him. I followed both of them and wondered how it would go if I said Walter Kage had sneaked into my bedroom when I wasn't looking.

There was nobody in my bedroom; at least I couldn't see anybody and neither could Bayley nor his shadow. They stood in the entrance and the lieutenant made a big thing of whistling softly in his teeth.

'What a godamn heave! You'd say it's Morning Glory or Meet Me in the Garden after Dusk?' he said to the cop.

'More like Old Tom,' the joker cackled. 'But Walter Kage isn't here, Lieutenant,' he added brightly.

'No kidding?' Bayley scowled. 'If he isn't hiding here, then where is he hiding?'

'You'd better find a real lonely place to hide yourself, chief, when you hear from

my lawyer,' I said coldly.

'He could be under the bed,' the cop said when another rush of inspiration overpowered him. 'Do you want me to look under the bed, Lieutenant?'

'I want you to act like a police officer,' Bayley rasped at the guy. His nose wrinkled up in disgust. 'Let's go through the rest of the joint.'

'You're weaving a web that's going to be the death of you, Lieutenant,' I said thickly. 'Last time you pulled a stunt like this, you had to get down on your knees to me to worm yourself off the hook.'

'This is murder, Muller. I've reason to believe Walter Kage came to ground here. The car he was driving is parked on the street, not more than ten yards from your front door.'

'Whose car?' I croaked. 'Walt Kage's?'

'Not Walt Kage's. The one he stole. He left his own car on Frinton and took off in another one.'

I said nothing else as they went through the apartment. Satisfied at last — or so I figured — Bayley insisted on going back to my office for a minute.

'Yeah, you do that, Lieutenant. There's always the off chance of Kage hiding himself in my filing system.'

I saw what was on his mind when he stooped to retrieve Kage's baseball cap from the office floor. His mouth screwed up ominously as he flung it to me and told me to try it on for size.

'But I haven't played baseball in years, Matt. I just happened to take it out and dust it down. Well, you know what it's like,' I added weakly. 'I hang on to things I should have tossed away. Call it having a sentimental streak. Why, I bet there are things that catch you by the throat when you take them out of the glory-hole once in a while to remind you that you were once young and had a sense of humour, and — '

'Try it on, shamus.'

'Right now, chief? With this mutt getting ready to laugh his leg off. Well, if you really do insist.'

The cap would have fitted my head if it could have swollen about an inch. 'There you are, Lieutenant,' I said and whipped it off again. 'That was me when I was the

best damn pitcher in the state.'

'He can sure pitch a lousy line,' the uniformed cop said.

Bayley said, 'Yeah!' He grabbed the baseball cap and stuffed it into his pocket. 'We'll see what the lab boys have to say about this, Muller. It just might be the straw that's gonna break your back,' he appended threateningly.

They stalked out of the office and slammed the door behind them. I waited until I heard the outer door slam with equal force, then hurried to the bedroom and found Walt Kage squirming on his stomach from under the bed. The guy's face had gone a dirty shade of green, and the wan grin of gratitude he gave me did nothing to help his appearance.

'You're a real brick, Mr Muller,' he said hoarsely. 'A real brick.'

'That's what I'm going to use to bat you over the skull, hero. You realize the sort of reputation I'm going to salvage from this gag? You realize you're about five different kinds of liar into the bargain?'

'Liar!' he began. 'But — '

'Come into my office,' I told him. 'Sit down,' I said when we got there. He took a chair and I fixed two drinks and handed him one. He gulped it off in two practised swallows. I took a chair opposite him and lit a cigarette. 'Now, pal, we've reached what you might call the moment of truth.'

'You still think I'm a liar, Mr Muller?'

'Fifty-seven varieties,' I snarled and took a jolt from my glass. 'For a start, you didn't tell me you drove here in a stolen car.'

'Stolen! Oh no, Mr Muller, I wouldn't steal a car. All I did was borrow a car. I knew that the police would be watching for me. I knew that if I came here in my own car it would be spotted right away.'

I let it ride. I asked him if he'd left home at anytime last night. The wrong answer to this one wouldn't win him three of a kind on a fruit machine; what it would win him would be a bundle of fives on the end of my arm.

'Yes, I did leave home last night. I went out for a couple of hours.'

'How many hours?' I said patiently.

'Three, maybe four,' he said sulkily.

'Oh, I know what you're thinking, Mr Muller. You think I'm a cold-blooded killer. You think I murdered Marvin Luce.'

'So you couldn't have murdered Marvin Luce? Even if you were dead sure he was a light-fingered bastard and all?'

He jerked like I'd kicked him in the stomach. Then he smiled feebly. 'I confess I wanted to murder him, Mr Muller. Given the right opportunity I might have murdered him. But I wouldn't have hit him on the head. I'd have killed him with my two hands. With my two hands, Mr Muller!'

I let that ride too. I asked him where he had been last night if he hadn't been out killing Marvin Luce.

'I drove around in my car. Don't ask me where, because I couldn't rightly tell you. I stopped at a couple of bars, had a few drinks. I was thinking of Gloria, Mr Muller. Wondering where she could be. Wondering why she hadn't contacted me, even.'

'Did you know that Luce was hanging

out in an apartment house on Western Avenue?'

Kage shook his head emphatically.

'Why didn't you accept Luce's offer and buy the information he was willing to sell you?'

'What information? It was a trick to get money out of me. Ten thousand dollars!'

'Don't you have that amount of money to spare?'

His laugh would have got a part in a horror movie. 'Really, Mr Muller! This is hardly the time or the place for flippancy. What information could Luce have possibly had that would have been worth ten thousand dollars?'

He had me there. I made a wild guess. 'It might have bought you news of your wife's whereabouts.'

'We've been over that ground before. No, it was something else he had on his mind.'

'How can you be sure?'

'I'm not sure. I admit I wasn't sure then and I'm not sure now. But I am firmly convinced that Luce was scheming some cheap confidence trick.'

I wasn't so ready to be convinced that this was so, but I didn't say as much to Kage. Luce had asked me for a paltry three grand to hear where Gloria was at. Did it mean desperation had prompted him to drop his price, or that he had been peddling two different slices of information? If so, what was in the parcel that Walt didn't buy?

'You've led me to believe that you and your wife got on like a pair of spooning doves, Walt. Would you say that makes a reasonable assessment of your relationship?'

'Naturally,' he said instantly. 'It wasn't until Luce began taking an interest in Gloria as something other than the wife of his boss that the trouble began.'

'You think she might have fallen for his cute style?'

'I think nothing of the sort, Mr Muller. It is most annoying to hear you say so.'

'Okay, so I won't say it. I'll frame it in this manner. Do you think that Marvin Luce fell in love with your wife and asked her to leave you and go to live with him?'

The guy's eyes clouded up while he

thought it over. Finally he shook his head.

'But you're becoming mixed up in your logic, Walter. You've already stated that Luce began to take an interest in Gloria as something other than your wife. If he didn't fall in love with her, what do you suppose did happen?'

'He was planning on a scheme,' Kage replied reflectively.

'And you haven't even half of an idea about what this so-called scheme comprised?'

He hesitated before shaking his head again. He sighed. 'If you could find my wife for me, Mr Muller . . . '

'Sure,' I said wearily. 'If I could find her. Let me fill you in some details, chum. Last night I had a visit from Marvin Luce — '

'You had what! You didn't tell me. You didn't — '

'I'm telling you now, Walt. He came of his own accord. He had a thing called a gun, and he kept poking it in my direction while we talked.'

'Did you tell the police about this?' Kage gulped.

'I didn't tell the police. I'm not a blabbermouth, Walt. I'm a private detective. I've learned to add things up for myself. A man hires me and I stay hired until the case is finished or I decide it is a crooked one.'

The guy's mouth went slack for an instant. He looked around for the baseball cap he'd just missed, and failing to find it he brought out the curved stem pipe and jammed it between his teeth. A nerve pulsed faintly in his cheek.

'What did Luce say to you?' he asked huskily.

'He had an offer for me too. He said he would tell me where your wife was at for the consideration of three grand.'

'And you didn't accept his offer!'

'I don't have that sort of money to fool around with, hero.'

The jibe sent colour storming through his features. He blinked rapidly for a couple of seconds.

'You don't have to be facetious, Mr Muller. I have the impression you are trying to hurt my feelings. I would gladly have paid an extra three thousand dollars

to have learned where my wife is.'

'So you could kill her, hero?'

'I done told you!' he snarled and got up with his right fist bunched. He grimaced at the memory of what had happened on his last expedition into mayhem and flopped back on his chair again. 'You are descending from one pettiness to another,' he said huffily. 'You keep on surprising me, Mr Muller.'

'Let's spring a whole parcel of them while we're at it, Walt. Last night too I had a 'phone call from your wife.'

Disbelief clutched at his facial muscles and wreathed them into a bleak mask. The muscles relaxed one by one while the stark truth filtered home to him.

'You . . . had . . . '

'Yeah, I had. I haven't told you yet that Luce was a scared lad when he visited. And I do mean scared as opposed to pretending to be. He was frightened out of his pants. The reason he wanted the three grand was because he was anxious to finance a quick painless flip out of everybody's business but his own. He said he wanted to get out of the mess he was

in before it was too late. I didn't pay him the three grand, so he didn't get out. Instead he had his head bashed in.'

Kage was plucking at his shirt front as though it might relieve some constriction that was choking up his chest.

'He was murdered, yes. But I didn't kill him. You must accept my word for it, Mr Muller. I didn't kill him! My wife . . . What did she say to you when she rang?'

'Here's where the picture gets more muddled, pal. Your wife sounded even more frightened that Luce. She asked me to lay off searching for her. She pleaded with me to leave her alone. She didn't want me to find her. She didn't want you to find her. You especially, hero. She said you had threatened her with death if she ever looked at another man — '

'She's a liar if she said that, Mr Muller! Oh, I could get as angry as any husband who was seeing his wife being wooed away from him. But I loved her too much ever to harm one single hair of her head.'

He seemed sincere enough when he

said it. I wondered if he was sincere. I considered pulling out my prize punch and watching how he reacted to it. But the time was not ripe. The time would be ripe when and if Larry Stern uncovered what I hoped he'd uncover.

I gave Kage the rest of the sordid tale concerning Marve Luce. I told him how Luce had been visited at the Western Avenue apartment by a woman. I explained how my inquiries had practically proved that the woman was none other than his wife. The ex-movie star reeled from the beating he was taking. He said nothing when I'd finished and I got up to fix him another drink.

I should have switched my eyes to the back of my head when I did it. The first indication I had of his wanderlust was the sound of the door being dragged open. I wheeled in time to see one of his heels disappearing from sight. After that there was the sign of a brief scuffle, and immediately after that another door slammed.

Harry came into the office with one of his brows arching quizzically. He was

straightening his necktie that had gone awry.

'Didn't you want to hold him, sir?'

'Why should I hold him if he doesn't want to stay?'

'But the police, Mr Muller. It's only reasonable to assume they'll have left someone to watch out front.'

'It's Walt that's running the risk — Yeah, I see what you're driving at, Harry. If the cops pick up Kage making a beeline out of this building they're going to figure I'm half as guilty as he is, at least. But to make anything stick they'll have to prove Kage took a powder from this apartment and not some other one.'

There was still one facet that mustn't be overlooked. Kage had come here plus his baseball cap and gone away minus it. And when Bayley cottoned on to whose head-gear it was he could make it plenty rough for little old Muller.

'I'll go down and look around, sir.'

'Suit yourself,' I replied and addressed myself to the drink I'd fixed for Walt as Harry left the office. It was five minutes

before Harry returned.

There was no evidence of Walt Kage, no evidence of police being in the vicinity either. Perhaps he had managed to slip off without being spotted.

'Let's hope you're right, pal,' I said musingly. I figured that if Kage was a killer — as I was almost completely convinced he was — then the sooner the cops had him under lock and key the better for everybody. Especially his wife. I could always dream up a yarn to keep Bayley's wolves at bay. I'd done it before and I could do it again.

I let a half-hour drift and reckoned by the end of that time that Kage, if he had run foul of the cops on the street, would be at headquarters, and that any second now the 'phone would ring or the doorbell would ring to announce the lieutenant's reactions.

It was the 'phone which rang, but it wasn't police headquarters at the other end. As it turned out the summon was from Larry Stern's office.

'I've got the stuff you wanted, bigshot. Will you have it by courtesy of Mr Bell or

would you prefer to come over here and listen?'

'Will it take long, Larry?'

'Milly has prepared a neat and pithy capsule. It shouldn't take much more than a minute for you to swallow it down.'

'Let's have it, chum.'

He did and I listened carefully until he'd finished. Then I thanked him, promised him payment on the nose. After which I collected my hat and headed down to pick up the Jag.

15

Hetty wasn't in the house, Ferguson told me when he answered the door at Clifftop in the early afternoon. She was down swimming in the bay, he thought. He knew that she had been wearing a swimsuit and robe when she left the house, and she was carrying a towel.

'You haven't heard anything from Mr Kage, Mr Muller?' the guy said when he had finished explaining.

'He hasn't come home?'

Walt hadn't come home. What was more, there had been a further visit from the police. I hadn't noticed the prowl car parked off the road on this trip. Did it mean they'd caught up with Walt when he left my apartment, or did it mean they were focusing their attention elsewhere?

'How long ago since the cops were here?'

'You might have met them on the road, Mr Muller. They left ten minutes ago.

Fifteen at the very most.'

'They were asking for Mr Kage?'

'They searched the house again,' Ferguson told me. 'They must have been searching for Mr Kage.'

What else would they have been searching for if not Walt? Our paths might have crossed in the village without either the cops or me realizing it. So where was Kage if not in the greedy clutches of Matt Bayley?

'Mr Kage didn't bother to ring through a message of any kind?' I asked Ferguson next.

His brief hesitation told me he hadn't the same faith in me he might have harboured at the outset of my inquiries.

'No, sir, he didn't.'

'Have you never learned to tell lies without batting an eyelash, buster? So Walt has been on the 'phone? And don't say he hasn't, because you haven't had enough practice at being a liar to fool a kid in a kindergarten.'

Ferguson's face flushed and he dipped his gaze to his toes for a moment. When he raised his head there was an expression

of resignation in his eyes.

'All right, Mr Muller. I'm sorry. It's just that I don't wish to appear disloyal to Mr Kage.'

'What's with all this disloyal stuff, Ferg? I'm hired by the hero of the wide screen, ain't I? Excuse me, am I not?'

'Of course, Mr Muller. There was a telephone call. I answered it. The person who spoke used a disguised voice. I recognized it as belonging to Mr Kage straightaway.'

'What did he have to say?' I queried curiously.

'He asked to speak with Miss Hetty.'

'And he did?'

'Their conversation was a prolonged one. When it was over Miss Hetty seemed very worried, I imagined.'

'She didn't comment?'

'Not to me, sir.'

'Then she changed into her swimsuit and took off for the beach? Just like that?'

'Not quite, Mr Muller. The call came through around lunch time. Two hours ago, at least. And, Mr Muller . . . '

'Yeah?' I urged when he became bashful.

'I'll be most grateful if you refrain from telling anyone the source of your information.'

'Don't give it a second thought, Ferg. Would I be in business if I went around spilling things on butlers?'

I left him and went to the Jag. I'd used the hill road to reach here in order to ascertain if the cops were still waiting for Walt, and it was how I'd missed seeing Hetty on the beach. Now I took the cliff path to the beach and wondered if the dame would be willing to take me into her confidence regarding her confab with Walt.

She was lying sprawled out on the warm sand, a perfect cameo in the sunshine that shimmered around her. She was wearing the lower half of her bikini, but the top half had been cast aside — not too far aside — and the marvellous peaks of her bosom looked golden and ripe and challenging. The beach robe was tossed nearby, as was her towel, and for all she seemed to worry about somebody

approaching her, I could have been over somewhere on Malibu, maybe, instead of within leering distance.

Even when I braked the Jag to a halt and climbed out, she didn't move a muscle of her wonderful framework, and for an instant the awful thought presented itself that Hetty had shared a fate similar to Marvin Luce's.

I stood for a moment and brought a cigarette from my pocket. The tobacco tasted so mundane and disappointing in such a context that I immediately plucked the cigarette from my lips and flung it to the sand.

'You could catch it in the neck for that, Muller,' she said without turning her head.

'Whatever else you do, be reasonable, Hetty baby. I'm two whole yards from you at the very least. I did dabble in Yoga one time, but I never did graduate to projecting myself from my body. Even if I could manage the trick, what would be the use? I mean, I'm the sort of guy who likes to bring his body along for the ride.'

'I'm talking about you littering up the

beach,' Hetty elucidated in a crisp voice. 'And I'm not talking about the cigarette you just tossed away.'

I went on over and stood looking down at her. The wide, green-flecked eyes had the cosy encompassing warmth of an ice-field. The full red lips were curved into a pout that could easily turn into a snarl.

'So I haven't been treating you right?' I hazarded. 'So that gives you licence to turn my innards into an insatiable furnace? So if you covered up even one of them, baby — '

'You big bundle of bluff,' Hetty said in a charged whisper. 'You led Walter up the garden path. You told him you would work for him, and now look what you've done!'

'What have I done, honey-chile?'

'You believe he really did murder Marvin Luce.'

'Is that what he told you over the 'phone?'

She sat up at that and stared straight into my eyes.

'Who — who told you he was speaking

to me over the 'phone?' she demanded harshly.

'Never mind who told me. I know that he was. I want to hear what he said to you, Hetty. I want to know where he's at, what his future plans are.'

'Why should you bother?' she sneered bitterly. 'You and the cops! You're little better than a cheap cop yourself, Muller.'

'Don't be too hard on them, baby. Don't be too hard on me either. I'm like the guy who got caught out in midstream and didn't know which way to jump.'

'Meaning you're not sure what to believe?'

'Can you help me bring the picture into focus?'

'I wouldn't throw water over you if you were on fire, Muller.'

'So you intend to let Walter go to the wolves? Is that what you planned when you started out on this safari, Hetty?'

It was calculated to bring her up short, and that's what it did too — with coloured ribbons on. Hetty lunged to her feet with one graceful lyric of movement that put her bosom to jutting within

inches of my chest. Fear flickered momentarily in the wide blue eyes and she caught her tongue in her teeth for an instant.

'Do you realize what you've just said, Mr Muller?' she choked furiously. 'When did you ever hear of a girl setting out to ruin her own brother?'

'Not very often, I'll admit, Hetty. Brothers and sisters must stick together after all. And I did say brothers and sisters.'

Colour ran through her face in a frantic pulsing of blood. Then the blood receded and left her face pale and taut under the golden tan she'd acquired. I figured she might lose her balance and fall, and I reached out a steadying hand to her arm. She thrust it off with a vicious gesture, stooped and gathered up her bikini. She fastened it over the twin challenging mounds to prove she could really do it for herself. Then she slung her robe across her shoulders, lifted her towel and swung lithely towards the cliff path.

'Where are you off to, Hetty?'

'Anywhere, so long as I get away from

you, Mr Muller,' she sang back over her shoulder.

'And it happens you're not Walt's sister at all?'

Had I sent a bullet racing at her spine it wouldn't have jerked her up so straight and rigid a second before the sap seemed to ebb and leave her. When I reached her she had her eyes closed and her mouth twisted as though she was racked with pain. The eyes opened slowly and now they were blank, vacant caverns. The mouth relaxed until it was loose and lifeless.

'How — how did you find out, Paul?'

'It wasn't so hard, honey,' I said gently. 'I found out what Walt's real sister looked like. She was skinny and flat-chested. She had a yen to get on the stage or movie screen. Even if she'd taken all the body beautiful courses she couldn't have developed into what you are at this minute. Curves like those are heaven-sent and not something you set out to acquire. In short, Hetty — or whoever in hell you are — some dames have it and some dames don't.'

She was silent for a while after I stopped speaking. At length she gave her shoulders a fatalistic shrug and looked towards the cabin cruiser. A wistful gleam came into her eye and she laid tanned fingers on the back of my hand.

'If we're going to talk this over, Paul, we could do it more comfortably in the boat.'

'Perhaps you could talk in the boat, baby. Talking is the last thing I'd think of if we crawled into any kind of cocoon. Right now I've got to talk. Or, to be more exact, Hetty, you've got to talk and I've got to listen.'

'What an awful pity, Paul,' she said sadly. 'Some people start out being the best of friends, and finish up being the worst of enemies.'

'Like in Walter and Gloria?' I suggested.

'You've got a complex about Walter and Gloria. Don't you ever consider anything at all but work? Does the licence you carry around have to fill in for your heart?'

'Just on the times when my heart fails

me, moonflower. This could be one of them. It's a long walk up to the house and you're bound to have swum a lot of the energy out of yourself.'

'Want to take a bet on it?' she said with a little of her former sparkle. 'I could leave you panting by the wayside if I really took it into my head, Paul.'

'I wasn't going to suggest any sort of marathon, honey,' I said patiently. 'I was going to suggest we walk to the car and then let the car take us on to the house.'

'Do you have a firm rule about talking in cars?'

I shook my head. I took her elbow and led her to the Jag. She slumped down on the passenger seat and hooked a pair of cheaters on the end of her nose. When I slipped under the wheel I lifted them off.

'This is one time I want to be able to watch the green flecks in your eyes, Hetty.'

'Have you got a cigarette?'

I offered her the pack but she demurred and told me to choose her one.

'Then put our two cigarettes in your mouth and light them together, Paul. I

saw it in the movies a few times. I even saw couples doing it in the park. I figure it's kind of cute and romantic. I figured I'd have liked a guy who would have lit my cigarettes for me.'

'So you're basically a sentimentalist?' I urged when I'd done what she said.

'Basically.' She puffed deeply and sighed. 'How did you learn about Hetty? It was thin ice to skate on at the beginning, wasn't it?'

'Yeah, it was. I can see Kage imagining he could get away with it. Somehow it detracts from your obvious intelligence. It wasn't hard finding out what I did. Kage's agent put me on the track. An investigator pal did the remainder of the rough work. Kage's real sister met a Wyoming cowhand and married him a year ago.'

'My name is Willa Striker,' Hetty said musingly. 'I met old Walt a long time ago, when he was still making pictures. I thought he could get me a part in a picture. I was crazy to be an actress. He said he would see what he could do. He took me under his wing, if you see what I

mean. But he kept putting me off. I got mad enough with frustration to walk out on him. Later I wrote to him. He was married to Gloria by then and I thought he might have mellowed sufficiently to give me a minor break.

'I didn't hear from him until he visited. He could get me a part, he said. At acting too. But there wouldn't be any cameras around to record my efforts. At first I shied from the deal — '

'What was the essence of the deal, baby?' I broke in.

'He was down flat on his uppers, practically,' she said. 'He was very bitter, Paul. He had married a plain jane thinking she was loaded with green stuff.'

'And she wasn't?'

'Not loaded the way Walter expected her to be. Also, they were getting in each other's hair. He mentioned insurance. Something about a fat policy. I know nothing about insurance. I was crazy, I guess, to listen to him. Damn thing was, I was more crazy about Walter Kage than I've ever been over a guy.'

'Who would have guessed?' I couldn't help muttering.

'Oh, it cooled, Paul. One disillusion followed another. By this time I was ensconced at Clifftop as his sister. Gloria swallowed the sister gag without coughing once. I wasn't exactly welcome, but I was tolerated. Walter kept saying there were big things ahead of us. I often wondered what he meant by that. He said immediately he collected the insurance he would divorce Gloria and marry me. I wouldn't have to act for a living. I wouldn't have to do anything for a living.'

'But why did he need you to see his ambitions fulfilled? Was he in love with you?'

'I believe he is in love with me. He said he might need me when the time came. All I would have to do was say what he told me to say.'

'And to date you've done precisely what he ordered?'

'Almost. Not quite. Well, it does become a bore when a girl has nothing better to do than loaf around. Immediately I laid eyes on you — '

'Skip it,' I said crisply. 'You're not a blonde, Hetty — or Willa — or whatever tag you care to use, so you don't have to act dumb. Are you going to sit there and tell me you've no idea what wide-screen hero Walt was planning to do?'

'What was he going to do, Paul? I know you imagine he might have murdered Marvin Luce — '

'Do you also know that I imagine his wife could be the next victim in line for a broken skull?'

'No! Walter would never — You — you're saying that Walter might have planned to murder Gloria to collect — '

'Go on,' I said coldly when she ran down again. 'To collect the insurance money, baby. So at last the nickel clicks home, and you realize what you've let yourself in for?'

She slumped back on the seat and stared straight ahead of her for a moment. Her cigarette was finished and she asked me for another one. I supplied it and let her puff it alight for herself. Her gaze was muddy.

'I don't believe it,' she said finally.

'That Kage is going to kill Gloria if he can make it look good enough for the insurance people?'

'I didn't tell you everything, Paul. I was going to tell you earlier, but I changed my mind. You're taking a one-sided view of this whole thing. As far as you're concerned, Gloria is the wounded party. What would you say then if I told you that Gloria had tried to kill Walter?'

I stared blankly at her for a moment, then I grinned. 'A nice try, baby. It's an original angle, I'll grant you. But without the necessary proof where does your version stand?'

'Walter confided in me,' she explained rapidly. 'He was standing on the balcony of their bedroom one night. It was late and he hadn't switched the lights on. He thought he was alone on the balcony — until someone pushed him from behind, that was. He went over the railing but managed to catch at the climbing vines. When he made it to the bedroom there was no one there.'

'I just bet there wasn't, honey. And without a witness it shows how fertile the

guy's imagination is.'

'You believe he was telling me a lie?'

'If it happened in his imagination, then I believe he was only telling half a lie.'

The dame shuddered and drew her robe around her. 'Please take me up to the house, Paul.'

'I wasn't thinking of taking you to the house. I was thinking of taking you to the cops.'

'Oh, no! You wouldn't . . . '

'On one condition I'll agree to postpone it at least.'

'What condition?' she panted anxiously.

'That you tell me where Walter rang you from.'

'He — he didn't say where he was ringing from.'

'In that case I'd better take you to the cops, Willa.'

I switched on the motor and went into reverse in order to be facing the cliff path. I had gone forward about twenty yards when her fingers dug into the muscle of my forearm.

'All right, Paul! Damn you, I'll tell you.'

'Make it snappy, honey. Once I make

up my mind about a course of action it takes a lot to divert me.' I kept driving as I spoke. She caught my arm some more and tugged wildly.

'Stop!' she cried. 'It will take a minute to explain. I don't want to go up to the house where we'll be overheard.'

I stalled and switched off the motor. The dame lay back and struggled with herself for a few moments. I was reaching for the switch when she started talking.

'He — he asked me to take a car and meet him tonight. I was to wait until midnight, then drive to the hotel where he's hiding out and pick him up.'

'Where were you to take him from there?'

'He didn't say. Honestly, Paul, he didn't say!'

'Okay,' I told her. 'Simmer down. Tell me the name of the hotel. Tell me the truth too, gorgeous, or you'll be skinny and flat-chested like his sister by the time they release you from prison.'

'The Hotel Rex. It's on River Street . . . '

I drove her up to the front of Clifftop

and flung open the car door for her. She was so nerveless she almost fell on her face when she climbed out.

'One more thing, Willa Striker,' I said in a soft voice. 'Go in and ring Walt and the deal's off. Do anything to make him switch his roost and the deal's off. And do remember, honey, I'd much rather have you as you are than old and grey-haired and bosomless and all.'

'You bastard,' she said venomously. 'You cheap, cheap bastard.'

I threw her a salute and angled for the hill road that would take me to the village and Anfield.

16

Kage wasn't at the Hotel Rex when I reached it. He was stopping there as Wilbur Todd, I found out after I'd spent five minutes and ten bucks on the desk-clerk. He was in room forty-six, the clerk said. No, he didn't know when Mr Todd would return. He palmed me a key to go up and look at the room if I wasn't satisfied. I wasn't satisfied and I went up in the elevator to the fourth floor and nosed around. When I came back I gave the clerk the key, then told him to keep quiet about my call or he'd be searching for a new job in the morning.

From the hotel I headed for the nearest employment agency. Nobody at the agency had ever heard of Hilda Dornier. I drew blanks at three more agencies before getting the idea to request the one I was at to ring round the remaining agencies and put out a feeler. The old biddy in charge yielded to my boyish charm and

did as I asked her.

'You're in luck, Mr Muller,' she announced finally. 'Hilda Dornier is registered at the Probart Agency on Millwell Street. If you'd care to go there, they think they may be able to help you.'

I thanked her and set off for Millwell Street and the Probart Agency. By the time I reached the building and the agency office in the building, the information I required was practically on tap. Hilda Dornier was presently employed in the household of Grantley Hitchens, a guy who had started out from a filling station and made his load from used automobiles. I said thanks again and went back to the street. I shut myself in the handiest 'phone booth and rang through to the Hitchens' homestead.

Hilda Dornier wasn't at work today, I was told. This was her day off. Yes, I might find her at home. Her address was already in my possession. Miss Dornier lived in an apartment house on Berkdale Street.

My next stop was the apartment house on Berkdale Street, and when I arrived

there it was Hilda Dornier herself who answered my knock. She was thin and tough and durable, and she listened sceptically to my opening spiel. Then she asked me in and listened some more while I enlarged on the reason for my visit.

'A private detective, eh? And you want to hear about Mrs Donovan and her husband. Well, I don't know, Mr Muller. It was quite a time ago and I've never been one to gossip.'

Nevertheless she couldn't resist talking about her stay at Clifftop. Yes, Lauran Donovan had drunk more than was good for him, and yes, he had horsed around too much for any woman's liking. The row he and Gloria had on the night he was killed on the beach? Yes, there was a row. Hilda knew, because she had heard it. When Donovan flung from the house he was drunk, and plenty. His wife had gone out about the same time. Hilda had thought they both drove off in the car. But no, Gloria hadn't been with her husband when he crashed. Rumours? Naturally there were rumours. But a

woman ought to know when to talk and when to keep quiet.

It was as much as I could get out of Hilda Dornier. It could all add up to something significant, or it could be as relevant as last Sunday's lunch.

On arrival at my office I rang through to the cops. The desk sergeant said that Lieutenant Bayley wished to speak to me.

'Well, chief,' I began before he could get going, 'anything new on the Walt Kage and wife saga?'

'Listen, mug,' the lieutenant snarled, 'and listen good. We've found out that Kage was in the habit of running around in a baseball cap. We're practically certain he called on you in person.'

'But, Matt — '

'Listen, like I said, shamus,' Bayley barked. 'Kage committed that murder. At this minute he's figuring out the best way to commit another one on his wife. Now, if you know anything, Muller, you'd better talk fast.'

'You mean you haven't got a lead, Lieutenant?'

'I suppose you have, chum. This could

break you, Muller. Into little pieces. So for the last time I'm gonna ask you to co-operate the way you ought to co-operate.'

It was all old hat and I said good-bye and hung up before he had finished his patter. A few minutes later I put a call through to Clifftop. It was Ferguson who answered and I told him I wished to have a word with Hetty.

'Sorry, Mr Muller. She isn't here. Miss Hetty packed her bags and drove off in her car about twenty minues ago. Have you heard anything fresh on Mr Kage?'

I said no. Ferguson asked me if I thought Miss Hetty had left Clifftop for good. It was possible, I said. I told him not to get excited about it. Then I hung up again and thought about Hetty.

Had she taken off with the intention of making her departure a permanent one? Had she picked up Walt at some other rendezvous and both of them were taking off together?

I figured I should ring the Hotel Rex and check with the desk clerk. Then I changed my mind and decided to wait.

There was a guy who could be trusted so far and no further, and there was no point in gumming up the works prematurely. I'd just have to trust my luck and hope for the best.

<p style="text-align:center">★ ★ ★</p>

The rest of the afternoon dragged. At eleven-thirty I left for River Street and the Hotel Rex, telling myself I was the world's prize optimist if I expected Willa Striker to have observed the rules, and that Walt Kage would be sitting in his hotel room waiting for her when I walked in on him.

Fate has its own way of putting a twist in a tale.

By the time I reached River Street police sirens were in full cry, and when I drove up to the front of the hotel, official cars were filling the parking spaces. An ambulance raged in at my rear, siren blasting, warning light blinking.

I went to the lobby in a sort of daze and straightaway was confronted by a tall cop. 'Sorry, mister,' he said. 'Business has

closed down for the evening. You'd better find yourself another hotel.'

'What happened?' I demanded weakly. 'Did somebody throw a bomb.'

'A man was murdered here tonight,' the cop began. 'Hey, come back!' he yelled when I ducked round him and lunged towards the stairway.

My heart was pumping like mad when I arrived on the fourth floor. A group of rubber-necks were keeping a safe distance from the room where Walt Kage had booked in. I pushed past them, beat off another cop, and came to a halt at sight of the crumpled heap on a blood-stained rug.

'So you pop up again, mug,' Matt Bayley sneered. 'Talk about Dracula and his yen for blood — '

'Put a cork in it,' I growled at Bayley. 'He was my client, wasn't he? How did he die? Who killed him'

'Listen to the man!' the lieutenant gagged to the stiff-faced audience. 'He wants it served up on a gold platter. He was shot, mug. In the back. We don't know who killed him, mug. The killer

didn't wait long enough to tell us.'

'The killer!' I said hoarsely and stared down at what used to be ex-movie actor Walt. No matter what failings the guy had had, you couldn't help feeling that the world had been deprived of something interesting and maybe intriguing. Standing there too a lot of wheels began clicking around crazily in my brain. Pieces of the puzzle dropped from nowhere to form a pattern that fairly took the breath from me. The lieutenant yelled when I swung to leave the room.

'Hold on, shamus. Where in hell do you think you're going?'

'To find another client,' I said bleakly. 'I've just lost the one I had, haven't I? I gotta have clients to stay in business.'

I swept down to the lobby and looked longingly at the 'phone booths covered by the eagle-eyed cops. The one who'd tried to sell me the brush-off was striding purposefully towards me when I hot-footed on to the street. I flung myself into the Jag, rapped a squad car in reversing, rapped another one going forward. Finally I was free of the tangle. I drove as

far as a drugstore, went in and shut myself in the 'phone booth. Ferguson the butler answered the jingle at Clifftop.

'This is Muller, Ferg. Tell me one thing and tell me no more. Did Miss Hetty put in an appearance again?'

'No, sir. But — Hold on, Mr Muller. Mrs Kage has come home and she wishes to speak with you.'

'Mrs Kage is there?' I yammered. 'Tell her not to bother to come on. Tell her I'll be with her in thirty minutes.'

I was too. At the end of a wild drive I braked on the forecourt at Clifftop and was admitted by Ferguson. Mrs Kage would see me in the lounge, he said.

'The police rang, Mr Muller. We — we've learned that Mr Kage was murdered tonight . . . '

I prowled through to the lounge and entered without rapping. Gloria Kage was sitting on a chair close to the bar. Her face was covered with her hands and her shoulders were shaking. An empty glass was turned over at her elbow. She raised her head slowly and uncovered her face. It was red and tear-streaked. I said

nothing while she rose to her feet and took a faltering step towards me. She looked just like her photos said she would.

'You are Mr Muller, aren't you?'

'That's right. And you are Gloria Kage. So you've heard that Walt is dead. So you came home immediately you heard the news?'

She patted her cheeks and her eyes with a handkerchief. The ghost of a bitter smile hovered briefly at her lips.

'I didn't hear until I did arrive home, Mr Muller. How could I? The police have just called. Oh, it's dreadful! Too dreadful for words . . . Just when I decided to forgive Walter for everything, somebody has to murder him. And I know who, Mr Muller. I know who murdered him!'

'You do?' I took a seat when she slumped back on her chair and brought a Lucky to my mouth. 'Have you informed the police of your suspicions?'

'Not — not yet. It came to me when I heard that Hetty had gone. She wasn't his sister at all, Mr Muller. I knew it from the very start. I tried to live with it. But I

couldn't. I took as much as I could take, as any woman could take. As I told you when I called your office, I was frightened. Then Marvin was murdered — '

'You know who killed Marve as well, naturally?' I said coolly and struck a match for my cigarette.

'How can I say? Oh, I admit I was foolish. I thought I could start a new life with Marvin. But no! It was not to be. Whatever Walter was, whatever torture he had imposed on me, I still loved him, Mr Muller. And now, now . . . ' She dropped her head and covered her face and her shoulders began shaking again.

'You still haven't told me who killed Walt,' I reminded her when a moment rode by.

'It was Hetty,' she said vehemently. 'That's who. Her name wasn't Hetty at all. She was a pick-up of Walt's from somewhere. Walter must have told her they were through, and then, blinded by jealousy, she went after him and killed him.'

I let another moment drift past. Then I

got up and fixed two stiff drinks. I gave Gloria Kage one of them and resumed my seat. She stared expectantly at me, so I didn't keep her waiting.

'That's an angle,' I admitted. 'And a good one. But here is another one you'd better consider, baby.'

'What!' she panted. 'You — you don't believe me?'

'You left Walt, sure, Mrs Kage, and I dare say you had all the grounds you needed for leaving him. But whatever you had, baby, you didn't have any sort of licence for killing him.'

'I killed Walter!' she gasped. 'You're out of your mind. You're — '

'Listen,' I cut in icily. 'You left Clifftop, Mrs Kage. You also left a trail that a blind man could have followed. You did it deliberately, so it would be real easy for your husband to find you at that motel on the other side of Culver Springs. You banked on him following you, and what you didn't consider was the possibility of Walt hiring a private detective to follow you. You had a rendezvous with Marvin Luce at the motel, and if your plan went

right Walt would have bust into the motel unit instead of me, been murdered by Luce and left there for the manager to find.'

'You're mad!' she hissed. 'Completely mad.'

'Let me finish, Mrs Kage. The plan bounced like you know, and when Luce saw the victim was a private detective he let me off with a sore skull. Later Luce got the wind up. You might have figured you had a hold on him, but Marve figured the risk of making a break was worth it. First of all he tried to sell your husband a packet of information. Naturally he couldn't say what it was, and unfortunately for Walt he didn't buy. The information would have saved your husband's life. It would have let him know you were planning to murder him. When Walt wouldn't buy, Luce contacted me. He offered to tell me where I could find you for the consideration of three grand. He was plenty scared when he visited, Gloria. He might have argued with you, threatened to blow the whole story to the police, so you took the next

step necessary and bashed his skull in.'

'No, I didn't. *No!*'

'I don't know how you traced Walt to that cheap hotel, honey. But you managed it somehow. There you shot him. By this time you had murdered three men. Oh, yes, we mustn't forget your first husband, Lauran. You had a hefty policy on his life, and didn't you need something for a rainy day when Lauran was drinking so much and gambling so much? The gag you pulled on Lauran Donovan was a lulu. Getting him stoned. Getting him into his car. Sending him off down that beach path to the rocks.' It was crazy guessing and I knew it. Yet I also knew there was a grain of truth in it by the downward, vicious twisting of the dame's lips. But Gloria could be punished for only one murder, so it didn't really matter anyhow.

'All right,' she panted huskily. 'I did murder Marve. He was set on double-crossing me and he deserved it. I did murder Walter,' she went on vehemently. 'I had every right to murder him. He married me because he was flat broke almost and thought I would give him free

303

rein with the insurance money I'd collected on Lauran's policy. It didn't take long for me to find out he hadn't married me for love! So I set out to punish him. He was flat broke and I kept him flat broke. Then he introduced his so-called sister. What was she anyhow but a cheap damn strumpet! They were plotting between them. I had my first warning when Walter suggested insuring each other. Little did he know I was a past-master at the insurance game!' She laughed hysterically, emptied her glass and flung it to the carpet. 'All the time he was figuring out how to kill me I was figuring out with Marvin how to kill him.'

'It must have been quite a ball.'

'It would have been a big ball if Marvin had kept his nerve,' she retorted. 'But the louse was spineless. He turned yellow when he discovered he'd knocked out a private detective at that motel instead of Walter. What beats me is why Walter wanted to hire a detective at all.'

'Maybe he was as frightened as anybody, baby. Frightened of you. Maybe

he gave up the idea of killing you and was willing to settle for having you locked up in a rest home.'

'Nobody's going to lock me up in a rest home!'

She charged me as she spoke and I took a sharp kick to the ankle before tapping her one that sent her flying over the sofa. I don't usually do battle with dames, but this was one time when my conscience didn't even prickle. I lifted her handbag as she lay there in a state of temporary bemusement. It yielded a .38 automatic. It had been fired recently and there was one shell missing from the clip. I figured it clinched the deal and told Ferguson to 'phone the cops. I didn't have far to go to find the butler, because he and the rest of the staff were taking it all in from the doorway.

★ ★ ★

'So Kage really hired you in the first place to find his wife because he was scared of what she might do to him?' Bayley was saying much later when the dust had

settled and we reached his office to make a statement.

'It's possible it was his sole reason for hiring me, Matt. He might have set out with the notion of rigging up an accident for Gloria so he could collect on her dough. She did have the dough she collected when her first husband met with his accident.'

'Yeah, accident,' the lieutenant murmured with a hard chuckle. 'Knowing what I now know about the dame, my money says she somehow set up Lauran Donovan's accident.'

'Maybe, Matt, but we can't be sure. Anyhow, Walt could have had another reason for hiring me. He wanted to find Gloria all right. But maybe — if he was planning to kill her to collect on the insurance policy he had on her — he wanted to make a big show of seeking a reconciliation first of all, so that nobody would suspect him later.'

'You think they started out with the idea of killing each other for the money involved. Hell, I never really thought of that angle at the time! But where did you

get the inspiration that Kage might have intended murdering his wife?' he added suspiciously. 'You know what I've got, shamus? A fat hunch. That sister who was hanging around. Hetty. Did you get anything out of her? And when I come to think of it, where did she take off to anyhow?'

I wondered about Hetty for a moment and sighed regretfully. 'Maybe I could have made music with Hetty if I'd tried, Matt. Speaking in a professional context, of course.'

'Of course!' Bayley mimicked. 'But she shook the sand from her heels before you could get to first base with her,' he jibed.

'That's right, Matt. She did. But she sure looked swell when she was shaking sea water from her bathing costume.'

THE END

We do hope that you have enjoyed reading this large print book.

Did you know that all of our titles are available for purchase?

We publish a wide range of high quality large print books including:
Romances, Mysteries, Classics
General Fiction
Non Fiction and Westerns

Special interest titles available in large print are:
The Little Oxford Dictionary
Music Book, Song Book
Hymn Book, Service Book

Also available from us courtesy of Oxford University Press:
Young Readers' Dictionary
(large print edition)
Young Readers' Thesaurus
(large print edition)

For further information or a free brochure, please contact us at:
Ulverscroft Large Print Books Ltd.,
The Green, Bradgate Road, Anstey,
Leicester, LE7 7FU, England.
Tel: (00 44) **0116 236 4325**
Fax: (00 44) **0116 234 0205**

Other titles in the
Linford Mystery Library:

THAT INFERNAL TRIANGLE

Mark Ashton

An aeroplane goes down in the notorious Bermuda Triangle and on board is an Englishman recently heavily insured. The suspicious insurance company calls in Dan Felsen, former RAF pilot turned private investigator. Dan soon runs into trouble, which makes him suspect the infernal triangle is being used as a front for a much more sinister reason for the disappearance. His search for clues leads him to the Bahamas, the Caribbean and into a hurricane before he resolves the mystery.

THE GUILTY WITNESSES

John Newton Chance

Jonathan Blake had become involved in finding out just who had stolen a precious statuette. A gang of amateurs had so clever a plot that they had attracted the attention of a group of international spies, who habitually used amateurs as guide dogs to secret places of treasure and other things. Then, of course, the amateurs were disposed of. Jonathan Blake found himself being shot at because the guide dogs had lost their way . . .

THIS SIDE OF HELL

Robert Charles

Corporal David Canning buried his best friend below the burning African sand. Then he was alone, with a bullet-sprayed ambulance containing five seriously injured men and one hysterical nurse in his care. He faced heat, dust, thirst and hunger; and somewhere in the area roamed almost two hundred blood-crazed tribesmen led by a white mercenary with his own desperate reasons for catching up with the sole survivors of the massacre. But Canning vowed that he would win through to safety.

HEAVY IRON

Basil Copper

In this action-packed adventure, Mike Faraday, the laconic L.A. private investigator, stumbles by accident into one of his most bizarre and lethal cases when he is asked to collect a fifty thousand dollar debt by wealthy club owner, Manny Richter. Instead, Mike becomes involved in a murderous web of death, crime and corruption until the solution is revealed in the most unexpected manner.

ICE IN THE SUN

Douglas Enefer

It seemed like the simplest of assignments when the Princess Petra di Maurentis flew into London from her island in the sun — but anything private eye Dale Shand takes on invariably turns out to be vastly different from what it seems. Like the alluring Princess herself, whose only character flaw is a tendency to steal anything not actually nailed to the floor. Dale is in it deep, mixed-up with the most colourful bunch of fakes even he has ever run up against . . .

THE DRUGS FARM

P. A. Foxall

The police suspect an American hard-line drugs dealer escaped from custody to be in England and they know of the expensively organised release from a maximum security prison of an industrial chemist. Their investigations are hampered by their sheer innocence of the criminals' resources and capacity for corruption, even in the citadel of power. No wonder there seems little chance of uncovering the criminals' product — a dangerous and hallucinogenic drug — that could threaten the young everywhere.